Fundamentals of Capturing and Processing Drone Imagery and Data

Fundamentals of Capturing and Processing Drone Imagery and Data

Edited by
Amy E. Frazier
Kunwar K. Singh

CRC Press
Taylor & Francis Group
Boca Raton London New York

CRC Press is an imprint of the
Taylor & Francis Group, an **informa** business

First edition published 2021
by CRC Press
6000 Broken Sound Parkway NW, Suite 300, Boca Raton, FL 33487-2742

and by CRC Press
2 Park Square, Milton Park, Abingdon, Oxon, OX14 4RN

Library of Congress Cataloging-in-Publication Data
Names: Frazier, Amy E., editor. | Singh, Kunwar K., editor.
Title: Fundamentals of capturing and processing drone imagery and data /
 edited by Amy E. Frazier and Kunwar K. Singh.
Description: First edition. | Boca Raton : CRC Press, 2021. | Includes
 bibliographical references and index. | Summary: "Unmanned Aircraft
 Systems are rapidly emerging as flexible platforms for capturing imagery
 and other data across sciences. Many colleges and universities are
 developing courses on UAS-based data acquisition. This book is a
 comprehensive, introductory text on how to use unmanned aircraft systems
 for data capture and analysis. It provides best practices for planning
 data capture missions and hands-on learning modules geared toward UAS
 data collection, processing, and applications. Readers will learn how to
 process different types of UAS imagery for applications such as
 Precision Agriculture, Forestry, Urban Landscapes, and apply this
 knowledge in environmental monitoring and land-use studies"-- Provided
 by publisher.
Identifiers: LCCN 2021021247 (print) | LCCN 2021021248 (ebook) | ISBN
 9780367245726 (hbk) | ISBN 9780429283239 (ebk)
Subjects: LCSH: Aerial photography in geography. | Environmental
 monitoring--Remote sensing. | Earth sciences--Remote sensing. | Drone
 aircraft in remote sensing. | Drone aircraft--Scientific applications.
Classification: LCC G142 .F86 2021 (print) | LCC G142 (ebook) | DDC
 778.3/5--dc23
LC record available at https://lccn.loc.gov/2021021247
LC ebook record available at https://lccn.loc.gov/2021021248

ISBN: 978-0-367-24572-6 (hbk)
ISBN: 978-1-032-02249-9 (pbk)
ISBN: 978-0-429-28323-9 (ebk)

Typeset in Times
by SPi Global, India

Access the Support Material: https://www.routledge.com/9780367245726

Contents

PART I Getting Started with Drone Imagery and Data

PART II Hands-On Applications Using Drone Imagery and Data

Preface

AIM OF THIS BOOK

The motivation for *Fundamentals of Capturing and Processing Drone Imagery and Data* originated from a series of paper sessions and panel discussions on research and teaching efforts using drones that was held at the 2017 American Association of Geographers (AAG) meeting in Boston, Massachusetts. After those sessions, and in the many conversations with colleagues that followed, we recognized a growing and unmet need for a textbook that could be adopted into both undergraduate and graduate courses that would provide both a basic introduction to the fundamentals of working with drone technologies as well as practical experience processing drone imagery and data for a wide variety of analyses and applications. This book aims to provide just that – a general introduction to drones along with a series of hands-on exercises that students and researchers can engage with to learn how to integrate drone data into real-world applications. No prior background in remote sensing, GIS, or drones is needed to use this book. You do not need to have access to a drone or the capability to capture drone data to engage fully with this textbook. All data will be provided to you.

LEARNING PATHWAYS AND PREREQUISITES

Fundamentals of Capturing and Processing Drone Imagery and Data is designed for use by students in a college or university classroom or by self-learners. This section explains the learning pathways and prerequisites that will help you succeed in using this book to learn drone image and data processing and analysis skills.

To be successful using this book, you need to be able to navigate the file and folder structures on a computer and have working knowledge of spreadsheet software applications, such as Microsoft Excel or Google Sheets. The hands-on exercises contain complete step-by-step instructions, but it is recommended that you have some familiarity with GIS software such as ArcGIS or QGIS.

HOW TO USE THIS BOOK

If you are new to working with drone imagery and data, we recommend starting from the beginning of the book and working through the fundamentals in Part 1 before moving on to the exercises in Part 2. The Part 2 exercises are designed to "stand alone," meaning that you do not need to complete them in order, and there are no prerequisites for any of the chapters. However, the exercises are presented in an order that builds toward more advanced concepts, so we recommend completing earlier chapters first.

Each of the 12 hands-on exercises in *Fundamentals of Capturing and Processing Drone Imagery and Data* follows the same general format. The exercises are designed to take approximately 3–4-hours, which aligns with the length of a typical lab period. However, it is important to recognize that additional processing time may be needed beyond the expected length depending on your computer processing power. Each exercise chapter first introduces the application area and then provides step-by-step instructions for completing the exercise. Throughout the exercises, you will be presented with questions that test your knowledge and ask you to reflect on what you have learned. At the end of each chapter is a set of *Discussion and Synthesis* questions, which are

designed to have you think more deeply and critically about the central problems of the chapter and discuss these scenarios with your classmates. Finally, many chapters contain a section called *Collecting the Data Yourself* that provides guidance on how to collect images or data similar to those provided with the chapter on your own.

We have extensively tested all of the exercises in this book. However, various glitches related to software updates are always a possibility. We strongly urge instructors to work through the material prior to classroom implementation and check for the latest updates.

HARDWARE AND SOFTWARE REQUIREMENTS

The exercises in this book use a combination of basic desktop computing software (e.g., Microsoft Office products), proprietary geospatial software packages (e.g., ArcGIS, Agisoft Metashape, Pix4Dmapper), and open-source software (e.g., Mission Planner, QGIS, HEC-RAS, Spark AR) and the R open-source programming language. The table at the end of this section provides a road map for which software packages/programs are needed for each exercise.

HARDWARE

The text assumes users are working on a PC running Windows. In most cases, Mac-compatible versions of the software are available. For exercises that utilize Agisoft Metashape or Pix4Dmapper, the processing time and maximum project size that can be processed is limited by the amount of RAM available. We recommend at least 32GB of RAM.

GIS SOFTWARE

Several of the exercises utilize ArcGIS in either the Desktop or Pro version. Regardless of the version used in the directions, the exercises can be completed with either of these options or with QGIS. While step-by-step instructions are provided for all chapters, some familiarity with GIS is recommended.

AGISOFT METASHAPE

Agisoft Metashape (formerly Agisoft Photoscan) is a stand-alone software product for performing photogrammetric processing of digital images and generating 3D spatial data. Agisoft Metashape is utilized in five of the chapters. A trial version and can be downloaded from https://www.agisoft.com/downloads/request-trial/. For the exercises in this book, the Professional version of Agisoft Metashape is needed.

PIX4DMAPPER

Pix4Dmapper is a photogrammetric software for drone imagery. Pix4Dmapper is used in one of the chapters. A trial version can be downloaded from https://support.pix4d.com/hc/en-us/articles/202560729-How-to-get-a-trial-of-Pix4D-Desktop.

R/RSTUDIO

R is an open-source programming language and environment for statistical computing and graphics. For the chapters that utilize R, we recommend you use Rstudio, which is an interface that allows you to organize your R work into projects and interface with other software and sites.

You should download the latest version of R and then RStudio in order to run the code provided in this book. At the time of writing, the latest version of R is 4.0.3. New versions are released periodically, and you are encouraged to download the most recent version.

The simplest way to download and install R is to visit the R website and navigate to the download pages area. A quick internet search for "download R" should take you there. If not, you can try the following sites for Windows, Max, and Linux, respectively:

http://cran.r-project.org/bin/windows/base/
http://cran.r-project.org/bin/macosx/
http://cran.r-project.org/bin/linux/

When installing R, you may have to set a mirror site, which is the site from which the installation files will be downloaded to your computer. A good rule of thumb is to choose a mirror site that is near your location. Once you have downloaded the files, run the installation app to install the software. If you are running Windows, an R icon will be installed on the desktop, or you can search for R from the Start menu. On a Mac, you can find R in the Applications folder. The interfaces for Mac and Windows are slightly different, but the protocols are similar.

The base installation of R includes many commands and functions, but for some of the exercises you will need to install additional packages. These additional packages are listed in the individual chapters. It is recommended that you check to ensure packages are installed before attempting the exercises.

You can download the free version RStudio, which is sufficient for the exercises in this book, from https://www.rstudio.com/products/rstudio/download/

EXCEL OR OTHER SPREADSHEET SOFTWARE

Several exercises make use of Microsoft Excel (or another spreadsheet software such as Google Sheets) for performing basic calculations. It is possible to perform these calculations in other statistical software (e.g., SAS, R, SPSS, etc.) as well.

DATA

All of the necessary data and files for this book can be downloaded from the book website: routledge.com/9780367245726. If you are working in a computer lab or on a public computer, it is recommended that you save all of your files to an external drive. The data used in the exercises are real-world data collected for scientific studies. In many cases, these exact same data have been used in publications. Since the data are not simulated or perfect, you will be exposed to the nuances of working with imperfect data in an imperfect world.

Ch.	Exercise	Est. Time to Complete*	Software
8	Planning Unoccupied Aircraft System (UAS) Missions	3–4 hours	• MissionPlanner⁺ • GPS unit (optional)
9	Aligning and stitching drone-captured imagery	1–2 hours	• Agisoft Metashape Professional • QGIS/ArcGIS
10	Counting wildlife from drone-captured imagery using visual and semi-automated techniques	2–3 hours	• ArcGIS

(Continued)

Ch.	Exercise	Est. Time to Complete*	Software
11	Terrain and surface modeling of vegetation height using simple linear regression	3–4 hours	• Agisoft Metashape Professional • ArcGIS • Spreadsheet software
12	Assessing the accuracy of geospatial products derived from SfM-MVS techniques	4 hours	• Agisoft Metashape Professional • QGIS or ArcGIS • Spreadsheet software
13	Estimating forage mass from unmanned aircraft systems in rangelands	2–5 hours	• Pix4Dmapper • ArcGIS/QGIS • Spreadsheet software
14	Applications of UAS-derived terrain data for hydrology and flood hazard modeling	3–4 hours	• Agisoft Metashape Professional • ArcGIS • HEC-RAS+
15	Comparing UAS and terrestrial laser scanning (TLS) methods for geomorphic change detection	3 hours	• Agisoft Metashape Professional • ArcGIS Desktop • GCD 7 Add-In for ArcGIS+
16	Digital preservation of historical heritage using 3D models and augmented reality	3–4 hours	• Agisoft Metashape Professional • ArcGIS/QGIS • Spark AR Studio+ • Spark AR Player App+
17	Identifying burial mounds and enclosures using RGB and multispectral indices derived from UAS imagery	3–4 hours	• Agisoft Metashape Professional • R/Rstudio with GDAL package installed
18	Detecting scales of drone-based atmospheric measurements using semivariograms	1–2 hours	• Agisoft Metashape Professional • R/Rstudio with gstat package installed • QGIS/ArcGIS
19	Assessing the greenhouse gas carbon dioxide in the atmospheric boundary layer	3–4 hours	• Excel with Visual Basic for Applications (VBA)

* Estimated completion times do not include processing time. Processing times in Agisoft Metashape and Pix4Dmapper will vary depending on hardware capabilities.

+ Instructions for downloading and installing Mission Planner software are provided in Chapter 8. Instructions for downloading and installing HEC-RAS are provided in Chapter 14. AddIn download and installation details for Chapter 15 are available on the Geomorphic Change Detection (GCD) software website: http://gcd.riverscapes.xyz/Download/. Additional instructions are provided in the chapter.

FONT CONVENTIONS

- This text uses Times.
- **Bolded** terms are defined in the Glossary at the end of the book. In the hands-on exercises in Part 2, certain steps are also bolded.
- `Courier New` font is used when referencing data folder, files, and directories in the hands-on exercises in Part 2
- `Noto Sans Mono CJK JP` font is used when referencing code snippets in the hands-on exercises in Part 2
- Double quotation marks are used to indicate the "file name" when instructions are given for how to name output files in the hands-on exercises in Part 2.
- *Notes: these are written in quotations and provide supplemental information for the steps in the exercises.*

Acknowledgments

We are most grateful for the many people who helped with this book. First, we would like to thank our many colleagues that encouraged us to write this book and recognized the need for a book that not only covered the basics of capturing and processing drone imagery and data but also had the potential to advance practical knowledge of data processing and analysis. We wish to thank the many authors that contributed chapters to this book. Without your varied perspectives and expertise, we would not have been able to achieve the aim of this book. Feedback from very dedicated external reviewers also improved the chapters. AEF would specifically like to thank Arnold Kedia, Stephen Stoddard, Stuart Guffy, and Sevag Sassounian from the School of Geographical Sciences and Urban Planning (SGSUP) at Arizona State University for their help in testing the hands-on exercises. AEF would also like to thank the many SGSUP interns who contributed to exercise testing during summer 2020. Many thanks go to Taylor and Francis personnel, specifically Irma Britton (Senior Editor) and Rebecca Pringle who were very helpful during production and flexible to the unique structure of this book.

AEF would like to thank Arizona State University's School of Geographical Sciences and Urban Planning and the SPatial Analysis Research Center (SPARC), and KKS would like to thank AidData, a research lab at William & Mary, and the Global Research Institute, and the Center for Geospatial Analytics at North Carolina State University for providing support and resources. Both AEF and KKS also thank their wonderful colleagues who helped this book become reality.

Amy E. Frazier
Arizona State University

Kunwar K. Singh
The College of William & Mary

Editors

Amy E. Frazier is on the faculty in the School of Geographical Sciences and Urban Planning at Arizona State University and is a core faculty member in the Spatial Analysis Research Center (SPARC) and the Center for Global Discovery and Conservation Science. Her research combines remote sensing, GIScience, and landscape ecology to study environmental change.

Kunwar K. Singh is a Geospatial Scientist at AidData research lab and an Affiliate Faculty in the Center for Geospatial Analysis at the College of William & Mary. He has extensive experience in remote sensing data acquisition, processing, and analysis, including the application of LiDAR (light detection and ranging) and UAS to measure, map, and model landscape characteristics and resources. His research focuses on land and vegetation dynamics and their impacts on natural resources.

Contributors

Qassim Abdullah, PhD, CP, PLS, has more than 40 years of combined industrial, research and development, and academic experience in analytical photogrammetry, digital remote sensing, and civil and surveying engineering. As chief scientist for Woolpert, Dr. Abdullah designs, develops, and implements evolving remote sensing technologies for geospatial users. Abdullah serves as an adjunct professor at Penn State and the University of Maryland, Baltimore County (UMBC), ASPRS fellow, and publishes a monthly "Mapping Matters" column in the PE&RS Journal. Abdullah received several prestigious awards among them the Fairchild Photogrammetric Award and in 2019 he received the ASPRS Lifetime Achievement Award.

José Juan Arranz Justel has a PhD in Geographic Engineering. Currently, he is Professor at the Universidad Politecnica de Madrid, teaching the subjects of Spatial Analysis, Remote Sensing, Linear Civil Works Layout, and Computer Applications Development. He is the author of the software of Digital Models and treatment of point clouds MDTopX distributed by Digi21.net. His experience and contributions are focused on the development of algorithms for the management of point clouds, raster images, and digital models, from a cartographic point of view. He is a pilot of RPAs with different characteristics and has a module of Expert in BIM data processing.

Sergio Bernardes is the Associate Director of the Center for Geospatial Research and Adjunct Assistant Professor in the Department of Geography at the University of Georgia. He directs the Disruptive Geospatial Technologies Lab (DiGTL), dedicated to software/hardware solution development and applications of unmanned aerial systems, augmented, mixed, and virtual reality, to collect and explore geospatial data. Since 1989, he has been working on the interface between applications and the development of software solutions for the geospatial field, including the design and implementation of large geospatial projects for government, industry, and academia. He is an FAA-certified remote pilot and has been using unmanned aerial systems for remote sensing since 2013.

Tamika Brown received a Master of Geospatial Information Science and Technology at North Carolina State University. She is currently interested in geospatial crime mapping and its effect on privacy.

Wing H. Cheung is a Professor of Geography and Geographic Information Science at Palomar College, where he also coordinates the school's Drone Technology, Geographic Information Science, and Environmental Studies programs. He is currently the Principal Investigator of the National Science Foundation (NSF) funded Unmanned Aircraft System operations Technician Education Program (UASTEP) and an Assistant Director of the NSF funded National Geospatial Technology Center of Excellence (GeoTech Center). He is an FAA-certified Part 107 drone pilot. His research focuses on the emerging applications of drone technology in GIS, flood risk mapping, and human–environment interactions in the context of natural hazards.

Anthony R. Cummings teaches in the School of Economic, Political and Policy Sciences at the University of Texas at Dallas. Cummings's work focuses on human–environment interactions and is situated within the swidden agriculture landscapes of Guyana.

Ron Deonandan is an electrical engineer with responsibilities for the management of the Hydrometeorological Service of Guyana Automatic Weather Station Network. Ron's role includes installation, operation, data collection, maintenance, and expansion of the Weather Station Network. Ron is actively exploring how UAS can make a difference in providing more efficient weather data to Guyanese.

Alexandria M. DiMaggio is a Graduate Research Assistant for Caesar Kleberg Wildlife Research Institute at Texas A&M University–Kingsville. Her research includes using Unmanned Aerial Vehicles for biomass estimation and the effect of grazing on invasive species in semiarid landscapes. Her focus is on tanglehead, a native invader to South Texas.

Petr Dvorak is an aerospace engineering professional with interest in remote sensing from unmanned aircraft. Currently, he works in the role of Head of Aerial Intelligence at DataFromSky, providing traffic insights to engineers, researchers, and governments. Petr also acts as a researcher at Brno University of Technology, where he leads the UAV group. He earned degrees in aerospace engineering in Brno (CZ) and Bristol (UK), and he has more than 23 years of experience with unmanned aircraft.

Jennifer Fowler is Director of the University of Montana's Autonomous Aerial Systems Office. Her expertise lies in areas of autonomous atmospheric data collection and weather modeling research. She has 15 years of experience with autonomous systems and collaborations around the world. Her current focus is coordination of UM faculty, staff, and students for understanding and decision-making regarding implementation of unmanned aircraft systems (UAS), establishing the infrastructure and resources in order to create sustainable autonomous aerial research and to stimulate UAS-related innovation, entrepreneurship, and workforce development in the state of Montana.

Gil Rito Gonçalves is Assistant Professor at the University of Coimbra where he teaches Photogrammetry, Remote Sensing, and 3D Modelling. As researcher of INESC–Coimbra he has been involved as principal investigator and team member in several research projects funded by the Portuguese Foundation for Science and Technology (FCT) in the areas of Laser Scanning, Image Processing, and Remote Sensing of the Environment. His research interests are in geospatial computer vision and geo-information extraction from spaceborne, airborne, UAS, and terrestrial imagery and laser scanning data. From 1991, he is a FAI-certified paragliding pilot with more than 2000 hours flown and has been involved in the use of UAS for Photogrammetry and Remote Sensing since 2015.

Jacquy Gonsalves is a logistics officer at the Hydrometeorological Service of Guyana. Jacquy has been working on mapping unfamiliar landscapes in Guyana and is keen on understanding how swidden landscapes impact weather forecasting models.

Benjamin L. Hemingway is a Postdoctoral Research Scholar in the School of Geographical Sciences and Urban Planning at Arizona State University. His expertise is in geostatistics, GIScience, and remote sensing.

Sorin Herban is Professor of Geodesy at the Politehnica University of Timisoara, Vicedean of Civil Engineering Faculty. His area of interest is related to creating 3D models for cultural heritage objects using digital photogrammetry and terrestrial lesser scanning techniques, remote sensing and its applications in environmental processes, monitoring the settlements of buildings and

landslides areas. In the last five years, he managed or took part in important international projects under EU, SEE, and Bilateral with Germany, Italy, Norway, Island, China, etc. He is leading the laboratory of Geoinfomatics and Land Measurements at Politehnica University of Timisoara.

Zach Hilgendorf is a PhD student and researcher in the School of Geographical Sciences and Urban Planning at Arizona State University. His research interests include coastal, aeolian, and fluvial geomorphology, sediment transport processes, dune ecosystem restoration, and restoration/applied geomorphology. His current research utilizes close-range remote sensing technologies (e.g., terrestrial laser scanning, UAS) to explore geomorphic change in beach-dune environments over time and space.

Jarrod C. Hodgson is an ecologist at the University of Adelaide in Australia. He has extensive experience in the application of drones for biological monitoring in tropical, temperate, and polar environments.

Travis Howell earned a master's in Forest Management and GIS at North Carolina State University, and he is a Remote Sensing Project Manager at WithersRavenel in Cary, North Carolina. He specializes in UAS LiDAR, UAS photogrammetry, and terrestrial HD scanning data acquisition and point cloud analysis. He has been flying UAS's since 2014 and a licensed Part 107 pilot since its inauguration in 2016.

Gustavo Britto Hupsel de Azevedo is an Electrical and Computer Engineer at the University of Oklahoma in the Center for Autonomous Sensing and Sampling. His expertise is in sUAS, sensor integration, and system development.

Jennifer L.R. Jensen teaches remote sensing and GIScience in the Department of Geography at Texas State University in San Marcos. Her research focuses on remote sensing applications for land cover/land-use change, landscape ecology, and vegetation structure modeling using a variety of platforms including both fine and coarse resolution passive satellite systems, lidar, and UAS.

Jose de la Luz Martinez is a Rangeland Management Specialist for the Natural Resources Conservation Service. He provides agency technical leadership in all areas of grazing land management and conservation for the South Texas Region.

Marguerite Madden is the Director of the Center for Geospatial Research and a Professor in the Department of Geography at the University of Georgia, where she teaches courses in remote sensing and geographic techniques. Her research over the past 40 years has used emerging geographic technologies to assess the impacts of animal and human activities on vegetation distributions and landscape patterns. Dr. Madden is a Fellow and Past President (2007) of the American Society for Photogrammetry and Remote Sensing, Past President of the International Society for Photogrammetry and Remote Sensing Technical Commission IV, "Digital Mapping and Geodatabases" (2008–2012) and she was the ISPRS Council Second Vice President (2012–2016).

Salvatore Manfreda is Professor of Water Management, Hydrology, and Hydraulic Constructions at the University of Naples Federico II. He is currently the Chair of the COST Action Harmonious (CA16219) and the Scientific Coordinator of the Research Grant aimed at the Development of the Flood Forecasting System of the Basilicata Region Civil Protection. He has broad interest on flood risk, distributed hydrological modeling, stochastic processes in hydrology, soil moisture process, vegetation patterns, and UAS-based monitoring.

Katherine Markham is a doctoral student at the Center for Geospatial Research at the University of Georgia. Katherine's interests include biodiversity conservation, land-use change, and the use of remote sensing to complement conservation and ecological fieldwork.

Elinor Martin is a faculty member in the School of Meteorology at the University of Oklahoma and is an affiliate faculty at the South Central Climate Adaptation Science Center and Center for Autonomous Sensing and Sampling. Her expertise is in climate variability and change.

Adam J. Mathews teaches introductory geospatial technologies, remote sensing, and GIS in the Department of Geography, Environment, and Tourism at Western Michigan University in Kalamazoo, Michigan. His research uses high-to-very high spatial resolution imagery and 3D data from lidar and UAS-based Structure from Motion to examine a variety of environmental topics including land cover/land-use change, vegetation canopy modeling, and urban analyses.

Persaud Moses is a Makushi farmer who lives in the village of Wowetta, North Rupununi, Guyana. Persaud is a botanist who studies and documents his people's interactions with the plants found in their forests. Persaud works with his elders to understand how they have used plants in the past and seeks to ensure their knowledge is passed on to the next generation of Makushi children.

Jaylene Naylor is the Assistant Director of the University of Montana's Autonomous Aerial Systems Office. In that role, she has had many opportunities to work with a wide array of faculty, staff, and students as well as many public and private sector groups on remote sensing projects with UAS. She has 13 years of experience in developing and teaching physics lab courses and on special projects involving platforms such as the Pixhawk flight controller. She is a UAS pilot and trainer of students and faculty and is also responsible for drone maintenance and development of workflows including data processing.

Arnold Norman is a village leader and Makushi farmer from the village of Wowetta, North Rupununi. Arnold is an agriculturalist by training and has a keen interest in understanding how UAS technology can improve food production in his village.

J. Alfonso Ortega-S. is a Professor and Research Scientist at The Caesar Kleberg Wildlife Research Institute at Texas A&M University–Kingsville. He is a range scientist and his research focuses on the application of rangeland practices to maintain and/or improve habitat for wildlife and domestic animals. In addition to his academic activities he has ample experience in ranching, and he is a consultant for cattle/wildlife operations in South Texas and Northern Mexico.

Michael T. Page is a Graduate Research Assistant for Caesar Kleberg Wildlife Research Institute at Texas A&M University–Kingsville. His research includes using Unmanned Aerial Vehicles for Range and Wildlife Studies. Other research includes using geospatial technologies and spatial sciences to analyze wildlife habitat and rangeland condition.

Humberto L. Perotto-Baldivieso is an Associate Professor and Research Scientist at The Caesar Kleberg Wildlife Research Institute at Texas A&M University–Kingsville. He is a landscape ecologist and his research focuses on the development of methodologies and applications of spatial sciences to rangelands and wildlife habitat. This includes the analysis of landscape patterns, land-use land cover change, and their potential impact on wildlife and livestock.

Elizabeth Pillar-Little is a research scientist and assistant director of the Center for Autonomous Sensing and Sampling at the University of Oklahoma. She is an atmospheric chemist, and her research focuses on exploring the interplay between chemistry, aerosols, and boundary layer processes. Her expertise is in atmospheric chemistry and aerosol properties.

Christoph Reudenbach is Head of the Department of GIS and Environmental Modelling at the University of Marburg. His work includes the development of Software and Hardware for capturing drone imagery in high temporal and spatial resolution. The resulting workflows have been implemented in large-scale research projects.

Sebastian Richter holds degrees in biology and geography. He is working as a lecturer at the Philipps–University of Marburg and as a GIS Analyst at an Environmental Consulting Office where he is implementing workflows for drone-based monitoring of wildlife disturbance in the renewable energy sector.

Britta Ricker is on the Faculty in the Copernicus Institute for Sustainable Development at Utrecht University in the Netherlands. Her research focuses on the use of accessible spatial technologies, particularly mobile map interfaces and UAS technology, for monitoring and communicating the effects of change. Her work combines qualitative research methods with remote sensing, cartography, and GIS. She has worked with the United States Federal Emergency Management Agency, the Commission for Environmental Cooperation, and recently she has published a book with the United Nations about Mapping the Sustainable Development Goal Indicators.

Agnes Schneider graduated in Archaeology at the Eötvös Loránd Tudományegyetem in Budapest and is currently graduating in Physical Geography at the Philipps–University of Marburg. She has worked at various archaeological excavations and is interested in understanding (archaeological) landscape patterns and sites through statistical and spatial analysis of remote sensing and archaeological data using open-source software and reproducible workflows.

Jochen E. Schubert is a geomatics and hydraulic modeling Research Specialist at the University of California, Irvine, in the Department of Civil and Environmental Engineering. His research leverages drones to collect data for flood hazard modeling in data-scarce regions, to monitor plastic debris in transboundary watersheds on the US-Mexico border, and to study beach dynamics in Southern California. Jochen is also a consultant for the NSF funded UASTEP program, where he assists with the design and implementation of UAS workshops for high school students as well as professional development workshops for faculty members. He is an FAA-certified Part 107 drone pilot.

Angad Singh is the Director of Business Development at BRINC Drones; formerly a Business Development Executive at Pix4D. Angad is a known industry speaker, having presented and taught workshops around the globe and at many university remote sensing programs. A graduate of McGill University in Montreal, Canada, he focused his undergraduate research on using drones, remote sensing, and machine learning to produce a crop yield prediction model for corn. He is very appreciative to the editors of this book, university advisor Dr. Margaret Kalacska, and Dr. Prabhjot Kaur.

Craig Turner is a research technician and teaching laboratory coordinator for the School of Geographical Sciences and Urban Planning at Arizona State University. As an avid mountain biker, he has a love for the outdoors that has fueled his desire to study earth processes. His passion

for technology led him to his role at Arizona State University and exploring the world of remote sensing in different environments.

Ian J. Walker is a Professor and geomorphologist in the Department of Geography at the University of California, Santa Barbara. His research expertise includes coastal and aeolian geomorphology, sediment transport processes, coastal erosion, sand dune systems, and dune ecosystem restoration. His research involves field measurement of geomorphic processes and use of close-range remote sensing technologies (e.g., terrestrial laser scanning, UAS, time-lapse photography) to explore process-response dynamics of beach and dune environments.

Acronyms and Abbreviations

AGL	Above Ground Level
AMSL	Above Mean Sea Level
AMT	Above Mean Terrain
ABL	Atmospheric Boundary Layer
AUVSI	Association for Unmanned Vehicle Systems International
BeUAS	Belgian Drone Federation
CAA	Civil Aviation Authority (U.K.)
CCD	Charge Coupled Device
CMOS	Complementary metal–oxide–semiconducto
CHM	Canopy Height Model
CFR	Code of Federal Regulations
DCM	Digital Canopy Model
DEM	Digital Elevation Model
DHM	Digital Height Model
DSM	Digital Surface Model
DTM	Digital Terrain Model
EASA	European Aviation Safety Agency
FAA	Federal Aviation Administration (U.S.)
GCD	Geomorphic Change Detection
GNSS	Global Navigation Satellite System
GPS	Global Positioning System (U.S.)
GSD	Ground Sampling Distance
ICAO	International Civil Aviation Organization
IMU	Inertial Measurement Unit
Lidar	Light Detection and Ranging (also written LiDAR, LIDAR, or lidar)
MAV	Micro air vehicle – generally weighing less than 1g
MSL	Mean Sea Level
MVS	Multi-view Stereo
NAIP	National Agriculture Imagery Program (U.S.)
NASA	National Aeronautics and Space Administration (U.S.)
nDSM	Normalized Digital Surface Model
NDVI	Normalized Difference Vegetation Index
NTSB	National Transportation and Safety Board
RPA	Remotely Piloted Aircraft
RPAS	Remotely Piloted Aircraft System
RPV	Remotely Piloted Vehicle
SIFT	Scale Invariant Feature Transform
SfM	Structure from Motion
sUAS	small unmanned (unoccupied, uncrewed) aircraft system – generally weighing less than 25 kg
TLS	Terrestrial Laser Scanning
TIN	Triangular Irregular Network
UA	Unmanned (unoccupied, uncrewed) aircraft
USGS	United States Geological Survey
UAS	Unmanned (unoccupied, uncrewed) aircraft system

UAV	Unmanned (unoccupied, uncrewed) aerial/air vehicle
VGI	Volunteered Geographic Information
VLOS	Visual line of sight
VO	Visual observer
VRF	Visual Flight Rules
VTOL	Vertical takeoff and landing

Part I

Getting Started with Drone Imagery and Data

1 Introduction to Capturing and Processing Drone Imagery and Data

Amy E. Frazier and Kunwar K. Singh

CONTENTS

INTRODUCTION

Drones, also referred to as UAS, UAVs, RPVs, or RPAS are rapidly emerging as the "go to" platforms for capturing imagery and other data. The latest innovations in hardware coupled with the decreasing cost of consumer electronics have made drones accessible to a wide audience, leading to rapid adoption of these technologies. Mapping and monitoring with drones is becoming a staple in many industries like forestry, agriculture, surveying, construction, oil and gas, and real estate as users can quickly collect their own aerial data to inform decision-making. Drones are also being used to monitor wildlife, forecast weather, and detect chemical releases. The proliferation of these technologies is so widespread that new businesses are being created focused entirely on providing drone services to capture and generate data and products for clients. In short, drones are powerful technologies for capturing imagery and data that are transforming not only the way in which companies operate and research is conducted around the world but allowing anyone to engage in "personal remote sensing" (Jensen 2017).

BOOK STRUCTURE

This book introduces the fundamentals of capturing and processing drone imagery and data. The learning materials contained in this book were developed by experts working at the leading edge of drone research and applications. The book is divided into two parts. The first part provides a gentle introduction to the science and art of collecting and processing drone imagery and data and a practical foundation for undertaking missions and analyses. The second part builds on this foundation through a collection of hands-on exercises that will help you master data collection and data processing workflows.

Starting in Chapter 1, you will learn the foundational terminology, platform characteristics, and aspects of safe operations that are important to consider before you take flight. Since much of the data collected using drones and many of the applications you will engage with in the second part involve remotely sensed imagery, Chapter 2 provides a brief introduction to the theory of remote sensing and photogrammetry, specifically as they relate to drones. Remotely sensed data can be captured using a wide array of different sensors, and Chapter 3 introduces some of the most common sensors being flown on drones. Chapter 4 will walk you through the mission planning process for capturing images from drones, and Chapter 5 will help you understand the regulatory environment in which flight planning will take place and the rules for safe operations in U.S. airspace. Chapter 6 shifts to post-flight data processing and introduces the workflows for processing images into data products. Lastly, Chapter 7 introduces readers to the techniques of aerial cinematography, an emerging use area.

Armed with an understanding of remote sensing, data collection sensors, and processing techniques, you will be well equipped to tackle the hands-on exercises in the second part of this book. The second part includes 12 exercises that have been designed to teach many different aspects of drone data collection and processing. The exercises have been sequenced to progress from preflight mission planning in Chapter 8, to basic data processing and visual analysis in Chapters 9 and 10, to more advanced data processing to produce 3D surface models and orthomosaics in Chapters 11–14. Once you have established a solid foundation for developing products from drone imagery, Chapters 15–17 introduce more advanced integration of those products with additional datasets using add-on software programs, including augmented reality applications. The final exercises in Chapters 18 and 19 focus on capturing and analyzing non-imagery, atmospheric data.

Together, the 12 exercises introduce a wide variety of applications that are presented in more detail below and include wildlife surveying (Chapter 10), agriculture (Chapter 11), rangeland management (Chapter 13), hydrological modeling (Chapter 15), coastal geomorphology (Chapter 16), historical artifacts and preservation (Chapters 16 and 17), and atmospheric monitoring (Chapters 18 and 19). You will be introduced to some of the most widely used software for processing drone data including Mission Planner, Agisoft Metashape, and Pix4Dmapper, and you will gain experience creating a range of data products that can be imported into any of the leading GIS software platforms. After completing the hands-on exercises, you will have command of the skills for capturing and processing drone imagery and data for a wide range of applications.

DRONE TERMINOLOGY

Before diving into the nuts and bolts of capturing and processing drone data, it is useful to unpack some of the terminology you will come across in this book and beyond. Knowing the different terms and acronyms can also help you identify the appropriate rules and regulations for flying, wherever you are located. A **drone** is simply a pilot-less aircraft. The first instances of powered drones were developed by militaries around the world for combat purposes, and so

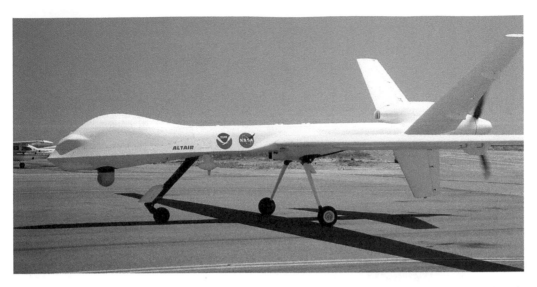

FIGURE 1.1 A photo of a Predator drone taken at a U.S. Air Force base. Photo is in the public domain
https://commons.wikimedia.org/wiki/File:Predator_Drone_021.jpg

the term "drone" has carried a somewhat negative connotation over the years. The term drone
was even considered taboo, and researchers and scientists made a concerted effort to use more
neutral terms like "unmanned" or "unoccupied" aircraft and "remotely piloted vehicles"
instead. More recently, perception has shifted, as the uses of these technologies beyond mili-
tary endeavors are becoming more widespread. For instance, the Predator drone (Figure 1.1)
has been used by the United States Air Force for offensive operations, but it has also been used
for civilian operations to monitor severe weather and wildfires. Recent research suggests the
term "drone" is no longer impacting public support for their use (Pytlik Zillig et al. 2018).
Around the world, agencies such as the French Directorate for Civil Aviation, the French
Federation of the Civil Drone, and the Belgian Drone Federation (BeUAS) have all officially
adopted the term "drone."

Another common term and acronym you will see is **unmanned aerial vehicle**, or UAV.
This term was popular among enthusiasts and researchers in the early rise of drone use, and it
is used around the world. However, many have noted that the term "vehicle" does not fully
capture the integrated components of the entire system. So, while you will still see the term
UAV used around the world, many agencies have adopted other naming conventions.
Specifically, agencies in the United States and the United Kingdom have officially adopted
the terminology **UAS** to refer to these as **unmanned/unoccupied/uncrewed** or **unpiloted
aircraft system**. The use of the word "system" recognizes that a drone is more than just a fly-
ing platform but consists of a system of complementary technologies including the physical
platform with its sensor hardware, a ground station where the platform can be controlled
remotely, and a communication link between the ground and the platform that allows data and
information to be passed between the two (Figure 1.2). Examples of institutions that have
adopted "UAS" as the official term include the U.S. Department of Defense, the U.S. National
Science Foundation, and the U.K. Civil Aviation Authority. In the U.S., the term small
unmanned aircraft system (sUAS) is also used to refer to platforms weighing less than 55 lbs.
The similar term **remotely piloted aircraft system** (RPAS) has been adopted by organiza-
tions such as the International Civil Aviation Organization (ICAO), the European Aviation

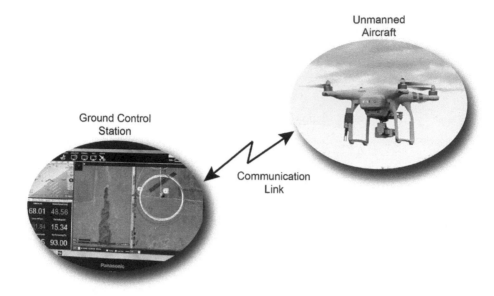

FIGURE 1.2 The three components of a UAS: (1) the unmanned aircraft platform, (2) the ground control station, and (3) the data communication link between 1 and 2.

Safety Agency (EASA), the Civil Aviation Safety Authority in Australia, and the Civil Aviation Authority in New Zealand.

> The terms **UAS** and **drone** are adopted in this book and are used interchangeably throughout the chapters. You may also come across any of the other terms and acronyms that refer to the same thing.

FLYING AND SAFE OPERATIONS

Safety is the most important priority when operating a drone as a hobbyist, researcher, or in a commercial capacity. Putting an aircraft into national airspace can be dangerous, and it is necessary to follow all of the correct steps to minimize risk to other aircraft, people, and property. First and foremost, it is important to **know the federal, state, and local regulations for the area in which you plan to fly**. Temporary flight restrictions can change at any time, and you need to be certain that your operations are compliant with all national, state, and local regulations at all times. There are many information sites and apps that you can use to determine where you are allowed to fly. Chapter 5 will dive deeper into safe operations for drones with a focus on flying in the United States. The bottom line is that before you fly, be sure you know the local, state, national, and international rules for operating drones.

PLATFORMS

One of the first decisions to make when getting started with drones is which type of platform to choose. Most drones are classified as either **fixed wing** or **rotary wing**, and these can range in size from miniature drones that fit in the palm of your hand to massive aircraft that require runways to take-off and land. Certain platforms are better suited for certain types of missions, so knowing the

	Fixed Wing	Rotary Wing
Flight Times	Long	Short
Cruising Speed	High	Low
Payload Capacity	High	Low
Areal Coverage	Large	Small
Wind Resistance	High	Low
Take-off & Landing	Large area	Small area
Maneuverability	Low	High
Skill to Operate	Higher	Lower
Cost	Generally Higher	Generally Lower
Example Applications	Large area mapping; meteorology; weather surveillance; pipeline monitoring	Small area mapping; surveying; inspections; aerial cinematography; marketing; emergency response; real estate

FIGURE 1.3 Comparison of fixed-wing versus rotary-wing aircraft.

benefits and disadvantages of each type can help you choose a platform that best suits the needs of your project (Figure 1.3). In general, rotary-wing platforms are smaller, slower, and can cover less area compared to fixed-wing platforms. However, rotary-wing platforms are often easier to maneuver and control and can be cheaper to acquire and operate than fixed-wing platforms.

FIXED-WING PLATFORMS

Fixed-wing platforms, sometimes called **flying wing**, are designed and operate like traditional airplanes. Fixed-wing platforms consist of a rigid wing that makes flight possible by generating lift caused by the forward airspeed of the drone (Figure 1.4). Kitewing platforms are also included in this category. Airspeed is generated by a propeller being turned by an internal combustion engine or electric motor. The main advantage of a fixed-wing platform is that the structure is simple compared to a rotary wing, which means they have more efficient aerodynamics. This efficiency translates into longer flight durations at higher speeds, enabling larger surveys during a given flight. Fixed-wing aircraft are also able to carry more weight (including sensors) for longer distances while using less power. Fixed-wing platforms are ideal for longer flight missions, such as oil and gas pipeline inspections, because they can fly longer than rotary-wing drones on a battery cycle. They are typically more stable in high winds compared to rotary wings, and their design allows them to glide down to Earth if they ever lose power, theoretically allowing them to recover more safely from a power loss than a rotary-wing platform.

There are some disadvantages to using fixed-wing platforms. Fixed-wing aircraft tend to cost more than rotary-wing platforms. Operations can be more challenging, particularly when it comes to maneuvering these platforms in the air. Other disadvantages are the sometimes large takeoff and landing zones required for these aircraft, making them ill-suited for use in certain terrain or

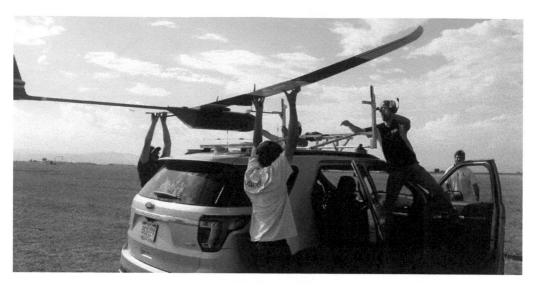

FIGURE 1.4 A fixed-wing drone being loaded onto a car rooftop-mounted launcher. [Photo credit: Jamey D. Jacob].

situations. Some platforms require a runway or a large launcher, which makes it more difficult to transport them to remote sites. Drone companies are innovating this drawback though and have started to develop fixed-wing platforms with vertical takeoff and landing (VTOL) capabilities. This specific type of fixed-wing platform takes off vertically like a helicopter, and once it has reached the desired flying altitude, it pivots to a horizontal position to fly the mission. When the mission is complete, the platform switches back to its rotor capabilities for a vertical landing.

ROTARY-WING PLATFORMS

Rotary-wing platforms, often referred to as simply "multi-rotors," look and operate more like helicopters. They consist of blades that revolve around a fixed mast, known as a rotor. The number of rotors can vary with a minimum of one rotor (helicopter) up to three rotors (tricopter), four rotors (quadcopter), six rotors (hexacopter), eight rotors (octocopter), and even more. Unlike fixed-wing aircraft, which require a constant forward movement to remain airborne, the blades of a rotary-wing platform are in constant motion, producing the required airflow to generate lift and keep the platform airborne. Control of the platform comes from varying the thrust and torque from the rotors. For example, a quadcopter's downward pitch is generated from the rear rotors producing more thrust than the rotors in the front, which enables the rear of the quadcopter to raise higher than the front thus producing a nose-down attitude.

A big advantage of rotary-wing platforms is their ability to take off and land vertically, which allows them to be operated within smaller and more confined areas compared to fixed-wing aircraft. Rotary-wing platforms are also comparatively easier to maneuver and so are well suited for applications like telephone pole inspections where tight turns and hovering are required. However, rotary-wing aircraft are generally more complicated to maintain and repair. The lower speed of these platforms relative to their fixed-wing counterparts also results in shorter flight ranges that lead to many more flights being required to survey large areas. However, rotary-wing platforms are frequently adopted for mapping because they are easier to operate, cheaper, and have smaller space requirements for takeoff and landing (Figure 1.5). According to DroneDeploy, a leading cloud-based software platform for processing drone-captured imagery, more than 95% of mapping with their software occurs with rotary-wing aircraft.

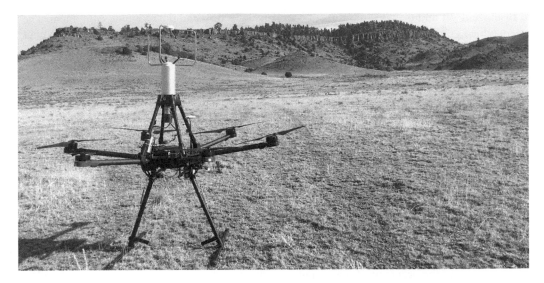

FIGURE 1.5 A rotary-wing (hexacopter) drone awaiting flight.

Which Platform to Choose?

Choosing which type of platform to use for imagery and data collection is a big (and potentially very expensive!) decision. First, know your mission and data collection needs. If you need a drone to capture pictures for a real estate brochure, you will likely want to choose a different platform than if your mission is to monitor 100 kilometers of oil and gas pipelines. Next, consider your budget. A fixed-wing platform might be able to cover a larger area faster than a rotary-wing platform, but the tradeoff in cost and operations might not be worth the time saved. While it might be tempting to buy a platform with all of the bells and whistles, you may be able to generate a similar product with a cheaper option. A look at some of the most common platforms being used for terrestrial mapping applications showed that almost 40% of studies used a low-cost (<$2000) platform like the DJI Phantom (Singh and Frazier 2018). It is very possible to capture high-quality images and generate accurate models without breaking the bank.

Some questions to ask yourself as you are considering what type of platform to select are:

- What is the budget for the project?
- What areas, landscapes, or structures are you looking to document?
- What is the extent of the area, landscape, or structures?
- What object sizes are you aiming to resolve with the data or imagery?
- What are the weather or other flying conditions likely to be?
- How much room will there be on-site in which to take off and land safely?
- What type of sensor is required, and how large of a payload can the platform handle?

PAYLOAD

The **payload** refers to the amount of weight that can be carried by the platform. The term comes from the aviation industry and refers to the part of the load from which revenue can be derived (e.g., passengers and cargo). The term is most often used to refer to all of the weight other than

the fuselage itself and includes the cameras, sensors, batteries, and data logging equipment. The more payload your platform can carry, the more flexibility you have to adapt the platform to your specific data collection needs. For example, lidar sensors are typically heavier than basic cameras, so having a platform that can carry heavier sensors allows you to add them to your suite of technologies as your drone capabilities grow.

CAMERAS AND NON-IMAGERY SENSORS

Since image capture has become a primary use of drones for civilian applications, this book focuses mainly on capturing and processing drone imagery. Chapter 3 provides an in-depth look at some of the most commonly used cameras and imaging sensors for drones. However, there are many other types of non-imagery data that can be captured from drones. Figure 1.6 shows a DJI Phantom quadcopter that has an iMet (Intermet Systems) meteorological sensor secured to the front left leg of the drone. The iMet sensor measures temperature and humidity, and in this case required no special hardware integration other than a bit of duct tape! The placement of meteorological sensors on the drone, as seen in Figure 1.6, is important since the downwash from the rotors can impact the accuracy of measurements. Placing a temperature sensor on top of a platform may also impact measurements since thermal radiation may be affected by the temperature of the drone, especially darker colored platforms. You will work with atmospheric data captured with an iMet sensor in Chapter 18.

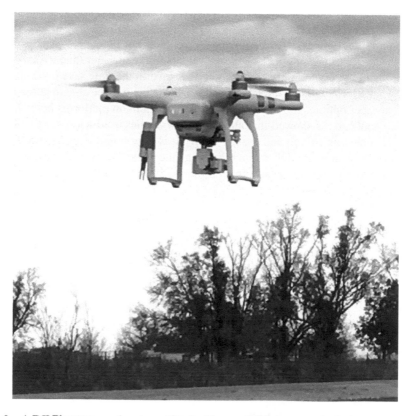

FIGURE 1.6 A DJI Phantom quadcopter outfitted with a small iMet meteorological sensor on the front left leg of the aircraft to measure temperature and humidity. [Photo Credit: Amy Frazier].

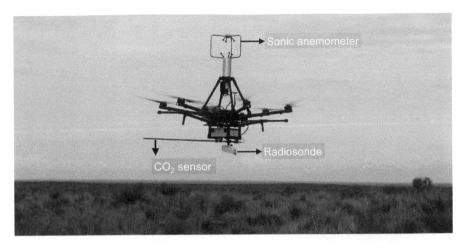

FIGURE 1.7 A rotary wing (hexacopter) outfitted with an ultrasonic anemometer to measure wind speed and direction, a radiosonde to measure basic thermodynamic variables of temperature and humidity, and a carbon dioxide sensor. [Photo credit: Jamey D. Jacob].

More sophisticated, non-imagery sensor payloads can also be integrated into larger platforms. In Figure 1.7, a DJI M600 hexacopter, which can handle a heavier payload, has been outfitted with a sonic anemometer on top. An **anemometer** measures wind speed by sending sound pulses back and forth between its sensors and measuring the speed of sound as it is changed slightly by the wind. In this case, the sensor has been installed high above the rotors to minimize the impact of rotor wash on the measurements. Carbon dioxide (CO_2) sensors are also being flown as payloads on drones (Figure 1.7) to capture measurements of greenhouse gases in the atmosphere. Sensors such as these can be flown along pipelines to detect leaks or in the atmosphere to better understand how greenhouse gases are distributed. You will work with data captured from a CO_2 sensor in Chapter 19.

DRONE APPLICATIONS

In the second half of this book, you will be introduced to a suite of applications that use drone data from across the world (Figure 1.8). You will work through a variety of hands-on exercises using data collected from research and data collection flights. If you are eager to collect data yourself, there are also instructions for how you can capture similar datasets and recreate the exercises with your own project data. Some of the most common applications are highlighted below.

AGRICULTURE

Farmers and other land managers are often tasked with monitoring large areas of land and are tapping into the power of drones to conduct aerial surveys that allow them to map and monitor farmland and rangeland efficiently and sustainably (Figure 1.9). With the right sensors, land managers can monitor crop health and status using vegetation indices, which are mathematical combinations or transformations of the image spectral bands that accentuate green plants so that they appear distinct from other features in the image. Land managers can also use drone imagery to create three-dimensional (3D) models of their fields to measure crop height, structure, and biomass (Mathews and Jensen 2013; DiMaggio et al. 2020). You will use drone imagery to measure canopy heights (Chapter 11), estimate forage mass (Chapter 13), and compute some common vegetation indices used in agriculture (Chapters 14 and 17).

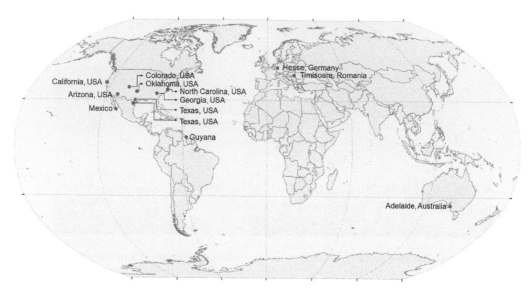

FIGURE 1.8 Study sites around the world where drone data were collected for the exercises in the second part of this book. [Figure credits: Kunwar Singh]

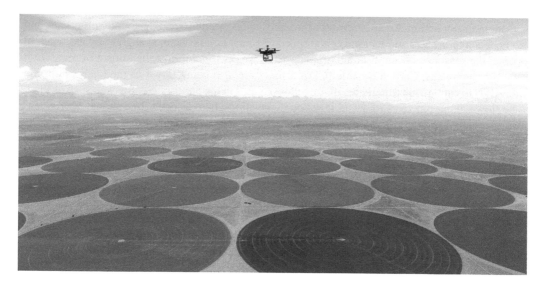

FIGURE 1.9 Drone flying over agricultural fields. [Photo credit: Victoria Natalie].

WILDLIFE SURVEYS

Drones are being used to automate wildlife surveys, which can save reserve managers and conservationists time and money. Drones can be used for making wildlife counts "on the fly" with videography. They can also be used to capture imagery that is then processed and analyzed for wildlife censuses. Infrared sensor technology can aid in identifying wildlife that may be hidden from above by thick vegetation or during colder seasons. Drones offer a minimally obtrusive means to count wildlife that can provide more accurate and consistent surveys compared to traditional methods using human observers from helicopters or airplanes (Hodgson et al. 2018).

Compared to methods where a human observer is standing on the ground, drones offer a superior vantage point in which wildlife is not obscured by objects in the foreground. You will use drone imagery to perform wildlife counts using visual interpretation and semi-automated machine learning techniques in Chapter 10.

GEOMORPHOLOGY

Geomorphology is the study of the physical landforms of the surface of the earth and their evolution by physical, chemical, or biological processes operating at or near the surface of the Earth. Geomorphologists study changes in the Earth surface and terrain, and drones are making it easier and safer to capture precise measurements of landform changes over large areas. The development of accurate methods for deriving three-dimensional (3D) models from drone images to study topographic change provides a powerful tool for geomorphological research (Fonstad et al. 2013; James et al. 2019). In Figure 1.10, Little Sahara sand dunes, a geomorphic anomaly in the landscape, is captured from the air. You will use drone imagery to study geomorphic changes in dunes in Chapter 15 and analyze flooding in Chapter 16.

HISTORICAL AND CULTURAL HERITAGE PRESERVATION

Historical preservation of buildings, natural sites, and cultural objects often involves surveys to ensure the structural integrity and cultural connections are maintained. One of the primary components of historical preservation and heritage management is assessing the condition of these artifacts, especially if restoration is needed. Close contact, or "hands-on" assessments are not always ideal, especially when the artifacts are fragile. Close contact methods can also require specialized equipment, which can make these types of preservation projects expensive. Drones can be used to image these cultural artifacts to perform remote condition assessments, create 3D models of monuments, and even create virtual tours through historical sites (Campana 2017; Skondras et al. 2018). In Chapter 16, you will build a 3D model of a historical cemetery and explore a cultural monument in an augmented reality app. In Chapter 17, you will use image enhancement techniques to identify burial mounds and enclosures in an archaeological site.

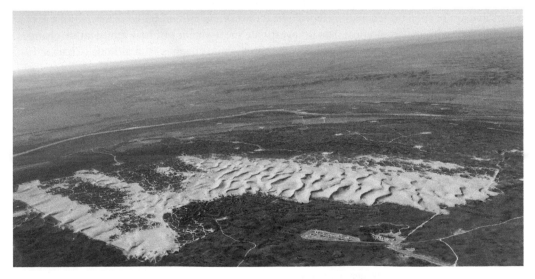

FIGURE 1.10 Aerial view of the "Little Sahara" sand dunes in central Oklahoma. The dunes formed over time from terrace deposits, remnants of prehistoric times when a river flowed through the area.

FIGURE 1.11 A photo from the 2018 LAPSE-RATE Campaign (de Boer et al. 2020) showing calibration of the atmospheric sensors on drones using a ground-based meteorological tower. [Photo credit: Jamey D. Jacob].

ATMOSPHERIC STUDIES

The lowest portion of Earth's atmosphere, commonly referred to as the atmospheric boundary layer (ABL), plays an important role in the formation of weather events. But historically, this region has been one of the most difficult to understand because it has been hard to access for large-scale sampling and mapping. Conventional meteorological survey instruments such as weather towers, weather radar, weather balloons, and satellites have not been able to provide even simple measurements like temperature, pressure, humidity, and wind velocity at adequate spatial or temporal coverage of this region (Hemingway et al. 2017). Manned aircraft flights at these low altitudes can be dangerous. In the last decade, drones have made it easier to capture data in regions that are beyond the reach of meteorological towers and ground-based radars (Figure 1.11). You will work with meteorological data to investigate the dynamics of how temperature changes with altitude dynamics (Chapter 18) and how carbon dioxide changes with altitude (Chapter 19).

OTHER APPLICATIONS (TABLE 1.1)

TABLE 1.1

Examples of the Many Applications Utilizing Drones for Data Collection

Applications with Imaging Sensors	Applications with Other Types of Sensors
• Identifying invasive plant species	• Monitoring nuclear radiation at contaminated sites
• Monitoring forest loss and degradation	• Sampling thermodynamic variables in the atmosphere
• Surveilling glacier loss and sea ice melting	• Delivering fertilizer and water inputs to crops
• Documenting archaeological digs and excavation sites	• Monitoring gas leaks from pipelines
• Quantifying landslide volume and mass wasting	• Plume tracking
• Surveilling volcanic eruptions	• Weather forecasting
• Charting coastal change from sea-level rise	
• Monitoring the growth of algal blooms in water bodies	
• Marketing for real estate and tourism	
• Inspecting power lines and other infrastructure	

ETHICS AND PRIVACY

Drones are powerful machines that have democratized aerial data collection. Drone users carry the burden of responsibility for ensuring these technologies are operated in a manner that protects individual privacy and adheres to the informal systems of ethics. The cameras and sensors carried onboard give operators the ability to take pictures or record people without their consent. Given the rapid growth in the use of drones, it is difficult for regulatory agencies to enforce rules designed to prevent "peeping toms" or other nefarious uses. While agencies around the world have been quick to adopt regulations to ensure safe operations within national airspace, similar regulations to protect individual privacy have not yet been widely adopted. For now, it remains largely up to the drone operators to ensure that drone flights and data collection are undertaken in a manner that is ethical and protects individual privacy. Some questions to ponder or discuss are below.

- Does allowing civilians to fly drones with cameras and videos attached automatically violate privacy? In what situations is it ethical or unethical to capture photographs or videos of people via drones?

- Is it ethical to fly a drone over someone's backyard and take pictures? What would or would not make this behavior unethical? What if the flight was for research purposes?

- In what circumstances might the benefit of utilizing drones outweigh the privacy risks? Are there situations in which benefits outweigh potential harms? Who should decide?

REFERENCES

Campana, S. (2017). Drones in archaeology. State-of-the-art and future perspectives. *Archaeological Prospection*, 24(4), 275–296.

De Boer, G., Diehl, C., Jacob, J., Houston, A., Smith, S. W., Chilson, P., ... & Kelly, J. T. (2020). Development of community, capabilities, and understanding through unmanned aircraft-based atmospheric research: The LAPSE-RATE Campaign. *Bulletin of the American Meteorological Society, 101*(5), E684-E699.

DiMaggio, A. M., Perotto-Baldivieso, H.L., Walther, C., Labrador-Rodriquez, K.N., Page, M.T., de la Luz Martinez, J., Rideout-Hanzak, S., Hedquist, B.C., & Wester, D.B. (2020). A pilot study to estimate Forage mass from unmanned aerial vehicles in a semi-arid Rangeland. *Remote Sensing*, 12(15), 2431.

Fonstad, M. A., Dietrich, J. T., Courville, B. C., Jensen, J. L., & Carbonneau, P. E. (2013). Topographic structure from motion: a new development in photogrammetric measurement. *Earth Surface Processes and Landforms*, 38(4), 421–430.

Hemingway, B. L., Frazier, A. E., Elbing, B. R., & Jacob, J. D. (2017). Vertical sampling scales for atmospheric boundary layer measurements from small unmanned aircraft systems (sUAS). *Atmosphere*, 8(9), 176.

Hodgson, J. C., Mott, R., Baylis, S. M., Pham, T. T., Wotherspoon, S., Kilpatrick, A. D., ... and Koh, L. P. (2018). Drones count wildlife more accurately and precisely than humans. *Methods in Ecology and Evolution*, 9(5), 1160–1167.

James, M. R., Chandler, J. H., Eltner, A., Fraser, C., Miller, P. E., Mills, J. P., Noble, T., Robson, S., & Lane, S. N. (2019). Guidelines on the use of structure-from-motion photogrammetry in geomorphic research. *Earth Surface Processes and Landforms*, 44(10), 2081–2084.

Jensen, J.R. (2017) (e-book) *Drone Aerial Photography and Videography: Data collection and image interpretation.*

Mathews, A. J., & Jensen, J. L. (2013). Visualizing and quantifying vineyard canopy LAI using an unmanned aerial vehicle (UAV) collected high density structure from motion point cloud. *Remote Sensing*, 5(5), 2164–2183.

Pytlik Zillig, L.M., Duncan, B., Elbaum, S., & Detweiler, C. (2018). A drone by any other name: Purposes, end-user trustworthiness, and framing, but not terminology, affect public support for drones. *IEEE Technology and Society Magazine*, 37, 80–91.

Singh, K.K., & Frazier, A.E. (2018). A meta-analysis and review of unmanned aircraft system (UAS) imagery for terrestrial applications. *International Journal of Remote Sensing*, 39, 5078–5098.

Skondras, E., Konstantina, S., Angelos, M., & Dimitrios, D. V. *A route selection scheme for supporting virtual tours in sites with cultural interest using drones.* In *2018 9th International Conference on Information, Intelligence, Systems and Applications (IISA)*, pp. 1–6, IEEE, 2018.

2 An Introduction to Drone Remote Sensing and Photogrammetry

Amy E. Frazier, Travis Howell, and Kunwar K. Singh

CONTENTS

INTRODUCTION

Remote sensing is one of the main applications of drones, so it is useful to start with a brief introduction to remote sensing, aerial photography, and photogrammetry as they relate to drone data capture and processing. This chapter will introduce some of the basics of remote sensing and photogrammetry along with the fundamentals of using drones to capture these data. For readers interested in a more in-depth treatment of remote sensing and photogrammetry, additional suggestions for supplemental reading are provided at the end of this chapter.

REMOTE SENSING WITH DRONES

Remote sensing is the science and art of obtaining reliable information about an object, area, or phenomenon through the analysis of data acquired by a device that is not in contact with whatever is being measured. Your eyes are a type of remote sensing "device" or instrument—you rely on them constantly to acquire information about the world without actually coming into direct contact with objects they are sensing. Cameras are another common type of remote sensing device that can capture information (photographs/images) of objects and places on earth without having to physically be in contact with those things. In contrast, a thermometer is not a remote sensing device – it must be in direct contact with whatever medium or substance it is measuring in order to capture reliable information.

Remote sensing devices record energy that is reflected or emitted from materials and objects and use that signal as a *surrogate* for that material or object. **Passive remote sensing** systems rely on the energy produced by the sun, while **active remote sensing** systems produce their own energy. This chapter focuses on passive remote sensing. Active remote sensing systems like lidar are covered in Chapter 3.

Both passive and active remote sensing systems rely on electromagnetic energy. Electromagnetic waves are created whenever an electrical charge is accelerated. Thermonuclear fusion taking place on the surface of the sun produces a continuous spectrum of electromagnetic energy that can be used for remote sensing. Electromagnetic radiation travels from the sun to Earth in a near-vacuum at the speed of light. When the radiation enters Earth's atmosphere, the waves come in contact with particles and molecules in the atmosphere and, eventually, objects on the surface of the earth (Figure 2.1).

Humans cannot see these waves of electromagnetic radiation with our eyes, but we can feel the radiation from certain wavelengths on our skin as heat. Radiation from the sun includes not only this heat, or **thermal** radiation, but the entire continuous spectrum of electromagnetic energy from very small gamma rays, which are the size of atomic nuclei, all the way up to very large radar rays, which can be as long as a building or a mountain (Figure 2.2). The narrow region in

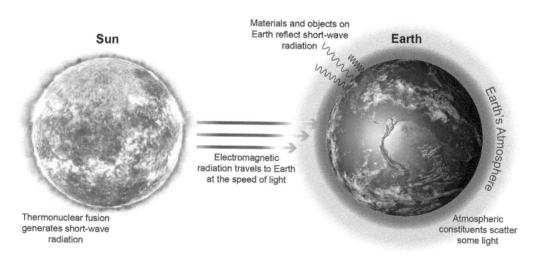

FIGURE 2.1 Diagram of the path of electromagnetic radiation generated via thermonuclear fusion on the sun traveling to Earth where some light is scattered by atmospheric constituents. Radiation that travels all the way to Earth reflects off of materials and objects. [After Jensen 2016; Strahler and Strahler 1989].

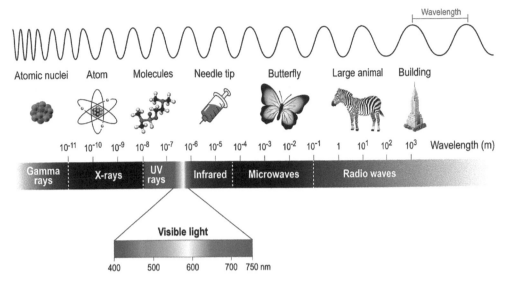

FIGURE 2.2 The electromagnetic spectrum showing categories of rays and approximate wavelengths.

Figure 2.2 labeled "Visible light" is the only portion of the electromagnetic spectrum, sometimes abbreviated "EM spectrum," that humans can observe with the naked eye. As you can see, this region is quite small compared to the entire spectrum, which is why we must rely on sophisticated sensors to capture information beyond this narrow range.

As their name suggests, electromagnetic waves have two parts: an electric part and a magnetic part. Remote sensing for image collection is concerned mainly with the electric part of EM radiation, where waves are differentiated by wavelengths. The term **wavelength** refers to the distance from one wave crest to the next. As you can see from Figure 2.2, gamma rays have very small wavelengths, while radio waves have very large wavelengths. The measurements in Figure 2.2 are in meters (m), but in optical remote sensing, wavelength units are often measured in nanometers (nm), which are one billionth of a meter, or micrometers (μm), which are one millionth of a meter. Visible light that humans can see with the naked eye ranges from about 400–750 nm (0.4–0.75 μm), which is about the size of a single-celled protozoan.

Of the visible wavelengths of light, red light has the longest wavelengths (about 700–750 nm), and blue light has the shortest wavelengths (about 400–450 nm). When capturing remote sensing images with drones, it is rare for a sensor to measure reflectance of wavelengths smaller than blue light (e.g., ultraviolet, or UV light). This is because Earth's atmosphere does not effectively transmit these wavelengths, meaning most do not make it all the way through the atmosphere to Earth. However, it is common to measure wavelengths longer than red light. These longer wavelengths are referred to as **infrared light** because they are literally "beyond the red light" region of the EM spectrum. You will see the term "near-infrared" used frequently throughout this book, which means light that is just beyond the red region. Near-infrared is sometimes abbreviated NIR, and this type of light is very useful for studying healthy vegetation, which reflects NIR light strongly. Short wave infrared, or SWIR, wavelengths are at the far end of the infrared region just before microwaves (Figure 2.2). SWIR light is useful for studying minerals and soil/vegetation moisture content, but most of the off-the-shelf sensors being flown on drones do not have the capability to capture reflectance in this region of the spectrum.

A BRIEF HISTORY OF AERIAL PHOTOGRAPHY AND PHOTOGRAMMETRY

Many years of developments in photography, aerial photography, and photogrammetry have paved the way for the current science of capturing and processing drone imagery into useful data products. The major developments in these fields are summarized below starting with the conceptual origins of photography in the 5th-century B.C.E. through to the modern age of mapping.

ORIGINS OF PHOTOGRAPHY

The concept of photography dates all the way back to the 3rd- to 5th-century B.C.E., when observations were made that light from a solar eclipse would make an image of the eclipsed sun on the ground as it passed through the leaves of a tree (Gernsheim 1986). The earliest version of a light projection box, the **camera obscura**, was soon created, which would flip an image upside down as the light moved in a straight line. These early discoveries did not actually capture hard-copy images, and it would take more than 2000 years for the modern photographic process to be invented by Joseph Nicéphore Niépce in the mid-1800s. Niépce was the first to develop a hard-copy image, and his oldest surviving photograph dates from around 1827 (Figure 2.3). Not long after, Louis Daguerre, who was Niépce's associate, developed the daguerreotype process, which was the first commercially viable method for producing hard-copy photographs.

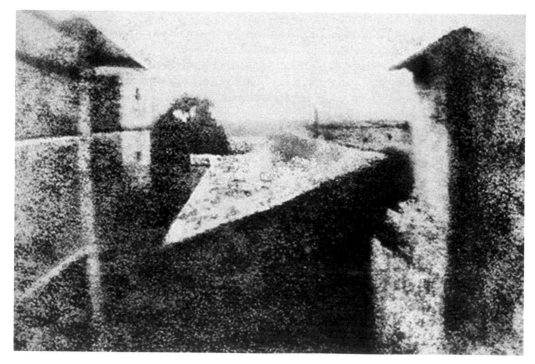

FIGURE 2.3 A copy of *View from the Window at Le Gras* – Niepce's earliest known surviving photograph. (This work is in the public domain).

Origins of Aerial Photography

As the technologies enabling photography became more refined, humans began to contrive ways to capture photographs that gave them a "birds eye view" of the world. The desire to gain a unique, "top down" perspective of the world ultimately led to the field of **aerial photography** in which photographs are captured from airborne platforms. In 1858, the first known aerial photograph was captured from a hot air balloon in 1858 by a French photographer known as Nadar. Today, the eponymous term **nadir** is used in remote sensing to refer to the point on Earth directly below the sensor or observer. Sadly, Nadar's first aerial photo captured from the hot air balloon was lost, but since then, scientists have explored all sorts of other mechanisms to take pictures from the sky including kites and rockets (Colomina and Molina 2014). Tiny cameras have even been strapped to carrier pigeons (Figure 2.4).

Aerial photographs can be captured either vertically (straight down) or at an oblique angle. **Vertical photographs** are collected when the optical axis of the camera is within +/− 3 degrees of perpendicular to Earth's surface. If the angle of the camera is greater than 3 degrees, then the image is characterized as being captured from an **oblique** (side angle) perspective. Oblique photographs can be further categorized as either low or high obliques (Figure 2.5). In a **low oblique** aerial photograph, the horizon is not visible in the image. In a **high oblique** aerial photograph, the horizon is visible.

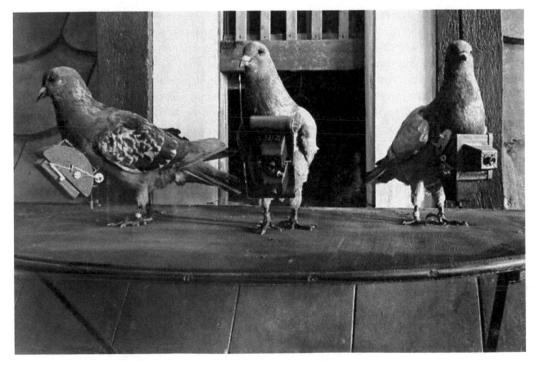

FIGURE 2.4 Homing pigeons outfitted with tiny, breast-mounted cameras. As the pigeon flew home, the camera would automatically capture photos of Earth. (Attribution: This work is in the public domain in the United States because it was published (or registered with the U.S. Copyright Office) before January 1, 1925.)

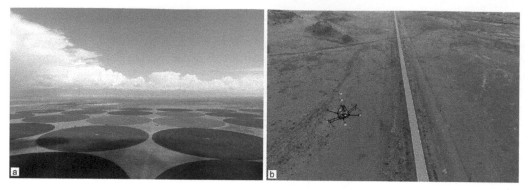

FIGURE 2.5 (a) A high oblique aerial photograph taken from a drone showing agricultural fields. (b) A low oblique photograph taken from a drone showing a road (with a hexcopter drone in the foreground). [Photo credits: Victoria Natalie].

PHOTOGRAMMETRY AND MODERN MAPPING

As photography and aerial photography advanced through the 19th century, scientists began developing methods to make accurate measurements of distances from photographs. This work led to the field of photogrammetry. The term **photogrammetry** comes from the Greek words for "light" (photo), "that which is drawn or written" (gramma), and "to measure" (metron). So photogrammetry literally means "to take measurements from photographs." The American Society of Photogrammetry and Remote Sensing (ASPRS) defines photogrammetry as the art, science, and technology of obtaining reliable information about physical objects and the environment through processes of recording, measuring, and interpreting images and patterns of electromagnetic radiant energy and other phenomena.

There are many variations of photogrammetry, but a common process used with drone imagery involves creating three-dimensional (3D) models of Earth from sets of overlapping two dimensional (2D) images. The specific techniques used to create these 3D models are detailed in Chapter 6, but a brief introduction and some background on how these and other photogrammetric techniques operate are provided below. The science behind these techniques dates back at least to the early 1400s when Leonard da Vinci noticed the basic ideas behind perspective. **Perspective** is the angle at which an object is viewed. By combining multiple perspectives together, it is possible to produce a 3D representation, much the same way your eyes do.

HANDS-ON EXERCISE: PERSPECTIVE

Hold your pointer finger about 12 inches, or 30 centimeters, from your face. Without moving your finger, first close your left eye, leaving your right eye open, and then switch so your left eye opens but your right eye is shut. Notice how your finger appears to move or change its position as you view it with your different eyes.

This illusion happens because your eyes are separated from each other, and each has a slightly different perspective, or viewing angle, of your finger. Your brain merges the two views into a single image, creating a 3D reconstruction from the two different angles. This phenomenon is called **stereoscopic representation**.

Perspective and stereoscopic representation are concepts that have fascinated scholars for centuries. In fact, Leonardo da Vinci may have been experimenting with stereoscopic representation as early as the Middle Ages. Some scholars believe that the *Mona Lisa*—da Vinci's famed portrait housed in the Louvre museum in France—may be the oldest surviving example of 3D artwork (Carbon and Hesslinger 2013). In 2012, scientists uncovered a "knock-off" Mona Lisa at a museum in Madrid. After undergoing scrutiny, it was determined that the second Mona Lisa was painted from a slightly different angle than the original. Some speculate that the second version was painted by one of da Vinci's students, who may have been sitting slightly behind him off his left shoulder, which gave the "knock-off" a slightly different perspective. However, the precision with which the copy was made suggests there may have been a more intentional attempt by da Vinci himself to create a stereoscopic representation. In particular, certain features of Mona Lisa are painted at precisely different perspectives that mirror the difference in perspective between a pair of human eyes (Carbon and Hesslinger 2013). Is it possible that da Vinci painted one version using only his left eye and the other using only his right?

While Leonardo da Vinci may have been experimenting with stereoscopic representation more than five centuries ago, **stereoscopy**, or seeing in stereo, was not proposed as an official theory until the late 1830s when Charles Wheatstone invented the **stereoscope**. Wheatstone demonstrated that it was possible for the brain to recombine two, 2D images, each drawn from a slightly different perspective, into a 3D image. A stereoscope is a device for viewing stereoscopic pairs of separate images by forcing the brain to fuse multiple images into a 3D object. Figure 2.6 shows an early 1930s stereoscope where it is possible to see how the two pictures, captured from slightly different perspectives, are positioned in the back of the device so that each eye, looking through the binoculars in the front of the device, views a separate image. The human brain can combine the two views into a 3D image of the church in exactly the same way it combines the two images of your finger into a 3D representation.

It did not take long for the principles of stereoscopy to be extended to aerial photographs. Less than ten years after the Wright Brothers pioneered the first airplane flight in 1903, the basic principles of photogrammetry and stereoscopic vision were being applied to aerial photographs to

FIGURE 2.6 A 1930s stereoscope. The one pictured here is a toy, but it demonstrates the principles of how the device worked to split the images seen by each eye. (Photo credit: Nieborak at Polish Wikipedia – Transferred from pl.wikipedia to Commons by Pjahr using CommonsHelper. Public Domain.)

take measurements of distances and directions of ground features. As the airplane flew along a flight line, photographs of Earth were captured in succession. As long as there was overlap in the successive photos, the same object would be visible in multiple photographs but from slightly different perspectives. This change in position of an object from one photograph to the next caused by the forward movement of the aircraft is known as **stereoscopic parallax**. Differences in parallax can be used to measure the heights of objects and extract topographic information such as elevations and contour lines from images using stereoscopic instruments. Aerial photogrammetric techniques were employed at scale during World War I to map terrain and plot the positions of enemy lines and infrastructure (Collier 2018). Long before drones were a reality, soldiers would hang over the edge of the aircraft while it was in flight to snap pictures over enemy lines.

MODERN PHOTOGRAMMETRY USING DRONE IMAGERY

Fast forward 100 years, and drones have made it much easier to capture sets of overlapping photographs over an area of interest. There has also been a renewed interest in photogrammetric techniques during the past decade, leading to the development of modern algorithms and software programs for generating 3D models from drone imagery. Several companies including AgiSoft and Pix4D have capitalized on this renewed interest in drone photogrammetry by developing robust software platforms that take advantage of the increased computing power on personal computers to put photogrammetric processing power into the hands of users.

Throughout this book, you will be introduced to the Structure from Motion workflow (Snavely et al. 2008). Structure from Motion, or SfM, relies on the same basic photogrammetric principles as stereoscopic photogrammetry to generate 3D models from sets of overlapping, offset images (Westoby et al. 2012). Using the Scale Invariant Feature Transform (SIFT) algorithm (Lowe 2004) along with computer vision techniques, 3D photogrammetric models can be built from drone images by detecting and matching the same features across images to create 3D point clouds (Lucieer et al. 2014). You will practice these techniques in several of the hands-on

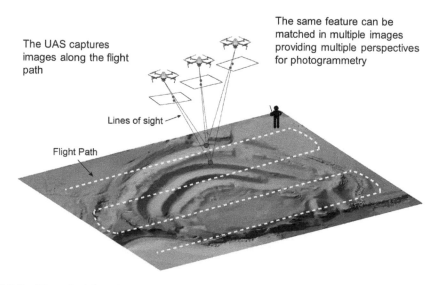

FIGURE 2.7 The principles of photogrammetry can be applied to multiple photographs captured from a UAS as it travels along its flight path capturing images. The multiple images capturing the same ground feature provide the multiple perspectives needed for 3D recreation.

exercises. Capturing a 2D image of Earth essentially flattens, or removes any depth perspective. SfM provides a means to re-create 3D representations from multiple, overlapping photographs.

The key for creating accurate 3D models from aerial photographs is to capture many images with high amounts of overlap so that the same feature can be identified in several different images (Figure 2.7). The more perspectives of a single point you can capture, the more information will be available to triangulate the point in 3D space accurately. Designing a flight plan that allows you to capture proper amounts of overlap is addressed in Chapter 4. The SfM workflow and the types of products you can generate from overlapping drone photos are detailed in Chapter 6.

GENERAL CONSIDERATIONS FOR CAPTURING IMAGES WITH DRONES

Due to their small size and limited payload capacity, drones are subject to a range of platform and sensor uncertainties that can impact the quality of the data being collected. Like other remote sensing systems, the two most common types of error introduced into images captured by drones are radiometric and geometric errors (Jensen 2016). **Radiometric errors** affect how closely the brightness values captured by the sensor reflect the true irradiance or reflectance from the object or surface being sensed. Radiometric errors can be introduced from internal factors, such as the sensitivity of the sensor, as well as external factors like sun angle, topography, or atmospheric effects that vary in space and time. **Geometric errors** affect the proper positioning of images and pixels in the correct planimetric location, which is necessary if the data are to be associated with other spatial data. Geometric errors in drone-captured images are often introduced from platform instability. It is important to know what types of distortions might be impacting the images captured from a drone, since these errors can affect the accuracy of any derived products or analyses (Singh and Frazier 2018; Kedzierski and Wierzbicki 2015).The discussion below focuses on radiometric and geometric effects in images and how to correct for them; sensor calibration is discussed in Chapter 3.

RADIOMETRIC ERRORS AND EFFECTS

Two types of radiometric effects are important for drone remote sensing: internal effects due to the sensor and system, and external effects introduced by forces beyond the system such as the atmosphere or environment.

Internal effects from sensor imperfections can result in uneven illumination across the image, causing certain areas of the image to receive more or less light than others. **Vignetting** occurs when areas near the center of the image are brighter than the edges. Differences in brightness make it difficult to visually interpret a scene and can also affect any quantitative analyses performed on the images. The forward motion of the platform can also introduce undesirable radiometric effects such as blurring (Sieberth et al. 2016), and unsteady platforms can lead to camera tilting. Tilted cameras capture images at varying angles, causing different areas of the study area to be illuminated differently. Radiometric calibration of the sensor can help mitigate some of these internal effects (discussed in Chapter 3). However, since drone sensors typically do not undergo the same level of calibration as sensors carried onboard satellites or manned aircraft, it is important to recognize that internal radiometric effects may be affecting the quality of images captured by the drone.

External effects from the atmosphere, the angle of the sun when the images were captured, and the topography of the surface can also distort the amount of radiation received at the sensor. Atmospheric effects are caused by molecules and aerosols in the atmosphere (e.g., from clouds, haze, dust, pollution, etc.) that scatter and absorb wavelengths of light differently. These effects can reduce or even completely block certain wavelengths of light from reaching

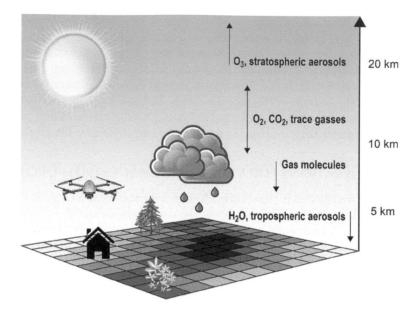

FIGURE 2.8 Atmospheric constituents vary with altitude and can create unwanted radiometric distortions in imagery. Light wavelengths can be scattered or absorbed by the various aerosols, molecules, and gasses in the atmosphere, which change over space and time.

the sensor. The types and concentrations of these atmospheric constituents vary with altitude and location (Figure 2.8), and they also change over time, which makes it difficult to know precisely how the atmosphere is affecting measurements. Drones fly at a low enough altitude (typically below 400 ft, or 120 m) that many of these atmospheric effects are reduced, but they are not entirely absent, and illumination differences from sun angles, shadows, and shading can still impact images. Therefore, radiometric correction of the images to account for these effects is often necessary.

RADIOMETRIC CORRECTION

Radiometric corrections can be applied to images to reduce radiometric errors and improve the accuracy of the pixel values as well as any derived products or analyses. Radiometric correction is particularly important when images will be compared across time to investigate changes or when they will be used for spectral analyses, such as computing indices of plant health. Atmospheric effects can be corrected using models that account for the effects of scattering and absorbtion in the atmosphere. These methods require knowledge of parameters such as the amount of water vapor or the distribution of aerosols in the atmosphere at the time of image capture, which can be difficult to measure. A simpler method when these types of atmospheric data are not available is the **dark object subtraction** method (Chavez 1988), which relies on the assumption that some pixels in the image are in complete shadow, and so the radiances received from these pixels at the sensor are due entirely to atmospheric scattering. The values of these dark pixels can be subtracted from each pixel in the image to account for atmospheric effects. A modification of the dark object subtraction method has been developed specifically for drone-captured images (Wierzbicki et al. 2018).

Another method for radiometrically correcting drone-captured images relies on precise spectral reflectance measurements from special field targets to adust the brightness values of the pixels in the image to match known reflectances (Figure 2.9). These targets are manufactured to provide

FIGURE 2.9 *In situ* collection of reflectance target data for radiometrically correcting drone images using a spectroradiometer (backpack unit). The target is laid out on a flat area and reflectance readings are captured with a spectroradiometer and compared to the reflectance values in the image. [Photo credit: Suzanne W. Smith].

specific spectral reflectances, which can be measured using a hand-held, field spectroradiometer (worn as a backpack unit in Figure 2.9). The precise spectral reflectance measurements captured from the spectroradiometer can then be related to the reflectance of the targets captured in the images to build a relationship between the "true" values from the targets and the measured values in the images. Using simple regression methods such as empirical line calibration (see Jensen 2016 for a detailed description), reflectance values across the entire image can be corrected.

Geometric Errors and Effects

All imagery captured from aerial platforms contains some degree of geometric distortion. These distortions can be introduced from predictable sources, such as the fact that the Earth is curved and rotating while images are being collected. Systematic sources of error such as these can be identified and fixed relatively easily. Other geometric distortions are more random, like those introduced during windy days when the platform is unstable. These external errors are more complicated and difficult to fix. **Geometric correction** is the process to compensate for both the systematic and random distortions to the size and locations of image pixels. The goal of geometric correction is to ultimately produce a corrected image with a high level of geometric integrity in which the data are in their proper *x, y,* and sometimes *z* locations.

Altitude changes and attitude changes (i.e., roll, pitch, and yaw of the aircraft) are two of the most common external geometric errors impacting the quality of drone images. Altitude changes can occur even when the drone is being flown at a constant elevation above the ground if the elevation of the ground itself is changing underneath the drone (Figure 2.10). These shifts in the alititude of the platform above the ground can result in images that contain different pixel sizes, or resolutions, which can in turn impact the geometric accuracy of products derived from the images (Thomas et al. 2020). However, there is growing consensus from the drone remote sensing community that capturing images from multiple altitudes and including sets of images that have

FIGURE 2.10 Schematic showing how the height, or altitude, of the drone above ground level (AGL) can change due to changes in the ground surface elevation, even if the true elevation of the drone above mean sea level (MSL) does not change.

different resolutions in the SfM process may actually create more accurate 3D products (Carbonneau and Dietrich 2017; Fonstad et al. 2013).

Attitude is the orientation of the platform in space, and it can be affected by wind or other atmospheric turbulence. The platform can rotate along three axes referred to as roll, pitch, and yaw. **Roll** tilts the wings or rotors down toward the ground, **pitch** tilts the nose of the aircraft down or up, and **yaw** spins the aircraft so that it crabs into the wind. These changes in aircraft attitude lead to expansion or compression in the image geometry (depending on the direction the aircraft is rotating). Mounting the sensor to a **gimbal**, which is a mechanism to keep the sensor pointing vertical to the ground when the platform moves, can help reduce geometric distortions.

GEOREFERENCING AND GEOMETRIC CORRECTION

Georeferencing is the process of aligning the images to a known coordinate system, usually for the purpose of overlaying other spatially referenced data or performing more advanced spatial analyses. Georeferencing involves geometrically correcting the positions of the pixels by shifting, rotating, scaling, or warping the data. There are several ways to georeference images captured from drones. The first, known as **direct georeferencing**, uses the location information stored within the image file metadata to scale and transform the images to real-world coordinates. The second approach, **indirect georeferencing**, uses reference data collected on the ground to scale and transform the images into the correct coordinate system. The ground reference data are known as **ground control points**, or GCPs, and typically consist of high contrast colored targets (e.g., black and white) that can easily be seen from the drone (Figure 2.11). A high precision global navigation satellite system (e.g., GPS) is used to capture the precise coordinates of the target on the ground, and those coordinates can then be assigned to the target location in the images.

With traditional photogrammetry, a small number of optimally placed GCPs (typically at the corners of the study area and the center) was considered sufficient to georeference image products. For drone-based photogrammetry, much denser deployments of GCPs are usually employed (James et al. 2017), but the optimal number and placement of GCPs is still being debated (Manfreda et al. 2019). Some scholars have suggested that around 10–20 GCPs per square kilometer of study area is sufficient (Gindraux et al. 2017), but other researchers have found that the optimal number

FIGURE 2.11 (a) A ground control point (GCP) target that has been placed in the field site to assist with indirect georeferencing of the drone images. (b) A close-up view of the GCP, which was constructed using paper plates and black tape and has been anchored to the ground with a nail. (c) A global navigation satellite system (GNSS) base station setup at the site to improve accuracy of the location measurements.

and placement will vary according to the study objectives and site terrain (Agüera-Vega et al. 2017; Singh and Frazier 2018). At a minimum, GCPs should be placed so that the minimum bounding geometry formed by the GCPs encompasses the entire study area. It is also important to carefully remove any outliers (i.g., GCPs with potentially erroneous location measurements) so that they do not negatively impact the accuracy of derived models (James et al. 2017).

DOMING AND DISHING

Doming and dishing are geometric artefacts that can arise in the 3D models derived from drone images during SfM processing. Doming appears as convex vertical artifacts, while dishing appears as concave vertical artifacts. They result from a combination of capturing images in near-parallel directions along with lens distortions from multiple images that combine and propagate through the SfM process (James et al. 2017). An example of the doming effect in the point cloud generated from the set of drone images is shown in Figure 2.12. These geometric distortions are not necessarily apparent in the images themselves, but rather appear in the products derived from those images. Doming and dishing effects can be mitigated by incorporating a variety of convergent views from different camera angles into the image set, including oblique images, and configuring flight plans to include nonparallel flight lines (Eltner and Schneider 2015; James and Robson 2014; Peppa et al. 2016; Wackrow and Chandler 2011).

DATA PRODUCTS DERIVED FROM DRONE IMAGES

Capturing images is usually just the first step in a drone-based remote sensing project workflow to produce usable data products. The set of overlapping images can be processed into various data products using SfM processes, including georeferenced point clouds, digital elevation models, and orthophotos and orthomosaics. These products are briefly introduced here, they are discussed further in Chapter 6.

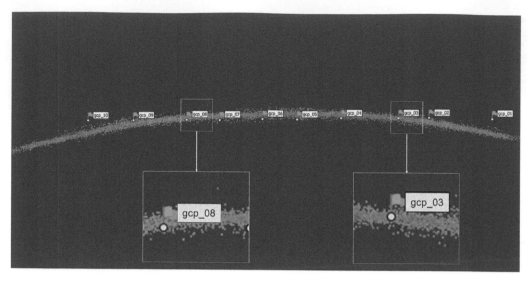

FIGURE 2.12 Example of vertical doming of the surface in a 3D point cloud captured from drone images [Figure credit: Zach Hilgendorf].

GEOREFERENCED POINT CLOUDS

A **point cloud** is a set of data points that represents a 3D shape or object. Point clouds, such as the one shown in Figure 2.13, can be generated from overlapping drone images by matching the same features across images (Lucieer et al. 2014). When the images are georeferenced, the 3D point cloud can also be georeferenced to give precise x, y, and z coordinates for each point. The point clouds themselves can be rendered for visualization and inspection, but more often they are converted to a polygon **mesh**, which is a collection of vertices, edges, and faces that define the 3D shape of an object.

FIGURE 2.13 Point cloud with the points symbolized by color according to elevation.

DIGITAL ELEVATION MODELS

A digital elevation model, or DEM, is a raster image where each pixel represents the elevation, or height, of the surface or object in that pixel. A DEM can be produced directly from the point cloud or mesh produced from the overlapping images. DEM is a general term describing any type of elevation surface. If the DEM represents elevations of the ground surface only, it is referred to as a digital terrain model (DTM). If the DEM represents ground elevations along with heights of structures such as buildings and trees, it is referred to as a digital surface model or DSM. If only the heights of the structures such as buildings and trees are needed, the DTM can be subtracted from the DSM to produce height models such as a canopy height model, or CHM, to represent vegetation.

ORTHOPHOTOS AND ORTHOMOSAICS

An **orthophoto** is an aerial photograph that has been geometrically corrected so that measurements can be made on the photograph as if it were a scaled map. Unlike a raw image captured from a drone, an orthophotograph can be used to measure true distances because it is a scaled representation of the Earth's surface, having been adjusted for topographic relief, lens distortion, and camera tilt. Many overlapping images can be stitched together and geometrically corrected to create an **orthomosaic**. Orthomosaics provide a similar "wall-to-wall" view as you would see in a satellite view in Google Maps. **Image stitching** is the process of combining multiple images with overlapping fields of view to produce a seamless scene over the study area.

IMAGE ENHANCEMENT AND CLASSIFICATION

After images have been orthorectified and stitched together into an orthomosaic, they can be digitally enhanced to highlight subtle patterns or information that might otherwise be missed (Jensen 2007). **Image enhancement** improves the appearance of the images, making them easier to interpret. Images are commonly enhanced along three dimensions:

1. **Radiometric enhancements**: these techniques enhance images based on the individual brightness values, or reflectances, within each pixel.
2. **Spatial enhancements**: these techniques enhance images based on the reflectance values of each pixel but also consider the neighboring pixel values
3. **Spectral enhancements**: these techniques enhance images by transforming values on a band-by-band basis.

RADIOMETRIC ENHANCEMENT

Images captured from drones often have low contrast in the pixel values, which can make it difficult to decipher features in the images. Radiometric enhancement expands the range of brightness values in order to create more contrast for visually interpreting the data. Consider the image in Figure 2.14 captured from the Sentinel-2 MSI instrument. The left side of the image (Figure 2.14a) is considerably brighter than the right (Figure 2.14b) because a contrast stretch has been applied, stretching the range of reflectance values across the full range of brightness values to create an image that displays the same data but is brighter and clearer.

SPATIAL ENHANCEMENT

Spatial frequency is the number of changes in pixel brightness values per unit distance for a region of an image. In areas where there are very few changes in brightness, the spatial frequency

FIGURE 2.14 An image captured by the Sentinel-2 Multispectral Imaging sensor displayed using a false color composite: the near-infrared band is displayed using the red channel, the red band with the green channel, and the green band with the blue channel. The left side (a) has been contrast stretched compared to the right side (b) to highlight differences: it is easier to identify river features (squiggly red lines), and there is more contrast between the cultivated areas (deep red) and surrounding land (shades of light to dark green).

is low. In areas where there are many changes in brightness, such as cities, spatial frequency can be high. Spatial enhancement can smooth out image contrast in high-frequency areas or accentuate contrast in low-frequency areas. The primary mechanism for spatially enhancing images is through spatial convolution filters, which are moving windows that scan across an image and reassign pixel values based on the values within the window (Pratt 2001). **High pass filters** accentuate small differences in the window while **low pass filters** smooth out variation in the window. Spatial enhancements can be especially useful to identify anomalies or defects during inspections of pipelines, railroads, and other utilities with drones (Wu et al. 2018).

Spectral Enhancement

By combining the pixel values from multiple bands through simple formulas, images can be spectrally enhanced to accentuate features that would not otherwise be identifiable. The most common spectral enhancements are vegetation indices, like the normalized difference vegetation index (NDVI). NDVI is used as a measure of whether a pixel contains live, green vegetation based on how a pixel reflects certain wavelengths of light (Figure 2.15). NDVI was initially developed to normalize the effects of the sun's angle on images to make it easier to determine when crop "green up" was occurring across the Great Plains of the United States (Rouse et al. 1973). It is now widely applied across many different systems to monitor everything from droughts to wildlife habitat. The NDVI equation incorporates the Red and NIR bands to produce a single, normalized value for each pixel ranging between −1 and 1. Values less than or equal to 0 signal an absence of vegetation (e.g., snow or ice), while values closer to 1 indicate healthy, green vegetation.

$$NDVI = (NIR - Red) / (NIR + Red)$$

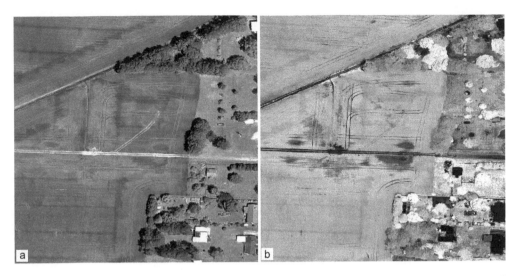

FIGURE 2.15 (a) True-color composite captured from a drone, and (b) Normalized difference vegetation index (NDVI) computed for the same area. The trees show high levels of NDVI (white) while the buildings indicate low.

There are many other spectral indices that have been developed to highlight various natural and physical features in landscapes. You will be introduced to additional spectral indices in Chapter 17. Readers are also directed to Jensen (2007) for a more complete review of some of the most commonly used indices.

IMAGE CLASSIFICATION

Image classification is the process of turning pixel reflectance or brightness values into useful information on the land covers in the landscapes. There is a fundamental difference between spectral reflectance data acquired by a sensor and information classes defined by humans (Jensen 2016). Information classes have meaningful interpretations and can be readily applied to problem solving and decision-making. By grouping, or classifying, pixels with similar reflectance values into land cover "themes," the maps can be used to measure the amounts of different land cover types present in a study area and monitor how these land covers change over time.

Two types of classification are commonly used to classify drone images: pixel-based techniques and object-based techniques. The primary difference between these two is that **pixel-based classification** techniques assign each pixel to a land cover class based solely on the spectral information contained within the pixel, without considering the spatial context of the surrounding pixels. An issue with pixel-based classification techniques when using high-resolution drone imagery is that a considerable portion of the signal from a single pixel can actually be coming from the surrounding area (Townshend et al. 2000). **Object-based classification** techniques take into account the spectral information in a pixel as well as its spatial relationships with other surrounding pixels in an attempt to identify groups of contiguous pixels, or objects that are homogenous in terms of land cover (Blaschke 2010). Object-based classification techniques are often preferred for classifying high-resolution images, such as those captured by drones (Myint et al. 2011; Kalantar et al. 2017). These techniques generally operate by

segmenting the image into sets of pixels that have similar spectral characteristics. The user can then classify the different objects based on their knowledge of the study area. You will use image segmentation in Chapter 10.

SUMMARY

This chapter introduced some of the basics of remote sensing and photogrammetry as they relate to drones. Remote sensing and image data collection have become one of the primary applications of drones in both research and commercial endeavors. The basic principles of photogrammetry can be applied to overlapping sets of images captured from drones to build 3D point clouds from 2D images. After geometrically and radiometrically correcting the drone images, they can be subjected to the structure from motion approach to generate 3D models, which can then be used to derive digital elevation models, digital surface models, and orthomosaics. Orthomosaics can be enhanced for visual interpretation or classified into thematic maps for quantitative analyses.

REFERENCES

Agüera-Vega, F., Carvajal-Ramírez, F., & Martínez-Carricondo, P. 2017. Assessment of photogrammetric mapping accuracy based on variation ground control points number using unmanned aerial vehicle. *Measurement* 98, 221–227. doi:10.1016/j.measurement.2016.12.002.

Blaschke, T. (2010) Object based image analysis for remote sensing. *ISPRS Journal of Photogrammetry and Remote Sensing*, 65, 2–16.

Carbon, C. C., & Hesslinger, V. M. (2013). Da Vinci's Mona Lisa entering the next dimension. *Perception*, 42(8), 887–893.

Carbonneau, P. E., & Dietrich, J. T.. 2017. Cost-effective non-metric photogrammetry from consumer-grade sUAS: Implications for direct georeferencing of structure from motion photogrammetry. *Earth Surface Processes and Landforms*, 42(3), 473–486. doi: 10.1002/esp.4012.

Chavez Jr, P. S. (1988). An improved dark-object subtraction technique for atmospheric scattering correction of multispectral data. *Remote Sensing of Environment*, 24 (3), 459–479.

Collier, P. (2018). The development of photogrammetry in World War 1. *International Journal of Cartography*, 4(3), 285–295.

Colomina, I., & Molina, P. (2014). Unmanned aerial systems for photogrammetry and remote sensing: A review. *ISPRS Journal of Photogrammetry and Remote Sensing*, 92, 79–97.

Eltner, A., & Schneider, D. Analysis of Different methods for 3D reconstruction of natural surfaces from parallel-axes UAV images. *The Photogrammetric Record* 2015, 30; 279–299.

Fonstad, M. A., Dietrich, J. T., Courville, B. C., Jensen, J. L., & Carbonneau, P. E.. 2013. Topographic structure from motion: A new development in photogrammetric measurement. *Earth Surface Processes and Landforms*, 38(4), 421–430. doi: 10.1002/esp.3366.

Gernsheim, H. (1986). *A concise history of photography*, 3rd revised edition (No. 10). Dover Publications Inc., New York.

Gindraux, S., Boesch, R., & Farinotti, D. (2017). Accuracy assessment of digital surface models from unmanned aerial vehicles' imagery on glaciers. *Remote Sensing*, 9(2), 186.

James, M. R., & Robson, S. (2014). Mitigating systematic error in topographic models derived from UAV and ground-based image networks. *Earth Surface Processes and Landforms*, 39(10), 1413–1420.

James, M.R., Robson, S., d'Oleire-Oltmanns, S., & Niethammer, U. 2017. Optimising UAV topographic surveys processed with structure-from-motion: Ground control quality, quantity and bundle adjustment. *Geomorphology*, 280, 51–66.

Jensen, J. (2007) *Remote Sensing of the Environment: An Earth Resource Perspective*, 2nd Edition. Upper Saddle River, NJ: Prentice Hall.

Jensen, J. (2016) *Introductory Digital Image Processing: A Remote Sensing Perspective* (Pearson Series in Geographic Information Science) 4th Edition. by John Jensen.

Kalantar, B., Mansor, S. B., Sameen, M. I., Pradhan, B., & Shafri, H. Z. (2017). Drone-based land-cover mapping using a fuzzy unordered rule induction algorithm integrated into object-based image analysis. *International Journal of Remote Sensing*, 38(8–10), 2535–2556.

Kedzierski, M., & Wierzbicki, D. (2015). Radiometric quality assessment of images acquired by UAV's in various lighting and weather conditions. *Measurement*, 76, 156–169.

Lowe, D. G. 2004. Distinctive image features from scale-invariant keypoints. *International Journal of Computer Vision*, 60(2), 91–110. doi: 10.1023/B:VISI.0000029664.99615.94.

Lucieer, A., Jong, S. M. D., & Turner, D. 2014. Mapping landslide displacements using Structure from Motion (SfM) and image correlation of multi-temporal UAV photography. *Progress in Physical Geography: Earth and Environment*, 38(1), 97–116. doi: 10.1177/0309133313515293.

Manfreda, S., Dvorak, P., Mullerova, J., Herban, S., Vuono, P., Arranz Justel, J. J., & Perks, M. (2019). Assessing the accuracy of digital surface models derived from optical imagery acquired with unmanned aerial systems. *Drones*, 3(1), 15.

Mathews, A.J. (2015) A practical UAV remote sensing methodology to generate multispectral orthophotos for vineyards: estimation of spectral reflectance using compact digital cameras. *International Journal of Applied Geospatial Research*, 6(4), 65–87.

Myint, S.W., Gober, P., Brazel, A., Grossman-Clarke, S., & Weng, Q. (2011). Per-pixel vs. object-based classification of urban land cover extraction using high spatial resolution imagery. *Remote Sensing of Environment*, 115, 1145–1161.

Peppa, M., Mills, J.P., Moore, P., Miller, P.E., & Chambers, J.C. 2016. Accuracy assessment of a UAV-based landslide monitoring system. *The International Archives of the Photogrammetry, Remote Sensing and Spatial Information Sciences*, 41, 895–902.

Pratt, W.K. (2001). *Digital Image Processing*, New York: John Wiley, 656p.

Rouse, J.W., Haas, R.H., Schell, J.A., & Deering, D.W., 1973. *Monitoring vegetation systems in the Great Plains with ERTS. Proc. Third Earth Resources Technology Satellite-1 Symposium, Goddard Space Flight Center, NASA SP-351, Science and Technical Information Office*, Washington, DC: NASA, pp. 309–317.

Sieberth, T., Wackrow, R., & Chandler, J.H. 2016. Automatic detection of blurred images in UAV image sets. *ISPRS Journal of Photogrammetry and Remote Sensing*, 122, 1–16.

Singh, K. K., & Frazier, A. E. (2018). A meta-analysis and review of unmanned aircraft system (UAS) imagery for terrestrial applications. *International Journal of Remote Sensing*, 39(15–16), 5078–5098.

Snavely, N., Seitz, S. M., & Szeliski, R. (2008). Modeling the world from internet photo collections. *International Journal of Computer Vision*, 80(2), 189–210.

Strahler, A.N. & Strahler A.H. (1989). *Elements of Physical Geography*, 4th edition, New York: John Wiley & Sons, 562.

Thomas, A. F., Frazier, A. E., Mathews, A. J., & Cordova, C. E. (2020). Impacts of abrupt terrain changes and grass cover on vertical accuracy of UAS-SfM derived elevation models. *Papers in Applied Geography*, 6(4), 336–351.

Townshend, J.R.G., Huang, C., Kalluri, D., DeFries, R., Liang, S., & Yang, K. (2000). Beware of per-pixel characterization of land cover. *International Journal of Remote Sensing*, 21(4), 839–843.

Wackrow, R., & Chandler, J. H.. 2011. Minimising systematic error surfaces in digital elevation models using oblique convergent imagery. *The Photogrammetric Record*, 26 (133), 16–31. doi: 10.1111/j.1477-9730.2011.00623.x.

Westoby, M. J., Brasington, J., Glasser, N. F., Hambrey, M. J., & Reynolds, J. M. (2012). "Structure-from-Motion" photogrammetry: A low-cost, effective tool for geoscience applications. *Geomorphology*, 179, 300–314.

Wierzbicki, D., Kedzierski, M., Fryskowska, A., & Jasinski, J. (2018). Quality assessment of the bidirectional reflectance distribution function for NIR imagery sequences from UAV. *Remote Sensing*, 10(9), 1348.

Wu, Y., Qin, Y., Wang, Z., & Jia, L. (2018). A UAV-based visual inspection method for rail surface defects. *Applied Sciences*, 8(7), 1028.

SUGGESTED READINGS

Carrivick, J.L., Smith, M.W., Quincey, D.J. (2016). *Structure from Motion in the Geosciences*. John Wiley & Sons, Ltd. DOI:10.1002/9781118895818

Jensen, J.R. (2016). *Introductory Digital Image Processing: A Remote Sensing Perspective* (4th Edition) (Pearson Series in Geographic Information Science).

Jensen, J.R.. (2007). *Remote Sensing of the Environment: An Earth Resource Perspective*, 2nd edition. Pearson. ISBN-13: 978-0131889507

Linder, W. (2016). *Digital Photogrammetry: A Practical Course*, 4th edition. Springer-Verlag Berlin Heidelberg. DOI: 10.1007/978-3-662-50463-5

Luhmann, T., Robson, S., Kyle, S., & Boehm, J. (2015). *Close-Range Photogrammetry and 3D Imaging*. Berlin/Boston: Walter De Gruyter GmbH, 684.

3 Choosing a Sensor for UAS Imagery Collection

Angad Singh

CONTENTS

INTRODUCTION

The increasing accessibility of drones can be attributed to the decreasing cost of consumer electronics and the ease with which they can be flown right "out of the box." While drones are fun to fly, their real value is as flying cameras and sensors – robots that can provide an aerial perspective through the sensors they carry on board. This chapter provides a practical overview of some of the most common sensor systems available for use today. The discussion focuses on general technical considerations for answering science questions rather than specific sensor brands or manufacturers. Because the primary purpose of a drone is often to collect high-quality data, it is important to critically think about the sensor on the drone in the context of what

domain-specific questions need to be answered. These considerations are particularly important if the research plan calls for processing the images into high-quality three-dimensional (3D) models and maps (see Chapter 6).

Understanding why, when, and under what conditions a certain camera or sensor should be used is one of the most important aspects of drone imagery collection. One could spend hours learning about all of the components of cameras, how each type of sensor is used for remote sensing, and the many other factors that go into the function and design of a sensing system for a drone study. This chapter will introduce some of these aspects including the differences between active and passive sensors, sensor characteristics, the concept of radiometry and why it is important in the context of UAS sensors, and finally the chapter will discuss some of the most commonly used passive sensors for capturing UAS imagery including optical RGB (Red, Green, Blue) cameras, multispectral and hyperspectral sensors, and thermal (infrared) sensors.

PASSIVE AND ACTIVE SENSORS

Remote sensing sensors can be divided into two main categories: passive and active sensors. This chapter focuses primarily on passive sensors as they are more common, but a brief overview of active sensors is also provided.

Passive Sensors

Passive sensors operate much like human eyes and detect natural energy, such as sunlight, that is reflected or emitted from an object. Think about trying to locate objects in a completely dark room – it is difficult to discern useful information with your eyes in complete darkness. Now imagine turning on the lights in the room. Light being emitted from a source such as a lamp is projected around the room, reflecting off of different objects. Your eyes can now see, or rather *sense*, the different colors and shapes of the objects in the room. **Passive sensors** similarly rely on an existing light source that illuminates objects, and they record the energy that is reflected or emitted from those objects (Jensen 2016). In most situations, the light source that passive sensors rely on is the sun.

The concept of passive remote sensing is illustrated in Figure 3.1. The diagram shows the basic process for using electromagnetic radiation for Earth observation. It is important to remember that the light signals captured by sensors are just surrogates for the actual materials and objects on earth. Different materials reflect different wavelengths of light, and from those different signals, it is possible to determine the type of material or objects being sensed. How an object or material reflects different wavelengths of light across the entire electromagnetic (EM) spectrum is referred to as its **spectral signature**.

Pushbroom versus Frame Cameras

Frame sensors take a snapshot of an area, and that area is projected onto film or a two-dimensional array of detectors located in the camera focal plane using the camera optics. Most cameras used with drones are frame sensors, just like the camera on a smartphone. Frame sensors can be further divided into charge-coupled device (CCD) and complementary metal–oxide–semiconductor (CMOS) sensors. CCD sensors contain an array of capacitors that carry an electric charge across the circuit without distortion. This process makes CCD sensors very high-quality in terms of light sensitivity. CMOS sensors are typically low cost, efficient cameras that have a rectangular sensor made up of rows and columns of pixels. Most of the cameras you will encounter being used on drones are CMOS sensors (Vautherin et al. 2016). **Pushbroom sensors** operate more like the light scanner in a photocopy machine, which moves across a page, capturing rows one at a time. A pushbroom sensor similarly captures images as rows of pixels, line by line, as it scans the Earth.

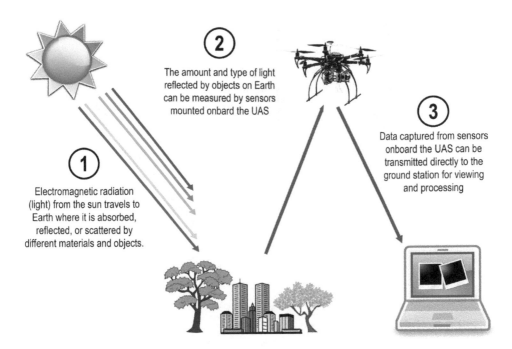

FIGURE 3.1 Illustration of the process of passive remote sensing. (1) Electromagnetic radiation from the sun is scattered or reflected by materials and objects on Earth. (2) The sensor onboard a UAS measures the amount of light being reflected by the surface across the EM spectrum. (3) Data from the sensor can be transmitted directly to the ground for viewing or analysis. [Figure credit: Amy E. Frazier].

ACTIVE SENSORS

Active sensors rely on their own source of energy, emitting light in the direction of the target and then capturing the portion of the light pulse that is reflected back to the sensor. The most recognizable example of an active sensor is lidar (light detection and ranging), which is sometimes colloquially called a laser scanner. A lidar unit, such as the one shown mounted on a drone in Figure 3.2, emits a pulse of light (a laser beam) toward an object or Earth. The unabsorbed light reflects off the object, and any light that is reflected back in the direction of the sensor can be measured.

Laser sensors are equipped with a very high precision clock, which measures exactly how long it takes for the light to travel to the object and back. Since light travels at the constant speed of 3×10^8 m/s, it is possible to convert the time it took for the light to travel to the object and back to the sensor into a measurement of the distance between the sensor and the object. Lidar is widely used to measure tree heights, terrain features, and topography. Lefsky et al. (2002) provide a concise review of lidar and applications for ecosystem studies. Radar (radio detection and ranging) and sonar (sound detection and ranging) work similarly to lidar except instead of emitting light waves, they emit radio waves or sound waves, respectively.

Active sensing systems like lidar, radar, and sonar can be expensive because they require high precision components. They also often require heavy-lift UAS platforms to carry the payload, which can limit the type of drone on which they can be mounted (Resop et al. 2019) and add cost to a mission.

Discrete Return versus Full-Waveform Lidar

A lidar sensor receives the full waveform, or distribution of EM light energy that has been reflected from an object or the surface of the Earth. However, different types of lidar systems record the light in different ways (Figure 3.3). A **discrete return** lidar system records multiple, individual points

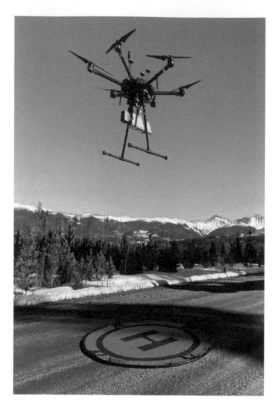

FIGURE 3.2 DJI M600 Pro Airframe (Schenzen, China) with Yellowscan VX20 (Montferrier sur Lez, France) lidar payload. [Photo credit: Nathan Stephenson, Denver, Colorado.]

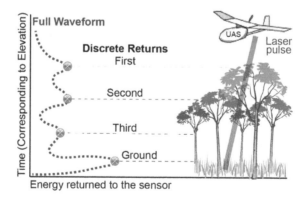

FIGURE 3.3 Comparison of discrete return versus full-waveform lidar. Discrete return systems capture only a few of the largest magnitude returns. Full-waveform systems capture the entire profile of energy returned to the sensor. [Figure credit: Amy E. Frazier].

corresponding to the largest returns, or peaks, in the distribution. When a pulse of light is emitted from the laser scanner, the light pulse might encounter a leaf, for example, and return part of the pulse back to the scanner. The leaf structure will transmit some of the light through the leaf though, where it may travel to the ground before reflecting back to the scanner. By separating these different returns and measuring the precise time for each to travel back to the sensor, these systems can be used to determine height and 3D structure of vegetation. Discrete return systems typically record

anywhere from 1–5 (but sometimes more) returns from each laser pulse (Sumnall et al. 2016). In contrast, **full-waveform** systems record a nearly continuous distribution of back-scattered intensity for each laser pulse (Wagner et al. 2008). Since the entire distribution is being captured rather than just a few points, full-waveform lidar datasets are larger and more complex to process.

SENSOR CHARACTERISTICS

SENSOR SIZE AND RESOLUTION

The focal plane of a camera is where the incident rays coming from the object are focused and collected. For digital cameras, the focal plane is occupied by the CCD array. The **resolution**, or number of pixels in the array, conveys the level of detail that can be captured in an image. For example, a 20-megapixel camera captures images that each contain 20 million pixels, or little squares, each of which holds a unique reflectance measurement. While typically a larger number of pixels means a more detailed image, it is important to balance the number of pixels with an appropriate sensor size, otherwise the captured images may not be as clear as expected.

Sensor size refers to the physical size of the sensor. A common sensor size for cameras used on drones is "1-inch," but in reality, a 1-inch sensor roughly measures about 12.80 mm × 9.60 mm (exact measurements may vary by manufacturer). A 1-inch sensor is typically 12 or 20 megapixels. Given that the sensor size is the same, the raw pixel size in the 12-megapixel camera will be bigger than the 20-megapixel camera, which means it will not show as much detail. There are many different sensor size options; however, it is common to see APC-S (25 mm × 16.7 mm) as well as Full Frame (36 mm × 24 mm) options on the market.

Figure 3.4 shows three common sensor sizes for drone cameras that are regarded as good for photogrammetry applications. The figure also provides some examples of drone camera models for each sensor size.

Focal Length

The **focal length** is the distance from the center of the lens to the focal plane, or imaging point, where the light for the image is collected. For a simplified explanation, the focal length can be regarded as the "zoom" capability of the camera. A camera with a longer focal length will be able to zoom in more compared to a camera with a shorter focal length. With a shorter focal length, you may be able to view a wider area through the camera lens, but you will not be able to zoom in as far. Focal length is usually presented in millimeters.

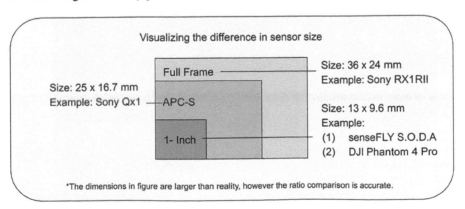

FIGURE 3.4 Sensor size comparison chart for three common sensors used on drones: a 1-in. sensor, an APC-S sensor, and a full-frame sensor. Cameras integrated into the DJI Phantom 4 Pro and eBee senseFLY SODA platforms are 1-in. cameras.

In Figure 3.5, the practical difference between photographs taken from the exact same location and with the same camera (Nikon D3200) but with different focal lengths is clear. In the photograph taken with a 10-mm focal length, the barn to the left is visible as well as the patch of snow in front and several fence posts around the garden on the right. The second photograph is of the same scene, and the photographer was standing in the exact same spot, but the image was captured with a 20-mm focal length. The second image appears "cropped" and more zoomed in compared to the first image. While the area captured is not as wide, features that are farther away can be seen with more clarity, including details of the bark in the white birch tree in the center (Figure 3.5).

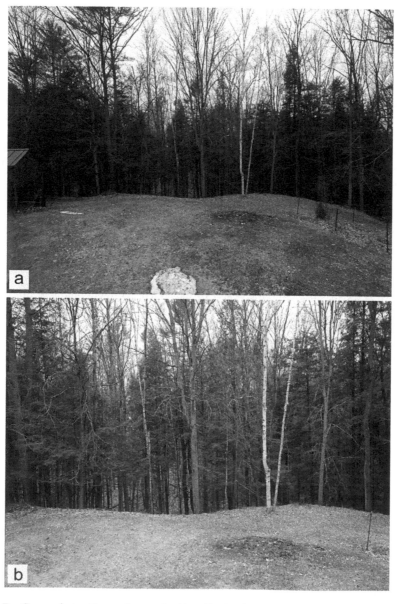

FIGURE 3.5 Comparison of two photos of a New England woods scene taken with (a) a 10-mm focal length on the top and an image captured with (b) a 20-mm focal length on the bottom. Both images were taken from the same spot with a Nikon D3200 RGB camera. [Photo credit: Joshua Himmelstein].

For photogrammetry purposes, it is important that the focal length remain consistent for images captured during a flight, meaning that each image in the dataset should be captured at exactly the same focal length (Strecha et al. 2015). If the camera on the drone has a longer focal length, the footprint of the image (i.e., how much area the image is capturing) will be smaller compared to a camera with a shorter focal length. The practical implication of capturing images with different focal lengths is that the same object will appear to be different sizes on different images. These differences make it difficult for software algorithms to identify matching keypoints among the same feature in multiple photos, which is needed to create 3D models and other useful image products.

A second consideration when choosing a focal length is that when the flying altitude of the drone is kept the same, a camera with a longer focal length will require more images to be collected in order to cover the same area and maintain the same amount of image overlap (which is needed for photogrammetric processing). A longer focal length and more images also means there will be more data to process after the flight, leading to greater computational costs and time. In contrast, a longer focal length will provide higher resolution (more detailed) images and produce higher resolution data products for analyses. All of these considerations must be weighed when determining an appropriate focal length for capturing images.

SHUTTER TYPE

Shutters limit the amount of light that passes to the focal plane. Frame cameras are equipped with either a **linear rolling shutter (LRS)** or a **global shutter** (also called a leaf shutter) (Figure 3.6). Both types of shutters can be mechanical, meaning a physical part is moving inside the camera to expose the CCD to light, but today these components are typically electronic. LRS cameras capture data one row at a time. Global shutter cameras capture data for every pixel in the sensor field of view at the same moment. For high-quality photogrammetry work, it is more advantageous to have a global shutter camera because it minimizes blur. However, most consumer drone sensors, like those integrated on DJI platforms and GoPro cameras, use a rolling shutter because they are less expensive and more compact. When using an LRS sensor, straight lines may appear curved due to the combination of the way the shutter operates and the forward movement of the drone platform. Some image processing software platforms have LRS correction algorithms to minimize the effects, or distortions, that can be introduced by a linear rolling shutter (Vautherin et al.

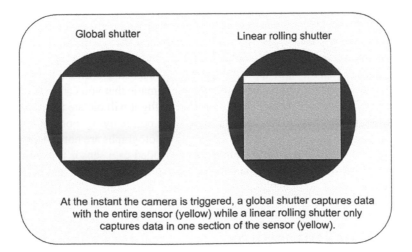

At the instant the camera is triggered, a global shutter captures data with the entire sensor (yellow) while a linear rolling shutter only captures data in one section of the sensor (yellow).

FIGURE 3.6 Global shutter on the left compared to a linear rolling shutter on the right. The global shutter captures the entire scene at once while a linear rolling shutter captures the image row by row.

2016). However, the software may not automatically correct for these distortions so be sure to check the options before beginning any image processing.

LENS TYPE

Different lenses can also impact the geometry of the images and create varying geometric distortions. A **rectilinear lens** takes images in which straight features, such as building walls, appear as straight lines. Since this type of lens matches what a viewer would see with their eyes, these lenses are sometimes referred to as **perspective** lenses. In contrast, a **fisheye lens** is a wide-angle lens that is curved, like a fish's eye, to capture a larger area in a single photograph. Fisheye lenses are common in action sports cameras and for capturing wide landscape shots. A drawback of fisheye lenses is that they distort the size and shape of objects, making straight objects appear curved, or bowed. While most modern photogrammetry software can correct for distortions from a fisheye lens, it is preferable to use a rectilinear lens while capturing drone imagery for photogrammetry applications (Strecha et al. 2015).

Figure 3.7 shows two photographs of a building and parking lot from a drone with the camera facing nadir. Image (a) was captured with a perspective lens while image (b) was captured with a fisheye lens. Curved distortions in the building, parking lot, and surrounding areas are clear on the image captured with the fisheye lens.

GIMBALS

Gimbals are key for capturing clear images. A **gimbal** is a device that holds and stabilizes the sensor from vibrations or platform movement, as well as allowing the direction the camera is facing to be changed. A **two-axis gimbal** allows the camera to move up and down and stabilizes it along two axes of movement in the drone: the pitch and roll. A **three-axis gimbal** allows the camera to move up, down, left, and right. This flexibility stabilizes the camera along all three axes of movement: pitch, yaw, and roll. Many off the shelf drones come with a three-axis gimbal already integrated. While the physics of gimbals is not directly relevant to this chapter, their use for mounting and controlling sensors on a drone is a topic for thought.

ADDITIONAL CONSIDERATIONS

In addition to the sensor characteristics described above, there are many other aspects that can be adjusted such as the white balance, aperture (f/stop), ISO, and shutter speed, to name a few. For instance, many cameras have the option to adjust the white balance, which tunes the color balance of light in the images so that the light appears a neutral white and any artificial light is counterbalanced. There are usually settings for sunny, cloudy, or automatic that you can experiment with as you collect imagery. The environmental conditions during flight will dictate the most appropriate camera settings so it is important to research the conditions before flying. For example, setting an appropriate white balance on a sunny day will ensure the photographs are not overexposed, which can result in a loss of detail. Aftermarket filters can be added to a sensor to change the way a photograph looks. However, for scientific and industrial applications, these types of lens filters are not typically recommended and changing the settings too drastically might affect imagery post processing (Strecha et al. 2015).

GEOMETRIC CAMERA CALIBRATION

Geometric camera calibration is the process of determining the geometric properties of a camera needed to relate 2D points in the image plane of a camera with 3D points in the world scene being

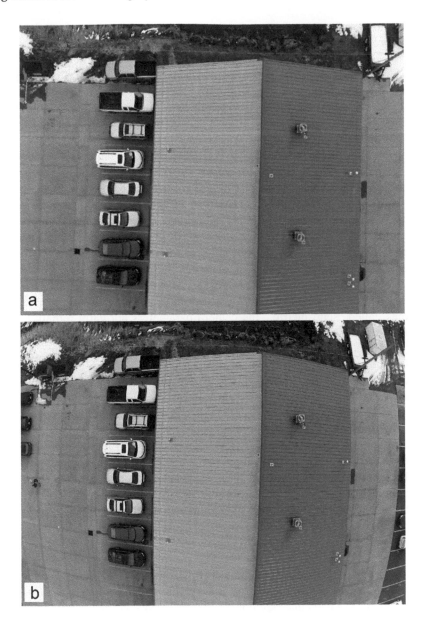

FIGURE 3.7 (a) Perspective lens image – a rectilinear image where straight lines appear straight. (b) Fisheye image, characterized by a distorted, "bubble-like" appearance. Objects like the building roof that should appear straight instead appear curved. [Figure credit: Jon McBride, Rocky Mountain Unmanned Systems, Salt Lake City, Utah].

viewed by the camera. The estimated parameters are used to correct for lens distortions and determine the location of the camera when it captured the image, which are needed for 3D scene reconstruction, a common application of drone imagery. Historically, photogrammetric sensors used for 3D reconstruction were calibrated in a laboratory to determine the intrinsic geometry and distortions needed for geometric calibration. These **metric cameras** could then be used to make precise measurements without additional control of the inner and relative orientation (Kölbl 1976). Geometric camera calibration is critical when using metric cameras for photogrammetry.

With drones, metric cameras are often too large to carry onboard and too expensive, so alternative calibration procedures are needed to rectify image distortions. The most significant systematic errors associated with 3D models derived from drone imagery are caused by poor calibration of the camera model (James and Robson 2014), particularly from radial distortions, which increase in magnitude with increasing distance from the optical center (Luhmann et al. 2013). Fortunately, modern advancements and algorithm development in structure from motion (SfM; Snavely et al. 2008) software have enabled these distortions to be estimated directly from the imagery without the need for high precision geometric camera calibration. Pre-calibration and self-calibration are two common approaches to determine the distortion model, specifically when the imagery is to be used in an SfM photogrammetric workflow (see Chapter 6 for more details).

Pre-calibration is the process of determining the intrinsic geometry and distortion model of the camera before the bundle adjustment step in SfM. Pre-calibration can be done by the camera manufacturer (as with metric cameras) since the assumption is that the intrinsic geometry of a camera is constant as long as no serious physical impact to the camera occurs. More commonly though, pre-calibration is done by the user where a two-dimensional planar pattern, such as a black and white checkerboard, is observed with the camera from multiple angles (Triggs 1998; Zhang 2000; Chari and Veeraraghavan 2014). The intrinsic and distortion model parameters can then be computed (Griffiths and Burningham 2019). With pre-calibrated sensors, sometimes called "semi-metric," the camera parameters normally remain fixed during processing (James et al. 2019).

Advances in self-calibration methods have also made it possible for nonmetric cameras to be used onboard drones to capture images that are of sufficient quality for creating photogrammetric models (Harwin et al. 2015). **Self-calibration** is the process of determining the intrinsic camera parameters, such as the optical center and focal length, directly from uncalibrated, overlapping images. Advances in automated feature identification and matching have enabled users to model distortions from consumer-grade cameras relatively easily using self-calibration approaches to test for and correct distortions automatically (Woodget et al. 2017). These approaches are often built into photogrammetric software applications making self-calibration relatively easy. However, while self-calibration approaches may work in environments and terrain where there are sufficient features for mapping, other environments (e.g., cropland with little variability) may require more rigorous calibration approaches (Griffiths and Burningham 2019).

BORESIGHT CALIBRATION

Boresighting refers to the process of determining the differences between the orientation of the sensor along its rotational axes and the orientation of the platform along its rotational axes. These differences can result due to a particular assembly of the sensor (Skaloud and Lichti 2006). **Boresight calibration** is the process of computing exactly how the drone is moving and being affected by wind so that the sensor can provide accurate measurements of distance. Platform rotation is typically measured using an **inertial measurement unit** (IMU), which is a device containing gyrometers and accelerometers to measure rotation and acceleration. Improvements in the accuracy of these sensors have led to advances in calibrating imagery and data with high spatial accuracy (Habib et al. 2018).

Boresight calibration can be achieved by flying over a site where accurate ground control points have been determined. Using the imagery or data from that site, aerial triangulation can be performed to compute the exterior orientation parameters, while the IMU measures the interior orientation parameters (e.g., roll, pitch, and yaw). By comparing the two sets of orientation angles, it is possible to establish differences in the rotations of the camera with respect to those of the IMU. These differences are then used to correct all future IMU-derived orientations so that the imagery or data can be used for mapping or analysis.

It is important to note that the above explanation is the most common way the term "boresighting" is used in regards to remote sensing; however, this term can also mean that multiple lenses on one sensor are designed so that the images align perfectly, even if the lenses are physically offset.

RADIOMETRY AND RADIOMETRIC CALIBRATION

Radiometry is the science of measuring electromagnetic radiation (Wolfe 1998). While the mechanics of radiometry are quite complicated, it is important to know if the camera being used is radiometrically calibrated as that can impact the accuracy of the measurements. A camera that is radiometrically calibrated will capture true (or close to true) reflectances from the objects in the field of view. Having radiometrically calibrated sensors onboard a drone is important for performing accurate spectral analyses with the resulting images (Singh and Frazier 2018).

If a sensor is not properly calibrated, comparisons may yield inaccurate or erroneous results. For example, in agricultural applications, changes in the reflectance of red and near infrared light from crops can help determine whether water or nutrient inputs are needed. If the sensor is not properly calibrated, it may not be clear if changes between image acquisitions are due to actual changes in the crop status or simply sensor uncertainties, with the latter potentially leading to improper fertilizer or water inputs. Together, radiometric calibration of the sensor (discussed below) along with radiometric correction of the images (introduced in Chapter 2) can help mitigate many of these factors (Kalacska and Bell 2006). It should be noted that radiometric calibration for long-wave infrared (thermal) sensors works differently than calibration for multispectral and hyperspectral sensors. Thermal sensors are discussed later in this chapter.

RADIOMETRIC CALIBRATION

Radiometric calibration is an adjustment or set of adjustments applied to a sensor that allow it to function as accurately and with as little error as possible. Radiometric calibration requires knowing the environmental (light) conditions at the time the images were collected. There are several methods that can be used for radiometric calibration including use of a reflectance panel or a downwelling light sensor (sometimes referred to as a sunshine sensor). Radiometric calibration of off-the-shelf digital cameras is complicated by the fact that most camera manufacturers do not publish the specific wavelength intervals captured by each band in the sensor (Mathews 2015). So while you may know the camera being used is capturing images in the Red, Green, and Blue channels, it may not be possible to determine the exact wavelength intervals at which those channels are sensitive.

On common tool remote sensors use is a calibrated **reflectance panel**. The panel is a flat object covered in a special coating that has close-to-perfect diffuse spectral reflectance as. The photo in Figure 3.8 shows a reflectance panel that has been mounted in a protective carrying case in the lower right corner. The reflectance panel is the white square in the black case without any writing or printing on it. The panel is designed to reflect light in all directions uniformly, regardless of environmental conditions. In the field, the panel is placed on the ground, and the sensor is positioned parallel to the panel, often around chest height, to take a calibration photo. This step can be done before the sensor is attached to the platform, or the entire platform can be maneuvered to align the sensor above the panel to capture a calibration image. The reflectance readings from the panel can then be used to calibrate the rest of the images. Best practices suggest capturing a reading from the calibration reflectance panel before and after each flight in order to provide an accurate representation of the light conditions during the flight.

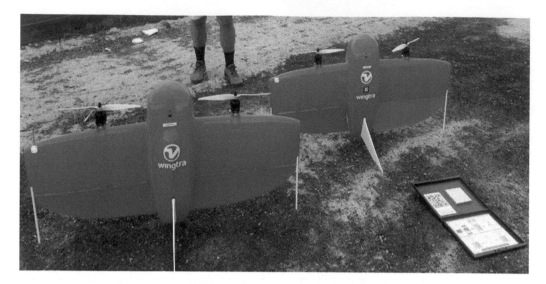

FIGURE 3.8 Two of Wingtra One's vertical takeoff and landing (VTOL) drones equipped with Micasense Rededge multispectral sensor and calibration panel. The calibration panel is located within the black case in the lower right and is the smallest white square with no markings.

A second method for calibration is through a downwelling light sensor, or DLS. The DLS is mounted on top of the drone and is positioned facing up toward the sky. During flight, when the camera on the drone captures images, the DLS will record complementary data on the lighting conditions. The DLS reading can then be used to calibrate each image to account for sun illumination and sun angle effects. DLS sensors are becoming more common since they can account for small variations in light conditions that may occur during a flight (Schneider-Zapp et al. 2019).

COMMON PASSIVE SENSORS USED WITH DRONES

RGB CAMERAS

The most common type of sensor being used onboard drones are RGB digital cameras (Mathews 2015; Singh and Frazier 2018). RGB stands for Red–Green–Blue and refers to the three channels of the visible portion of the electromagnetic spectrum of light that are detected by the sensor. Human eyes are also able to detect light in the "visible" range of the electromagnetic spectrum (see Chapter 2). Therefore, RGB cameras are designed to capture images that resemble how humans see materials and objects.

RGB sensors are quite common; they are the type found on most smartphones. Computers are able to composite the three values corresponding to the three bands of light together to display a three-band image as a single, multicolor composite image on the screen (Figure 3.9). RGB cameras are often used to capture images that are then processed into data products such as orthomosaics and 3D models such as digital elevation and surface models. The creation of high-resolution models and maps using a basic RGB camera mounted to a drone is creating innovations in many industries. For example, land surveyors are transitioning from taking hundreds of measurements manually by walking or driving around a site with a powerful and highly accurate differential GPS system to using drones with RGB cameras and photogrammetry software to produce these highly precise geospatial datasets that are central to their work (Li and Liu 2019).

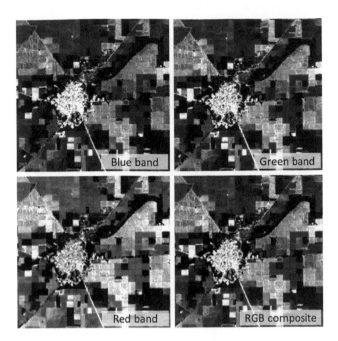

FIGURE 3.9 Example of an agricultural area in Haryana, India showing the individual Blue, Green, and Red bands (black is low reflectance and white is high reflectance) as well as an RGB composite of the three bands. [Figure credit: Amy E. Frazier].

MULTISPECTRAL SENSORS

Multispectral sensors capture reflectance in multiple bands of the electromagnetic spectrum. Typically, multispectral cameras designed for drones capture anywhere from 3 to 10 wavebands of light. Many of the multispectral cameras on the market are specifically designed to capture reflectance in the near-infrared (NIR) region of the EM spectrum and a small (approximately 15–45 nm wide) range of wavelengths known as the red edge, which sits between the red and NIR regions (Figure 3.10). The NIR and red edge bands are particularly helpful for studying vegetation as plants reflect a large amount of light in these regions, but humans are not able to sense these wavelengths of light with the naked eye. Figure 3.10 shows a typical reflectance signature of vegetation. Notice how there is a small spike in reflectance from vegetation in the green band. The chlorophyll in vegetation reflects greener light relative to the other colors of visible light, which is why humans see plants as green. There is also a steep increase in reflectance through the red edge, with reflectance plateauing in the NIR region.

Since the band placement for many multispectral sensors targets the biochemical components of vegetation, these sensors are frequently used for environmental applications such as crop monitoring, ecological restoration, and to detect invasive species (Alvarez-Taboada et al. 2017; Jiménez López and Mulero-Pázmány 2019; Mogili and Deepak 2018). The agriculture industry in particular uses these sensors to monitor in-field variations of growth, identifying areas where crops are healthy and where they are stressed. For example, Mathews (2014) used a kitewing UAS equipped with both an RGB camera and a second camera that had been adjusted to capture a NIR band by replacing the internal hot mirror with clear glass to identify spatial variations in vine canopy area and canopy vigor for a vineyard in Texas. The NIR images were then used to create maps of the normalized difference vegetation index (NDVI) to highlight differences in canopy vigor across

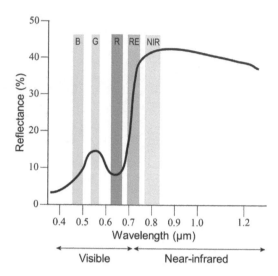

FIGURE 3.10 Typical reflectance curve for vegetation (black line) with approximate placement of blue (B), green (G), red (R), red-edge (RE), and near-infrared (NIR) bands on a multispectral sensor. Not all multispectral sensors will have the same bands. [Figure credit: Amy E. Frazier].

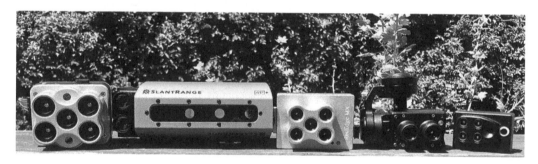

FIGURE 3.11 Several popular multispectral sensors on the market. From left to right: Micasense Altum, Slantrange 4P, Micasense Rededge MX, Senterra 4 K, Parrot Sequoia. [Photo credit: Dr. Greg Crutsinger, Scholar Farms].

the vineyard and delineate different management zones throughout the vineyard where different inputs might be needed (e.g., water, nutrients).

As noted above, multispectral cameras can be designed to capture specific bands, or the hot mirror in an RGB camera can be removed and replaced with clear glass to allow the CCD or CMOS to sense NIR wavelengths (Cheng and Rahimzadeh 2005). Figure 3.11 shows some popular drone-specific multispectral cameras on the market, including the Micasense Rededge (Micasense, Seattle, USA) and the Parrot Sequoia (Parrot, Paris, France). Notice how these sensors have multiple lenses, each of which captures reflectance from a different band. During image capture, the multiple sensors trigger simultaneously, each capturing a separate image. These multiple images can then be co-registered during post-processing to ensure the pixels from the different bands are located in the exact same position (Schneider-Zapp et al. 2019).

HYPERSPECTRAL SENSORS

A typical multispectral sensor might have 4 or 5 bands ranging fromabout 450 to 850 nm, but within this same range, a hyperspectral sensor might have more than 100 very narrow bands. The higher **spectral resolution** that characterizes hyperspectral sensors provides a precise digital "fingerprint" or spectral signature of the material or objects being imaged. This spectral signature provides more information compared to the few data points from a multispectral sensor, and the data can be analyzed more intensely to uncover the biophysical or chemical components of the material or object.

Hyperspectral imagery is typically described and presented as a **hyperspectral data cube** (Figure 3.12) because the tens or hundreds of bands can be conceptualized as a large stack forming a cube. Whereas a single pixel in the multispectral image in Figure 3.12 would have five values, one corresponding to each band, the same pixel in a hyperspectral image might have hundreds of values, each representing the amount of light reflected by that pixel at a particular narrow waveband. Since hyperspectral sensors can capture an almost continuous picture of how light is reflected across the electromagnetic spectrum within each pixel, they provide more opportunities for data mining.

Today, only a handful of case studies have utilized hyperspectral sensors mounted on a drone. A Canadian team designed and built a 288 band uCASI pushbroom hyperspectral sensor (ITRES Research Limited, Calgary, Canada) with spectral bands ranging from 401 to 996 nm (Arroyo-Mora et al. 2019), providing an early account of system capabilities. The system cost upwards of $100,000 USD when including the cost of the sensor, high precision inertial measurement unit (IMU) and GPS, and a DJI M600 Pro airframe that was needed to successfully carry this payload (Arroyo-Mora et al. 2019).

The high cost of hyperspectral sensors puts them beyond the reach of many researchers and hobbyists. These systems are also heavier than most off the shelf cameras, and therefore require a more robust platform with a larger payload capability. The weight of the sensor can also significantly reduce the battery life and flying time of the drone, potentially requiring more flights to image an area. As of early 2020, there was still no off-the-shelf drone equipped with a hyperspectral sensor that was "ready to launch" out of the box. Given the costs and complexities of acquiring and integrating these systems, it is recommended users consult with someone who has experience integrating hyperspectral sensors on drones before making a costly purchase.

In addition to the use of these sensors for vegetation studies, there are many other fascinating applications of hyperspectral sensors that will push the boundaries of remote sensing. For example, Jackisch et al. (2018) used a hyperspectral sensor affixed to a UAS to monitor acid mine

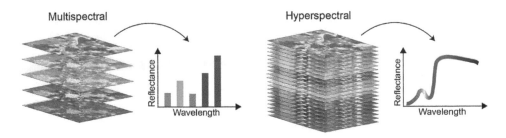

FIGURE 3.12 Comparison of a multispectral image stack (left) and a hyperspectral image cube (right). The multispectral image contains five bands and provides a coarse understanding of how the materials in a pixel reflect light. The hyperspectral image contains many more bands, providing a finer understanding of how the materials in a pixel reflect light. [Figure credit: Amy E. Frazier].

drainage from an open pit extraction mine in the Czech Republic. Using a Rikola hyperspectral camera (Senop Oy, Kangasala, Finland) mounted on a Aibotix Aibot X6v2 hexacopter, the authors found evidence of jarosite and goethite minerals, both of which are associated with acidic environmental conditions. In another application, Kalacska and Bell (2006) demonstrated how hyperspectral imaging can be used to detect mass grave sites, which is important for historic sites preservation or the persecution of war crimes. Decomposing organic matter will change the chemical composition of the soil, and therefore change the properties of how light is reflecting off the site. With the narrow bands of a hyperspectral sensor, it is possible to target specific wavelengths corresponding to these chemical signatures to identify where these graves might exist. This example may seem a bit gruesome, but it highlights the capabilities of remote sensing to push the boundaries of science. While Kalacska and Bell (2006) employed an airborne sensor, as technologies improve, we will likely see similar applications with UAS-mounted sensors.

THERMAL CAMERAS

Thermal detectors, or microbolometers, are sensors designed to detect infrared radiation, or heat. Unlike the other types of sensors that have been discussed so far that produce images from light reflected from objects on Earth, thermal cameras produce images based on the amount of heat emitted by objects. When infrared radiation ranging between 7.5 and 14 μm strikes the detector material, it heats it up and changes its electrical resistance. Those changes are then measured and translated into temperatures to create an image. Thermal sensors are used in a wide variety of applications including search and rescue operations, measuring water stress in plants and crops, and commercial applications such as roof inspections to determine where heat loss is occurring (Rudol and Doherty 2008; Zarco-Tejada et al. 2012; Ribeiro-Gomes et al. 2017). Thermal sensors are one example of a technology that is becoming cost-effective and readily accessible for use with UAS (Figure 3.13).

Most thermal cameras used in drone research are air cooled (Ribeiro-Gomes et al. 2017), meaning the ambient temperature of the sensor is the same as the temperature around the camera. The effect of air cooling is that the camera is less sensitive to changes in temperature, meaning an image analyst will have a harder time detecting a human running in the hot sun on a day when the temperature is 36.7°C (98°F), than detecting someone out for a stroll on a cold winter day. Many higher end thermal sensors are gas cooled, which keeps the detector core very cold and makes

FIGURE 3.13 Right: DJI M600 Pro Airframe with DJI Xt2 Thermal Camera. [Photo credit: Paul Aitken, Founder of Drone U.]. Left: Rendering of how a thermal image of the landscape would look. For demonstration only.

them much more sensitive to changes in temperature. However, these sensors are typically more expensive and so have not been used very often in basic research studies with drones.

When choosing a thermal camera, it is important to consider several aspects of the sensor design and performance including the radiometric accuracy, resolution of the imagery, and frame rate.

Radiometric Accuracy

In the context of thermal imaging, **non-radiometric sensors** provide only the relative difference in temperatures between objects in the field of view. In other words, non-radiometric sensors can provide an indication of which objects are hotter and which are cooler, but they do not allow for direct measurements of absolute temperatures. On the other hand, **radiometric sensors** can provide accurate temperature readings for certain objects in the scene.

A radiometric camera requires the user to input certain variables corresponding to the environmental conditions. The **reflected temperature** is any thermal radiation originating from objects in the surrounding area that might reflect off the target you are measuring. **Emissivity** refers to a material's ability to emit thermal radiation and can broadly be conceptualized as whether a given material holds heat well or not. For objects with higher emissivity, the reflected temperature will not have as much influence. However, for objects with lower emissivity, estimating the true reflected temperature is critical for taking accurate temperature measurements. A true radiometric thermal camera requires a user to understand how to calculate and input these two factors in order to achieve accurate readings. For this reason, many industrial inspectors who utilize thermal cameras can take certification exams to become **thermographers**.

Resolution and Frame Rate

Typically, the highest resolution thermal camera on the market is 640 × 512 pixels, which is not very high when compared to many RGB cameras. If your goal is to produce thermal maps (ortho mosaics of the thermal images), you will want a thermal camera with the highest resolution possible.

The frame rate of the camera is also an important consideration. Thermal sensors are typically available as 9 Hz or 30 Hz, meaning the sensor captures nine or 30 images per second, respectively. If the sensor has a lower frame rate, it can be necessary to fly the drone at a low speed to ensure images are clear and in focus.

Sensor resolution is also an important consideration for anomaly detection. An **anomaly** is an area or region in the image that has a value that is different than what was expected. For example, if there is a hole in a roof, and warm air is escaping from the house through this hole, the hole should show up as an anomaly on a thermal image. In order to visually assess an anomaly, it usually needs to be at least 3 × 3 pixels large, which requires understanding the camera's resolution and then flying at an altitude where you can ensure an anomaly would be visible in the imagery. With a higher resolution sensor, you can fly higher and the anomaly will still be visible to the eye. However, with a lower resolution sensor, you would need to fly much closer to the ground, which means the inspection will take more time.

Figure 3.14 shows a thermal image of a solar panel array next to a photo of the same array. Notice the yellow circle highlighting a potential anomaly on the right side of the solar panel. The discoloration in the image indicates the infrared radiation being sensed by the camera at that spot is different from the surrounding pixels. This anomaly could indicate an issue with that particular solar cell, or, the anomaly may signal a problem with the sensor (camera) or the image. In order to confirm whether the issue is with the solar array or the sensor, **ground truthing** is needed, which means someone must physically visit the site and verify whether the solar cell needs to be replaced.

FIGURE 3.14 A side-by-size view of an orthophoto of a solar panel installation on the left and a thermal image of the same area on the right. In the thermal image, an anomaly is circled on the far-right side. [Photo credit: Paul Aitken].

To improve the resolution of thermal cameras, some manufacturers produce **boresighted thermal cameras**. This technology offers an opportunity to mount a thermal camera and an RGB camera together on a drone platform. The two sensors are angled so that they both view the same surface. Figure 3.14 shows imagery captured by a DJI XT2 (Schenzeng, China) thermal sensor built with a FLIR thermal core (FLIR, Wilsonville, Oregon). The RGB camera provides the underlying geometry, and the thermal image is layered on top. This integration of an RGB photo and a thermal image allows you to view objects for context while examining the thermal data.

Thermal sensors sense the amount of "heat" or long-wave infrared electromagnetic energy being emitted from a surface or object rather than capturing imagery by measuring the amount of light being reflected off a surface but rather by sensing. Recognizing this difference is critical to understanding the factors that go into thermal imaging and how to interpret thermal imagery. Thermal sensors are very powerful tools that can be incredibly useful for research and applications. It should be noted though that some higher end thermal sensors are regulated by the International Traffic in Arms Regulations (ITAR), which controls the sale and export of some of these sensors to protect national security. This last point is important because to date, civilian researchers have had only limited access to some of the best thermal sensors. The field of thermal imaging with drones is likely to advance in the future as better technologies become more accessible.

SUMMARY

Choosing a sensor for UAS data collection is one of the most important aspects of project design. There are many different types of sensors on the market, and each captures different types of data in different ways. Choosing the most appropriate sensor for the project at the start will help ensure you capture the right kind of data to answer the question at hand. RGB cameras are the most prevalent type of sensor used on drones for imagery collection. RGB cameras are useful for taking aerial images, and those images can also be used for making 3D models and maps. Multispectral and hyperspectral sensors capture imagery data with more spectral precision than RGB cameras.

Thermal cameras capture the amount of infrared light coming off a surface as heat. Understanding the characteristics that factor into sensor choice and design will enable you to choose a sensor that is best suited to answer a research question or achieve the project aims. Drones are powerful tools when utilized as flying cameras. Their power is already being harnessed by scientists, researchers, and society at large.

REFERENCES

Alvarez-Taboada, F., Paredes, C., & Julián-Pelaz, J. (2017). Mapping of the invasive species Hakea sericea using unmanned aerial vehicle (UAV) and WorldView-2 imagery and an object-oriented approach. *Remote Sensing*, 9(9), 913.

Arroyo-Mora, J.P., Kalacska, M., Inamdar, D., Soffer, R., Lucanus, O., Gorman, J., Naprstek, T., Schaaf, E.S., Ifimov, G., & Elmer, K. (2019). Implementation of a UAV–hyperspectral pushbroom imager for ecological monitoring. *Drones*, 3, 12.

Chari, V, & Veeraraghavan, A (2014) Lens distortion, radial distortion. In: Ikeuchi, K (ed) *Computer Vision*. New York: Springer, 443–445.

Cheng, C., & Rahimzadeh, A. (2005). *Hacking Digital Cameras*. Hoboken, NJ: John Wiley & Sons, Inc.

Griffiths, D., & Burningham, H. (2019). Comparison of pre-and self-calibrated camera calibration models for UAS-derived nadir imagery for a SfM application. *Progress in Physical Geography: Earth and Environment*, 43(2), 215–235.

Habib, A., Zhou, T., Masjedi, A., Zhang, Z., Flatt, J. E., & Crawford, M. (2018). Boresight calibration of GNSS/INS-assisted push-broom hyperspectral scanners on UAV platforms. *IEEE Journal of Selected Topics in Applied Earth Observations and Remote Sensing*, 11(5), 1734–1749.

Harwin, S., Lucieer, A., & Osborn, J. (2015). The impact of the calibration method on the accuracy of point clouds derived using unmanned aerial vehicle multi-view stereopsis. *Remote Sensing*, 7(9), 11,933–11,953.

Jackisch, R., Lorenz, S., Zimmermann, R., Möckel, R., & Gloaguen, R. (2018). Drone-borne hyperspectral monitoring of acid mine drainage: An example from the Sokolov lignite district. *Remote Sensing*, 10(3), 385.

James, M. R., & Robson, S. (2014). Mitigating systematic error in topographic models derived from UAV and ground-based image networks. *Earth Surface Processes and Landforms*, 39(10), 1413–1420.

James, M. R., Chandler, J. H., Eltner, A., Fraser, C., Miller, P. E., Mills, J. P., ... & Lane, S. N. (2019). Guidelines on the use of structure-from-motion photogrammetry in geomorphic research. *Earth Surface Processes and Landforms*, 44(10), 2081–2084.

Jensen, J.R. (2016) *Introductory Digital Image Processing: A remote sensing perspective*. 4th Edition. Pearson.

Jiménez López, J., & Mulero-Pázmány, M. (2019). Drones for conservation in protected areas: present and future. *Drones*, 3(1), 10.

Kalacska, M., & Bell, L.S. (2006). Remote sensing as a tool for the detection of clandestine mass graves. *Canadian Society of Forensic Science Journal*, 39, 1–13.

Kölbl, O. R. (1976). Metric or non-metric cameras. *Photogrammetric Engineering and Remote Sensing*, 42(1), 103–113.

Lefsky, M.A., Cohen, W.B., Parker, G.G., & Harding, D.J. (2002). Lidar remote sensing for ecosystem studies: Lidar, an emerging remote sensing technology that directly measures the three-dimensional distribution of plant canopies, can accurately estimate vegetation structural attributes and should be of particular interest to forest, landscape, and global ecologists. *Bioscience*, 52, 19–30.

Li, Y., & Liu, C. (2019). Applications of multirotor drone technologies in construction management. *International Journal of Construction Management*, 19, 401–412.

Luhmann, T., Piechel, J., & Roelfs, T. (2013). Geometric calibration of thermographic cameras. In *Thermal Infrared Remote Sensing* 27–42. Dordrecht: Springer.

Mathews, A.J. (2014). Object-based spatiotemporal analysis of vine canopy vigor using an inexpensive unmanned aerial vehicle remote sensing system. *Journal of Applied Remote Sensing*, 8, 085199.

Mathews, A.J. (2015) A practical UAV remote sensing methodology to generate multispectral orthophotos for vineyards: estimation of spectral reflectance using compact digital cameras. *International Journal of Applied Geospatial Research*, 6(4), 65–87.

Mogili, U. R., & Deepak, B. B. V. L. (2018). Review on application of drone systems in precision agriculture. *Procedia Computer Science*, 133, 502–509.

Resop, J.P., Lehmann, L., & Hession, W.C. (2019). Drone laser scanning for modeling riverscape topography and vegetation: Comparison with traditional aerial Lidar. *Drones*, 3, 35.

Ribeiro-Gomes, K., Hernández-López, D., Ortega, J. F., Ballesteros, R., Poblete, T., & Moreno, M. A. (2017). Uncooled thermal camera calibration and optimization of the photogrammetry process for UAV applications in agriculture. *Sensors*, 17(10), 2173.

Rudol, P., & Doherty, P. (2008, March). *Human body detection and geolocalization for UAV search and rescue missions using color and thermal imagery*. In *2008 IEEE aerospace conference* (pp. 1–8). IEEE.

Schneider-Zapp, K., Cubero-Castan, M., Shi, D., & Strecha, C. (2019). A new method to determine multiangular reflectance factor from lightweight multispectral cameras with sky sensor in a target-less workflow applicable to UAV. *Remote Sensing of Environment*, 229, 60–68.

Singh, K.K., & Frazier, A.E. (2018). A meta-analysis and review of unmanned aircraft system (UAS) imagery for terrestrial applications. *International Journal of Remote Sensing*, 39, 5078–5098.

Skaloud, J., & Lichti, D. (2006). Rigorous approach to bore-sight self-calibration in airborne laser scanning. *ISPRS Journal of Photogrammetry and Remote Sensing*, 61(1), 47–59.

Snavely, N., Seitz, S. M., & Szeliski, R. (2008). Modeling the world from internet photo collections. *International journal of computer vision*, 80(2), 189–210.

Strecha, C., Zoller, R., Rutishauser, S., Brot, B., Schneider-Zapp, K., Chovancova, V., Krull, M., & Glassey, L. (2015). Quality assessment of 3D reconstruction using fisheye and perspective sensors. *ISPRS Annals of Photogrammetry, Remote Sensing & Spatial Information Sciences*, 2(3): 215.

Sumnall, M. J., Hill, R. A., & Hinsley, S. A. (2016). Comparison of small-footprint discrete return and full waveform airborne lidar data for estimating multiple forest variables. *Remote Sensing of Environment*, 173, 214–223.

Triggs, B (1998) *Autocalibration from planar scenes*. In: *European conference on computer vision (ECCV98)*, Freiburg, Germany, 2–6 June 1998, pp. 89–105.

Vautherin, J., Rutishauser, S., Schneider-Zapp, K., Choi, H.F., Chovancova, V., Glass, A., & Strecha, C. (2016). Photogrammetric accuracy and modeling of rolling shutter cameras. *ISPRS Annals of Photogrammetry, Remote Sensing & Spatial Information Sciences*, 3(3): 139–146.

Wagner, W., Hollaus, M., Briese, C., & Ducic, V. (2008). 3D vegetation mapping using small-footprint full-waveform airborne laser scanners *International Journal of Remote Sensing*, 29, 1433–1452.

Wolfe, W. L. (1998). *Introduction to radiometry* (Vol. 29). Bellingham, Washington: SPIE Press.

Woodget, A.S., Austrums, R., Maddock, I.P., & Habit, E. (2017). Drones and digital photogrammetry: from classifications to continuums for monitoring river habitat and hydromorphology. *Wiley Interdisciplinary Reviews Water*, 4, e1222.

Zarco-Tejada, P. J., González-Dugo, V., & Berni, J. A. (2012). Fluorescence, temperature and narrow-band indices acquired from a UAV platform for water stress detection using a micro-hyperspectral imager and a thermal camera. *Remote Sensing of Environment*, 117, 322–337.

Zhang, Z (2000) A flexible new technique for camera calibration. *IEEE Transactions on Pattern Analysis and Machine Intelligence* 22(11): 1330–1334.

4 Mission Planning for Capturing UAS Imagery

Qassim Abdullah

CONTENTS

INTRODUCTION

The vast majority of UAS operations involve collecting aerial imagery. This chapter focuses on imaging sensors (digital cameras), which are widely used for geospatial projects. The successful execution of any mapping project requires a tremendous amount of planning that should be performed by an experienced professional who is familiar with all aspects of mapping such as aerial data acquisition, sensor technologies, ground controls survey, map production processes, scheduling, and cost estimation. This chapter details the important activities involved in mission planning and flight plan development. Mission planning involves:

1. Defining product specifications and accuracy requirements;
2. Researching operational site restrictions;
3. Selecting an imaging sensor and computing image geometry;
4. Planning aerial imagery collection;
5. Estimating costs and developing a delivery schedule.

DEFINING PRODUCT SPECIFICATIONS AND ACCURACY REQUIREMENTS

To begin planning the mission, the planner needs to discuss expectations and requirements with the client or product end user. The planner must ascertain the product's intended use, positional accuracy requirements, spatial resolution, number of spectral bands (i.e., a 3-band natural color (RGB) imagery vs. 4-band imagery that contains the near-infrared (NIR) band), data processing software, data format, the frequency of data acquisition if it is more than once (as it influences the stability of ground control targets), and the datum and coordinate system.

RESEARCHING OPERATIONAL SITE RESTRICTIONS

Next, the planner needs to get acquainted with the project site to understand any operational restrictions and safety aspects. Some project locations may dictate operational and hardware requirements. Some site limitations (e.g., uneven topography, tall trees, etc.) may force the planner to use vertical take-off and landing (VTOL) UAS instead of a fixed-wing UAS. Proximity to airports, road systems, or populated areas must also be analyzed and mitigated prior to the development of the flight plan. There are many options for assessing study area characteristics, but planners primarily rely on two types of maps to orient themselves to the study area before proceeding with a project design: (1) topographic maps and (2) sectional aeronautical charts. The topographic map and the aeronautical chart together provide an overview of the area and the ground cover content (i.e., natural and human-constructed features) as well as the area restricted for airspaces, such as airport approaches, high towers, and no-fly zones, to name a few.

TOPOGRAPHIC MAPS

Topographic maps are available for many places on earth and can often be obtained through government agency websites. Topographic maps depict ground relief such as landforms, terrain, and drainage features such as lakes and rivers, land covers (e.g., forests and urban areas), administrative boundaries, populated areas, transportation routes and facilities (including roads and railways), and other human-constructed features. In the United States, topographic maps are maintained and distributed by the United States Geological Survey (USGS). The maps are referred to as "Topo Quadrangle Maps." These maps can be ordered online or downloaded for free or minimal charge. The U.S. Topo Quadrangle Map shows details of the topography of the terrain (Figure 4.1). This type of map reveals all the information that a UAS mission planner needs to know about the topography in the project area. Topography affects flight plan parameters such as the spacing between flight lines, imagery spacing, and flying altitude.

SECTIONAL AERONAUTICAL CHARTS

The second type of map that UAS mission planners rely on are Sectional Aeronautical Charts, which are also called VFR charts. The VFR acronym is adopted from "visual flight rules," referring to the way a pilot relies on the visual see-and-avoid rule during flight. These charts are one

FIGURE 4.1 Portion of a United States Topographic Quadrangle Map (Source: USGS). Each contour line connects points that share the same elevation.

FIGURE 4.2 Example of a Sectional Aeronautical Chart for Seattle, Washington, USA (Source: FAA). A brief description next to a small black square indicates the exact location for many of the landmarks, such as stadiums, pumping stations, refineries, etc., that are easily recognized from the air. A small black open circle with descriptive type indicates oil, gas, or mineral wells. A small black closed circle with descriptive type indicates water, oil, or gas tanks.

of the primary references that pilots rely on for navigating in the airspace. The 1:500,000 scale Sectional Aeronautical Chart Series (Figure 4.2) is designed for visual navigation of slow- to medium-speed aircraft. The topographic information featured on these charts consists of the terrain relief and a judicious selection of visual checkpoints used for flight under VFR. The checkpoints include populated places, drainage patterns, roads, railroads, and other distinctive landmarks. The aeronautical information on sectional charts includes visual and radio aids to navigation, airports, controlled airspace, restricted areas, topographical relief, obstructions such

as radio and television towers, and related data. The charts are updated every six months, and Alaska charts are updated annually. In the United States, the VFR can be downloaded from the Federal Aviation Administration (FAA) website. Complete instructions on reading these charts can be found in the following links:

- FAA Aeronautical Chart Users' Guide (https://www.faa.gov/air_traffic/flight_info/aeronav/digital_products/aero_guide/)
- How to read a VFR Sectional Chart (https://www.youtube.com/watch?v=6ITjUfl80bs)

Besides reviewing maps of the area, other useful tools, some of which were developed by the FAA, can be used to examine the flying conditions for a project. Some notable resources are as follows:

1. The FAA App, B4UFLY. The app provides situational awareness to recreational flyers and other drone users as it shows on an interactive map where UAS can and cannot be flown.
2. Users can also utilize the FAA site Visualize it: See FAA UAS Data on a Map (https://faa.maps.arcgis.com/apps/webappviewer/index.html?id=9c2e4406710048e19806ebf6a06754ad)
3. The AirMap App (https://app.airmap.com/geo?34.017931,-118.496046,9.417193z)
4. Google Maps is another useful tool that UAS users use frequently to view their project site from above and use street view to check out the operational environment and any obstacles.

SELECTING AN IMAGING SENSOR AND COMPUTING IMAGE GEOMETRY

Selecting the right imaging sensor is a critical part of the mission planning process. Although most planners use automated flight planning software, the selected camera configuration leads to choosing flight parameters such as flying altitude, flight lines layout, UAS speed, and imagery overlap. The information provided below explains the different components of digital cameras, which are one of the most widely used as sensors on UAS.

THE DIGITAL SENSOR (CAMERA)

A digital camera, like the one in your smartphone, is called a "digital frame" camera to distinguish it from other designs of digital cameras, including "push broom" cameras. Digital frame cameras have the same geometric characteristics as a film camera but employ an array of charge-coupled device (CCD) instead of film as the recording medium. The sections below discuss the focal plane or the CCD array, the lens cone and camera lens, and the shutters.

Focal Plane and CCD Array

The focal plane of an aerial camera is the plane where rays of light reflected from an object are focused. In digital cameras, the focal plane is occupied by either a light-sensitive, CCD array or a complementary metal–oxide–semiconductor (CMOS) array, which captures the incident light rays. The CCD or CMOS array is a two-dimensional array of pixels. The sensor is mounted at the focal plane of the camera. When an image is taken, all pixels of the sensor are exposed simultaneously to the incident light, thus producing a digital frame.

The size of a digital camera is measured by the size of its sensor. The higher the number of pixels in the sensors, the bigger and more expensive the camera. If a camera has a sensor with 4000 by 4000 pixels, it is called a 16-megapixel camera. That is because it has 16 million pixels.

Lens Cone and Camera Lens

The lens for a mapping camera usually contains compound lenses, which form the lens cone. The lens cone contains a shutter, a filter, and a diaphragm. In mapping aerial cameras, the lens assembly is the most important and most expensive part of the camera. Cameras on a UAS are usually low-quality, consumer-grade cameras. Mapping cameras are called metric cameras and are built so that the internal geometry of the camera holds its characteristics despite harsh working conditions and changing operational environments. Cameras used with UAS are smaller and lighter in weight. Mapping cameras should be calibrated to accurately determine their internal geometry. In other words, the process of camera calibration determines an accurate value of the lens focal length, the principal point coordinates, and models the lens distortion.

Shutters

Shutters are used to limit the passage of light into the focal plane. Digital cameras are equipped with either mechanical shutters or electronic shutters or a combination of both. Most digital camera shutters are designed according to two mechanisms: the leaf shutter (or the dilating aperture shutter) or the rolling shutter (known as curtain or sliding shutter). The leaf shutter exposes the entire sensor array at once, while the rolling shutter exposes one line of pixels at a time. For aerial imaging from a moving platform, such as a UAS, a leaf shutter is recommended because it minimizes image blur. Most processing software provides an option to correct for the image blur caused by the rolling shutter. The shutter speed of aerial cameras typically ranges between 1/100 and 1/16,000 seconds for mechanical shutters and up to 1/32,000 seconds for electronic shutters.

Filters

One of the camera accessories is the optical filter. The optical filter is inserted in the optical path to restrict certain wavelengths of light from entering the camera. There are various filters designed for certain purposes. A polarizing filter for example is used to reduce reflections or to suppress glare from water surfaces. Some filtering effects are applied during image processing in digital cameras, eliminating the need to physically install a filter in front of the lens.

Diaphragm

The diaphragm is an opaque structure with an opening in its center (called an aperture) used to block unwanted light from entering the camera, except what goes through the aperture. The iris in the human eye is equivalent to the camera diaphragm.

GEOMETRY OF VERTICAL IMAGERY

Understanding the geometry of an aerial image plays a key role in designing a successful and efficient flight plan for a mission. The size of the camera sensor array, lens focal length, and flying altitude (above a certain datum) will determine the image scale, or the ground resolution of the image. Therefore, it is essential for a flight planner to have all of this information understood and available before designing a mission.

In photogrammetry, we usually deal with three types of imagery (photography). The different types of imagery are defined in terms of the angle of the camera's optical axis relative to the vertical (nadir) angle. The three types of imagery are as follows:

1. True vertical aerial imaging: ±0° from nadir;
2. Tilted or near-vertical aerial imaging >0° but less than ±3° (most used); and
3. Oblique aerial imaging: between ±35° degree and ± 55° off nadir.

In this chapter, we will focus on the first two types: true-vertical and near-vertical imaging. Vertical imagery is the term used when the camera is looking at nadir or close to nadir. In other words, the camera is looking either straight down to the ground or is looking a few degrees to either side of the aircraft.

Scale of Vertical Imagery

As the sun's light is reflected off a ground object, some of that light enters the camera through the lens. This physical phenomenon enables us to express the ground-image relation using trigonometric principles. In Figure 4.3, ground point "A," located at the left edge of the image coverage on the ground, is projected at image location "a," and ground point "B" is projected at image location "b" on the imaging sensor array. These relations enable us to compute the ground coverage and scale of an image.

The **scale** of an image is the ratio of the distance of the image to the corresponding distance on the ground. Although the scale is meaningless in digital imagery, the term scale is a valuable term to illustrate the ground resolution of digital imagery. In Figure 4.3, the distance on the ground "AB" will be projected on the image on Line "ab." Therefore, the image scale can be computed using the following formula:

$$\text{Image Scale} = \frac{ab}{AB} \tag{4.1}$$

From the similarity of the two triangles in Figure 4.3, the scale of the image can also be expressed as

$$\text{Image Scale} = \frac{f}{H} \tag{4.2}$$

where f is the focal length of the selected camera and H is the flying altitude of UAS.

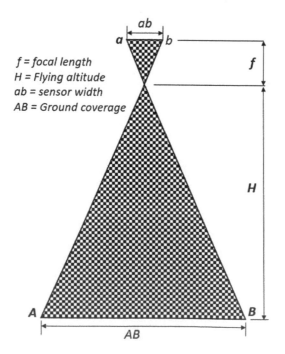

FIGURE 4.3 Geometry of a vertical image

Scale is expressed either as a unitless ratio such as 1/12,000, 1:12,000, or in a pronounced unit ratio such as 1 inch = 1000 feet or $1'' = 1000'$. The latter method is also known as "scale text." It is important to understand that in digital cameras, the scale does not play any role in defining the image quality as it does with film-based cameras. In digital cameras, the term **ground sampling distance** (GSD) is used to describe the quality of the image resolution, while in film-based cameras the term **film scale** is used.

To illustrate how the scale formula in Equation 4.1 can be used to compute the image scale for a digital camera, let us assume that we are dealing with a digital aerial camera with a focal length of 100 mm and a CCD physical size of 0.01 mm (or 10 microns). If such a camera is used to acquire imagery with a GSD of 30 cm (or approximately 1 feet), the scale of this imagery can be calculated using Equation 4.1 and is derived as follows:

From Figure 4.3 and Equation 4.1, assume that the distance "*ab*" represents the physical size of one camera pixel or CCD, which is 0.01 mm, and the distance "*AB*" is the ground coverage of the same pixel, or 30 cm. This results in a scale of 1/30,000 or 1 inch = 2500 feet.

$$\text{Image Scale} = \frac{ab}{AB} = \frac{0.01\text{mm}}{30\text{cm} \times 10\text{mm}/\text{cm}} = \frac{0.01\text{mm}}{300\text{mm}} = \frac{1}{30,000} \, or \, 1'' = 2500' \qquad (4.3)$$

Imagery Overlap

Image overlap is the amount of overlap in the ground coverage of two adjacent (overlapping) images. It is measured as a percentage of the total image coverage. In photogrammetry, two types of overlap are considered: forward lap (also called end lap) and side lap. High overlap between two images is important to develop a high-quality photogrammetric stereo view and process a high-quality three-dimensional (3D) model.

Forward overlap describes the amount of image overlap intentionally introduced between adjacent images taken successively along a flight line. This type of overlap is used to form the stereo pairs required for photogrammetric stereo viewing and processing. Typical forward lap required for photogrammetric work is 60%. In other words, two consecutive photos must share common coverage of at least 60% of the area on the ground. This amount ensures every object on the ground will be present in at least two images. Because of the light weight of many UAS platforms, they are often subject to substantial air dynamics, which impact the airframe causing rotations of the camera during an imaging session. For this reason, it is recommended to design the flight with a minimum of 70% forward lap to compensate for platform instability. The distance in the air between the centers of two consecutive images, which will dictate the amount of overlap, is referred to as Air Base "*B*" (Figure 4.4).

Side overlap, or side lap, describes the amount of overlap between images from adjacent flight lines. This type of overlap is needed to make sure that there are no gaps in the coverage. The typical value for the side overlap for photogrammetric work is 30%. However, for UAS, it is recommended to design the flight with a minimum of 40% side lap, again to compensate for external effects such as platform instability. The distance in the air between two adjacent flight lines is called **line spacing** and is represented by the segment "*SP*" (Figures 4.4 and 4.5).

Image Ground Coverage

Ground coverage of an image is the distance on the ground covered by one side of the sensor array, and it is represented by the "*G*" and "*W*" segments in Figure 4.4. Ground coverage of an image is determined by the camera's internal geometry (focal length and the size of the CCD array) as well as the flying altitude of the UAS above a certain datum. If the sensor array is rectangular, as it is in Figure 4.4, then the ground coverage of the image is "*G*" × "*W*" as shown in Box 4.1.

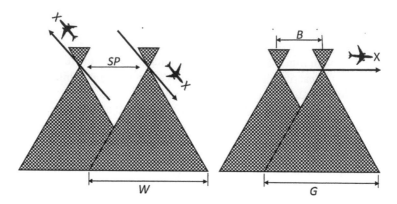

FIGURE 4.4 Aerial data acquisition flying geometry. For the figure on the left, the line spacing (SP) represents the distance in the air between two adjacent flight lines. For the figure on the right, the line spacing (B) represents the distance between consecutive images along the same flight line. Note the differing airplane orientations between the right and left images, which result in W being the width and G being the length of the image coverage.

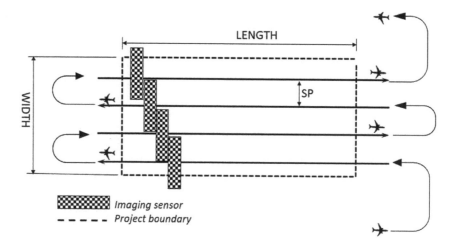

FIGURE 4.5 Geometry of the mapping block showing parallel flight lines that have been spaced to ensure sufficient side overlap of the images (checkered areas).

BOX 4.1 COMPUTING IMAGE GROUND COVERAGE

Imagine you have a digital camera with an array size of 6000 pixels by 4000 pixels. If the pixel size (the physical size of one CCD) is 10 microns (0.01 mm), and you are flying over a project site to acquire imagery with a GSD of 0.01 m (1 cm), 60 % forward lap, and 50 % side lap, the resulting ground coverage of an image is calculated as follows:

1. Ground coverage along the width of the array (W) = 6000 pixels × 0.01 m/pixel = 60 m
2. Ground coverage along the height of the array (G) = 4000 pixels × 0.01 m/pixel = 40 m
3. Ground coverage per image = $W \times G$ = 60 m × 40 m = 2400 m²

PLANNING AERIAL IMAGERY COLLECTION

DESIGN A FLIGHT PLAN

Once the planner has established the required image resolution and the required positional accuracy of the end product, the flight-planning process begins. Before starting this process, the planner needs to do the following:

1. Determine the shape of the project area and flying direction;
2. Determine the optimal mounting orientation for the camera;
3. Compute the number of flight lines;
4. Compute the number of images;
5. Compute the flying altitude;
6. Determine an appropriate flying speed;
7. Compute the optimal trigger speed; and
8. Select waypoints

Before establishing the flight-planning process, it is important to note the following best practices in camera mounting and flight directions.

PROJECT GEOMETRY AND FLYING DIRECTION

An efficient flight plan minimizes the number of turns the UAS makes between flight lines in order to save battery life or fuel. Turns made outside of the project area shorten battery or fuel life without gaining productivity and should be avoided. To reduce the number of turns, one needs to reduce the number of flight lines needed to cover the project area while also considering the required minimum side lap. To achieve this, it is best to always fly parallel to the longest dimension of the project as illustrated in Figure 4.5. In Figure 4.5, the study area is a rectangle that is wider east to west than it is north to south. The flight lines are therefore laid out east to west along the longest dimension of the project area. It should be noted that this is a suggested best practice, but there may be cases where other factors such as wind direction force you to fly otherwise.

CAMERA MOUNTING

It is good practice to always align the wider dimension of the CCD array to be perpendicular to the flight direction to reduce the number of flight lines when using a camera with a rectangular sensor array, as described in Figure 4.5.

COMPUTING THE NUMBER OF FLIGHT LINES

To estimate the number of flight lines needed to cover the project area, such as the one shown in Figure 4.5 and described in Box 4.2, you need to perform the following computations:

1. First, compute the coverage on the ground of one image (along the width of the camera CCD array, or "W" in Figure 4.4) as was described in Box 4.1.

2. Next, compute the flight line spacing or distance between flight lines ("*SP*" in Figure 4.4) as follows:

$$SP = \text{Image coverage}(\text{"width"}) \times (100 - \text{desired amount of side lap}) / 100 \qquad (4.4)$$

3. The number of flight lines (NFL) needed to cover the study area is then calculated as:

$$NFL = (\text{project "width"} / SP) + 1 \qquad (4.5)$$

4. Always round up the number of flight lines (NFL) to the nearest integer to make sure you cover the entire width of the project (i.e., an NFL value of 3.2 becomes 4).

If your project area is aligned like in Figure 4.5, it is best to begin the first flight line at the east or west boundary of the project, if possible. You will notice in Figure 4.5 that the flight direction for each flight line alternates between east-to-west and west-to-east from one flight line to the next adjacent one. Flying the project in this manner increases the aircraft's fuel efficiency or battery life so the aircraft can spend more time in the air.

BOX 4.2 COMPUTING THE NUMBER OF FLIGHT LINES

You have been asked to design a flight plan for a study area that is 800 m wide by 1200 m long. Using the camera settings and the *W* and *G* values computed above in Box 4.1, you now need to compute the number of flight lines you will need to cover the study area. The images need to be captured with 50% side overlap.

1. The coverage on the ground of a single image (*W*) computed in Box 4.1 was 60 m

2. The distance between flight lines (*SP*) is computed as:

$$SP = \text{Image coverage}(\text{"width"}) \times \frac{100 - \text{desired amount of side lap}}{100}$$

$$SP = 60\,\text{m} \times (100 - 50) / 100 = 60\,\text{m} \times (50) / 100 = 3000 / 100 = 30\,\text{m}$$

3. The number of flight lines is computed as the project area width (800 m) divided by the distance between the flight lines (*SP*), which was 30 m. Remember to add 1 to ensure full coverage:

$$NFL = (800\,\text{m} / 30\,\text{m}) + 1$$

$$NFL = 27.67$$

4. Lastly, round up the number of flight lines to the nearest integer to make sure you cover the entire width.

The number of flight lines needed to cover the project area is 28

COMPUTING THE NUMBER OF IMAGES

Once the number of flight lines has been determined, you need to perform the following computations to determine how many images are needed to cover the project area, also shown in Box 4.3:

1. First, compute the coverage on the ground of one image (along the height of the camera CCD array, or "G") as was noted earlier.

2. Compute the distance between two consecutive images ("B" in Figure 4.4). This distance is also called the "air base" and is computed as

$$B = G \times (100 - \text{amount of end lap} / 100) \qquad (4.6)$$

3. The number of images per flight line (NiPL) is then computed as

$$NiPL = (\text{project 'length'} / B) + 1 \qquad (4.7)$$

4. Always round up the number of images (i.e., an NiPL value of 25.2 becomes 26.)

5. Be sure to add two images at the beginning of the flight line before entering the project area and two images after exiting the project area (i.e., a total of four additional images for each flight line). These additional images ensure continuous stereo coverage. Therefore, the number of images per flight line ends up being:

$$NiPL = (\text{project "length"} / B) + 1 + 4 \qquad (4.8)$$

6. From here, it is easy to compute the total number of images that will be captured for the project (NiProj):

$$NiProj = NFL \times NiPL \qquad (4.9)$$

BOX 4.3 COMPUTING THE NUMBER OF IMAGES FOR A PROJECT

Now you try it. Compute the number of images that will be captured for this project. The amount of end overlap you need is 60%.

1. The coverage on the ground of one image (G) was computed in Box 4.1 as 40 m.

2. The distance between two consecutive images (B) is computed as:

$B = G \times (100 - \text{amount of end lap}/100) = 40 \times (100 - 60)/100 = 1600/100 = 16$ m

3. The number of images per flight line (NiPL) is then computed as

$$NiPL = \left(\frac{\text{project 'length'}}{B} \right) + = \left(1200\frac{m}{16} \right) + 1 = 761 \text{ images per flight line}$$

4. Since 1200/16 is an integer, there is no need to round up in this situation

5. Add two images to the start and end of the flight line = 76 + 4 = 80 images

6. The total number of images is then the number of flight lines from Box 4.2 (28) multiplied by the number of images per flight line (80)

$$NiProj = 28 \times 80 = 2,240 \text{ images}$$

COMPUTING THE FLYING ALTITUDE

Flying altitude is the altitude above a certain datum that the UAS flies during data acquisition. The two main datums used are either the mean (average) terrain elevation (AMT) or above mean sea level (AMSL). Figure 4.6 illustrates the relationship between the aircraft and the datum and how the two systems relate to each other. In Figure 4.6, an aircraft is flying at 3000 feet above mean terrain elevation (AMT). This positioning is also referred to as above ground level (AGL). Figure 4.6 also shows the mean terrain elevation is AMT situated 600 feet above mean sea level.

The flying altitude of the aircraft in Figure 4.6 can be expressed in two ways. If mean terrain is being used as a reference datum, then flying altitude is expressed as 3000 feet AMT, or AGL. However, if sea level is being used as the reference datum, the flying altitude is expressed as 3600 feet ASL, or AMSL. To determine at what altitude a project needs to be flown, one needs to go back to the camera's internal geometry and the scale discussions in the previous sections. Let's assume that the imagery will be acquired with a camera that has a lens focal length (f) of 35 mm and with a pixel size "ab" (Figure 4.3) of 10 microns (or 0.01 mm). Let's also assume that the imagery needs to be acquired with a GSD (AB from Figure 4.3) of 3 cm. The flying altitude will be computed as follows using Equation 4.1:

$$\text{Image scale} = \frac{f}{H} = \frac{ab}{AB}$$

Equation 4.1 can be rearranged as

$$H = \frac{(f)(GSD)}{ab} = \frac{35\,\text{mm} \times 0.03\,\text{m}}{0.01\,\text{mm}} = 105\,\text{m}$$

This flying altitude can be expressed as 105 m AMT (or AGL), or 705 m AMSL if the terrain in the project is 600 m above mean sea level, as it is in Figure 4.6.

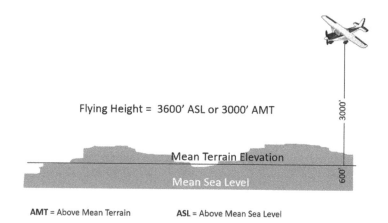

Flying Height = 3600' ASL or 3000' AMT

3000'

Mean Terrain Elevation

Mean Sea Level

600'

AMT = Above Mean Terrain **ASL** = Above Mean Sea Level

FIGURE 4.6 Schematic of the two main datums for flying altitude: above mean terrain (AMT) and above mean sea level (AMSL).

UAS Flight Speed for Image Collection

Controlling the speed of the UAS is important for maintaining the necessary forward/end lap expected for the imagery. Flying the UAS too quickly will result in less forward lap than anticipated, while flying the UAS too slowly will result in too much overlap between successive images. Both situations can reduce the quality of the anticipated products and may cause problems for the project budget. Smaller than anticipated overlap reduces the capability of using the imagery for stereo viewing and processing and developing 3D models, since these procedures require a certain amount of overlap between images. Too much overlap can result in collecting too many unnecessary images that may adversely affect the project budget or processing time. In the previous subsections, the process was shown to compute the **air base**, or the distance between two successive images along one flight line, that satisfies the amount of end lap necessary for the project. Computing the time between exposures is a simple matter once the air base and the UAS speed are determined. Such time computations are important for determining the total time needed to acquire the imagery. These computations are also useful for knowing how much battery life or fuel will be needed to complete the flight.

Computing the Time between Consecutive Images

After the camera exposes an image, the UAS needs to move a distance equal to the air base before it exposes the next image. If we assume the UAS speed is v, then the time t between two consecutive images is calculated from the following equation as

$$\text{Time}(t) = \frac{\text{Air base}(B)}{\text{Aircraft Speed}(v)} \tag{4.10}$$

Therefore, for a computed air base of 60 m using a UAS with speed of 5 m/s, the time between exposures is equal to:

$$\text{Time}(t) = \frac{60\,\text{m}}{5\,\text{m/s}} = 12\,\text{s} \tag{4.11}$$

Waypoints

In the navigation world, **waypoints** are a set of abstract GPS points in the airway laid out specifically for the purposes of air navigation. Waypoints create "highways in the sky" for the UAS to navigate. The more precise definition used by mapping professionals describes waypoints as sets of coordinates to locate the beginning and end points of each flight line. Waypoints are important for the pilot and camera operators to execute a flight plan. Waypoints for manned aircraft image acquisition are usually located some distance outside of the project boundary on either side of the flight line (e.g., a few hundred meters before approaching the project area and a few hundred meters after exiting the project area). For UAS missions, waypoints are typically located at a distance equivalent to a few air base units on both sides of the flight line, depending on the flying altitude and the flying speed. The pilot, or the remote pilot, uses way points to align the aircraft to the flight line before entering the project area.

EXERCISE TO DESIGN A FLIGHT PLAN AND LAYOUT

In this hands-on exercise, you will design a flight plan and layout for a project in which the client asked you to capture natural color (three-band, RGB), vertical (nadir facing), digital aerial imagery. The project area is 2 km long in the east–west direction and 1 km wide in the north–south direction. The client requested the imagery to have a pixel resolution, or GSD, of 5 cm using a frame-based digital camera with a rectangular CCD array of 6000 pixels across the flight direction "W" and 3000 pixels along the flight direction "G" and a lens focal length of 20 mm. The array contains square CCDs with a dimension of 10 microns (0.01 mm). The forward (end) lap and side lap are to be 70% and 50 %, respectively. The imagery should be delivered in GeoTIFF file format with 8 bits (1 byte) per band or 24 bits per color RGB. Calculate:

1. The number of flight lines necessary to cover the project area if the flight direction was parallel to the east–west boundary of the project. Assume that the first flight line falls right on the southern boundary of the project;
2. The total number of digital photos (frames);
3. The ground coverage of each image (in square meters);
4. The storage requirements in gigabytes aboard the aircraft required for storing the imagery. (Assume each pixel requires one byte of storage per band; so each of the three RGB bands needs $W \times G \times 1$ byte/per pixel);
5. The flying altitude;
6. The time between two consecutive images if the aircraft speed is flying at 12 m/s.

The solution can be found at the end of the chapter.

ESTIMATING COSTS AND DEVELOPING A DELIVERY SCHEDULE

Estimating costs and developing a delivery schedule are two of the most important aspects of mission planning, especially if you want to keep your client happy! Experience with projects of a similar size and nature is essential in estimating cost and developing a delivery schedule. In estimating costs, the following primary categories of effort and materials are considered:

- Labor – this is all the person-power you will need to complete the project including a remote pilot, visual observer(s), and technicians who can process the imagery after it is collected if needed.
- Materials – in addition to the UAS and camera, you will need to account for expendable materials such as batteries, additional propellers, which sometimes break or become damaged and need to be replaced, as well as any specialized computer software needed to achieve the project objectives.
- Overhead – These are the indirect costs or nonlabor, fixed expenses required to operate your business. Some examples of overhead costs are rent for office space, insurance, etc.
- Profit – This is the amount you ultimately make on the project after the other three expenses have been paid.

Once quantities are estimated as illustrated in the above steps, hours for each phase of the project can be established. Depending on the project deliverable requirements, the following labor items are typically considered when estimating costs:

- Aerial imaging
- Ground control survey
- Aerial triangulation
- Stereo-plotting
- Map editing
- Orthomosaic production
- Lidar data cleaning (if appropriate)

Delivery Schedule

After the project hours are estimated, each phase of the project can be scheduled based on the following:

- Number of instruments or workstations available;
- Number of trained personnel available;
- Amount of other work in progress and its status; and
- Urgency of the project to the client.

The schedule should also consider the constraints on the window of opportunity due to weather conditions. Aerial missions for geospatial mapping are usually flown at certain conditions that include:

- Clear sky days – no rain, fog or clouds;
- At the time of day where the sun angles are greater than 30 degrees;
- Leaf-off conditions; and
- No snow on the ground.

A day that is suitable for aerial imaging is a day where there are clear skies with no rain, fog, or clouds, and flying at a time of day when the sun angles are larger than 30 degrees. States in northern latitudes with frequent cloudy days may not experience very many suitable days for UAS imagery collection. For instance, states like Maine have only 30 cloudless days per year that are suitable for aerial imaging activities. Therefore, it is important to take that into consideration when planning a project.

SOLUTION TO DESIGN A FLIGHT PLAN AND LAYOUT

First, orient the camera so the longer dimension of the CCD array is perpendicular to the flight direction (Figure 4.5). This camera mounting strategy is important to minimize the number of flight lines and therefore the number of turns that the aircraft needs to make between flight lines. Remember, unnecessary turns waste fuel and battery power.

1. Computing the number of flight lines (NFL):

 a) First, compute the coverage area of each image:

$$W = \left(6,000 \, \text{pixel} \times 0.05 \, \frac{\text{m}}{\text{pixel}} \right) = 300 \, \text{m}$$

$$G = \left(3,000 \, \text{pixel} \times 0.05 \, \text{m} \, / \, \text{pixel} \right) = 150 \, \text{m}$$

b) Next, compute the line spacing or distance between flight lines (SP):

$$SP = \frac{\text{Image coverage}(W) \times (100 - \text{amount of side lap})}{100}$$

$$SP = \frac{6{,}000\,\text{pixels} \times 0.05\,\text{m / pixel} \times (100 - 50)}{100} = 150\,\text{m}$$

c) Next, compute the number of flight lines (NFL):

$$\text{NFL} = \frac{\text{project WIDTH}}{\text{SP}} + 1$$

$$NFL = \frac{1\,\text{km} \times 1{,}000\,\text{m / km}}{150\,\text{m}} + 1 = 6.67 + 1 = 7.67 = 8\,\text{flight lines (with rounding up)}.$$

2. Computing the number of images per flight line (NiPL):

 a) First, compute the air base or distance between two consecutive images (B):

$$B = \frac{\text{Image coverage}(G) \times (100 - \text{amount of end lap})}{100}$$

$$B = \frac{3{,}000\,\text{pixels} \times 0.05\,\text{m / pixel} \times (100 - 70)}{100} = 45\,\text{m}$$

 b) Next, compute the number of images per flight line (NiPL):

$$NiPL = \frac{\text{project LENGTH}}{B} + 1 + 4$$

$$NiPL = \frac{2\,\text{km} \times 1{,}000\,\text{m / km}}{45\,\text{m}} + 1 + 4 = 49.44 = 50 \;\text{images after rounding up}$$

 c) Lastly, compute the total number of images for the project:

$$NiProj = NFL \times NiPL$$

$$NiProj = 8\,\text{flight lines} \times 50\,\text{images / flight line} = 400\,\text{total images}$$

3. Computing ground coverage of each image (A):

$$A = WxG = 300\,\text{m} \times 150\,\text{m} = 45{,}000\,\text{m}^2$$

4. Computing storage requirements (in gigabytes) for the RGB images: Each pixel requires one byte of storage per band; therefore, each of the three RGB bands needs $W \times G \times 1$ byte/ per pixel, or:

$$Image\ storage = 6,000\ pixels \times 3,000\ pixels \times 1\ byte\ /\ pixel$$
$$= 18,000,000\ bytes = 18\ Megabytes\ (Mb)\ per\ band$$

$$Total\ storage\ requirement = \#\ images \times \#\ bands \times 18\ \frac{Mb}{image}$$
$$= 400\ images \times 3\ bands \times 18\ \frac{Mb}{image} = 12,096\ Mb = 12.1\ Gigabytes\ (Gb).$$

5. Computing flying altitude (H):

$$H = \frac{f \times GSD}{ab}$$

$$H = \frac{20\,mm \times 5\,cm}{0.01\,mm} = 10,000\,cm\ (100\,m\ or\ 300.48\,ft.)\ above\ the\ terrain.$$

6. Computing the time between consecutive images (T):

$$Time\,(T) = \frac{Air\ base\,(B)}{Aircraft\ Speed\,(v)}$$

$$Time\,(t) = \frac{45\,m}{12\,m\,/\,s} = 3.75\,s$$

5 Drone Regulations
What You Need to Know before You Fly

Jennifer Fowler and Jaylene Naylor

CONTENTS

This chapter focuses primarily on the rules and regulations in the United States but also includes general information on safe operations. If you are interested in learning about the rules and regulations in other countries, the website https://rpas-regulations.com/ has a guide to operating drones across the world.

Drone regulations in the United States have gone through many twists and turns as the Federal Aviation Administration (FAA) determines how to best integrate these new technologies into the national airspace. This chapter introduces the regulatory landscape of flying drones in the United States through the Code of Federal Regulations (CFR) and the practicalities of CFR Part 107, which permits operation in the national airspace. Next, the chapter walks through a history of drone regulations and the evolution of Part 107 including a discussion of many of the regulatory challenges encountered along the way. The chapter concludes with a general discussion on the key components for safe operations.

Drone/Small Unmanned Aircraft System (sUAS) operators must always be aware that the legal landscape can change, and regulations are not carved in stone. The most important step is to always check the most current regulations in the country, region, state, and municipality before you take -off! Where should you start? First, it is important to determine which type of user you are (Figure 5.1) by using the comprehensive set of resources on the FAA's sUAS website: www.faa.gov/uas. Additionally, if you have already purchased an sUAS, and it weighs more than 0.55 pounds (0.25 kg) and less than 55 pounds (25 kg), you will need to register it with the FAA.

STEP 1: SOLVING THE REGULATORY PUZZLE

Which entity does your operation fall under?

Recreational (Hobbyist)	Civil (Business/Commercial)	Public (Government)
"hobby" is a "pursuit outside one's regular occupation engaged in especially for relaxation."	Marketing, inspections, professional film making, ... all paid work.	Publicly funded law enforcement, fire departments and other government agencies including universities...

FIGURE 5.1 Federal Aviation Administration (FAA) criteria for sUAS aircraft classifications

THE U.S. CODE OF FEDERAL REGULATIONS

The CFR codifies the final version of the rules for federal agencies in the United States. A **regulation** is a statement issued by an agency on how that agency will enforce laws under its directive. U.S. agencies fall under the executive branch and obtain their authority to issue regulations from laws enacted by Congress. United States Code (USC) contains the recorded laws from Congress, while the regulations for implementing these laws are recorded in the CFRs (Charpentier 1997). A regulation comes about by Congress communicating to an agency what they would like done via legislation. For example, the Vision 100 – Century of Aviation Reauthorization Act of 2003, contained the following language,

> The Administrator of the Federal Aviation Administration shall conduct a study to determine the feasibility of developing a program under which prospective home buyers of property located in the vicinity of an airport could be notified of information derived from noise exposure maps that may affect the use and enjoyment of the property.

> (U.S. Congress 2003)

Once an agency proposes a new rule or rules that align with Congress' intent, a draft of that rule or rules gets posted for public comment as a notice of proposed rulemaking. The post appears in the federal register where public comments are submitted. In the 2003 example above, the post pertaining to noise exposure maps appeared on September 24, 2004 (14 CFR § 150.21). After review of all public comments, the agency may or may not revise the proposed rule. Finally, after legal review, the agency will post the final regulation. In the 2003 example, the result was the FAA making noise exposure map information available on their website.

The Most Recent Drone Regulations: 14 CFR Part 107

You may have heard about Part 107, as it is the most referenced drone regulation in the United States. Part 107 of the CFR lays out not only the law for Civil (i.e., business) UAS operations, which have overlap with Recreational operations, but it is also a great starting point for

determining best practices when beginning new operations of any type. The legal evolution of 14 CFR Part 107 is described in the sections below. Here, practical information is provided for readers looking to familiarize themselves with drone safety.

The majority of sUAS pilots other than hobbyists will operate under Part 107 regulations. After spending some time familiarizing yourself with drone safety (https://www.secureav.com/UASPC-annotated-v1.0.pdf) and Part 107 regulations more generally, you may want to begin studying for your Part 107 Remote Pilot Certification. The exam is administered at authorized testing centers and costs around $200 USD. Below you will find a list of recommended resources for Part 107 certification:

- The FAA has a comprehensive set of resources (https: //www.faa.gov/uas/resources/policy_ library/#107) for the Knowledge Test featuring a study guide and series of sample test questions.

- 3DR offers a study guide and many sample questions (https://www.3dr.com/government-services/faa-training/)

- King Schools Drone Pilot Test Prep Course (https://www.kingschools.com/ground-school/ drone-pilot/courses/written)

- Aviation Supply and Academics (ASA) provides their excellent "Remote Pilot Test Prep" book including five free practice exams that the authors have used in Part 107 exam prep courses. (https://www.asa2fly.com/Test-Prep-2020-Remote-Pilot-P4124C9.aspx)

Depending on your aviation background, expect to spend anywhere from 10-30 hours of self-study in preparation for the exam (Table 5.1).

TABLE 5.1

A Summary of the Major Provisions of the FAA Part 107 of the Federal Aviation Regulations (14 Code of Federal Regulations [CFR] Parts 21, 43, 61, 91, 101, 107, 119, 133, and 183, 2015)

Category	Provision
Operational limitations	• Unmanned aircraft must weigh less than 55 lbs. (25 kg)
	• Visual line-of-sight (VLOS) only; the unmanned aircraft must remain within VLOS of the remote pilot in command and the person manipulating the flight controls. Alternatively, the unmanned aircraft must remain within VLOS of a visual observer.
	• At all times, the sUAS must remain close enough to the remote pilot in command and the person manipulating the flight controls for those people to be capable of seeing the aircraft with vision unaided by any device other than corrective lenses.
	• sUAS may not operate over any persons not directly participating in the operation, not under a covered structure, and not inside a covered stationary vehicle.
	• Daylight-only operations, or civil twilight (30 minutes before official sunrise to 30 minutes after official sunset, local time) with appropriate anti-collision lighting.
	• Must yield right of way to other aircraft.
	• May use visual observer (VO) but not required.
	• First-person view cameras cannot satisfy the "see-and-avoid" requirement but can be used if the requirement is satisfied in other ways.
	• Maximum groundspeed of 100 mph (87 knots)
	• Maximum altitude of 400 feet above ground level (AGL) or, if higher than 400 feet AGL, remain within 400 feet of a structure.
	• Minimum weather visibility of 3 miles from the control station.

(Continued)

TABLE 5.1 (*Continued*)

A Summary of the Major Provisions of the FAA Part 107 of the Federal Aviation Regulations (14 Code of Federal Regulations [CFR] Parts 21, 43, 61, 91, 101, 107, 119, 133, and 183, 2015)

Category	Provision
	• Operations in Class B, C, D, and E airspace are allowed with the required ATC permission.
	• Operations in Class G airspace are allowed without ATC permission.
	• No person may act as a remote pilot in command or VO for more than one unmanned aircraft operation at one time.
	• No operations from a moving vehicle unless the operation is over a sparsely populated area.
	• No operations from a moving aircraft.
	• No careless or reckless operations.
	• No carriage of hazardous materials.
	• Preflight inspection by the remote pilot in command required.
	• A person may not operate an sUAS if he or she knows or has reason to know of any physical or mental condition that would interfere with safe operation.
	• Foreign-registered sUAS can operate under Part 107 if they satisfy the requirements of Part 375.
	• External load operations are allowed if the object being carried by the sUAS is securely attached and does not adversely affect the flight characteristics or controllability of the aircraft.
	• Transportation of property for compensation or hire is allowed provided that: o The aircraft, including its attached systems, payload and cargo weigh less than 55 pounds total; o The flight is conducted within VLOS and not from a moving vehicle or aircraft; and o The flight occurs wholly within the bounds of a State and does not involve transport between (1) Hawaii and another place in Hawaii through airspace outside Hawaii; (2) the District of Columbia and another place in the District of Columbia; or (3) a territory or possession of the United States and another place in the same territory or possession.
	• Most, but not all, of the restrictions discussed above can be waived if the applicant demonstrates that operation can be safely conducted under the terms of a certificate of waiver.
Remote pilot in command certification and responsibilities	• Establishes a remote pilot in command position. • A person operating an sUAS must either hold a remote pilot airman certificate with an sUAS rating or be under the direct supervision of a person who does hold a remote pilot certificate (remote pilot in command).
	• To qualify for a remote pilot certificate, a person must demonstrate aeronautical knowledge by either: o Passing an initial aeronautical knowledge test at an FAA-approved knowledge testing center; or o Hold a Part 61 pilot certificate other than student pilot, complete a flight review within the previous 24 months, and complete an sUAS online training course provided by the FAA. o Be vetted by the Transportation Security Administration. o Be at least 16 years old.
	• Part 61 pilot certificate holders will obtain a temporary remote pilot certificate immediately upon submission of their application for a permanent certificate. Other applicants will obtain a temporary remote pilot certificate upon successful completion of TSA security vetting.
	• The FAA anticipates that it will be able to issue a temporary remote pilot certificate within 10 business days after receiving a completed remote pilot certificate application.

(*Continued*)

TABLE 5.1 (*Continued*)
A Summary of the Major Provisions of the FAA Part 107 of the Federal Aviation Regulations (14 Code of Federal Regulations [CFR] Parts 21, 43, 61, 91, 101, 107, 119, 133, and 183, 2015)

Category	Provision
	A remote pilot in command must:
	• Make available to the FAA, upon request, the sUAS for inspection or testing, and any associated documents/records required to be kept under the rule.
	• Report to the FAA within 10 days of any operation that results in at least serious injury, loss of consciousness, or property damage of at least $500.
	• Conduct a preflight inspection, to include specific aircraft and control station systems checks, to ensure the sUAS is in a condition for safe operation.
	• Ensure that the small unmanned aircraft complies with the existing registration requirements specified in §91.203(a)(2).
	• A remote pilot in command may deviate from the requirements of this rule in response to an in-flight emergency.
Aircraft requirements	• FAA airworthiness certification is not required. However, the remote pilot in command must conduct a preflight check of the sUAS to ensure that it is in a condition for safe operation.
Model aircraft	• Part 107 does not apply to model aircraft that satisfy all of the criteria specified in section 336 of Public Law 112-95.
	• The rule codifies the FAA's enforcement authority in Part 101 by prohibiting model aircraft operators from endangering the safety of the National Air Space.

Source: https://www.faa.gov/uas/media/Part_107_Summary.pdf.

REGULATION VERSUS GUIDANCE: SAFE OPERATIONS ARE MORE THAN A ONE-STOP SHOP

To really get a full picture of sUAS regulations, it is best to start with understanding what to read. Of course, there are the regulations such as the CFR 14 Part 107 to peruse. In addition, there are also Advisory Circulars and FAA orders, notices, and bulletins. Advisory Circulars (ACs) are issued as guidance to the aviation public, and orders, notices, and bulletins provide information to FAA employees (ARSA 2019). Both can help immensely when determining what kind of sUAS operation is being undertaken. AC 107–2 (Civil) gives guidance to the public regarding civil aircraft operations under Part 107. AC 00-1.1B (Public) gives guidance to the public regarding public aircraft operations (PAO). While FAA Order 8900.1, Flight Standards Information Management System (FSIMS) Volume 16, Chapters 1–5 gives guidance to FAA employees concerning both civil and public operations (Table 5.2).

It is recommended to understand other pertinent sections of the law. For example, 49 CFR 830 (A-D) under NTSB (National Transportation Safety Bureau) contains information about notification and reporting of aircraft accidents or incidents for sUAS (i.e., 49 USC subtitle B chapter VIII Part 830, 2019). In addition to the FAA, the Federal Communications Commission (FCC) has legal authority in the United States over radio frequency bands used by some sUAS and pilots. For example, a remote pilot cannot verbally communicate with a manned aircraft from ground to air without an FCC license to do so (FCC 2019).

HISTORY OF DRONE REGULATIONS: THE FIELD IS OLDER THAN YOU MIGHT THINK

The history of sUAS regulations in the United States goes back much farther than many people realize. In fact, sUAS by its strict definition (14 CFR § 107.3) has its origins dating back to ancient China, 3rd century BC, where airborne paper lanterns were used in warfare for signaling troops (Komatz 2016; History of Lamps 2019). Although the term sUAS now encompasses many

BOX 5.1 HANDS-ON ACTIVITY

Look at the image below and refer to the FAA Code of Federal Regulations to answer the following questions.

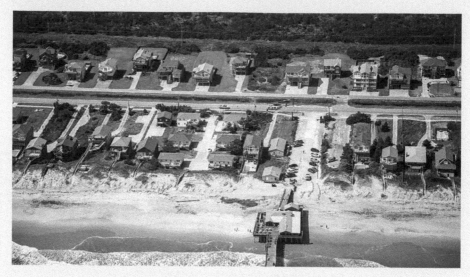

Q1 Can you spot the helicopter?

Q2 If this image was taken from a drone, would the drone flight be legal? Why or why not? Explain your reasoning.

Q3 If the helicopter was a drone, would the helicopter flight be legal? Why or why not? Explain your reasoning.

*Answers are at the end of the chapter. You are encouraged to discuss your answers with others.

TABLE 5.2

Comparison of Requirements for Public and Civil Operations as Outlined in FAA Order 8900.1

Public Requirements	Civil Requirements
Airworthiness requirements	No airworthiness requirement
FAA-issued pilot certificate not required	FAA-issued pilot certificate required
Requirement of 24-hour accident OR incident reporting to FAA	Requirement to file report within 10 days for accidents that meet certain thresholds
Monthly operations reporting	No operations reporting requirement
Register through Department of Transportation CAPS website	Register through FAADroneZone
Certificate of Authorization application has 16 sections to be completed and includes documentation on frequency spectrum analysis, airworthiness, etc.	Certificate of Authorization application has 6 sections to be completed

new and emerging technologies, consideration for integration into daily activities in the United States began with a document issued by the FAA in 1981 to advise model aircraft operators on safety standards in the national airspace, AC 91–57 (FAA 1981). At this time, the FAA was clear on the distinction between model aircraft or recreational uses of sUAS versus the commercial use of sUAS, which the FAA determined to be illegal.

THE EVOLUTION OF CFR 14 (AND ITS MANY ACRONYMS!)

The first edition of the CFR was published in 1938 (McKinney 2019). Since then, additional sections, parts, or titles have been added such as CFR Title 14 covering Aeronautics and Space, which encompasses Federal Aviation Regulations. The first hint at regulating unmanned platforms came in the form of Part 101 of CFR 14 regarding operations of moored and unmanned free balloons (e.g., paper lanterns) in the National Airspace System (NAS). Part 101 was originally implemented in the early 1960s (FAA 2017). Clearly, there was eventually need for clarification regarding model aircraft with the aforementioned 1981 FAA advisory on model aircraft, and this trend for clarification continued in September 2005 with a Memorandum titled "Unmanned Aircraft Systems Operations in the U.S. National Airspace System – Interim Operational Approval Guidance" (UAS Policy 05-01). This is where the FAA sent out guidance based on whether an unmanned aircraft is defined as a public aircraft, civil aircraft, or as a model aircraft (FAA 2005). To the present day, these definitions are incredibly important when a pilot is trying to figure out what regulations they need to follow (Figure 5.1).

Then, in 2007, the FAA posted an additional clarification of sUAS operations in the NAS (FAA 2007). In conjunction with their 2005 guidance, the FAA stated,

> For UAS operating as public aircraft the authority is the COA, for UAS operating as civil aircraft the authority is special airworthiness certificates, and for model aircraft the authority is AC 91–57.

COA is a **certificate of authorization**, and this could only be issued to a public agency. More details on COAs are covered in the section on public operations. In 2007, model aircraft still continued to follow 1981 guidance, but for civil aircraft operations the key sentences are, "operators who wish to fly an unmanned aircraft for civil use must obtain an FAA airworthiness certificate the same as any other type aircraft." The FAA was only issuing special airworthiness certificates in the experimental category, and wording noted that "UAS issued experimental certificates may not be used for compensation or hire" (FAA 2007). So, in essence, in 2007 a person could not fly an sUAS as a commercial venture.

BOX 5.2 CHALLENGED IN THE COURT OF LAW

In 2013, the limitation that sUAS could not be used for commercial ventures was challenged by two noteworthy court cases, *Raphael Pirker v. FAA* and *Texas EquuSearch v. FAA*.

Raphael Pirker v. FAA: In 2011 Mr. Pirker was fined $10,000 by the FAA for operating his sUAS "in a careless or reckless manner" for his company while gathering aerial images and video of the University of Virginia (Welch 2013). A National Transportation and Safety Board (NTSB) judge ruled in favor of Mr. Piker asserting that the FAA had never actually issued a regulation governing model aircraft and therefore could not enforce any regulations (Koebler 2014). The FAA appealed to the full NTSB, who reversed the Pirker ruling. In the end, Priker settled with the FAA in 2015 on a $1,100 fine without admitting fault.

Texas EquuSearch v. FAA: Texas EquuSearch is a volunteer search and rescue organization that received a cease and desist order from the FAA in 2013 in regard to their use of sUAS in missions it had been doing for over six years for no compensation. Texas EquuSearch sued, and an appeals court dismissed the lawsuit since the court could only review FAA final orders, and the order issued to Texas EquuSearch did not meet the requirements for a final order. The text read:

> The email at issue is not a formal cease-and-desist letter representing the agency's final conclusion that an entity ... has violated the law.
> **(Texas EquuSearch Mounted Search and Recovery Team v. Federal Aviation Administration, 2013)**

In the end, both the FAA and Texas EquuSearch claimed victory. The FAA's response to this lawsuit was that it had no bearing on whether they could regulate sUAS, and they would continue to do so (FAA 2014a). Texas EquuSearch resumed the use of drones in their operations (Associated Press 2014). This ultimately left it up to the FAA to decide if they wanted to continue to pursue Texas EquuSearch, and they did encourage the organization to request a COA.

Why was 2013 the year of so many lawsuits against the FAA? Because the industry was getting restless, particularly as they watched international sUAS development. According to the FAA Reauthorization Act of 2012, "The plan required under paragraph (1) shall provide for the safe integration of civil unmanned aircraft systems into the national airspace system as soon as practicable, but not later than September 30, 2015" (FAA 2012). It is possible to see just from lawsuits alone that there was a burgeoning industry for the already technologically capable civil sUAS well before the latest deadline for the FAA to find a way to integrate them legally into the NAS. But there was a section in the act, 333: Special Rules for Certain Unmanned Aircraft System, that did offer hope. Therefore, as of the date of the FAA Reauthorization Act of 2012 on February 14, 2012, there were three ways to legally fly sUAS in the United States:

(1) as a public entity,
(2) as a civil entity under Section 333, or
(3) as a recreational user or hobbyist.

Meanwhile, outside the United States, the sUAS industry was, and still is, booming with companies such as DJI in China growing (it currently holds two-thirds of the global market), and Israel Aerospace Industries contributing to Israel being one of the largest military UAS exporters in the world (Fannin 2019; Stub 2019). In addition to market development of the industry, countries such as Australia, Japan, and European Union member countries are leading cutting-edge research and development of new sUAS technologies. These examples also represent a varied regulatory landscape and understanding each country's laws is highly encouraged before a U.S. remote pilot engages in sUAS missions in a foreign country.

PUBLIC OPERATIONS: NOT AS SIMPLE AS THEY MAY SEEM

Because the FAA falls under the Department of Transportation, United States Code (USC) 49 defines public sUAS operations. In particular, the definition of who can operate a public aircraft is under 49 USC 40102 (a)(41)(A)-(F). The code states (49 USC § 40102 (a)(41)(A)-(F), 2010);

The term "public aircraft" can mean any of the following:

A. Except with respect to an aircraft described in subparagraph (E), an aircraft used only for the United States Government, except as provided in section 40125(b).

B. An aircraft owned by the Government and operated by any person for purposes related to crew training, equipment development, or demonstration, except as provided in section 40125(b).

C. An aircraft owned and operated by the government of a State, the District of Columbia, or a territory or possession of the United States or a political subdivision of one of these governments, except as provided in section 40125(b).

D. An aircraft exclusively leased for at least 90 continuous days by the government of a State, the District of Columbia, or a territory or possession of the United States or a political subdivision of one of these governments, except as provided in section 40125(b).

E. An aircraft owned or operated by the armed forces or chartered to provide transportation or other commercial air service to the armed forces under the conditions specified by section 40125(c). In the preceding sentence, the term "other commercial air service" means an aircraft operation that (i) is within the United States territorial airspace; (ii) the Administrator of the FAA determines is available for compensation or hire to the public, and (iii) must comply with all applicable civil aircraft rules under title 14, CFR.

F. An unmanned aircraft that is owned and operated by, or exclusively leased for at least 90 continuous days by an Indian Tribal government, as defined in section 102 of the Robert T. Stafford Disaster Relief and Emergency Assistance Act (42 U.S.C. 5122), except as provided in section 40125(b).

You may have noticed that the words "except as provided in section 40125(b)" are repeated in several of the definitions above (A, B, C, D, and F). It is worth noting that section 40125(b) refers to Aircraft Owned by Governments and defines the qualifications for public aircraft status. The exact wording is:

49 USC 40125 (b) – Aircraft Owned by Governments

An aircraft described in subparagraph (A), (B), (C), (D), or (F) of section 40102(a)(41) does not qualify as a public aircraft under such section when the aircraft is used for commercial purposes or to carry an individual other than a crewmember or a qualified non-crewmember.

Notably for sUAS operations, 40125(a)(2) states:

Governmental Function. – The term "governmental function" means an activity undertaken by a government, such as national defense, intelligence missions, firefighting, search and rescue, law enforcement (including transport of prisoners, detainees, and illegal aliens), aeronautical research, or biological or geological resource management.

Of note here is that the NTSB calls this list "a non-exclusive list of allowable government activities" (Petronis 2011). The FAA has limited oversight of public aircraft operations (PAO), although such operations must comply with the regulations of all aircraft operating in the NAS. Once an entity declares itself as a PAO by supplying a written letter declaring that the entity is legally a public entity (usually a letter from an attorney general), that entity can begin an application for a

certificate of authorization (COA) for sUAS operations with the FAA. The government entity conducting the PAO is responsible for oversight of the operation, including aircraft airworthiness and any operational requirements imposed by the government entity. Public aircraft operations may self-certify standards for unmanned aircraft (UA) airworthiness as well as pilot certification, qualification, and medical standards.

According to the FAA, "COA is an authorization issued by the Air Traffic Organization to a public operator for a specific UA activity." After a complete application is submitted, the FAA conducts a comprehensive operational and technical review. If necessary, provisions or limitations may be imposed as part of the approval to ensure the UA can operate safely with other airspace users. In most cases, the FAA will provide a formal response within 60 days from the time a completed application is submitted" (FAA 2019a). The FAA has an online application system to apply for COAs and lists publicly released COAs on its website.

What is noticeable when reviewing publicly released COAs is that public aircraft operations are restrictive in their scope based on defining the operational mission goals, operational location, and the UAS to be used. In addition, once a COA is granted and an entity begins operations, there are monthly reporting requirements to the FAA. All of this makes sense considering PAO determinations by the FAA are made on a flight by flight basis, and that determination is typically made after the fact. The lesson here is to keep excellent records and define operations, goals, and outcomes clearly for all involved in a PAO.

333 EXEMPTION: A STOPGAP MEASURE

Section 333 of the FAA Reauthorization Act of 2012 stated:

> the Secretary of Transportation shall determine if certain unmanned aircraft systems may operate safely in the national airspace system before completion of the plan and rulemaking required by section 332 of this Act or the guidance required by section 334 of this Act.

The goal for civil operators therefore became to obtain a Section 333 exemption so they could operate sUAS for compensation. The first 333 exemptions were granted in September 2014 (AUVSI 2016). The process for a 333 exemption involved defining all relevant regulations in CFR 14 Part 91 (General Operating and Flight Rules), that could not be met by an sUAS operator. For example, a civil sUAS application would need to request an exemption from section 91.107 covering the use of safety belts, shoulder harnesses, and child restraint systems! sUAS typically do not have passengers, and animals small enough for a flight may not take well to being restrained by a safety belt. But CFR 14 Part 61 (Certification of Pilots, Flight Instructors, and Ground Instructors) could not be exempted. Hence, **in 2012 sUAS operators in the U.S. had to hold at least a private pilot certificate!** This also meant that CFR Part 67 (Medical Standards and Certification) could not be exempted.

At the risk of oversimplifying the situation, it all can be boiled down to the following: as of 2012, the Federal Aviation Regulation Aeronautical Information Manual (FAR AIM) consisting of 1090 pages **did not have a single page dedicated to civil sUAS operations**, and the FAA had just three short years – until September 30, 2015 – to devise the regulations that would be added into the FAR AIM. In the meantime, commercial entities were clamoring to use sUAS for compensation, so the only available path was to ask to be exempted from relevant regulations contained within the FAR AIM. It ultimately took until August 29, 2016 for all of this to change.

RECREATIONAL OPERATIONS: DISRUPTIVE REGULATION

The FAA Reauthorization Act of 2012 also influenced model aircraft operations under section 336, Special Rule for Model Aircraft. It went further than the 1981 document by codifying the following into law (FAA 2012):

> Notwithstanding any other provision of law relating to the incorporation of unmanned aircraft systems into FAA plans and policies, including this subtitle, the Administrator of the FAA may not promulgate any rule or regulation regarding a model aircraft, or an aircraft being developed as a model aircraft, if:

> (1) the aircraft is flown strictly for hobby or recreational use;
> (2) the aircraft is operated in accordance with a community-based set of safety guidelines and within the programming of a nationwide community-based organization;
> (3) the aircraft is limited to not more than 55 pounds unless otherwise certified through design, construction, inspection, flight test, and operational safety program administered by a community-based organization;
> (4) the aircraft is operated in a manner that does not interfere with and gives way to any manned aircraft; and
> (5) when flown within 5 miles of an airport, the operator of the aircraft provides the airport operator and the airport air traffic control tower (i.e., when an air traffic facility is located at the airport) with prior notice of the operation (model aircraft operators flying from a permanent location within 5 miles of an airport should establish a mutually-agreed upon operating procedure with the airport operator and the airport air traffic control tower (when an air traffic facility is located at the airport)).

The motivation for outlining the limitations of FAA oversight on model aircraft operators seems to have come from the years of experience working with the Academy of Model Aeronautics (FAA 2014b). This did not mean the FAA does not have a role in model aircraft operations as Section 336 (b) states,

> Nothing in this section shall be construed to limit the authority of the Administrator to pursue enforcement action against persons operating model aircraft who endanger the safety of the national airspace system.

Rather it was assumed by many that the FAA did not see a reason to hold hobbyists to the same standards as civil or public entities using sUAS. But, when it came to registering aircraft, the FAA did announce an sUAS registration rule in December 2015 (FAA 2015). This rule required sUAS owners aged 13 or older to register their aircraft weighing more than 0.55 pounds and less than 55 pounds – including payloads. This ruling stems from 49 USC section 44102 outlining registration requirements for aircraft. The system to handle registration requests involved using paper forms and the mail service for registration, which was not equipped to handle the volume of registrations by sUAS. Therefore, the FAA developed an electronic system for registration (14 CFR § 48 2018).

This new requirement did not go over well with hobbyists, in particular John Taylor, who sued the FAA. He argued that the FAA Reauthorization Act of 2012 could not regulate recreational use of sUAS if the five criteria stated in the law were being followed, and that criteria did not include registration. In May 2017, a federal appeals court agreed with Mr. Taylor and struck down the 2015 rule for recreational users to register their sUAS (Laris 2017).

14 CFR PART 107…FINALLY!

To recap the story so far, by roughly early 2016, public aircraft operators had a clear path for obtaining FAA guidance and permission for operations. Model aircraft operators also had a clear path for obtaining FAA guidance and permission for operations. Civil aircraft operators were still waiting for clearer FAA guidance and an easier path to permission for operations. But wait, didn't the often mentioned FAA Reauthorization Act of 2012 required the FAA to have a solution by September 30, 2015? Yes, well that solution was not reached until June 21, 2016 with the release of the new rules for civil sUAS operations that officially went into effect on August 29, 2016 (FAA 2016).

BOX 5.3 HANDS-ON AIRSPACE ACTIVITY

Navigating Low Altitude Authorization and Notification Capability (LAANC)

Go to the web address below and find the closest city to your area to determine access to controlled airspace at or below 400 feet.

https://faa.maps.arcgis.com/apps/webappviewer/index.html?id=9c2e4406710048e1980
6ebf6a06754ad

Now check the same information on the B4UFLY app. The app is available to download for free at the App Store for iOS and Google Play store for Android.

Q1 Does the information obtained from the FAA match the information in the B4UFLY app? Which source should you trust if they are different?

Q2 Can you legally fly as a hobbyist outside your current residence? Can you legally fly as a Part 107 commercial operator outside your current residence?

Important: As the pilot in command you are ultimately responsible for knowing the airspace class in which you are planning to fly regardless of what a third-party app may be indicating. Many online classes are available for preparation to take the FAA aeronautical knowledge test. Make sure you are prepared before you fly.

THE FINAL WORD FOR NOW: FAA REAUTHORIZATION ACT OF 2018

The most recent changes in the regulations came on October 3, 2018 with the latest FAA Reauthorization Act (Public Law 115–254, 2018). Among the many changes, the Section 333 used by Civil aircraft operators was repealed and replaced by the Special Authority for Unmanned Systems. A summary of highlighted sections is below. These changes emphasize the need to keep abreast of federal, state, and local regulations before you take to the air. Even though you may think you are legally operating, the laws may have changed, and you may not actually be in compliance. Always check before you fly.

Section 342 – The FAA has 90 days to report to Congress on their strategy to implement the Low Altitude Authorization and Notification Capability (LAANC), the Integration Pilot Program (IPP) and the UTM Pilot Program (UPP) (Poss 2019).

Section 345 – Speaks directly to the FAA interest in allowing sUAS flights over people (FAA 2019b).

Section 346 – Establishes a call for guidance concerning public actively tethered unmanned aircraft systems.

Section 348 – The FAA has one year to update existing regulations to authorize the commercial carriage of property by operators of sUAS.

Section 349 – The FAA can require model aircraft operators to register their aircraft, additionally hobbyists will need to pass an online FAA aeronautical knowledge test.

Section 350 – The FAA has 270 days to establish specific regulations, procedures, and standards for sUAS operated by institutions of higher education for educational or research purposes.

Section 358 – The Comptroller General has 180 days to review privacy issues associated with sUAS.

Section 364 – The FAA must establish standards for using Counter-UAS technology.

Section 372 – The FAA must establish a pilot program for remote detection or identification of sUAS. This can help detect illegal sUAS use. Public Comments have already been taken under 84 FR 72438.

Section 373 – The Comptroller General has 180 days to submit the results of a study of the roles of the Federal, State, local and Tribal governments in the regulation and oversight sUAS in the NAS. This speaks directly to contention over who has the ability to regulate airspace, how laws are getting enforced, and to establish consistency with existing laws.

Section 375 – The FAA will develop a plan to allow for the implementation of unmanned aircraft systems traffic management (UTM) services that expand sUAS operations beyond visual line of sight.

As you can see from these highlights, sUAS regulations are continually changing and adapting to new technologies. Staying on top of these changes can be challenging, but the FAA does post information promptly on their website and they issue guidance regularly. To ensure that you are operating legally and safely keep checking in with the FAA. That way you know you can keep your props spinning!

KEY COMPONENTS FOR SAFE OPERATIONS: CHECKLISTS AND EMERGENCY PROCEDURES

Pre- and post-flight checklists and emergency procedures are critical to maintaining safe and efficient sUAS operations, but they are mostly absent from many of the Part 107 test preparation materials. Emergency procedures should include what to do in the event of loss of communication with the aircraft, loss of GPS signal, flyaway incidents, and accidents, among other procedures. The activity in Box 5.4 below highlights the importance of pre-flight planning and mitigating risks that may possibly violate Part 107. If there are any questions that arise contact your closest FAA flight standards district office. Contact information can be found here: https://www.faa.gov/about/office_org/field_offices/fsdo/

BOX 5.4 SAFE OPERATIONS ACTIVITY

In this activity, you will prepare pre- and post-flight checklists for a sUAS mission. Write down as many factors as you can think of that might affect your flight and that you would want to check pre-flight. Then write down as many factors you can think of that you would want to check post-flight. Some categories to consider for both the pre- and post-flight checks are listed below:

- For a pre-flight checklist, categories to consider include the weather, flight details, batteries, platform structural check, and sensor calibration.

- For the post-flight checklist, categories might include recording flight details, disarming the aircraft, inspecting the aircraft, and proper storage.

After you have constructed your lists, you can compare them to the checklists developed by the authors, which can be found at the end of this chapter.

SOLUTIONS TO HANDS-ON ACTIVITIES

Box 5.1 Hands-on Activity – Can you find the Helicopter?

1. The helicopter is along the road in the photo just right of center.

2. Maybe – Part 107 states a drone, "Must yield right of way to other aircraft." And, section 107.23 states, "No person may: **(a)** Operate a sUAS in a careless or reckless manner so as to endanger the life or property of another" Without more details, it is difficult to tell from a snapshot if Part 107 is being followed.

3. Maybe – In addition to the same consideration from question 2, Part 107 states, "Small unmanned aircraft may not operate over any persons not directly participating in the operation." It is again difficult to tell from the one image if any people were directly under the flight path.

Box 5.4 Safe Operations Activity

Examples of pre- and post-flight checklists developed by the authors at the Autonomous Aerial Systems Office at University of Montana. Note: you may have more or different items on your lists depending on platform, field conditions, etc.
UM Phantom 4 Pro base preflight checklist

1. Update the firmware to the latest version if an upgrade notification is shown in the DJI Pilot app.
2. Confirm flight plan. Check airspace.
3. Confirm battery and remote controller are fully charged.
4. Confirm weather forecast is within flight minimums.
5. Confirm signage and barriers are ready to deploy for nonparticipating individuals.
6. Confirm required maps are loaded on iPad.

UM Phantom 4 Pro field preflight checklist

1. Inspect propellers, motors, and camera for obstructions.
2. Inspect propellers for damage (DO NOT use aged, chipped, or broken propellers).
3. Propellers are mounted correctly and firmly.
4. Inspect proper installation and seating of battery.
5. Confirm MicroSD card is properly installed.
6. Record weather conditions.
7. Avoid interference between the remote controller and other wireless equipment. Make sure to turn off the Wi-Fi on your mobile device.

8. Confirm Aircraft Flight Manual and emergency contacts are near Pilot in Command.
9. Ensure gimbal is functioning normally.
10. Check that the PAF switch is in the desired position.
11. Confirm Home Point and RTH Setting.
12. Perform IMU calibration if necessary (aircraft does not perform normally)
13. Perform compass calibration – required if flight is 50 miles away from previous flight and calibration.
14. Motors can start and are functioning normally.
15. Execute the CSC (Combination Stick Command).

16. Confirm surrounding area is safe to fly.

UM Phantom 4 Pro field post-flight checklist

1. Confirm motors are not rotating.
2. Power off the aircraft first, then switch off the remote controller.
3. Inspect every part of the aircraft particularly after any crash or violent impact. Note any findings in the logbook.
4. Set discharge of batteries and remote controller.
5. Log flights in PIC logbook.

6. Download flight logs and images/data and backup.

REFERENCES

1 CFR § 150.21 (2004) Airport Noise Compatibility Planning.
14 CFR § 107.3 (2019) Small Unmanned Aircraft Systems
14 CFR § 48 (2018) Registration and Marking Requirements for Small Unmanned Aircraft
14 CFR Parts 21, 43, 61, 91, 101, 107, 119, 133, and 183 (2015). Retrieved from https://www.faa.gov/uas/media/RIN_2120-AJ60_Clean_Signed.pdf
49 USC § 40102 (a)(41)(A)-(F) (2010). Retrieved from https://www.govinfo.gov/content/pkg/USCODE-2010-title49/pdf/USCODE-2010-title49.pdf
ARSA: Aeronautical Repair Station Association. (2019) *Rulemaking*. Retrieved from http://arsa.org/regulatory/faa/rulemaking/
Associated Press (2014). *Texas Search Group Resumes Drone Use*. Retrieved from https://www.nbcdfw.com/news/local/Texas-Search-Group-Resumes-Drone-Use-269384261.html
AUVSI: Association for Unmanned Vehicle Systems International (2016). *Commercial Exemptions: By the Numbers*. Retrieved from https://www.auvsi.org/our-impact/commercial-exemptions-numbers
Charpentier, C.F. (1997). *Understanding the USC and the CFR: This is CRUCIAL!*, Retrieved from http://www.supremelaw.org/wwwboard/messages/93.html
FAA: Federal Aviation Administration. (1981). Advisory Circular 91–57, *Model Aircraft Operating Standards*. Retrieved from https://www.faa.gov/documentLibrary/media/Advisory_Circular/91-57.pdf
FAA: Federal Aviation Administration. (2005). Memorandum AFS-400 UAS Policy 05-01, *Unmanned Aircraft Systems Operations in the U.S. National Airspace System – Interim Operational Approval Guidance*. Retrieved from http://www.sarahnilsson.org/app/download/960959143/FAA+policy+05-01.pdf
FAA: Federal Aviation Administration (2007) Unmanned Aircraft Operations in the National Airspace System, *Federal Registration*, Vol. 72, No. 29 6689. Retrieved from https://www.govinfo.gov/content/pkg/FR-2007-02-13/pdf/E7-2402.pdf
FAA: Federal Aviation Administration. (2012). *158 Cong. Rec. 16*. Retrieved from https://fas.org/sgp/news/2012/02/faa-uas.html

FAA: Federal Aviation Administration. (2014a) *FAA Statement on Texas Equusearch UAS Court Decision [Press Release]*. Retrieved from https://www.faa.gov/news/press_releases/news_story.cfm?newsId=16674

FAA: Federal Aviation Administration. (2014b). *FAA, AMA Work Together on Model Aircraft/UAS Safety*. Retrieved from https://www.faa.gov/news/updates/?newsId=75599&omniRss=news_updatesAoc&cid=101_N_U

FAA: Federal Aviation Administration. (2015) *FAA Announces Small UAS Registration Rule [Press Release]*. Retrieved from https://www.faa.gov/news/press_releases/news_story.cfm?newsId=19856

FAA: Federal Aviation Administration. (2016) *Small Unmanned Aircraft Regulations (Part 107) [Fact Sheet]*. Retrieved from https://www.faa.gov/news/fact_sheets/news_story.cfm?newsId=20516

FAA: Federal Aviation Administration. (2017). *Title 14 Code of Federal Regulations Part 101 Aviation Rulemaking Committee (ARC): ARC Recommendations Report*. Retrieved from https://www.faa.gov/regulations_policies/rulemaking/committees/documents/media/Approved%20-%20Final%20Part101%20ARC%20Report%20-%20Dec%202017.pdf

FAA: Federal Aviation Administration. (2018). *Reauthorization Act of 2018, Public Law 115–254, 132 STAT 3186*. Retrieved from https://www.congress.gov/115/plaws/publ254/PLAW-115publ254.pdf

FAA: Federal Aviation Administration (2019a). *Certificates of Waiver or Authorization (COA)*. Retrieved from https://www.faa.gov/about/office_org/headquarters_offices/ato/service_units/systemops/aaim/organizations/uas/coa/

FAA: Federal Aviation Administration (2019b). Operation of Small Unmanned Aircraft Systems Over People, *84 Fed. Reg. 3856*, February 13, 2019 (to be codified at 14 CFR pt 107). Retrieved from https://www.federalregister.gov/documents/2019/02/13/2019-00732/operation-of-small-unmanned-aircraft-systems-over-people

Fannin, R. (2019). *Chinese Drone Maker DJI Rules The Market And Flies Too High For U.S.* Retrieved from https://www.forbes.com/sites/rebeccafannin/2019/06/26/chinese-drone-maker-dji-rules-the-market-and-flies-too-high-for-u-s/#28a7849a1147

FCC: Federal Communication Commission (2019). *Ground Stations*. Retrieved from https://www.fcc.gov/wireless/bureau-divisions/mobility-division/aviation-radio-services/ground-stations

History of Lamps (2019). *History of Sky Lanterns – Who Invented Sky Lantern?* Retrieved from http://www.historyoflamps.com/lantern-history/history-of-sky-lanterns/

Koebler, J. (2014). *Here's Why Commercial Drones Just Got Legalized*. Retrieved from https://www.vice.com/en_us/article/z4mne8/commercial-drones-just-got-legalized-heres-why

Komatz, K. (2016). *Fire Prevention 52: Sky Lanterns*. Retrieved from https://www.nps.gov/articles/fire-prevention-52-sky-lanterns.htm

Laris, M. (2017). John Taylor fought the FAA over registering drones. And won. But now what? *Washington Post*. Retrieved from https://www.washingtonpost.com/local/trafficandcommuting/john-taylor-fought-the-faa-over-registering-drones-and-won-but-now-what/2017/05/29/56b83bf8-416a-11e7-a dba-394ee67a7582_story.html

McKinney, R.J. (2019, September 16), *A Research Guide to the Federal Register and the Code of Federal Regulations*. Retrieved from https://www.llsdc.org/fr-cfr-research-guide#H-CFR

Petronis, K.L. (2011), *Public Aircraft Operations PAO 101 – The Basics*. Retrieved from https://www.ntsb.gov/news/events/Documents/public_aircraft-Panel_1_Petronis.pdf

Poss, J. (2019). *The "Why's" of the 2018 FAA Reauthorization Act*. Retrieved from https://insideunmanned-systems.com/the-whys-of-the-2018-faa-reauthorization-act/

Stub, S. T. (2019), *Israel's Anti-Drone Industry Takes Off*. Retrieved from https://www.usnews.com/news/best-countries/articles/2019-08-30/israels-anti-drone-industry-takes-off

Texas Equusearch Mounted Search and Recovery Team, et al. 2013 v. Federal Aviation Administration, USCA Case #14-1061 Document #1503448 retrieved from https://nppa.org/sites/default/files/Equusearch%20v%20FAA%20Order%2007-18-14.pdf

U.S. Congress (2003). Public Law 108–176, Vision 100 – Century of Aviation Reauthorization Act of 2003, 49 USC 47503, Sec. 322. Retrieved from https://www.congress.gov/108/plaws/publ176/PLAW-108publ176.pdf

Welch, C. (2013), *Remote aircraft pilot fights $10,000 FAA fine, could change drone rules*. Retrieved from https://www.theverge.com/2013/10/9/4821094/remote-aircraft-pilot-fights-faa-fine-could-change-drone-rules

6 Structure from Motion (SfM) Workflow for Processing Drone Imagery

Adam J. Mathews

CONTENTS

INTRODUCTION

While remotely piloted aircraft have been around for many years in a hobbyist capacity, increasingly inexpensive and easy-to-use, off-the-shelf drones with integrated RGB sensors (e.g., rotary-wing platforms such as the DJI Phantom series, DJI Mavic series, Parrot ANAFI) have rapidly transformed the remote sensing landscape, permitting a broader audience from many disciplines to capture domain-specific, high-quality aerial imagery for geospatial data generation. Image processing methods and practices for drone data, therefore, are tremendously important to the production of accurate, analysis-ready geospatial data (e.g., point clouds, digital elevation models, orthophotos) for a variety of applications.

Excitingly, inexpensive drones with the ability to capture high-quality aerial images and readily available image processing techniques (i.e., desktop software and cloud-based applications requiring little background knowledge in photogrammetry) have great potential to open the door to a broader base of aerial data collectors (e.g., OpenAerialMap) and analysts. However, wide adoption presents potential challenges such as a lack of data collection and data processing standards/protocols, increased data quality and analysis issues due to limited expertise, and

insufficient documentation and metadata, among others. Structure from Motion (SfM) provides the "go-to" photogrammetric workflow to process drone-captured aerial imagery. Compared to the restrictive nature of prior forms of photogrammetry that captured data using metric cameras in a systematic fashion (e.g., same altitude and camera angle, consistent percentages of overlap between images), SfM offers additional flexibility because it enables use of nonmetric digital cameras (Snavely et al. 2008).

IMAGE PROCESSING WITH STRUCTURE FROM MOTION (SFM)

Structure from Motion (SfM) reconstructs three-dimensional (3D) scenes through identification of corresponding feature points within overlapping images (Snavely et al. 2008; Ullman 1979). SfM photogrammetry provides an ideal method by which to process drone-collected aerial images. When flown from a low altitude (400 feet or lower in the United States to adhere to Federal Aviation Administration [FAA] Part 107 regulations; see Chapter 5), drones and mounted sensors with limited fields of view require a series of images to be able to map even small areas. **SfM**, a computer vision technique originating in the 1970s (Ullman 1979), creates 3D models from the series of two-dimensional (2D) images. Similar to traditional and modern forms of photogrammetry (analog or digital), the SfM workflow identifies unique features within images and compares areas of overlap between images to generate key points in 3D space (Figure 6.1). These keypoint matches constitute a sparse point cloud of X, Y, and Z locations (in an arbitrary or real-world coordinate system) of terrain and surface features (Kaminsky et al. 2009). SfM point clouds contain composited RGB color spectral information from the contributing images. Light detection and ranging (lidar) point clouds do not contain such spectral information. Each SfM point is colored according to the feature it represents (e.g., a green tree canopy point would appear green). RGB information is stored as attribute data for each point, allowing for natural color point cloud visualization and analysis of ground features/land covers (e.g., selection/differentiation of vegetation points using the green information) (Dandois and Ellis 2013).

Named for the movement of the camera between successively captured images (motion) and the 3D data it creates (structure), SfM integrates a series of algorithms (e.g., feature detection, keypoint correspondence, etc.) to generate point cloud data (Carrivick et al. 2016). Although commonly referred to simply as SfM, numerous algorithms and computational processes are required prior to actual SfM image matching (Figure 6.2). Specifically, **feature points**, which are points that can be tracked from one image to another, must first be detected within every image through the Scale Invariant Feature Transform (SIFT) (Lowe 2004) or similar algorithms. The **feature detection** step identifies distinct pixels within each image such as edges/corners of key objects. In Figure 6.1, for example, each of the selected images (1–3) contains a small building with distinct roof corners and a roof peak. These features are detected within each image to be compared to detected features in subsequent images through the process of **keypoint correspondence**. Feature points or keypoints from individual images are matched to their counterparts in other images using the Approximate Nearest Neighbor (ANN) algorithm (Arya et al. 1998).

Sometimes feature points are matched incorrectly. Filtering can help identify incorrect matches. Specifically, **keypoint filtering** that uses an approach such as the RANdom SAmple Consensus (RANSAC) algorithm (Fischler and Bolles 1981) follows the keypoint correspondence step to remove any poor keypoint matches. At this stage, **SfM bundle adjustment** (e.g., the Bundler algorithm) reconstructs the 3D environment (Snavely et al. 2008) using the matched/filtered keypoints and camera parameters (see section "Camera calibration and image characteristics" for more details). This process generates a sparse point cloud along with camera positions.

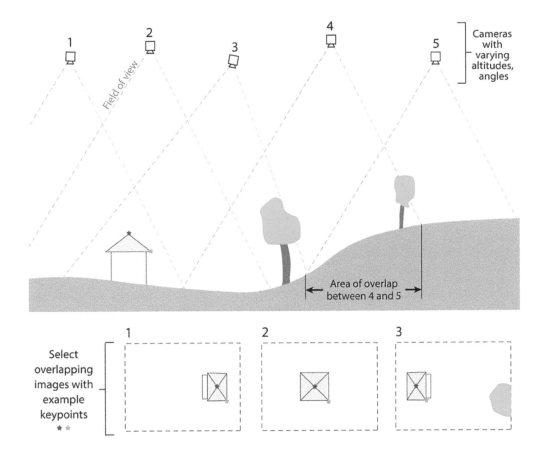

FIGURE 6.1 Input images and Structure from Motion feature matching to create initial keypoints.

GEOREFERENCING

The sparse point cloud produced by the bundle adjustment does not have real-world coordinates assigned to the points. If the goal of a study is to eventually take measurements or perform area-based analysis from the 3D model, the point cloud needs to be related to a ground system of geographic coordinates. Therefore, the next step in the SfM workflow is to accurately scale and locate the sparse point cloud using **georeferencing** (Figure 6.2). Georeferencing methods for UAS-acquired data include direct, indirect, and combined approaches (Mathews and Frazier 2017) as shown in Figure 6.3.

Direct georeferencing incorporates known camera locations (i.e., geotagged image metadata by the camera or drone Global Navigation Satellite System [GNSS] measurements) during or immediately following the SfM bundle adjustment stage to transform the point cloud to real-world coordinates. Direct georeferencing provides a less time-consuming method that minimizes fieldwork, which in some cases is not possible such as over an impassable marshy or densely vegetated area). Even when images are geotagged using non-survey-grade GNSS, direct georeferencing can produce accurate 3D data (Carbonneau and Dietrich 2017).

Indirect georeferencing integrates ground reference data during the bundle adjustment step to transform the point cloud and relate it to a ground system of geographic coordinates. The indirect georeferencing approach requires ground control points (GCPs). These can either be placed in the

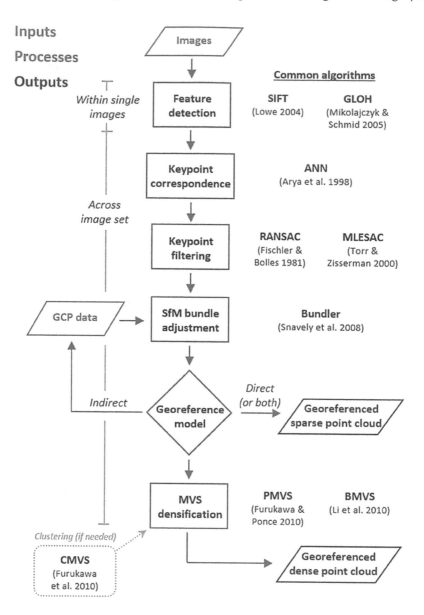

FIGURE 6.2 The Structure from Motion (SfM) workflow with key steps along and commonly used algorithms. The key inputs in SfM image processing workflow are drone-captured aerial imagery and field-collected ground control points (GCPs) that are used to produce georeferenced sparse and dense point clouds.

field (e.g., painted or taped targets, AeroPoints™ from Propeller Aero company, etc.), or they can be previously known targets at the study site (e.g., survey marks if on-site and visible) that are GNSS located (e.g., preferably to survey-grade accuracy). GCPs must be visually identified in the drone-collected images so that their real-world coordinates can be assigned to transform the point cloud accordingly. Many studies also rely on checkpoints (CPs), which are additional GNSS-measured locations on-site that are collected to check the accuracy of the produced 3D data.

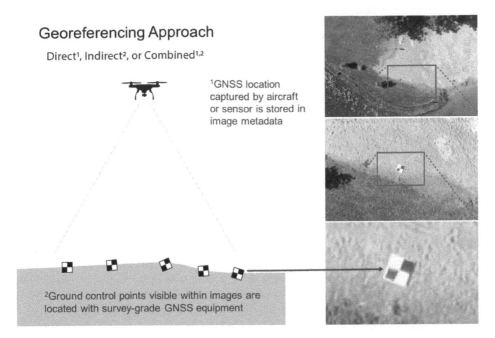

Georeferencing Approach

Direct[1], Indirect[2], or Combined[1,2]

[1]GNSS location captured by aircraft or sensor is stored in image metadata

[2]Ground control points visible within images are located with survey-grade GNSS equipment

FIGURE 6.3 Georeferencing methods for drone-collected images processed by way of Structure from Motion (SfM) include direct, indirect, and combined approaches. The direct method requires geotagging of aerial images during capture, the indirect approach incorporates GNSS-located Ground Control Points (GCPs), and the combined method utilizes both image geotags and ground-based data.

To improve georeferencing in derived SfM point clouds, direct and indirect approaches can also be combined by using image geotags along with GCP data. This **combined approach** is easily handled by most SfM software packages.

MULTI-VIEW STEREO

The **multi-view stereo (MVS) densification** process generates a dense point cloud from the object location and orientation information derived during the SfM process. Average point densities from the MVS process are at least two orders of magnitude higher than the SfM sparse point cloud (Carrivick et al. 2016), making the MVS point cloud comparable to a lidar point cloud in terms of density. Both the SfM and MVS point clouds are comparable to lidar in terms of vertical accuracy (Fonstad et al. 2013). Much like the SfM processing, MVS requires ample computational processing resources (e.g., high performing CPUs and GPUs). However, grouping or clustering image subsets can reduce the demand for computational resources (Furukawa and Ponce 2009; Furukawa et al. 2010). Software packages such as Agisoft Metashape allow users to manually group images into sets to create separate dense point clouds and later merge these "chunks" into a single dataset. MVS processing produces a dense point cloud, which is georeferenced and scaled during SfM bundle adjustment prior to MVS processing (Figure 6.2). The dense point cloud produced from MVS can directly be utilized to examine Earth surface features and detailed terrain, but it is often used to create subsequent data products for further analyses (discussed below).

Many SfM software packages (e.g., Agisoft Metashape, Pix4Dmapper) integrate the series of processes discussed above and shown in Figure 6.2 with specific algorithms, both proprietary and open source, and present them to users through a GUI as sparse (typically including SfM, all steps before SfM, and georeferencing) and dense (MVS) point cloud processes. Not surprisingly, the

nuances in the processing steps have led to inconsistencies in use of terminology. For this reason, the entire process including MVS is often referred to as just SfM.

DATA PRODUCTS

While the SfM process produces a point cloud in LAS file format (X, Y, and Z coordinates with RGB values and classification codes, if classified), geospatial data users and researchers often desire datasets in raster format such as digital elevation models (DEMs) and orthophotos. This is because completing analyses directly on the point cloud is computationally demanding and requires remote sensing specific knowledge. Therefore, raster datasets and derived data products remain more common for spatial analyses such as object-based image analysis of an orthophoto and hydrological modeling. Some common SfM point cloud-derived products are shown in Figures 6.4 and 6.5.

Digital Elevation, Terrain, and Surface Models

Point cloud-derived raster DEMs (i.e., DTMs), which represent the bare Earth terrain surface, and digital surface models (DSMs), which represent the bare Earth along with its surface features (e.g., trees, buildings, etc.) are the primary inputs for a variety of GIS analyses. The first step to creating these raster datasets is to filter and classify the SfM-generated point cloud (Figure 6.6). SfM and lidar data processing software provides options for automatically classifying point clouds using algorithms such as "multiscale curvature classification" (Evans and Hudak 2007) or assignment of classes through manual point selection.

According to the LAS file standards (ASPRS 2013), the basic approach for deriving products from point clouds is to first classify the points into ground and non-ground categories. Next, non-ground points can be assigned to several different classes such as the ground, low or high vegetation, buildings, and so on. DTMs are derived using height values from ground points, while DSMs incorporate height values from both ground and non-ground points. DTM and DSM raster values represent absolute elevation values (i.e., from sea level).

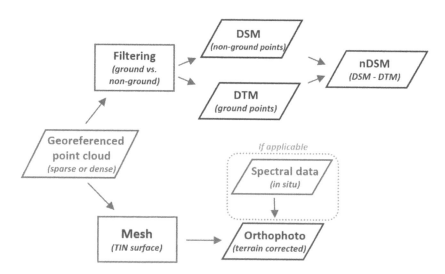

FIGURE 6.4 Examples of geospatial data products derived from SfM point clouds including digital surface models (DSMs), normalized digital surface models (nDSM), and digital terrain models (DTM). Orthophotos can also be derived from SfM point clouds.

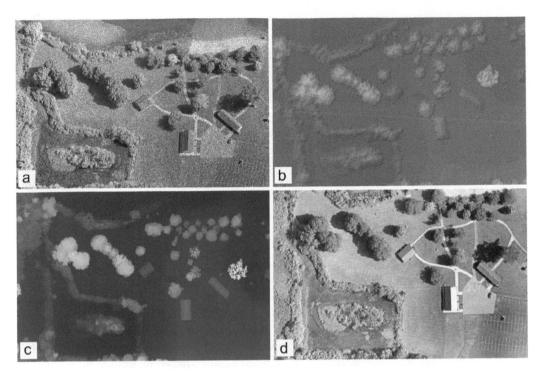

FIGURE 6.5 Structure from Motion-Multi-view Stereo (SfM-MVS) data products generated for a park near Kalamazoo, Michigan: (a) Multi-view Stereo (MVS) dense point cloud, (b) mesh or triangulated irregular network (TIN) surface, (c) digital surface model (DSM) raster, and (d) orthophoto.

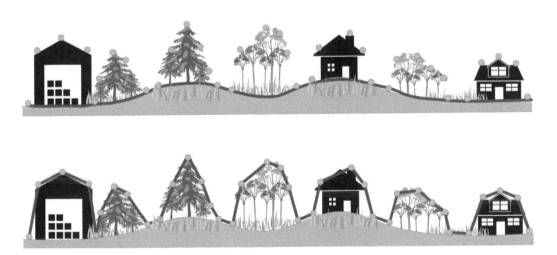

FIGURE 6.6 Comparative representation of digital terrain model (DTM) that represents the "bare ground" on the top and digital surface models (DSM) that is modeled using the object heights along with the bare ground on the bottom. Red line differentiates DTM from DSM. [Figure credit: Amy E. Frazier].

A **normalized DSM** (nDSM) is calculated by subtracting the DTM from the DSM raster, which creates relative height values from ground level (e.g., building height from ground level, and canopy height model, etc.). An nDSM is often used in estimating biophysical properties of vegetation and structure of human-made objects. DTMs can also be converted to other terrain data products such as contour lines.

Unlike lidar data, which can retrieve height information from beneath the tree canopy because laser pulses can penetrate the canopy and gaps, optically reliant SfM point clouds do not contain points beneath these and similar surface features (Dandois and Ellis 2013). Without manual effort (e.g., selection and reclassification of misclassified points, smoothing of raster surfaces), DTM surfaces created from ground points tend to contain abrupt elevation changes at and around dense canopies. To overcome this limitation, some studies incorporate an ancillary lidar-derived DTM along with an SfM-derived DSM (Jensen and Mathews 2016). In areas with less or sparse vegetation though, SfM-derived DTMs tend to be as accurate as their lidar-derived equivalents (Fonstad et al. 2013).

Orthophotos

An **orthophotograph** (or orthoimage) is an aerial image that has been geometrically corrected, or orthorectified, to remove terrain effects, lens distortions, and camera tilt (Figure 6.5d). The goal of orthorectification is to enable accurate distance measurements from a photograph. Orthophotos are an incredibly useful data product that can be generated from the SfM point cloud (Figure 6.4). SfM software typically converts the sparse or dense point clouds first into a **mesh surface** (equivalent to a triangular irregular network [TIN]) from which an orthophoto can be stitched together from the many individual aerial images and corrected to account for relief displacement (i.e., extrinsic geometric corrections). Terrain data are used as an input during the process to correct for relief displacement and generate orthophotos with minimal terrain distortions. Most software packages create mesh surfaces within the SfM processing workflow so users can visualize the terrain and develop terrain-corrected orthophotos. The low altitude of image-capturing drones paired with high-resolution onboard sensors results in very high spatial resolution orthophotos (commonly less than 4 cm pixels) (Turner et al. 2012).

If quantitative spectral analyses, such as computing normalized difference vegetation index (NDVI), are to be undertaken with the orthophotos, then it is necessary to radiometrically correct the images. This spectral processing step typically includes capturing reflectance measurements of targets *in situ* using a spectroradiometer (see Chapter 2) and using those in situ measurements to calibrate the measurements captured from the camera on-board the drone. Following standard remote sensing principles for field data collection such as capturing images and data near solar noon and under clear skies is recommended. Once the comparable spectroradiometer data and images have been captured, approaches such as empirical line calibration, which is a linear regression, can be used to correct the camera-recorded digital numbers and transform the values accordingly on a per-band basis resulting in spectral analysis-ready orthophotos (Mathews 2015).

SfM CONSIDERATIONS

IMAGE CAPTURE

The way in which images are collected with a drone influences the quality of the SfM point cloud and derived products. Simply put, the data collection procedure matters (see Chapter 4 on determining a flight path and plan for further details). SfM photogrammetry is different from traditional and modern digital forms of photogrammetry and, accordingly, new rules apply. For example, algorithms used in SfM image processing, such as Bundler, which was originally applied to ground-based images of popular tourist sites (Snavely et al. 2008), were created to handle images mined from a mixture of nonmetric cameras held at varying distances from the target

scene and pointed at different angles. As applied to capturing aerial images with a drone, varying altitudes and angles and including oblique convergent views (Figure 6.1) is encouraged to create accurate 3D data models (Wackrow and Chandler 2011).

Georeferencing methods can also influence data accuracy. Based on the sheer number of studies adopting indirect georeferencing, research consensus supports the use of these techniques as the preferred approach (Singh and Frazier 2018), although some argue that direct georeferencing offers sufficient accuracy given its low-cost inputs, which avoids the need for expensive survey-grade GNSS equipment and limits hours in the field (Carbonneau and Dietrich 2017). With indirect georeferencing, placement and number of GCPs is very important, where even distribution of a higher number of GCPs over the study site reduces both horizontal and vertical errors (Sanz-Ablanedo et al. 2018). Readers are encouraged to learn more about these issues and ways in which they have been resolved by examining the studies cited in this chapter.

CAMERA CALIBRATION

Although they are inexpensive and easy-to-use, nonmetric digital cameras present new challenges for photogrammetric practices with UAS imagery. Fortunately, algorithms used in SfM image processing were designed for such devices (Snavely et al. 2008). Regardless, intrinsic geometric corrections (i.e., camera calibration) are needed to remove distortions introduced by the camera. Without these corrections, SfM-derived terrain data can exhibit radial "doming" or "dishing" artefacts (Carbonneau and Dietrich 2017; Wackrow et al. 2007). **Doming** and **dishing** are convex and concave vertical artefacts, respectively, that occur due to the image capture approach and flight plan (e.g., parallel flight lines, capturing only nadir images) and/or camera calibration method (e.g., self-calibration [see next paragraph]) (James and Robson 2014). Including oblique convergent and nonparallel images, as illustrated in Figure 6.1, can help avoid these errors.

By default, most SfM software packages perform self-calibration using camera parameters derived from the SfM bundle adjustment process. Alternatively, pre-calibration requires the intrinsic geometry and distortion model of the camera be known prior to SfM bundle adjustment (Griffiths and Burningham 2019). The intrinsic geometry and distortion of a camera are determined by the camera manufacturer or completed by the user through a software utility by taking images of a 2D planar checkerboard pattern from several angles. Studies indicate that camera pre-calibration produces more accurate terrain data (Griffiths and Burningham 2019; Harwin et al. 2015) even though self-calibration is more commonly employed by users.

Further, cameras with global shutters are much more effective in capturing imagery from a moving platform (i.e., UAS) without data gaps compared to rolling shutters (Matese et al. 2017). A **rolling shutter** scans across the scene, which, when mounted on a moving aircraft (even those with slight movements when hovering), can result in data gaps between pixel rows that can be highly problematic for the SfM feature matching process. Alternatively, a **global shutter** captures the entire scene at once (i.e., every pixel is recorded simultaneously). Drone manufacturers that integrate off-the-shelf sensors continue to move away from rolling shutters or alter their rolling shutter devices to minimize data gaps, which ultimately diminishes distortions.

IMAGE CHARACTERISTICS

Image format (e.g., JPEG, TIFF, RAW, etc.) and storage are also important considerations for data collection and subsequent image processing. Selecting an optimal image format can avoid the need for data manipulation, which is often necessary for certain image formats that are based on data compression, such as JPEG. This concern is especially important in cases where spectral information is the focus of the analysis. Uncompressed file formats, such as RAW or TIFF, are efficient to store spectral information collected from the camera sensor. However, most SfM

software platforms are designed to ingest compressed file formats such as JPEG. These platforms often can handle uncompressed counterparts but not without requiring additional computational resources due to larger file sizes (i.e., uncompressed formats require around 3–5 times more storage space compared to compressed versions). Not surprisingly, most drone-SfM work uses images in JPEG format. Separately, attempts to use video files parsed into individual frames for input into the SfM process is common practice, but this has proven less successful because of blur within frames due to aircraft movement. This limitation, however, may change in the near future as imaging and processing capabilities improve.

MULTISPECTRAL AND HYPERSPECTRAL IMAGING DATA

Numerous multispectral and hyperspectral imaging sensors designed for drone-based remote sensing (e.g., MicaSense RedEdge-MX, Sentera 6X, BaySpec OVI) support analyses beyond 3D structure and visible (RGB) spectral information. SfM processing, though, is designed only to incorporate spectral data with three bands (e.g., RGB). For this reason, UAS imagery captured with additional spectral bands do not aid the SfM processing, and the additional information is only incorporated at the orthophoto generation stage.

Thermal sensors (e.g., FLIR Duo Pro R) fitted to drones provide another useful dataset for a wide variety of applications (e.g., vegetative canopy temperature assessment for precision agriculture, infrastructure inspection, wildlife identification, etc.). Thermal sensors capture single-band datasets, which prevents them from being a direct input for SfM processing. To overcome this limitation, it is necessary to fuse the single-band thermal images with RGB or multispectral images in order to be able to stitch images together over a larger area. Lightweight lidar sensors (e.g., Velodyne Lidar Puck series) can also be affixed onto drone platforms to collect 3D data directly through laser scanning (see Chapter 3 for more information on lidar sensors).

SOFTWARE

Agisoft Metashape (formerly PhotoScan) and Pix4Dmapper are the most commonly utilized SfM software packages for mapping applications (Singh and Frazier 2018). However, the black-box nature of these options can be problematic with regard to altering individual processing steps (e.g., camera calibration parameters, manually adjusting individual images within an orthophoto output, etc.) and reporting errors. Open-source alternatives are available such as MicMac (Rupnik et al. 2017) and VisualSFM (Wu 2013, 2019). Most of the algorithms utilized in the SfM and MVS processes are open source (Lowe 2004; Snavely et al. 2008), but integration of the many algorithms presented with a single GUI (such as MicMac) is needed for broader adoption.

APPLICATIONS

Not surprisingly, drone-captured image data and image processing workflows have been incorporated into a variety of mapping applications including archaeological site documentation, agricultural decision-making, ecosystem modeling of canopy heights (Jensen and Mathews 2016), detailed land cover change, and shallow stream bathymetric modeling (Dietrich 2017). The data products generated and utilized vary based on the application; some studies require height and 3D structural information while others require very high spatial resolution orthophotos. For the former, terrain data can model hydrological and other processes at unprecedented scales through use of standard and emerging GIS techniques and DEM of difference analysis using DTM or DSM rasters. Regarding the latter, very high resolution orthophotos support object-based image analysis for per-crop canopy area calculation, detailed small-area landscape analysis for habitat modeling (i.e., assessment of fragmentation), and much more.

OUTLOOK

Given the overall flexibility and ease of adoption, the utility of SfM image processing cannot be understated. Coupled with inexpensive drones that include integrated sensing capabilities, SfM has and will continue to revolutionize geospatial data, methods, and applications across many disciplines. Innumerable application areas (e.g., natural hazards, forestry, animal habitat, and monitoring) are already benefitting from very high spatial and temporal resolution data. Nevertheless, mappers beware, the relative ease of use of both drones and SfM image processing techniques do not remove uncertainty from produced data. These uncertainties can propagate into the data analyses and decision-making stages. Black box software that limits user ability to quantify and report errors serves to exacerbate these problems.

REFERENCES

Arya, S., Mount, D.M., Netanyahu, N.S., Silverman, R., & Wu, A.Y. (1998). An optimal algorithm for approximate nearest neighbor searching fixed dimensions. *Journal of the ACM (JACM)*, 45, 891–923.

ASPRS (2013). *LAS Specification Version 1.4–R13*. Bethesda, MD: American Society for Photogrammetry & Remote Sensing (ASPRS). https://www.asprs.org/wp-content/uploads/2010/12/LAS_1_4_r13.pdf.

Carbonneau, P.E., & Dietrich, J.T. (2017). Cost-effective non-metric photogrammetry from consumer-grade sUAS: implications for direct georeferencing of structure from motion photogrammetry. *Earth Surface Processes and Landforms*, 42, 473–486.

Carrivick, J.L., Smith, M.W., & Quincey, D.J. (2016). *Structure from Motion in the Geosciences*. Chichester, UK: Wiley-Blackwell.

Dandois, J.P., & Ellis, E.C. (2013). High spatial resolution three-dimensional mapping of vegetation spectral dynamics using computer vision. *Remote Sensing of Environment*, 136, 259–276.

Dietrich, J.T. (2017). Bathymetric structure-from-motion: extracting shallow stream bathymetry from multi-view stereo photogrammetry. *Earth Surface Processes and Landforms*, 42, 355–364.

Evans, J.S., & Hudak, A.T. (2007). A multiscale curvature algorithm for classifying discrete return LiDAR in forested environments. *IEEE Transactions on Geoscience and Remote Sensing*, 45, 1029–1038.

Fischler, M.A., & Bolles, R.C. (1981). Random sample consensus: a paradigm for model fitting with applications to image analysis and automated cartography. *Communications of the ACM*, 24, 381–395.

Fonstad, M.A., Dietrich, J.T., Courville, B.C., Jensen, J.L., & Carbonneau, P.E. (2013). Topographic structure from motion: a new development in photogrammetric measurement. *Earth Surface Processes and Landforms*, 38, 421–430.

Furukawa, Y., Curless, B., Seitz, S.M., and Szeliski, R. 2010. *Towards internet-scale Multi-View Stereo*. IEEE Conference on Computer Vision and Pattern Recognition (June 13-18, San Francisco, CA): 1434–1441. doi: 10.1109/CVPR.2010.5539802.

Furukawa, Y., & Ponce, J. (2009). Accurate, dense, and robust multiview stereopsis. *IEEE Transactions on Pattern Analysis and Machine Intelligence*, 32, 1362–1376.

Griffiths, D., & Burningham, H. (2019). Comparison of pre-and self-calibrated camera calibration models for UAS-derived nadir imagery for a SfM application. *Progress in Physical Geography: Earth and Environment*, 43, 215–235.

Harwin, S., Lucieer, A., & Osborn, J. (2015). The impact of the calibration method on the accuracy of point clouds derived using unmanned aerial vehicle multi-view stereopsis. *Remote Sensing*, 7, 11933–11953.

James, M.R., & Robson, S. (2014). Mitigating systematic error in topographic models derived from UAV and ground-based image networks. *Earth Surface Processes and Landforms*, 39, 1413–1420.

Jensen, J.L., & Mathews, A.J. (2016). Assessment of image-based point cloud products to generate a bare earth surface and estimate canopy heights in a woodland ecosystem. *Remote Sensing*, 8, 50.

Kaminsky, R.S., Snavely, N., Seitz, S.M., & Szeliski, R. (2009). *Alignment of 3D point clouds to overhead images*. In, *2009 IEEE Computer Society Conference on Computer Vision and Pattern Recognition Workshops* (pp. 63–70): IEEE.

Li, J., E. Li, Y. Chen, L. Xu, and Y. Zhang. 2010. *Bundled depth-map merging for Multi-View Stereo. IEEE Conference on Computer Vision and Pattern Recognition* (June 13–18, San Francisco, CA): 2769–2776. doi: 10.1109/CVPR.2010.5540004.

Lowe, D.G. (2004). Distinctive image features from scale-invariant keypoints. *International Journal of Computer Vision*, 60, 91–110.

Matese, A., Di Gennaro, S.F., & Berton, A. (2017). Assessment of a canopy height model (CHM) in a vineyard using UAV-based multispectral imaging. *International Journal of Remote Sensing*, 38, 2150–2160.

Mathews, A.J. (2015). A practical UAV remote sensing methodology to generate multispectral orthophotos for vineyards: Estimation of spectral reflectance using compact digital cameras. *International Journal of Applied Geospatial Research (IJAGR)*, 6, 65–87.

Mathews, A.J. and Frazier, A.E. 2017. Unmanned Aerial Systems (UAS). *The Geographic Information Science & Technology Body of Knowledge*, J.P. Wilson (ed.). Ithaca, NY: University Consortium for Geographic Information Science (UCGIS). doi: 10.22224/gistbok/2017.2.4.

Rupnik, E., Daakir, M., & Deseilligny, M.P. (2017). MicMac–a free, open-source solution for photogrammetry. *Open Geospatial Data, Software and Standards*, 2, 1–9.

Sanz-Ablanedo, E., Chandler, J.H., Rodríguez-Pérez, J.R., & Ordóñez, C. (2018). Accuracy of unmanned aerial vehicle (UAV) and SfM photogrammetry survey as a function of the number and location of ground control points used. *Remote Sensing*, 10, 1606.

Singh, K.K., & Frazier, A.E. (2018). A meta-analysis and review of unmanned aircraft system (UAS) imagery for terrestrial applications. *International Journal of Remote Sensing*, 39, 5078–5098.

Snavely, N., Seitz, S.M., & Szeliski, R. (2008). Modeling the world from internet photo collections. *International Journal of Computer Vision*, 80, 189–210.

Turner, D., Lucieer, A., & Watson, C. (2012). An automated technique for generating georectified mosaics from ultra-high resolution unmanned aerial vehicle (UAV) imagery, based on structure from motion (SfM) point clouds. *Remote Sensing*, 4, 1392–1410.

Ullman, S. (1979). The interpretation of structure from motion. *Proceedings of the Royal Society of London. Series B. Biological Sciences*, 203, 405–426.

Wackrow, R., & Chandler, J.H. (2011). Minimising systematic error surfaces in digital elevation models using oblique convergent imagery. *The Photogrammetric Record*, 26, 16–31.

Wackrow, R., Chandler, J.H., & Bryan, P. (2007). Geometric consistency and stability of consumer-grade digital cameras for accurate spatial measurement. *The Photogrammetric Record*, 22, 121–134.

Wu, C. (2013). *Toward linear-time incremental structure from motion. 2013 International Conference on 3D Vision – 3DV 2013*, Seattle, WA, 127–134. doi: 10.1109/3DV.2013.25.

SOFTWARE RESOURCES

Agisoft Metashape, https://www.agisoft.com/

Pix4Dmapper, https://www.pix4d.com/

MicMac, Rupnik, E., Daakir, M. and Deseilligny, M.P. 2017. MicMac – a free, open-source solution for photogrammetry. *Open Geospatial Data, Software and Standards* 2: 14.

VisualSFM, Wu, C. 2019. *VisualSFM: A Visual Structure from Motion System*, http://ccwu.me/vsfm/ (accessed 4 December 2019).

Carrivick, J.L., Smith, M.W., and Quincey, D.J.. 2016. *Structure from Motion in the Geosciences*. Chichester, UK: Wiley-Blackwell. ISBN: 978-1-118-89584-9OpenAerialMap, https://openaerialmap.org/

Science Education Resource Center (SERC) at Carleton College, https://serc.carleton.edu/getsi/teaching_materials/high-rez-topo/unit1-sfm.html

UNAVCO, https://kb.unavco.org/kb/category/geodetic-imaging/structure-from-motion-x28%3bsfm-x29%3b-photogrammetry/210/

USGS National UAS Project Office, https://uas.usgs.gov/

7 Aerial Cinematography with UAS

Britta Ricker and Amy E. Frazier

CONTENTS

INTRODUCTION

Imagine you are watching a video online that reveals an aerial perspective of tall, green densely packed tree branches enveloping the mountain below it. As the field of view shifts, and the camera moves forward quickly, you see the forest move rapidly beneath you. Suddenly, a person appears zip-lining through the trees. The camera is still moving as you seemingly soar past a group of energized tourists flying through the tropical canopy. In the distance ahead, there is a white, sandy beach where people are peacefully sunbathing and surfers are bobbing around in the waves. You start to pick up playful island music with hints of a steel drum in the background. This scene description evokes emotions of excitement and relaxation. Even from just the text description, you can get a "feel" of the place. Along with the aerial view of the landscape, you might desire to visit this forested tropical island that appears well equipped to host tourists. The scene you just experienced is a descriptive example of **aerial cinematography**. There are lots of examples of aerial cinematography on YouTube, and more are being added everyday (check out one example by Niklas Christl here: https://www.youtube.com/watch?v=wK87NFf4cok).

Aerial cinematography is the art of photography and camera work in filmmaking from an overhead perspective. It consists of moving photographic footage captured from an elevated perspective such as an airplane, helicopter, or more recently, unmanned aircraft systems (UAS, or drones). Aerial cinematography is now commonly used in the news, advertising and marketing, music videos, and other media outlets, due to its "wow" factor. The power of aerial cinematography is that it can offer a view of reality historically only accessible to those who could afford to hire an airplane or helicopter or who were resourceful enough to mount a camera to a balloon or a kite. Now, low cost, small, autonomous platforms carrying video cameras enable almost anyone to have "near-Earth" observation experiences, democratizing the aerial perspectives that were once reserved only for those with money and access to airplanes and helicopters.

Along with all of the positive benefits UAS provide, it is important to understand how aerial drone footage is being used to influence and shape knowledge, behavior, and politics. Just like aerial imagery, maps, and volunteered geographic information (VGI), aerial cinematography is a component of spatial media. **Spatial media** refers to the new set of services and channels that enable and enhance a person's ability to interact with and create geographic information in online environments (Elwood & Leszczynski 2013). Central in this definition is that the online environments are networked environments, or a **cyberinfrastructure**, in which these interactions take place. These networks are also known as the **geoweb** – which not only presents spatial information to users but also mediates a diverse set of communications, interactions, and transactions that go beyond traditional maps (Crampton 2009; Elwood and Leszczynski 2013; Wilson 2014). Over the last decade, there has been an increase in the types of interactive, open, and participatory portals for spatial media including online mapping platforms, databases for citizens to report information, virtual geodesign and planning tools, augmented reality media, and many others (Kitchin et al. 2017).

QUANTITATIVE MAPPING VERSUS QUALITATIVE VIDEOS

Imagery captured from drones is often used for *quantitative* purposes, such as generating ortho-photos and 3D models. Most of the chapters in this book focus on the tools and techniques being used to turn drone images into various forms of quantitative data that can be used to make precise calculations or measurements of the Earth to quantify feature heights and volumes or compute land change metrics. Drones can also capture data for *qualitative* purposes, such as spectacular photography and videos that can be used to characterize and describe places. Aerial photography and aerial cinematography are considered qualitative uses, particularly when they are used for communicating the value of a place. In Figure 7.1, you can see how a single piece of hardware can be used to collect data that can be processed to generate a wide array of outputs.

This chapter provides a perspective on how drones are being used to capture qualitative information through aerial cinematography and how geographic ideas can be communicated through aerial cinematography. First, the use of UAS in aerial cinematography is situated within communication geography, a subdiscipline of geography. Then, the specialized aerial cinematography techniques for specific geographic communication goals are described. Effective examples of aerial cinematography are introduced through a few case studies and lastly, tips are provided for how to plan and execute a successful UAS aerial cinematography mission.

GEOGRAPHIC COMMUNICATION WITH AERIAL CINEMATOGRAPHY

Communications geography is a subdiscipline of geography that explores the relationships between information and communication technologies and human conceptions of space and

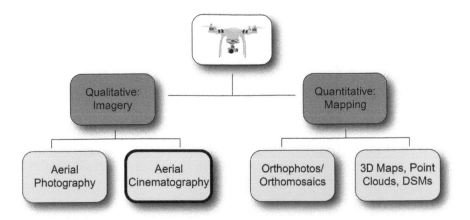

FIGURE 7.1 Overview of the data outputs that can be generated from UAS-captured imagery. This chapter focuses on aerial cinematography.

place. Geographers often use maps to document, measure, quantify, and communicate their findings. The complexity of the world sometimes makes it difficult to see the patterns emerging around us. Maps are representations or abstractions of reality that can help reduce some of that complexity to allow users to more clearly see these patterns. Maps, which can be tangible paper maps, three-dimensional (3D) models, or digital maps, regularly act as catalysts to facilitate spatial ideas and conversation, but maps are often seen as truth and power because they offer a "God's eye view" of the world from above. This view is considered disembodied, meaning it can lack a firm connection to human reality (Haraway 1991, Rose 1997).

Photographs, like maps, are ideologically hegemonic representations of a reality. Through repetitive exposure and dominant societal discourse, photographs and maps are generally accepted as "real" by viewers (Muehlenhaus 2013, 2014). Film and videos provide a different point of view of the complexities that exist in the world and can facilitate similar cognitive processes that occur during interaction with maps (Roberts 2012). Photos and moving images, like maps, may provide a linear perspective – an invented, artificial view of the world (Muehlenhaus 2014). Images, videos, and film can be used to augment digital maps or even populate information fields within maps. Together, maps and aerial imagery in the form of pictures or videos can be assembled in ways that tell stories and communicate information, helping the viewer to better understand the place. An early example is an aerial survey of Manhattan Island from New York City from 1921 (Figure 7.2 and Figure 7.3). Additional aerial photos of cities around the United States can be found on the Library of Congress website.

When maps are used to communicate the geography of a place, they can lead a viewer through a narrative of discovery that helps them build and retain knowledge about that location. Therefore, it is critical to consider how the footage from UAS aerial cinematography might be used for geographic communication and how it will be interpreted by the target audience. Being aware of the different visual politics between maps and imagery can help guide decisions surrounding what information needs to be collected and how that information should be collected and disseminated (Elwood and Leszczynski 2013). However, it is often a skilled mapmaker guiding this narrative and leading the user to a specific conclusion through effective **usability** – the ease of using a map or other media for an intended purpose. For an example, see this Esri story map about the use of drones in the United States https://storymaps.esri.com/stories/2015/nation-of-drones/.

FIGURE 7.2 Airphoto mosaic made by assembling 100 aerial photographs to generate a map of New York City in 1921. Fairchild Aerial Camera Corporation (1921). Retrieved from the Library of Congress, Geography and Map Division: https://www.loc.gov/item/90680339/.

FIGURE 7.3 New York City Aerial photo from 1945. Photograph showing a "birds eye" view looking south on Manhattan. Palumbo (1945). Retrieved from the Library of Congress: https://www.loc.gov/item/2014648274/.

ABSTRACTED VIEWS AND PHANTOM RIDES

Aerial cinematography is particularly useful for communicating abstracted views of reality and personalized tours (e.g., a cinematography "phantom ride," which is a moving image showing the landscape going by while providing the viewer a lay of the land and an overview of the landscape). Both abstracted views and phantom rides are considered spatial representations. An abstracted view presents a disembodied overview of an area or site (i.e., a map). For examples, see Google Earth Web Voyage examples like "A Better World with Jane Goodall's Roots and Shoots" from the Jane Goodall Foundation and these sweeping aerial images of Ireland with relaxing music (https://www.youtube.com/watch?v=RNKWoqDlbxc).

Phantom rides provide a bird's eye view of the landscape to the observer while making them feel as if they are flying, offering agency and an authoritative overview of a place. While phantom rides were once limited to large-scale productions, UAS have been democratizing these views for almost anyone. Low-cost action cameras can be easily mounted to UAS as well as helmets, bikes, smartphones, and other moving objects, allowing for the production of fluid space, making the viewer feel as if they were participating in the experience. The earliest examples of phantom rides in cinema were created using trains. The shots conveyed a sense of movement, but since the train was out of sight, the force generating the movement was invisible. A full range of examples from early cinema can be found on the British Film Institute Screen Online site. Another early example of an aerial phantom ride is from the 1900 Paris Exposition where Raoul Grimoin-Sanson simulated a hot air balloon ride by projecting images outward onto screens, offering a 360-degree view for the "riders" to see what it was like to float above Paris without ever leaving the ground (Figure 7.4).

Popular modern examples of the use of phantom rides with UAS include real estate "tours," where an agent offers sweeping imagery over a house and views of the surrounding neighborhood (search "luxury real estate drone footage" on YouTube, or see dronegenuity.com for examples). Phantom ride techniques are also used for tourism promotion by offering viewers an

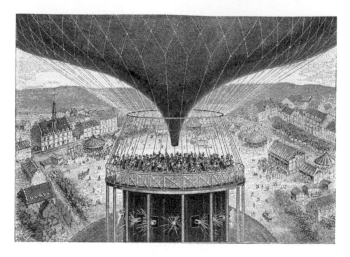

FIGURE 7.4 Illustration of the Cineorama simulated balloon ride at the 1900 Paris Exposition. Image is in the public domain.

📍 USA

🔥 4K Drone | Snow Mountains & Ski Resorts: Finland, Italy, Slovenia, Russia, Ukraine, USA | UHD

4,185 views · Mar 29, 2019 👍 43 👎 3 ➦ SHARE ≡₊ SAVE ...

FIGURE 7.5 Screenshot captured from a YouTube video showing sweeping images of ski resorts across Europe, Russia, and the United States.

epic "ride" through, for example, a beautiful snowcapped mountain ski resort, with the purpose of attracting travelers/tourists to visit a place and experience the views for themselves (Figure 7.5; search "beautiful drone footage" on YouTube for other examples). They are also increasingly being used in music videos (see Justin Bieber's "I'll Show You" or the band OK Go's "I won't let you down").

COMMUNICATING THROUGH UAS AERIAL CINEMATOGRAPHY

To effectively communicate with a viewer, a UAS cinematographer must consider three important factors: camera angle, navigation, and narrator. This section treats each of these factors in turn.

CAMERA ANGLE

Camera angle is the position of the camera barrel when a shot is taken. For platforms affixed with a gimbal, the camera can rotate about the axes, allowing the angle of the shot to be controlled through an interface offered with most drone specific apps. Different camera angles can be used to establish different relationships between the subjects and the viewer and induce different meanings or moods from the shots. Changing the camera angle used during aerial cinematography can alter how the aerial imagery is understood and the emotions a viewer associates with the place. For example, images captured with the camera angled at 90 degrees straight down from the UAS (i.e., nadir) offer an authoritative view that mirrors the view frequently employed by satellites to capture images for scientific purposes and measurements. While this view is necessary for creating orthomosaics and similar data products, when used for aerial cinematography, it can give the impression of a utilitarian, dispassionate and detached observer. When the camera is angled off-nadir, closer to 45 degrees, the view captured is off into the distance rather than straight down. Drone imagery captured of landscapes in this manner is more likely to evoke intense positive emotions of wonder compared to other angles (Mañas Viniegra et al. 2020). A UAS cinematographer should carefully consider what message they wish to convey with their work and how that message will be best captured using different camera angles. If the objective is to convey a value-neutral scientific perspective, the cinematographer may find the authoritative perspective, a 90-degree angle, is better suited than an off-angle perspective. If the objective is to evoke feelings of awe and splendor, an off-nadir or oblique perspective may be the best option.

NAVIGATION

The flight plan sets the navigation destination and waypoints that will be visited by the drone when creating an animated map or presenting aerial cinematography. The images update as the platform moves through space, creating a type of media that can be considered a personalized tour in the form of moving-image cartography or a first-person cartography (Verhoeff 2008, 2015). While maps can act as abstracted accounts of spatial experiences from a macro scale, video tours shot from the first-person view are filmed from the point of view of the traveler, which shifts navigation to a form of agency (Verhoeff 2012).

NARRATION

There are two levels of narration in moving images: micro (single shot) and macro (movement showing space) narratives (Gaudreault 1997). Compared to micro-narratives, macro-scale narratives are considered more truthful, convincing, or emotionally evocative (Gaudreault 1990; Verhoeff 2012). An example of a macro narrative is a **photomontage** that combines several images together to present the passing of time, conveying a sense that the viewer has witnessed a phenomenon firsthand. An example of a photomontage would be documenting the changing seasons (see this example https://www.youtube.com/watch?v=J22saLMWmbw) or capturing scenes from before and after a disaster (see this example of before and after a flood through false color composite images here https://bricker.users.earthengine.app/view/floodexamplesplitpane) (Figure 7.6). Another example of a time lapse is this before and after montage of the Malakal Refugee

FIGURE 7.6 Satellite imagery pre- and post-flood event to show change over time.

Camp (https://cdn.knightlab.com/libs/juxtapose/latest/embed/index.html?uid=ffa1a61c-ffd2-11e5-a524-0e7075bba956). Phantom rides are also considered macro scale narratives (Gaudreault 1990; Verhoeff 2012).

PLANNING AND EXECUTING A SUCCESSFUL UAS AERIAL CINEMATOGRAPHY MISSION

SELECTING A PLATFORM AND ACCESSORIES

The hardware and software associated with UAS are constantly evolving, and the choice of which platform and sensor to use will vary based on the budget and specific goals of the project. It is important to remember that not all platforms interface with all available software and autopilot apps, but most popular brands are quite versatile in terms of software. While the drone itself can be controlled using the remote controller supplied by the manufacturer, accessories like the camera or gimbal are often controlled using third-party apps that must be installed separately on a tablet or smartphone. There has been an influx of robust apps that leverage the software development kits for popular drone manufacturers, like DJI, to improve autopilot, cinematography, and mapping capabilities (e.g., DroneDeploy and Pix4D). For these apps to work properly and effectively, the operating system on the tablet and the drone must match the specs required by the app itself. Verifying the interoperability of your platform, accessories, and software before you go into the field will save you time and money.

TECHNIQUES FOR CAPTURING GREAT VIDEOS

There is great demand for experienced drone pilots that also possess strong videography skills in the new media domain of UAS aerial cinematography. Generating compelling imagery for cinematography is not easy though; it takes practice and patience. Viewers expect high-quality aerial footage, but flying a UAS in a way that generates beautiful imagery without inducing motion sickness is challenging! Creating powerful videos also requires knowledge of video editing and

post-processing techniques. While these topics are beyond the scope of this chapter, it is important to recognize the value of these skills for UAS aerial cinematography. The tips provided below can help reduce the amount of editing needed to make a compelling product. The aim is to take the best footage during your first flight so that you do not need to revisit your field site, which costs time and money. With good planning and informed flying, you can reduce the need to fly again.

Table 7.1 lists some important considerations when planning an aerial cinematography mission. Since there can be many settings to adjust, it is recommended you use a tablet computer in

TABLE 7.1

Considerations for Planning a UAS Aerial Cinematography Mission

Consideration	Why It Is Important	Tips
Autopilot vs. manual flying	Manual mode affords more control over the shot to capture specific angles and views but also creates more opportunity for error. The video may appear choppy. Autopilot mode ensures appropriate overlap of images to create orthophotos and offers more certainty about what will be captured in each shot. With autopilot, the footage will be calmer and smoother.	Autopilot mode generally leads to greater stability in the footage and smoother transitions. Using first-person view cameras that connect to goggles is useful for making changes to the path during flight. Autopilot functions may not always produce desired output. It is important to schedule enough time for re-flying after footage has been viewed.
Speed	Flight speed influences the attention of the viewer.	If the area is large and battery life is short, flight speed can be changed during post-processing to appear faster or slower.
Heading	Heading is the direction the aircraft is flying and is important because it determines the view.	The camera does not need to face the same direction as the aircraft heading, it can be modified during post processing.
Camera angle	Camera angle determines what is seen in the field of view. When the camera is pointed outward, the viewer will see what is in the distance and around them rather than what is directly underneath.	Camera angle is controlled by the gimbal. Not all gimbals rotate a full 360 degrees, so keep this in mind when purchasing equipment and planning your flight.
Gimbal angle and heading	Gimbal speed and smoothness drastically influence the quality of footage.	Gimbal angle and heading can be set to be pointing at a specific waypoint at all times. There are autopilot settings for this type of filming.
Altitude	Flying altitude determines the size of the swath that can be captured in a frame and the resolution of the imagery.	Check local regulations for altitude limits. Ensure no features like power lines, trees, or bridges are in the flight path. A trial run can be useful to find the optimal flying altitude, identify obstacles, and determine alternative paths if needed
Hover	Staying in one spot for a given period of time can create a visual effect that draws the viewer's attention	Hover effects can also be accomplished during post processing.
Time of day	Time of day can impact the "mood" of the footage and influence the narrative.	Sunrise and sunset may convey a mood of relaxation or hope for the future. When the sun angle is directly overhead, around noon, this offers the most light and potentially the best footage. Sometimes, shadows are wanted. Again, it is important to plan for the best time of day based on the communication goals of your project.
Flight frequency	Season, sun angle, human/animal behavior patterns.	Frequency should be determined by the project objective.

(Continued)

TABLE 7.1 (Continued)

Considerations for Planning a UAS Aerial Cinematography Mission

Consideration	Why It Is Important	Tips
Weather	Good weather will ensure optimal visibility for flying and is required to ensure you can spot the drone while it is flying. It is important that the drone is not lost or damaged during flight. Good weather is also important for clear footage.	Drones do not function well in wind. Know the specifications for each drone as each has a different wind threshold. Weather conditions, such as rain, hail, and snow may harm the drone. Even if the drone can fly in rain or snow, visibility will be negatively affected. Additionally, it is harder to maintain visual line of site during inclement weather.
First Person View (FPV) goggles	FPV goggles allow you to see the footage you are capturing in real time. Some goggles even have digital head tracking that moves the gimbal onboard as you move your head, giving you complete control of the imagery.	If the pilot-in-command is also wearing goggles, they may not see obstacles since the field of vision range is between 25 and 45%. It is recommended to always have obstacle avoidance enabled and make sure a designated visual observer is available when the pilot is wearing FPV goggles.

the field rather than a smartphone to take advantage of the increased screen size. Most navigation software apps offer a map view where you can place waypoints and also have separate windows for controlling and adjusting the parameters described in Table 7.1. These panes take up a lot of screen real estate, so unless you have really good eyes and tiny fingers, using a tablet or desktop computer to plan and program your autopilot program before you head into the field to fly is the best option. There are countless videos on YouTube and other social media platforms where drone enthusiasts share their tips and tricks for capturing UAS aerial cinematography. Learning from experienced pilots can save time, effort, and maybe even your drone. Additional online resources are listed at the end of this chapter. Always remember to check the local, state, and federal regulations before you plan to fly!

For more tips on how to execute aerial cinematography techniques, see this video from drongenuity: https://www.youtube.com/watch?v=qPuogd8Og0Q.

EXAMPLE APPLICATIONS FOR UAS AERIAL CINEMATOGRAPHY

There are countless ways in which UAS technologies can be used for social and environmental good (Chow 2012). The use of UAS aerial cinematography is particularity valuable for environmental and social impact assessments, tourism, journalism, and community engagement (see Table 7.2 for an overview of examples, communication goals, strategies, and descriptions). Below, a few of the most common applications for using UAS for aerial cinematography are highlighted.

ENVIRONMENTAL AND SOCIAL IMPACT ASSESSMENTS

Environmental and Social Impact Assessments (ESIA) are undertaken to assess any potential adverse social or environmental impacts from proposed or on-going projects, such as energy extraction or building a new industrial complex. Associated impacts might be related to changes in landscapes or heritage, air and soil quality, or loss of biodiversity. Aerial cinematography with UAS can help inform these assessments by documenting landscape conditions and visually communicating information about the geography of the site before, during, and after the proposed activity. ESIA reports often include viewshed and other visual landscape analyses, and UAS can aid in these types of assessments. In addition to capturing cinematography and aerial

TABLE 7.2

Examples of Communication Goals for Different Applications of UAS and Suggestions for Achieving Communication Goals

Examples	Environmental Advocacy Communication	Tourism	Journalism and Community Engagement
Communication goal	Communicate potential changes to a landscape in an Environmental and Social Impact Assessment, focusing on visual aspects such as viewshed changes.	Entice tourists to visit by showing the beauty of a remote island from above, including opportunities for high adventure.	Document changes in an urban neighborhood facing social decline for the purpose of motivating interventions – such as additional streetlights.
Intended output and target audience	Aerial cinematography to be shared at a town hall meeting during a voting event to promote informed decision-making.	Spectacular advertisement to be shared on social media to promote tourism.	Aerial cinematography made by community members to share with town hall and local police agencies to help reduce crime.
Flight plan and techniques	Create maps to show extent of damage to a landscape or create emotionally evocative aerial footage by flying over a proposed coal mine then flying over a school with children and others who are potentially affected by polluted runoff.	Match cinematography footage with a map to highlight points of interest most enticing to potential tourists (e.g., beaches, snorkeling spots, mountain trails, etc.)	Four flights: 1) A summer Saturday when children are playing. 2) Same place same time of year in the evening to show where streetlights are missing and different actors on the street. 3) Winter Saturday afternoon 4) Winter night to showcase seasonal changes.
Apps required for flying and software for post processing	Autopilot app to ensure image overlap to make maps and software with structure for motion image stitching capability and video editing software.	Autopilot functionality to ensure smooth flying. Video editing software to make the final movie.	Autopilot functionality to ensure smooth flying. Video editing software to make the final movie.
Possible interventions/solutions	Use footage to argue to install solar farm or wind farm instead of a coal mine, mitigate negative consequences of pollution in the community.	Tourists decide to visit based on these emotionally appealing and exciting aerial perspectives.	Use footage to argue for more streetlights and afterschool programs for children and teenagers to keep them engaged in a safe environment.

photography, UAS can be used to monitor changes to the landscape over time. This part of ESIA involves a combination of objective and subjective judgments (Knight and Therivel 2018) for which UAS are particularly expedient at capturing images and videos. Other information for ESIAs that can be gathered using UAS includes the number of people who are or will be influenced by an environmental change (population surrounding a point of interest), the magnitude of change on the landscape, quality of existing views, availability of alternative views, degree of visibility, duration of views, and the sensitivity of the landscape.

Tourism

UAS have become an integral advertising tool for the tourism industry and are widely used for promotion, viewscape development, and facilitating services during peak seasons. The footage

they provide as "flying tour guides" (Stankov et al. 2019) is used to showcase the beautiful layouts and amenities a resort has to offer. This aerial perspective offers a new dimension to promotional materials by revealing majestic vistas that evoke a sense of wonder, sweeping landscape views, and the thrill of flying. The tourism industry is eager to capture the emotions these tours evoke, package them as attractive videos, and sell these experiences to consumers. Increasingly, tourism researchers are investigating the effects of drones on the industry, with studies suggesting that social media users favor aerial imagery of populated tourist areas rather than other types of views of the same landscape (Stankov et al. 2019). More research is needed to measure tourist behaviors as a result of viewing aerial cinematography and to investigate how aerial cinematography can be used for virtual tourism.

The tourism industry is also rapidly emerging as an important market for drone *users* looking to create aerial cinematography (Stankov et al. 2019). In many destinations, tourists can bring a drone with them on vacation to document their experiences. By sharing these videos with others on social media, there is an opportunity to influence the purchasing decisions of others, creating a positive feedback loop that benefits both the tourism and drone industries.

JOURNALISM

As early as 2012, there were examples of drones being used by investigative journalists to document threats to environmental health and human safety. A drone enthusiast in Dallas captured aerial images of a local creek flowing red. He documented red blood draining directly into a stream near a meatpacking plant, which was contaminating the drinking water (Sidik 2012). These UAS-captured images were quickly picked up by the media, and the scene was labeled as a form of drone journalism. Drone journalism is an example of this new media technology being used by citizens to document environmental, social, and political causes (Tremayne and Clark 2014). As UAS technologies have become more accessible in society, their adoption for documenting news events has also increased since they offer a sometimes safer and more cost-effective means for capturing footage.

COMMUNITY ENGAGEMENT

Community-engaged researchers often utilize UAS to offer views of a community that might not otherwise be accessible. UAS leveraged by local communities can provide a form of media that affords agency and power to the people in these communities; they can generate their own aerial first-person perspectives and share their local knowledge through this view. For example, New America (http://drones.newamerica.org), a non-governmental organization (NGO) has been operating drones to monitor property rights, human rights, and global development. The New America team wrote a primer about how to use drones for aerial observation and maintain a website – World of Drones – devoted to resources for communities to use drones to make maps for social good. The organization also offers resources to help communities get started collecting their own drone imagery. With resources like these available, it is expected that additional examples of how drones can be used for community safety monitoring and reporting will emerge.

PARTICIPATORY METHODS AND MAPPING

Related to community engagement, participatory methods and mapping are another important application of UAS aerial cinematography. Participatory methods emerged from a recognition that local knowledge and experience are paramount for achieving results that reflect local realities and developing interventions that will lead to lasting social change. Local knowledge is required

to facilitate social change (Mohan and Stokke 2000), and participatory methods are particularly valuable in rural areas, where they can facilitate communication between community members and researchers or government officials (Rambaldi et al. 2006), offering an opportunity for local voices to be included and valued in the scientific process while simultaneously filling in missing data. **Participatory mapping** is when communities take part in the creation of maps that include their local knowledge and priorities and give a voice to marginalized populations. The maps can then be used to communicate this information to a wider audience (Vajjhala 2005).

Aerial imagery is an important part of both participatory methods and participatory mapping, but historically, state control of aerial photography, satellite imagery, and maps made it difficult for communities to access the data and master the knowledge and techniques for manipulating and interpreting the data (Rambaldi et al. 2006). UAS have helped to take a step toward democratizing aerial imagery and lessen some of the restrictions that have historically disenfranchised certain groups from spatial decision-making. UAS give individuals and researchers the ability to generate aerial images and scenes that can be used to make maps, show changes over time, and monitor those changes.

A great example of how drones are being used for participatory methods is citizensciencegis. org, a group dedicated to "connecting communities & scientists across the globe with maps, apps & drones." The team uses interdisciplinary research methods and geospatial technologies like UAS to identify community assets and help communities understand their needs and visions for the future. They also work with underrepresented residents to empower them to use these technologies to benefit their communities. An example of participatory mapping using UAS is the Appalachian Mountaintop Patrol, which works directly with communities negatively affected by the coal industry to better understand and communicate exactly what is polluting their waterways and drinking water and where. This endeavor, which uses UAS aerial cinematography to "peek over the trees," is led by the local community with input and guidance from artist and professor, Laura Grace Chipley (video footage from the project can be found here: https://player.vimeo. com/video/155573218). Lastly, OpenAerialMap is a platform where people share their aerial imagery that has been stitched together and can be used for participatory mapping and base maps (Johnson et al. 2017).

REFERENCES

Crampton, J.W. (2009) Cartography: performative, participatory, political. *Progress in Human Geography* 33(6), 840–848.

Chow, J. (2012, April). Predators for Peace. *Foreign Policy*. Retrieved from http://foreignpolicy. com/2012/04/27/predators-for-peace/ Accessed 24-2-2021

Elwood, S., & Leszczynski, A. (2013). New spatial media, new knowledge politics. *Transactions of the Institute of British Geographers*, 38(4), 544–559.

Fairchild Aerial Camera Corporation (1921) Aerial survey, Manhattan Island, New York City. [New York: The Corporation] [Map] Retrieved from *The Library of Congress*, https://www.loc.gov/item/90680339/. Accessed 24-02-2021

Gaudreault, A. (1997). Film, narrative, narration: the cinema of the Lumiere brothers. In *Early cinema: Space, frame, narrative*, edited by Thomas Elsaesser with Adam Barker. London: Bloomsbury (pp. 68–75).

Johnson, P., Ricker, B., & Harrison, S. (2017). *Volunteered Drone Imagery: Challenges and constraints to the development of an open shared image repository*. In *Hawaii International Conference on System Sciences*, Hawaii, USA (pp. 1995–2004). https://doi.org/978-0-9981331-0-2

Kitchin, R., Lauriult, T., & Wilson, M. (2017). *Understanding spatial media*. London, UK: SAGE.

Knight, R., & Therivel, R. (2018). Landscape and visual. *Methods of Environmental and Social Impact Assessment* Edited by Riki Therivel, Graham Wood. New York, NY: Routledge. ISBN 9781138647671.

Mañas Viniegra, Luis, García García Alberto, Luis and Martín Moraleda Ignacio, José (2020) Audience Attention and Emotion in News Filmed with Drones: A Neuromarketing Research. *Media and Communication*, 8(3). pp. 123–136. ISSN 2183–2439.

Mohan, G., & Stokke, K. (2000). Participatory development and empowerment: the dangers of localism. *Third World Quarterly*, 21(2), 247–268. https://doi.org/10.1080/01436590050004346

Muehlenhaus, I. (2013). The design and composition of persuasive maps. *Cartography and Geographic Information Science*, 40(5), 401–414. https://doi.org/10.1080/15230406.2013.783450

Muehlenhaus, I. (2014). Looking at the Big Picture: Adapting Film Theory to Examine Map Form, Meaning, and Aesthetic. *Cartographic Perspectives*, (77). https://doi.org/10.14714/CP77.1239

Haraway, D., 1991. *A Cyborg Manifesto: Science, Technology, and Socialist-Feminism in the Late Twentieth Century, Simians, Cyborgs, and Women: The Reinvention of Nature*. New York: Routledge, 149–182.

Palumbo, F. (1945). *Aerial view of New York City/World Telegram & Sun photo by F. Palumbo*. New York. [United States:] [Photograph] Retrieved from the Library of Congress, https://www.loc.gov/item/2014648274/.

Rambaldi, G., Kyem, P. A. K., McCall, M., & Weiner, D. (2006). Participatory spatial information management and communication in developing countries. *The Electronic Journal of Information Systems in Developing Countries*, 25(1), 1–9. Retrieved from http://www.ejisdc.org/ojs2/index.php/ejisdc/article/view/237

Rose, G., 1997. "Situating knowledges: positionality, reflexivities and other tactics", *Progress in Human Geography* 21(3), 305–320.

Roberts, L. (2012). *Film, mobility and urban space a cinematic geography of Liverpool*. Liverpool: Liverpool University Press.

Sidik, Almire. 2012. "Meat Packing Plant under Investigation for Dumping Pig Blood into Nearby Creek." GreenAnswers.com. http://greenanswers.com/news/274701/meat-packing-plant-under-investigation-dumping-pig-blood-nearby-creek.

Stankov, U., Kennell, J., Morrison, A. M., & Vujičić, M. D. (2019). The view from above: the relevance of shared aerial drone videos for destination marketing. *Journal of Travel & Tourism Marketing*, 36(7), 808–822. https://doi.org/10.1080/10548408.2019.1575787

Tremayne, M. and Clark, A (2014) New Perspectives from The Sky. *Digital Journalism*, 2:2, 232–246, DOI :10.1080/21670811.2013.805039

Vajjhala, S. P. (2005). Integrating GIS and Participatory Mapping in Community. *Sustainable Development*, (24 July 2005). Retrieved from http://citeseerx.ist.psu.edu/viewdoc/download?doi=10.1.1.134.4523&rep=rep1&type=pdf.

Verhoeff, N. (2008). Screens of Navigation: From taking a ride to making the ride. *Refractory Journal of Entertainment Media*. Retrieved from http://refractory.unimelb.edu.au/2008/03/06/screens-of-navigation-from-taking-a-ride-to-making-the-ride/

Verhoeff, N. (2012). *Mobile Screens: The Visual Regime of Navigation*. Amsterdam, The Netherlands: Amsterdam University Press.

Verhoeff, N. (2015). Footage: action cam shorts as cartographic captures of time. *Empedocles: European Journal for the Philosophy of Communication*, 5(1&2), 103–110. https://doi.org/10.1386/ejpc.5.1-2.103

Wilson, M. (2014) "Continuous connectivity, handheld computers, and mobile spatial knowledge," *Environment and Planning D: Society and Space* 32(3), 535–555.

OTHER USEFUL LINKS

https://www.youtube.com/watch?v=4YUK1ZokhmA

https://www.youtube.com/watch?v=BdtHWr_nDeU

https://www.google.com/search?rlz=1C1GCEU_nlNL847NL848&biw=1280&bih=561&ei=7G4wXYKSKaGBi-gPgbeq-A4&q=Cinematic+Drone+&oq=Cinematic+Drone+&gs_l=psy-ab.3..0l10.362477.362477..363475...0.0..0.40.40.1......0....2j1..gws-wiz.......0i71..12%3A0j13%3A0.5GGOgUEvKGI&ved=0ahUKEwiCuMvExL7jAhWhwAIHHYGbCu8Q4dUDCAo&uact=5

https://www.dronegenuity.com/best-easy-cinematic-drone-shots/

http://fromwhereidrone.com/7-simple-yet-amazing-cinematic-drone-shots-you-must-master/
https://www.tandfonline.com/doi/full/10.1080/21670811.2018.1533789?src=recsys
https://www.tandfonline.com/doi/full/10.1080/03098265.2014.1003799?src=recsys

OPEN-SOURCE HOLLYWOOD

https://opensource.com/article/18/9/academy-software-foundation
https://www.dronezon.com/learn-about-drones-quadcopters/drone-3d-mapping
 -photogrammetry-software-for-survey-gis-models/
https://www.flowmotionaerials.com/aerial-cinematography
http://m2aerials.com/

Part II

Hands-On Applications Using Drone Imagery and Data

8 Planning Unoccupied Aircraft Systems (UAS) Missions

Anthony R. Cummings, Ron Deonandan,
Jacquy Gonsalves, Persaud Moses, and Arnold Norman

CONTENTS

INTRODUCTION

The rapid development of unoccupied aircraft systems (UAS) and related technology and their increased availability and integration into the science and practice of remote sensing has given rise to the era of "personal remote sensing" (Jensen 2017). UAS have transformed the science and practice of remote sensing. Historically, sensors carried onboard orbital and suborbital systems have collected remotely sensed data, placing the data capturing process for any space on the planet almost entirely outside the control of end-users. These days, users can purchase a UAS from online merchants or physical "brick-and-mortar" stores that can carry a variety of sensors to collect high-quality remotely sensed data (Cummings et al. 2017b; Cummings et al. 2017c).

Concurrent with the increasing availability of UAS and the rapid development of sensors, scholars and industry personnel alike have developed software packages to make UAS operation more accessible. For example, you can purchase a DJI Phantom UAS, install the DroneDeploy application on your smartphone or tablet, and fly the UAS to collect data almost anywhere in the world. In this era of "personal remote sensing," scholars and hobbyists alike have greater control over the remote sensing data collection process and can contribute to improving our understanding of a rapidly changing world.

A key first step in pursuing UAS data collection is understanding the landscape within which you will operate and planning an appropriate mission to cover your area of interest. A **mission** provides the UAS flight control device with commands and instructions on where and how to fly over an area of interest. The commands and instructions contained in a UAS mission can include the flight altitude, speed, the number of locations (waypoints) to be visited during flight, and when to trigger a camera to capture images.

Typically, missions are created using software that contains all the necessary tools, including background imagery, that allows the operator to design a flight plan that will provide all the necessary instructions a UAS will need to cover the area. Most mission planning software platforms draw inputs from sources such as Google Earth and other powerful mapping sources (e.g., ArcGIS StreetMap, ArcGIS World Imagery, BingMap) to incorporate imagery, topographical data, and other landscape characteristics of an area of interest to give the mission planner bearing and orientation to the area of interest for which they will collect data (Figure 8.1). In many urban settings, the background imagery and other data (e.g., streets, topography) served through the

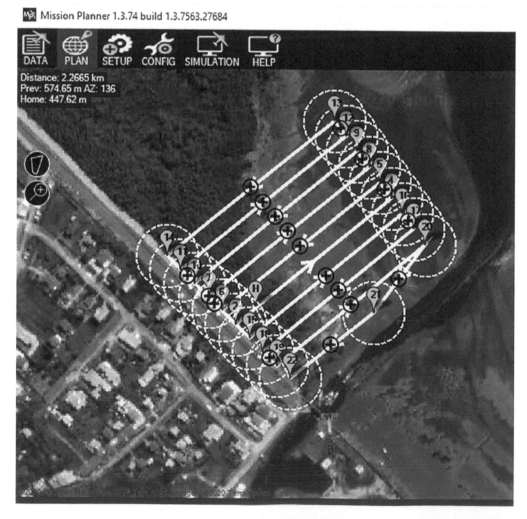

FIGURE 8.1 The familiar landscape: most mission planning software contains high-resolution imagery in the background that helps facilitate the process of developing UAS missions. The yellow lines and arrows represent the path a UAS will fly to capture data over the area of interest.

mission planning software are of high enough spatial resolution that the user can easily identify features and landmarks such as buildings, roadways, or intersections to aid the mission planning process. This chapter defines these areas where copious contextual data are available to aid the mission planning process as **familiar landscapes**. When working in familiar landscapes, the UAS operator can use the landmarks and features that are mapped and marked within the mission planning software to virtually "travel" to that place and become oriented with the landscape. The study area can become *familiar* to the mission planner before they physically visit the area to collect data, allowing them to make decisions about how and where to fly the UAS ahead of time.

In contrast to the situation where a mission is being planned in a familiar landscape, sometimes the UAS mission planning software may not contain high-resolution imagery of the area of interest (Figure 8.2) or the area of interest may be devoid of landmarks, preventing the mission planner from being able to properly orient themselves to the landscape before physically visiting the site. This chapter uses the term **unfamiliar landscape** to define areas where high-resolution imagery

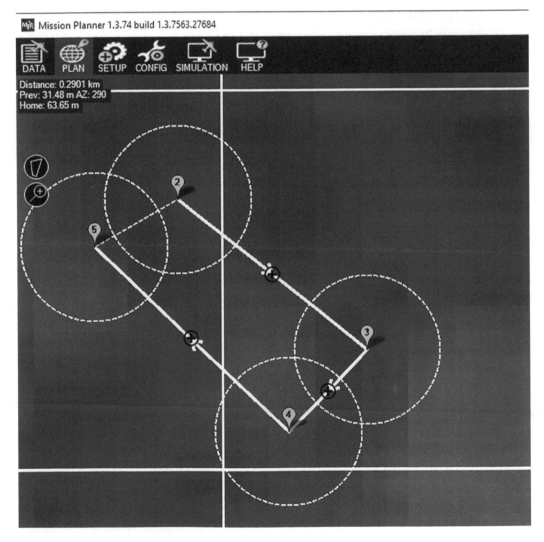

FIGURE 8.2 The unfamiliar landscape: the Mission Planner software lacks high-resolution imagery in the background or landmarks that may facilitate mission planning are absent. The yellow lines and arrows represent the path a UAS will fly to capture data over this landscape.

is unavailable, or landmarks are absent in the mission planning software. In a familiar landscape, the process to plan a mission is straightforward. Planning missions in unfamiliar landscapes can be much more challenging.

With the definitions of familiar and unfamiliar landscapes in mind, this chapter provides an introduction to creating UAS missions in both settings. The steps you will follow will be completed entirely within the freely available Mission Planner software, a powerful, open-source package for planning UAS missions. The chapter will guide you through the process of obtaining and installing a copy of Mission Planner software. You will then develop missions for both familiar and unfamiliar landscapes.

LEARNING OBJECTIVES

After completing this chapter, you will be able to:

1. Describe the main functions of the Mission Planning software package
2. Differentiate between a familiar and an unfamiliar landscape
3. Plan UAS missions in Mission Planner in both familiar and unfamiliar landscapes
4. Explain why UAS technology and mission planning processes may have limitations in certain areas.

HARDWARE AND SOFTWARE REQUIREMENTS

1. A computer (tablet, desktop, or laptop) running Windows operating system
2. Mission Planner software (instructions for downloading and installing are included below)
3. A Global Positioning System (GPS) unit or a smartphone GPS application such as Gaia GPS or GPS App (optional)
4. The exercise data downloaded to a known location on your computer.

Note: The steps described here are for the Windows operating system but should work for Android as well. If you would like to read more about mission planning beyond this chapter, please visit www.diydrones.com and www.ardupilot.org to explore the vast array of resources available.

PART 1: OVERVIEW OF MISSION PLANNER

There are several mission planning software options available to UAS users for planning missions over both familiar and unfamiliar landscapes. This chapter uses Mission Planner – a free, open-source software designed to take the user through the entire chain of events from building a UAS (and several other types of unmanned vehicles including airplanes, rovers, and submarines) to operating a UAS both manually and autonomously. The steps for downloading and installing the software are described below.

EXERCISE 1.1: DOWNLOADING AND INSTALLING MISSION PLANNER

To download the Mission Planner software, a type of Ground Control Station (GCS) Software, go to https://ardupilot.org/copter/. Once you are on the ArduPilot home page (Figure 8.3), go to the menu on the left-hand side, and select **First Time Setup**. Next, select the **Install Ground Station Software** option. This will bring you to the **Installing Ground Station (GCS) software** page

FIGURE 8.3 The ArduCopter Page for Downloading Mission Planner for Windows.

from where you will select **Mission Planner (Windows)** to download and install Mission Planner (Figure 8.3).

You can also navigate to the Mission Planner download and installation page by typing or clicking on the following link: http://ardupilot.org/planner/docs/mission-planner-installation.html.

The instructions at this link will give you step-by-step guidance on how to download the software to your computer. Once the Mission Planner software is downloaded to your computer, locate it in the Downloads folder (or wherever you saved the file) and double-click on the **MissionPlanner-latest** icon to install to your computer. After double-clicking the icon, follow the steps to install the software on your computer.

Q1 Explore the ArduPilot website to learn about some of the options for building and operating autonomous vehicles. In particular, return to the **Installing Ground Station (GCS) software** page and examine the other Ground Station software options that are available to you for planning UAS missions. Based on the number of operating systems on which the Ground Station software option can run (Windows, Mac OS X, etc.), which software appears to be the most versatile? Explain your answer.

Exercise 1.2: Navigating Mission Planner

Now that you have installed Mission Planner, go to **Start > All Programs > Mission Planner** and open the software. Mission Planner software helps the user to set up, complete missions, and troubleshoot challenges related to building and operating a UAS. The Mission Planner software has several menu options, five of which are relevant to this chapter. These five menus are described

FIGURE 8.4 Locations and descriptions of the menu options available in Mission Planner that are relevant to the exercises in this chapter: (a) Flight Data [DATA], (b) Flight Planner [PLAN], (c) Hardware Config [SETUP], (d) Software Config [CONFIG], (e) Help. The functions for each menu are described in the text.

below and their location within the software is shown in Figure 8.4. The description below provides their full names as per the Mission Planner software, with the shortened version included in parenthesis. The shortened version is used hereafter in this chapter.

1. Open each of the five menus and explore the options to familiarize yourself with their functions.

 a. **Flight Data (DATA):** allows the user to arm and disarm their UAS, provides details on the UAS operations during flight, provides feedback on the performance of the UAS instruments before, during and after flights, provides details on battery level during flight, and can be used to track the UAS orientation relative to the waypoints included in a mission during flight.

 b. **Flight Planner (PLAN):** is used to develop missions, save missions to your computer, access missions that have been saved on your computer, and allows the user to provide in-flight instructions to the UAS. This chapter will make extensive use of the functions in this menu.

 c. **Hardware Config (SETUP):** is used primarily during the stages of building and configuring a UAS hardware and for updating the firmware to the UAS, among other functions.

 d. **Software Config (CONFIG):** is used to set parameters for the UAS to use for its various operations, including for receiving and sending signals to the radio control, motor turn rates, and overall functioning of the UAS.

 e. **Help:** provides access to information on the version of the Mission Planner software and addresses user-related questions.

FIGURE 8.5 Mission Planner offers users multiple ways to represent geographical space, determine a location, and several options of background images that can be accessed from the PLAN menu (located in the area under the red box of the inset image and magnified in the larger image). The functions included in the figure include a) the location of the cursor (latitude and longitude), b) the drop dropdown menu to select GEO, UTM or MGRS locational reference system, and c) a dropdown menu to select a background with options for None (no background), Google Hybrid Map and several others.

Within the PLAN menu (Figure 8.4, Menu b), you can set all the parameters for operating the UAS including choosing between one of three ways to represent geographical space: Geographic Coordinate System (Latitude and Longitude), Military Grid Reference System (MGRS), and Universal Transverse Mercator (UTM) (see Figure 8.5 for the three options). In addition, you can choose a background from a series of options ranging from None (no background) to high-resolution imagery such as that contained in Google Earth Hybrid Maps. The background choices available to you in Mission Planner may vary from one area to another.

Go to the **PLAN** menu (Figure 8.4, Menu b) and explore the various background options, including images and maps, that are available to aid you in developing UAS missions. Use the maps and images available to you to locate your hometown or place of work.

Q2 If you were planning a UAS mission in your hometown or place of work, which background image would be most helpful for your mission planning needs? Do all of the background options available in Mission Planner cover your hometown or place of work?

To explore the functionality available on the PLAN menu for creating and saving missions, go to the PLAN menu (Figure 8.4) and set the locational reference system to **GEO** and the background to **GoogleHybridMap** (see Figure 8.5). *Note: you can view the latitude and longitude at the location of your cursor to the right of the dropdown menu for the locational reference system,*

Next, download the files for this chapter and save them to your computer. Once you have downloaded and saved the files:

2. Go back to Mission Planner, and select the **PLAN** menu

FIGURE 8.6 The PLAN menu on Mission Planner software allows users to (a) zoom in and out on an area of interest, (b) load (open) waypoint files, (c) save a waypoint files, (d) read a waypoint files, and (e) write a waypoint file to a UAS flight control.

3. Navigate to the area just below the dropdown menu from where you selected the background image and take note of the five green buttons (Figure 8.6). The "WP" on the buttons means "waypoint." A **waypoint** is a specific location (latitude and longitude), that provides a target location for the UAS. Multiple waypoints in sequence can form a polygon or line (in the locational reference system you chose) that you can set for your UAS mission to fly. The five buttons and their functions are:

a. **Load WP File**: allows you to upload a saved waypoint file to Mission Planner

b. **Save WP File:** allows you to save a file containing waypoints for a mission to your computer for use in Mission Planner in the future.

c. **Read WPs File:** allows you to recall or confirm the last mission file that you provided to your UAS

d. **Write WPs:** allows you to send a series of commands and instructions on how your UAS should operate (the mission) to your UAS.

e. **Write WPs Fast:** allows you to write the waypoint commands to your UAS in an expedited manner

Note: You can review the meaning of each command available to you in Mission Planner at https://ardupilot.org/copter/docs/mission-command-list.html.

4. Click on the **Load WP File** function and navigate to the location on your computer where you saved the data for this chapter. Open the `Greenfield_Outline.waypoints` file, which has predetermined waypoints, and load it into Mission Planner.

5. Explore the area and the waypoint file on the screen. Go to the **Command** dropdown menu (second column from left) and answer the following questions:

Q3 What are the coordinates of each waypoint in this file?

Q4 How many commands are included in this mission?

Q5 Based on your interpretation of the commands, what is this mission directing the UAS to do?

Q6 Why do you think the mission is designed in this manner with the waypoints in this order? What might the order of the waypoints and commands tell you about the purpose of the mission and what the UAS is expected to do?

PART 2: MISSION PLANNING IN A FAMILIAR LANDSCAPE

Now that you are familiar with Mission Planner software, the following steps will guide you through the process of developing a mission to fly a UAS in a familiar landscape.

EXERCISE 2.1: EXPLORING THE AREA OF INTEREST

In this exercise, you will develop a mission for a familiar landscape located in Greenfield, a coastal area of Guyana, South America (Figure 8.7). Guyana's coast, home to close to 90% of the country's population, has been historically fringed with mangroves. Since Guyana's coastline lies below sea level, mangroves have historically acted as a first line of defense from the Atlantic Ocean. Over the past century or so, anthropogenic pressures and natural processes have combined to reduce the presence of mangroves along Guyana's coastline. In the past decade or so, with sea levels rising and an increasing need to protect human populations and the country's economy, efforts have been made to restore mangroves along the coast. Greenfield is one of the areas where the people of Guyana, through the Guyana Mangrove Restoration Project (Conservation International 2018), have chosen to plant mangroves as a part of the strategy to safeguard the coastline. While the primary goal of increasing the mangrove presence along Guyana's coast is to respond to rising seas, mangroves are also associated with various other ecosystem services, such as nutrient cycling and carbon sequestration (Cummings and Shah 2018). Since mangroves have been regrown along the coast, honey production and tourism have increased revenues for communities along the coast.

FIGURE 8.7 Map of the study area in Greenfield, Guyana, South America.

FIGURE 8.8 The landscape surrounding the mission site in Greenfield along coastal Guyana. The Clonbrook Post Office (a) is located approximately west of the area of interest for the UAS mission.

Google Earth Hybrid Map imagery is available in Mission Planner for the Greenfield region, and that imagery can help you become familiar with the landscape as you construct the UAS mission. In this regard, the Greenfield area is considered a *familiar* landscape. You will use the data that accompany this chapter to become further acquainted with the area of interest in Greenfield.

1. Open a new instance of Mission Planner and go to the **PLAN** menu (refer to Figure 8.4).

2. Click the **Load WP File** button (refer to Figure 8.6), and navigate to the folder where you saved the files for this chapter.

3. Select the Greenfield_waypoints file, and click **Open**.

Note: If you receive a prompt asking you if you would like to **Reset Home to loaded coords***, you can click* **Yes***. This will recenter the display on the polygon. If you click* **No***, Mission Planner will zoom out to the appropriate scale and show you where the new mission is located relative to Home. You can then find where the new mission is located, right-click in Mission Planner and choose "Set Home Here" option.*

4. The Greenfield_waypoints file is a simple mission with the UAS flight lines colored yellow (see Figure 8.2). Use your mouse to explore the area where the mission is to take place and become familiar with the site.

5. Identify some landmarks in the general vicinity of this mission. For example, you will notice buildings with name labels along with community facilities, such as the Clonbrook Post Office located approximately 480 m west of the mission area (Figure 8.8).

As you explore the area of interest, identify five additional landmarks besides the Clonbrook Post Office. Hover your mouse over each landmark and note the latitude and longitude at which each is located (refer to Figure 8.5).

FIGURE 8.9 The polygon tool in Mission Planner (found in the top left corner under the red box in Figure 8.7) is used to create polygons for planning missions. The tool allows you to draw (create), clear, save, and load (access) polygons, including from a shapefile (SHP) to develop mission files. Mission Planner utilizes red lines, shown in the center of the figure, to outline a polygon. Polygon vertices (or nodes) are represented with red location markers, as seen toward the center of this figure. There are four vertices in the polygon illustrated in this figure.

TABLE 8.1
Approximate Coordinates of the Vertices (Corners) of the Area of Interest

Vertex	Latitude	Longitude
1	6.7349556	−57.9399902
2	6.7333121	−57.9390058
3	6.7320735	−57.9408672
4	6.7331017	−57.9418033

Q7 Create a table with the names of five landmarks and their approximate latitude and longitude. If you were planning to visit this area to fly a UAS, how useful would these landmarks be in helping you to prepare for your future mission? Is there other information that is not available through Mission Planner that would be helpful for planning the mission?

EXERCISE 2.2: DEFINING THE BOUNDARIES OF THE AREA OF INTEREST

You will now create a mission with specific parameters for this familiar landscape. You will begin by creating a polygon for the area of interest over which the UAS will fly. The polygon tool (Figure 8.9) will define the extent of the area of interest. The polygon in Figure 8.9 has the approximate vertex (corner) locations of those shown in Table 8.1, so you can refer to this figure as you create your own polygon.

To examine the polygon for Greenfield as it is displayed in Figure 8.9:

1. On the left-hand side of the **PLAN** menu, locate the **Polygon tool**.

2. Click on the Polygon tool and select the **Load Polygon** option.

3. Navigate to the location on your computer where you saved the files for this chapter and select the `Greenfield_polygon` file. This polygon shows the mission boundaries for the Greenfield study site.

Next, you will create your own area of interest polygon close to Greenfield. Navigate to an area on the coast near the Greenfield study area; it can be anywhere you choose. Your area of interest can be of any size and shape, but keep in mind that if the area is too large, it may impact your ability to cover the area in a single flight. For large areas of interest, you may need to create multiple UAS missions. Once you have decided where to create your polygon:

4. Click on the polygon tool and select the **Draw a Polygon** option.

5. Click on the map where you want to place the first vertex for the polygon; a red location marker will be added.

6. Click in the next vertex location to add a second marker.

7. Click again to add a third vertex.

8. Complete your polygon by clicking to create the fourth marker. You will notice a black icon with a (+) sign along each of the lines in your polygon. Clicking this icon will give you a new vertex along a line.

Note: It is possible that when you added a Polygon Vertex, the red polygon marker point did not show up on your screen. If this happens, it does not necessarily mean the point was not added; rather it may have been overlaid on top of the previous vertex. Use the zoom tool to zoom in on the vertex that is visible on your monitor. Next, take your mouse over the red polygon vertex and drag and drop it to a new location. This should allow you to see the other polygon vertex that was overlaid on the previous point. You can now drag and drop the red polygon marker to the correct location.

The end product should be a polygon similar to `Greenfield_polygon` file you opened earlier, but in a different location along the coast.

9. Save the polygon you created by clicking on the polygon tool > **Save Polygon**.

10. Navigate to a folder on your computer where you wish to save the polygon, and click **Save**.

Q8 Include a screenshot of your polygon from Mission Planner here.

EXERCISE 2.3: CREATING THE UAS MISSION

Now that you have created and identified your area of interest, you will next create a mission for your UAS to fly. You will first work through the process of creating a mission using the `Greenfield_polygon`. You will then have the opportunity to create a flight mission for your own area of interest using the polygon you created.

1. Open a new instance of Mission Planner and go to the **PLAN** menu.

2. Open the `Greenfield_polygon` (refer to the steps in Exercise 2.2 if needed). With the polygon open, you can add flight parameters to create a UAS mission.

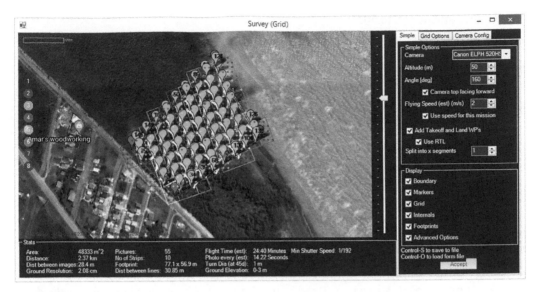

FIGURE 8.10 The Survey (Grid) menu provides options for setting a mission's parameters. By checking the Advanced Options checkbox (a) the user can configure the camera and grid options, in addition to the simple option where the camera being flown on the UAS can be set. This mission will take 20 to 40 minutes to fly and will capture 55 images.

3. Right-click somewhere in the Greenfield polygon and select **Auto WP > Survey (Grid)** to add flight parameters (Figure 8.10).

The Survey (Grid) will offer three separate menus for adding flight parameters by selecting the **Advanced Options** checkbox located in the **Display** area on the right-hand side of the screen (Figure 8.10). These options are as follows:

4. The **Simple** menu is where you select (1) the camera on the UAS, (2) the altitude at which the UAS will fly, (3) the azimuth angle (direction) the UAS will fly, and (4) the speed at which the UAS will fly.

5. The **Grid Options** menu allows you to set the distance between flight lines and the location from which the UAS will begin flying (**StartFrom**) the mission (e.g., Home, Bottom Left, Top Left, etc.). You can also input the amount of forward overlap and sidelap you desire for your images and whether the UAS should pause over waypoints.

6. The **Camera Config** option allows you to input information about the camera you are using. If your camera is available in the dropdown menu in the **Simple** tab, the default camera characteristics will be displayed here. If your camera is not listed, you can load a photo taken by your camera into the Camera Config tool (**Load Sample Photo**), and Mission Planner will automatically determine your camera's characteristics.

7. When you open the **Survey (Grid)** tool, the software will create a mission that covers the polygon (Figure 8.10, left). The details on this default mission will include the area to be covered by the flight, the number of images to be taken during the flight, and the flight time of your mission.

8. Go to the **Simple** tab and select **Canon Elph 520 HS** from the top right-hand side of the dropdown menu.

9. Set the Altitude (m) to 50.

10. Set the Angle (deg) to 160.

11. Set the Flying Speed (est) (m/s) to 2.

In summary, you are programming the UAS to fly the mission at a rate of 2 meters per second (m/s) at an altitude of 50 meters, along flightlines oriented at an angle of 160 degrees.

12. Once you have set these parameters, click the **Accept** button to create your mission.

Examine the mission created based on the above parameters. You will notice that Mission Planner automatically provided "commands" to the file (refer to Exercise 1.2 for a refresher on commands). Before you proceed to the next step, review the commands associated with each line of the mission. Reviewing commands is an essential step in the mission planning process as these commands are what the UAS will use for directions as it flies. Incorrect commands can lead to undesirable results like imaging the wrong area or not capturing images with the correct amount of overlap.

Note: the `Greenfield_Mission_Familiar_landscape.waypoints` *file in the data folder contains a mission matching the steps you just performed. If you had any trouble creating your mission, you can open this file and continue the next part using that file.*

The mission contains 24 lines of code:
- The first command is **TAKEOFF**. After the UAS has been powered on and the mission has been written to the flight control, this command will instruct the UAS to fly vertically to an altitude of 30 m.

- The second line has the command **DO_CHANGE_SPEED**, which instructs the UAS to change its speed as it approaches the first WAYPOINT in the mission located at Latitude (Lat) 6.7321623 and Longitude (Long) -57.9407356 (Line 4).

- Before the UAS flies to the first waypoint at an altitude of 50 m, it is commanded to **DO_SET_CAM_TRIGG_DIST** (Line 3 of the mission). This command tells the UAS to trigger the camera at a certain distance away from the waypoint to begin taking photographs. This distance can be set in the second column (Dist (m)).

13. Go through each line of the mission and carefully make a note of the commands. Click on a line in the mission with a **WAYPOINT** command and observe how Column 9 is activated. Note the Altitude at which the UAS will approach that position. Click on a **DO** command and observe how the column headings in the mission change.

Note: The DO_SET_CAM__TRIGG_DIST and other DO commands are "auxiliary functions" and are sometimes not necessary unless your camera or other equipment is integrated with the UAS flight control. The TAKEOFF and WAYPOINT commands, in contrast, are "navigation" commands and will affect the UAS position as it operates. Therefore, you need to pay careful attention to what each line of the mission is doing, especially the navigation commands.

Q9 Load the `Greenfield_Mission_Familiar_landscape.waypoints` file if you do not already have it loaded and examine Line 2 of the code where it says DO_CHANGE_SPEED. Is the UAS flying at a different speed here than what you set for the mission in your flight plan? How can you tell? Can you change the speed here? In which column would you change this speed? *Hint: with the DO_CHANGE_SPEED line selected, click on the "2" in the second column labeled "speed m/s."*

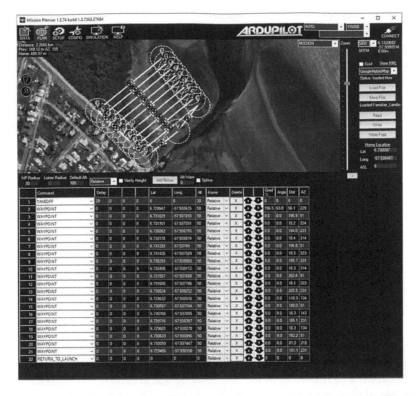

FIGURE 8.11 A mission for the Greenfield familiar landscape with commands for the flight. The commands in each line of the mission tells the UAS what to do. The first command, TAKEOFF, for instance, tells the UAS to begin flying once it is armed. The final command RETURN_TO_LAUNCH tells the UAS to return to the location from which it was launched.

Any line of the mission can be deleted by clicking "X" under the **Delete** column (Figure 8.11). Arrows located to the right of the **Delete** column will allow you to move a line up or down the list of mission commands. So, if you want the UAS to fly to a particular waypoint before another, you can make those decisions here. You can also delete any of the **DO** commands if you only want the UAS to fly the mission and not perform any auxiliary functions.

The final command in the mission is **RETURN_TO_LAUNCH**. This command is given after the UAS flies to the final waypoint. The RETURN_TO_LAUNCH command is a navigation command and tells the UAS to fly back to the position where it began the mission or where it first obtained a GPS lock before takeoff. If you are in the field, you want to pay particular attention to where your UAS began its mission since it will come back to that exact latitude/longitude point. Arrival location may vary by a few meters depending on GPS accuracy. *Note: Be mindful when launching from moving platforms, like boats, as the boat may move during flight and the RETURN_TO_LAUNCH command might result in the UAS landing in the water!*

Now that you have created a mission for the familiar landscape based on the provided polygon and are familiar with the commands, you will next create three different missions using the polygon you created for your area of interest. The missions will have different flying altitudes and you will be able to observe how changes in altitude impact the mission length and other factors.

14. Open the polygon you created in Exercise 2.2 and follow the steps outlined above to open the **Survey (Grid)** menu.

15. Create three missions with a Canon Elph 520 HS for UAS flying altitudes of 20 m, 40 m, and 60 m. For all three missions, use a flight speed of 2 m/s.

TABLE 8.2

Table for Recording Differences in Mission Time at the Different Flying Speeds and Altitudes and the Different Number of Photographs Captured from the Two Camera Types

			Number of Photographs	
Flight Speed (m/s)	Altitude (m)	Mission Flight Time	Canon Elph 520 HS	Cannon 330 HS
2	20			
	40			
	60			
10	20			
	40			
	60			

Open your three missions, one-at-a-time, in Mission Planner, and record how the altitude impacts the flight time for each mission. Also record how the number of photographs changes with altitude.

16. Next, change the camera to a Canon 330 HS, but keep the same flight speed and altitudes as before. Record how the number of photographs changes compared to the Canon Elph 520 HS. Create a table similar to the one in Table 8.2 to record your mission flight times and number of photographs.

17. Next, change the flight speed of your three missions from 2 m/s to 10 m/s using the same two cameras and flight altitudes settings. Add this information to compare how the flight times and number of photographs change with these new parameters.

Q10 How do the changes in cameras, flight speed, and altitude impact the number of images that will be taken during the flight? How might the number of images taken affect the quality of maps produced from those images? Include the table you created with your answers.

PART 3: MISSION PLANNING FOR THE UNFAMILIAR LANDSCAPE

Planning a UAS mission in an unfamiliar landscape requires a few more steps compared to planning a mission in a familiar landscape. You will repeat some of the same steps you utilized above for the familiar landscape but with some adaptations for when you have less information available.

Exercise 3.1: Exploring the Area of Interest

The unfamiliar landscape in which you will be working is located in Wowetta village, Southern Guyana. Wowetta village is about 330 km southwest of the familiar landscape on the coast of Guyana (Figure 8.12). The majority of the Guyanese landscape, close to 87%, is forested (dark green areas in Figure 8.12). Wowetta village is located on the edge of the forest and is the home of a group of Makushi indigenous peoples who have maintained strong traditional practices to their landscape for thousands of years. Some of these practices include **swidden agriculture**, which is a rotational farming technique where land is cleared and cultivated for about a year and then left to regenerate for a period longer than it was cultivated before being cultivated again. The Makushi people also have extensive knowledge of the ecosystem services available in their forests

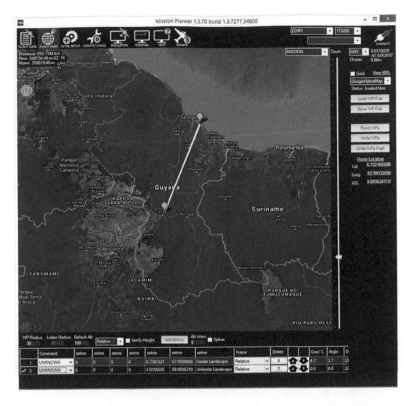

FIGURE 8.12 The location of the familiar landscape on the coast of Guyana and the unfamiliar landscape in Wowetta Village on the forest-savanna edge of Guyana where there is an absence of discernable landmarks.

and have helped to shape the forests around them to facilitate important ecosystem services (Cummings et al. 2017a). There is limited urban development in the Wowetta area and the larger Rupununi region of Guyana. The lack of urban infrastructure like buildings and roads means that there are very few landmarks in the background Mission Planner imagery to help orient you to the study site.

Begin by exploring the landscape.

1. Open a new instance of Mission Planner

2. Navigate to the location where you saved the data for this chapter and locate the `Wowetta_village.poly` file. Follow the directions outlined in Exercise 2.2 to open this file in Mission Planner.

Note: If you do not see the polygon after being loaded into Mission Planner, zoom out from the current location. The area of interest is in Southern Guyana (Figure 8.12). Use the map in Mission Planner to find Southern Guyana and look for the red location markers of the mission. Once you locate the polygon, right-click in the vicinity of the polygon > **Tracker Home > Set Here***. This will set the Home location near to the polygon and allow you to see the files as they are opened in Mission Planner.*

The `Wowetta_village` polygon was created by determining the bounding coordinates of the area of interest using a Global Positioning Systems (GPS) unit. The authors walked the edges of a cassava (*Manihot esculenta*) farm (Figure 8.13), and recorded the location of each corner vertex. The authors walked as close as possible to the corners of the plot and recorded the

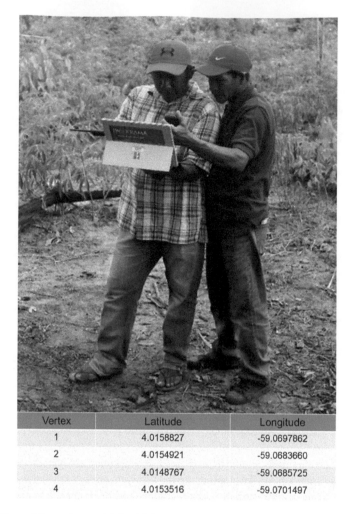

Vertex	Latitude	Longitude
1	4.0158827	-59.0697862
2	4.0154921	-59.0683660
3	4.0148767	-59.0685725
4	4.0153516	-59.0701497

FIGURE 8.13 Two of the authors – Makushi farmers – in the field locating the corners of the unfamiliar area of interest and collecting the locations using a hand-held GPS unit. The coordinates were saved on the GPS unit and then used to plan a UAS mission by modifying a "dummy mission."

GPS coordinates. The closer you are to the actual vertices when you capture GPS readings, the greater the chances your mission will fully cover the area of interest. However, in some cases, where the vertices of an area may be inaccessible (perhaps due to a dead tree or other obstruction being in the way, or if the area was flooded), you can capture GPS locations as close as possible to the corners to estimate the location. Using a compass in conjunction with your GPS is recommended to determine a general bearing from where you are standing to the actual vertex, in order to estimate the distance along that bearing to the vertex of interest. You can then use the distance and bearing to move your cursor in the direction of the edge and estimate the location of the vertex.

Once you have the `Wowetta_Village.poly` loaded into Mission Planner, you will see that this unfamiliar landscape will appear empty in Mission Planner compared to the familiar landscape (see Figure 8.2). The landmarks that were useful in aiding navigation in the familiar

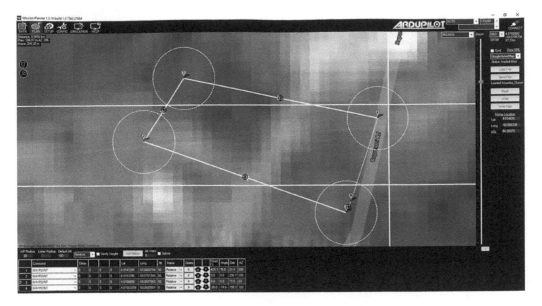

FIGURE 8.14 A "dummy" mission allows you to enter the coordinates of the corners of your study area that can be used to create a polygon and then a mission. The `Wowetta_Mission.waypoints` file provides the coordinates of the waypoints associated with this mission.

landscape are absent in this area, and so the process for exploring an unfamiliar landscape for UAS mission planning needs to be adapted.

EXERCISE 3.2: DEFINING A UAS MISSION WITHIN AN AREA OF INTEREST

Typically, uploading coordinates as a polygon into Mission Planner requires saving them as a shapefile or similar format. However, when you are in the field, and often when working in unfamiliar landscapes, you may have limited access to GIS software or the resources to make use of this option.

The methods outlined here take these circumstances into consideration. Instead of uploading a polygon, you will take an existing waypoints file and use it as a "dummy" file to modify the waypoints to match the coordinates recorded with the GPS (Figure 8.14). The dummy waypoints file will subsequently be used to create a polygon and develop the UAS mission.

1. Navigate to the files that came with your chapter, and open the file `Wowetta_Mission.waypoints` by following the steps outlined above.

2. Modify the latitude and longitude of the waypoints with the coordinates provided in Figure 8.13. The order in which you enter the points is not critical.

3. Next, move your mouse over each waypoint and double-click to check that the coordinates correspond with the values in Figure 8.13. The goal is to create a polygon that will reflect the shape of your area of interest as accurately as possible.

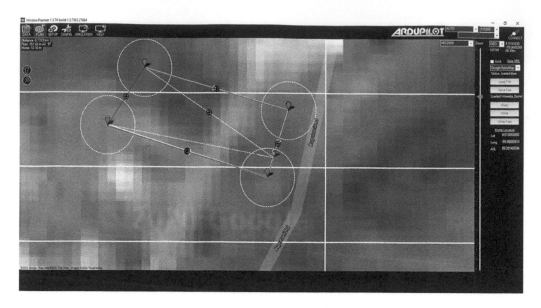

FIGURE 8.15 The polygon drawn over the edges of the area of interest using the "dummy" waypoints (yellow lines) and the polygon tool in an area of interest in Wowetta village. The white circles around the vertices indicate the general area the UAS will fly in the vicinity of that vertex.

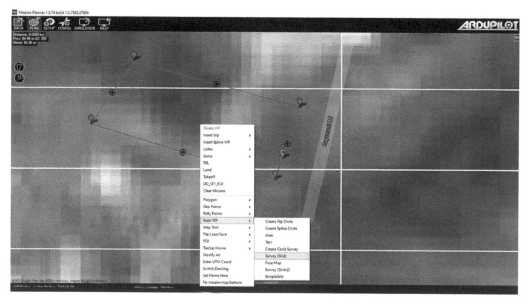

FIGURE 8.16 The Wowetta_village.poly that was used to create a mission using the Survey (Grid) option. Wowetta is an indigenous community in southern Guyana used to illustrate the unfamiliar landscape because high-resolution imagery are absent in Mission Planner and there are few landmarks within the landscape.

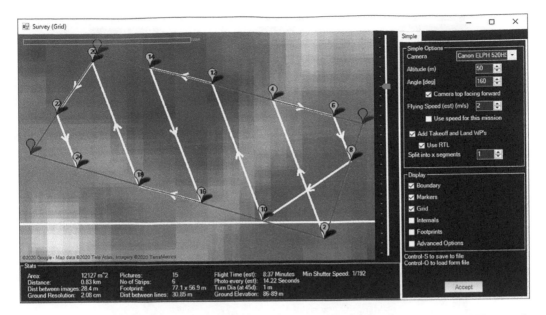

FIGURE 8.17 The survey grid produced when the parameters of the mission – an altitude of 50 m, angle of 160 degrees, and flying speed of 2 meters per second – are specified.

4. Next, you will create a polygon from the edited waypoint file following the steps outlined in Exercise 2.2 for the familiar landscape (Figure 8.15). This polygon will eventually be used to develop your mission.

5. Once you have created the polygon, save it to your computer with the name Unfamilar_landscape_polygon.

Note: If you were not able to create your own polygon using the steps outlined above, you can open the Wowetta_village.poly *from the data folder and use this file in the following steps.*

EXERCISE 3.3: CREATING THE UAS MISSION

Now that you have created the polygon for your area of interest, you can create a mission for the unfamiliar landscape following the steps outlined for the familiar landscape in Exercise 2.3.

1. Open Mission Planner and go to the **PLAN** menu.

2. Open the Unfamilar_landscape_polygon following the steps in Exercise 2.2.

3. Add flight parameters by right-clicking over the Unfamilar_landscape_polygon and select **Auto WP > Survey** (Grid; Figure 8.16).

4. Select a **Canon Elph 520HS** and check that "Advanced Options" is not selected (this will keep the mission simple).

5. Set the Altitude (m) to 50 m, and use an Angle (deg) of 160 (Figure 8.17).

6. Set the Flying Speed (est) (m/s) of the UAS to 2 m/s.

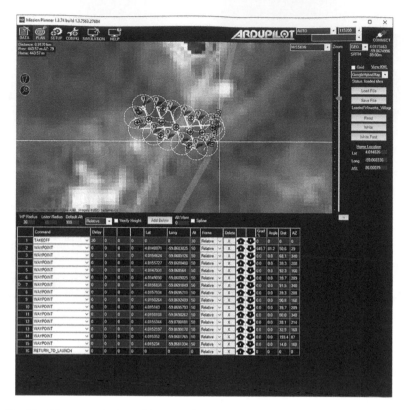

FIGURE 8.18 The Wowetta mission with respective commands for each line of the mission. The mission file includes details.

7. Once you have set these parameters, click **Accept**, and Mission Planner will automatically provide "commands" to the file.

8. Review the commands associated with each line of the mission.

Similar to the mission created in Exercise 2.3, the first command in this mission is "TAKEOFF" (Figure 8.18). This means that the UAS, once it is powered on, will take off vertically to an altitude of 30 m and then fly to waypoint number 1 (command line 2) before proceeding to the other waypoints in the mission.

The UAS will then RETURN_TO-LAUNCH after flying to waypoint number 13. The RETURN_TO-LAUNCH command will bring the UAS back to the position from where it began the mission or where it first secured a GPS lock before takeoff.

Q11 Consider the familiar and unfamiliar landscape for which you have created missions. In which landscape would you feel more confident creating missions and flying your UAS? Why?

Q12 What factors impact your level of confidence of working in either of these landscapes? How might you overcome some of the challenges of working in unfamiliar landscapes?

Q13 Virtually travel to Frazier Wells, Arizona (approximate lat/long 35.782382, −113.072049), a location in the United States where high-resolution imagery is available in Mission Planner

Does this location qualify as an unfamiliar landscape? What challenges would you face, if any, if you were asked to create a mission to fly a UAS over this area?

Optional Exercise: Collect Study Area GPS Data Yourself

You can create a UAS mission for a study area near your home, school, or field site by capturing your own coordinates using either a hand-held GPS unit or a GPS app on a smartphone. Once you have captured the bounding coordinates of the study area, create a mission following the steps outlined above.

1. Select an area near your home or work. If there is complete coverage of Mission Planner background imagery nearby, you can simply turn off the imagery in Mission Planner to simulate an unfamiliar landscape by going to the Flight Menu page and setting the background image to **None** (refer to Figure 8.5 to see the area in Mission Planner to remove background images). You can also leave the imagery on to practice creating missions in familiar landscapes.

2. Take your hand-held GPS unit to your unfamiliar area of interest and capture GPS coordinates for at least four vertices. *Note: Before beginning this part of the exercise, be sure you have permissions to collect GPS data in the area where you will be working.*

3. Save each coordinate bounding your area of interest to your GPS unit with a name you can easily recall. You may consider using a naming scheme such as: "V1," which corresponds to "Vertex 1."

4. Repeat the steps to obtain at least four points bounding your area and save these points using a similar notation. For example, number two will be named "V2," and so on for the other vertices in your landscape.

5. Pickup at the start of Exercise 3.2 to work through creating a polygon and mission for your chosen area of interest. Continue through Exercise 3.3.

Note: When you go into the field to capture the coordinates of the vertices, it is good practice to take a notebook and pen with you to sketch the relative shape of the area. You can then compare the area you sketched with the area of the mission once it is complete to ensure the two match.

DISCUSSION AND SYNTHESIS QUESTIONS

S1 Performing UAS flights in unfamiliar or remote areas poses special challenges. What would you do in an unfamiliar area if you were able to find the coordinates of your area of interest, but when, after creating the mission file, you realize your flight time is longer than your battery life? What adaptations can you make to ensure the entire area is flown by your UAS?

S2 What are some other considerations or challenges that you should plan for when working in unfamiliar or remote landscapes?

S3 In this chapter, an unfamiliar landscape was defined as a landscape in which background information (e.g., high-resolution imagery) was not available to assist with mission planning, and developing world setting was used for illustration. How else might you define an unfamiliar landscape?

S4 Is it possible that unfamiliar landscapes exist in highly developed areas of the world? Can you think of any examples from world regions where high-resolution imagery may not be available?

S5 After completing this chapter, can you think of any other unfamiliar landscapes where the approach proposed here may not be applicable? How would you approach developing missions in such landscapes? Are there landscapes where the methods outlined in this chapter may not be appropriate?

S6 Aside from Mission Planner, what other software options were available to you for planning UAS missions at Diydrones.com? Do you think any of these options may be more versatile than Mission Planner? Explain your answer.

ACKNOWLEDGMENTS

The authors thank the people of Wowetta, who allowed us to work in the village. We are grateful to Kene Moseley, Zola Narine, Dr. Oudho Homenauth and the entire team at the Guyana Mangrove Restoration and Management Department, National Agricultural Research & Extension Institute in Guyana for allowing us access to Greenfield. We are grateful to Michael Oborne and the entire team at ardupilot.org, who continue to develop software that makes open-source UAS operation so much easier and accessible.

REFERENCES

Cummings, A.R., Cummings, G.R., Hamer, E., Moses, P., Norman, Z., Captain, V., Bento, R., & Butler, K. (2017a). Developing a UAV-based monitoring program with indigenous peoples. *Journal of Unmanned Vehicle Systems*, 5, 115–125.

Cummings, A.R., Karale, Y., Cummings, G.R., Hamer, E., Moses, P., Norman, Z., & Captain, V. (2017b). UAV-derived data for mapping change on a swidden agriculture plot: preliminary results from a pilot study. *International Journal of Remote Sensing*, 38, 2066–2082.

Cummings, A.R., McKee, A., Kulkarni, K., & Markandey, N. (2017c). The rise of UAVs. *Photogrammetric Engineering & Remote Sensing*, 83, 317–325.

Cummings, A.R., & Shah, M. (2018). Mangroves in the global climate and environmental mix. *Geography Compass*, 12, e12353.

Jensen, J. (2017). *Drone aerial photography and videography: data collection and image interpretation*. Apple iBook. https://books.apple.com/us/book/drone-aerial-photography-and-videography/id1283582147

Conservation International. 2018. Setting the foundations for zero net loss of the mangroves that underpin human wellbeing in the North Brazil Shelf LME: State of mangroves in Guyana: An analysis of research gaps, and recommendations. Report by Conservation International. https://nbslmegef.files.wordpress.com/2019/11/state-of-mangroves-in-guyana.pdf

9 Aligning and Stitching Drone-Captured Images

Kunwar K. Singh, Tamika Brown, and Amy E. Frazier

CONTENTS

LEARNING OBJECTIVES

After completing this chapter, you will be able to:

1. Understand the process of image stitching
2. Create a stitched orthomosaic from a set of overlapping drone images

HARDWARE AND SOFTWARE REQUIREMENTS

This chapter requires:

1. Agisoft Metashape Professional. Instructions and screenshots use the Metashape "Classic" interface, which can be changed in the software via the Tools dropdown > Preferences > General tab > Theme (change to Classic)
2. The `precisionhawkData` folder located in the data folder contains the drone images for this chapter that you will need for this exercise.

INTRODUCTION

Image stitching is the process of combining multiple images with overlapping fields of view into a seamless image or photomosaic. The concept of aligning and stitching images is nearly as old as photography itself. These techniques are regularly used to create seamless mosaics for applications in creative photography (e.g., panoramic photographs; Figure 9.1), medical imaging, and even in satellite remote sensing. Historical aerial photographs are regularly scanned, aligned, and stitched together to study land-use change over large extents. However, unless stitching is completed properly, the mosaics can have identifiable stitching issues such as

FIGURE 9.1 An iPhone-generated panorama taken near Jasper National Park, Canada. The built-in panorama capabilities in the smartphone stitched together multiple images to create one, long photo. [Photo credit: Kunwar K. Singh].

FIGURE 9.2 Visible issues in stitched images including (a-c) identifiable seams, (b) blurriness at the edges, and (c) alignment. These mosaiced aerial photographs are from 1993 and show a suburban landscape near Raleigh, North Carolina.

visible seams, alignment, and blurriness at the edges, to name a few (Figure 9.2). These issues are common when creating mosaics of drone-captured images due to camera lens distortions and the presence of fewer ground control points (GCPs) relative to the number of images.

WORKFLOW FOR STITCHING DRONE-CAPTURED IMAGES

The image stitching workflow involves first capturing overlapping images with a drone and collecting GCPs. The amount of overlap will depend on the application, but typically drone studies utilize anywhere from 40% to 90% overlap. Next, tie points are identified in the overlapping images and later used to match features. **Tie points** are features or objects that can be easily identified in multiple, overlapping images (e.g., road intersections, rock outcrops, crop rows, building corners, trails, etc.; Figure 9.3). This step is automated in many software platforms.

Tie points are an essential part of the Structure from Motion (SfM) bundle adjustment process. They aid in photo alignment and are used to compute the acquisition geometry of each photo, including the location and direction the camera was facing when the image was captured as well as the camera calibration parameters. The alignment process generates a point cloud of the matched features that can then be used to transform the images for stitching. The more distinct features there are that can be matched across images, the higher the accuracy of the final product. Image areas with fewer or no tie points lead to distortions (e.g., alignment issues, mostly at the edges) in the resulting stitched image (Figure 9.4).

Surveyed GCPs (Figure 9.5a) can be incorporated into the image stitching workflow to help in identification of tie points and the overall georeferencing of the output product. GCPs are points on the Earth's surface with known coordinates that are used to build a geometric relationship between the ground reference and the images. GCPs are used to georeference remotely sensed satellite images, such as Landsat Level-1 imagery (Figure 9.5b). They are also used to georeference drone images, but the optimal number of GCPs needed for drone studies is still being debated. In general though, if the terrain is more homogenous (e.g., flat), fewer GCPs are needed, whereas more GCPs are needed in areas with varying terrain (Singh and Frazier 2018).

FIGURE 9.3 Locations of tie points (1–7) used to orthorectify aerial photographs from (a) 1986, (b) 1995, and (c) 2001.

FIGURE 9.4 A set of sample drone images (a to f) used for stitching a seamless image (g) represented in the same order as drone images with distortion on both sides due to lack of the tie points in that area.

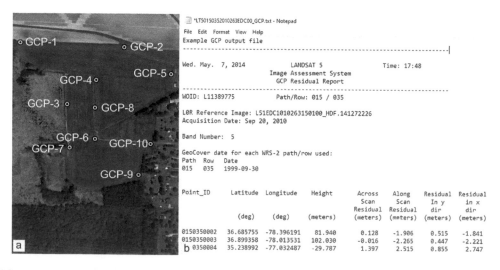

FIGURE 9.5 (a) Distribution of ground control points (GCP) across a suburban landscape in Raleigh, North Carolina used for stitching drone-captured images, and (b) a screenshot of the ASCII format GCP file included with Landsat L1T product. Each record corresponds to a single GCP.

After tie points have been identified and the images have been georeferenced, the final steps in the image stitching workflow involve the plane transformations and then adding transformed images to seamlessly blend the overlapping images to create a final composite image.

GENERAL CONSIDERATIONS FOR HIGH-QUALITY IMAGE STITCHING

There are no universal guidelines for maximizing the quality of stitched images. However, following certain practices can help improve results. First, it is useful to know before starting a project how the stitched imagery will be used. If the output is intended for visualization purposes only, shorter data acquisition and processing time may outweigh small gains in accuracy. If the output is intended to be used for quantitative analyses, then higher quality results may be needed. Understanding the different types of stitching approaches and algorithms as well as some of the common areas where errors can be introduced will help you create high-quality products.

Stitching approaches and algorithms: There are several different approaches for image stitching including minimizing pixel-to-pixel dissimilarities or extracting a set of features and then matching them to each other (Capel and Zisserman 1998; Szeliski 2006; Zoghlami et al. 1997). Feature-based alignment approaches, which rely on automatically recognizing adjacency relationships among an unordered set of images (Szeliski 2006), are robust both in terms of speed and quality compared to pixel-to-pixel differences. How these approaches are implemented along with key inputs (e.g., spatial consideration) varies by discipline.

In remote sensing and photogrammetry, a wide variety of stitching algorithms are available to relate pixel coordinates from one image to another or match features across multiple images using a spatial domain approach (Ghosh and Kaabouch 2016; Moussa and El-Sheimy 2016). In spatial domain matching, a similarity metric is used to match areas across images. Techniques utilizing similarity metrics include normalized cross-correlation (Zhao et al. 2006) and entropy and mutual information (de Cesare et al. 2008). Recently, algorithms based on the feature matching concept have been adopted due to their speed and accuracy. A notable example is the Scale Invariant Feature Transformation (SIFT; Brown and Lowe 2007; Liqian and Yuehui 2010; Lowe 2004), which is robust to translations, rotations, and scaling transformations in the image domain, making it ideal for working with drone images in which these effects are common due to platform instability.

It should be noted that the choice of software program will often dictate the image stitching approach and which algorithms are used, which can impact image quality. Many commercial software platforms (i.e., Agisoft Metashape, Pix4Dmapper, etc.) provide easy-to-use interfaces that can produce high-quality stitching results with minimal user effort. Open-source options may require greater knowledge of the input data and stitching algorithms by the user.

Capture unique features: As noted above, stitching algorithms rely on tie points to match one image to the next. The more distinguishable features there are in the images, the better the result will be. Surveying the study area prior to conducting a flight mission is recommended to ensure there are sufficient features that will be distinguishable in the imagery. Homogenous landscapes such as farmland or plantations may lack sufficient distinguishable objects. In these situations, artificial objects such as colorful buckets or targets can be manually placed in the study area to ensure there are identifiable features in overlapping images so that the feature matching step will be successful.

Capture large forward and side overlaps: Higher overlaps are preferred both for stitching images and creating orthomosaics (Singh and Frazier 2018). While many factors dictate image overlap, studies on drone imagery collection suggest at least 70% forward overlap and 50%–60% side overlap for most cases (Su et al. 2016). To maximize the use of overlap areas, it is recommended to avoid using wide-lens cameras (e.g., GoPro) that cause fisheye effects. It cases where these sensors must be used, it is advisable to remove these effects from the images using software such as Adobe Lightroom.

Determine an appropriate ground sampling distance: Ground sampling distance (GSD) is often set to be as high as possible even though the project objectives do not warrant such high resolutions. Over-sampling is a topic that deserves more attention in drone data acquisition efforts. Determining an optimal GSD appropriate to map and/or measure the targeted objects and constructing a flight plan to capture that GSD can help save time and money and improve image stitching. Since larger datasets are inherently more difficult to process, striking a balance between GSD, aerial coverage, and flying altitude will result in a suitable number of images for a high-quality seamless image without compromising areal coverage.

EXERCISE: CREATING A STITCHED ORTHOMOSAIC FROM DRONE-CAPTURED IMAGES

In this exercise, you will stitch together drone images captured over a wheat field in Nash County, North Carolina (Figure 9.6). The landscape is dominated by farmlands and suburban residential land uses. Images were captured by PrecisionHawk, a commercial drone and data company, using an RGB camera. The images were captured on 15 March 2018. You will use Agisoft Metashape software to load the drone images and create a 3D point cloud based on features that can be identified in overlapping images. You will then georeference the 3D model using ground control points (GCPs) captured in the field, and create a stitched, orthomosaic from the georeferenced data

1. Launch Agisoft Metashape Professional.

2. Using Metashape's main menu, go to **Workflow > Add Photos**. Navigate to the X5_RGB_120m folder housed in `precisionHawkData` folder, select all 179 images, and click **Open**. The images will be added to your Photos pane. Metashape organizes groups of images that were captured by the same camera into "Chunks." The Workspace pane will show the number of images (cameras) associated with each Chunk. Spheres representing the approximate location of each image will be visible in the Model pane.

You can explore the images in the Model pane using the mouse scroll wheel to zoom in and out.

Nash County
North Carolina, USA

FIGURE 9.6 Location of the study area in Nash County, North Carolina, USA.

3. Set the coordinate system for your photos by clicking the **Reference** tab at the bottom of the screen and then selecting the **Settings** icon on the Reference toolbar (furthest to the right, looks like two tools). Select the appropriate coordinate system (NAD83(2011), EPSG::6318) by clicking the dropdown under Coordinate System, selecting **More**, and typing "6318" into the Filter search. Click on NAD83(2011) and then click **OK**. Next to **Rotation angles**, select **Yaw, Pitch, Roll** from the dropdown. Under **Measurement Accuracy**, fill in the following parameters, and then click **OK** to run the process.

 a. Camera accuracy (m): 10
 b. Camera accuracy (deg): 2
 c. Maker accuracy: 0.005
 d. Scale bar accuracy: 0.001

Next, you will align the photos. In this step, Metashape will identify similar features (points) on multiple, overlapping images. The acquisition geometry of each photo will also be computed, including the location and direction the camera was facing when the image was captured, and the camera calibration parameters. The alignment process will generate a 3D point cloud of the matched features.

4. Go to **Menu > Workflow > Align Photos**. A window will open with options for you to select. Higher accuracy settings will result in more accurate camera position estimates but will take longer to run. Lower accuracy settings will take less time to run, but accuracy will be reduced. Selecting the Reference preselection will allow overlapping image features to match using a lower accuracy setting. Select the following parameters and click **OK**.

 a. Accuracy: Medium
 b. Generic preselection: checked
 c. Under Advanced:
 Key Point Limit: 40,000
 Tie Point Limit: 4000

Note: if you receive a warning that some photos failed to align, click OK. You will deal with these unaligned photos later in the exercise.

Next, you will georeference the point cloud you generated using GCPs that were captured in the field. The precise coordinates of these GCPs have been provided to you in the file in the data folder. You will load these GCPs into Metashape and then manually verify that they are located exactly in the center of the field targets where they were captured.

5. Switch to the **Reference** window by clicking on the Reference tab at the bottom of your Metashape interface. Select all of the images (Ctrl+A is a shortcut), then right-click to open the context menu and click **Uncheck** to uncheck the cameras listed by the Reference tab. The images contain GPS coordinates that were added during the flight, but these are less accurate than the field coordinates. You will use the field coordinates.

6. Click the **Import Reference** icon (left-most icon just above the camera list), and navigate to the `precisionhawkData` folder. Open the GCP file called `15March2018_GCP.csv`. Review the Import CSV window and ensure that the **Coordinate System** is set to NAD83(2011) (EPSG::6318), **Delimiter** is set to Comma, and the **Start import at row** box is set to 2. Leave all other defaults, and click **OK** when you are finished. Click **Yes to All**

FIGURE 9.7 Import CSV window showing coordinate system along with header of GCP file (i.e., Label, Latitude, Longitude, etc.) and GCPs.

when Metashape asks if it should create a new marker. Nine GCPs will be loaded under **Markers** in the Reference pane (Figure 9.7).

You will now need to position the markers representing the coordinates in the exact spot where the GPS coordinates were captured in the images. The ground targets used in the field look like mini checkerboards (Figure 9.8a), and the GPS location was captured at the very center of each target (Figure 9.8b).

7. Open an image by double-clicking it on the **Photos pane**. Images that contain a GCP have a white flag at the top in the Photo pane. *Note: The flag will turn green after it has been moved.* Find the flag in the image, and zoom in to locate the target nearby. Using your cursor, drag the flag marker to the center of the target. Zoom in on the target to make sure the flag marker is exactly in the center. Repeat this process for all the images in the pane.

FIGURE 9.8 (a) Before and (b) after placing GCPs on the image. If the flag is not on the top of a marker, you must move the flag to the middle of the GCP that is visible on an image. Notice how the flag turned green after it was moved.

> *Note: If a target is not immediately visible in an image, move to another image and come back later. As you move the flags, their positions in the other images will update, making it easier to find the target. Be sure to re-check all images at the end to make sure there are no white flags. Not all images will contain a GCP or marker.*

8. When you have finished relocating the GCP markers in all of the images, click the **Update Transform** icon (two arrows forming a circle) on the **Reference** window. Metashape will calculate errors associated with the transformation. You can inspect these errors by scrolling to the right of each marker.

9. Click **Save** when you are finished and name your Metashape file ("Stitching.psx").

10. After placing all the GCPs, the errors will be viewable in the **Reference** pane or by clicking the **View errors** icon. To minimize these errors, the alignment can be optimized based on camera position. Click **Tools**, select **Optimize Cameras**, and click **OK**.

You will now build the complex geometry needed to stitch the images. This step can be time-consuming depending on your computer's processing capacity. You can automate the step-by-step instructions below by creating a Batch Process, which is located beneath the **Workflow** menu.

11. Begin by clicking **Menu > Workflow > Build Dense Cloud**. Select the following parameters and click **OK**. Once the process is complete, click the **Save** button in the toolbar.

 a. Quality level: **Medium**
 b. Depth filtering: **Mild** under **Advanced**.

Next, you will build the mesh. A mesh is a continuous surface modeled over the point cloud. It can help you visualize the ground and surface features.

12. Go to the **Menu > Workflow > Build Mesh**. A dialog box will open. Input the following parameters and then click **OK**. When the process is completed, click the **Save** button in the toolbar.

 a. Source data: Dense cloud
 b. Surface type: Height field (2.5D)
 c. Face count: Medium
 d. Under Advanced: leave all defaults

13. The next step is to build texture onto the model to provide more visual detail. Go to **Menu > Workflow > Build texture**. Select the following parameters and then click OK. After the process is complete, click the **Save** button in the toolbar.

 a. Texture type: Diffuse map
 b. Source data: Images
 c. Mapping mode: Orthophoto
 d. Blending type: Mosaic (default)
 e. Texture size/count: 4096
 f. Under Advanced: leave all defaults

14. Lastly, you will develop an orthophoto. Go to **Menu > Workflow >** open the **Build Orthomosaic** box. Select the following parameters and click **OK**. After the process is complete, click the **Save** button in the toolbar.

 a. Projection: ensure the correct geographic coordinate system is (NAD 83, EPSG::6318)
 b. Parameters section:
 i. Surface: Mesh
 ii. Blending mode: Mosaic (default)
 iii. Pixel size: spatial resolution will be based on the average ground sampling resolution of the original images.

The final step in the workflow involves exporting the orthomosaic in a format that you can use in GIS software (e.g., ArcGIS or QGIS) for analyses.

15. To export the files, go to **File > Export > Export Orthomosaic > Export JPEG/TIFF/ PNG**, leave all other settings as the default values, fill out the Image description ("Nash County, North Carolina"), click **Export**. Assign the File name as "nashNCortho.tif" and **Save** as type GeoTIFF (*.tif).

16. Generate a comprehensive report that includes survey data, camera calibration, camera locations, camera orientations, GCPs, orthomosaic, and processing parameters by clicking on **File > Export**, and then **Generate report**. Fill out the details for each section, check the **Page numbers** box, and click **OK**. Indicate the name and path for the PDF ("nashNCortho_report.pdf") file that will be generated, and click **Save**.

17. Open ArcGIS or QGIS and load in the stitched orthomosaic. Zoom in and explore the image.

Q1 Are there any places in the stitched orthomosaic that you loaded into GIS software where you can see artifacts of the stitching (e.g., seams, distortions, etc.)? If yes, describe these artifacts and explain possible reasons for them?

Q2 What are the GSD and reprojection errors of the orthomosaic that you developed after aligning and stitching the drone-captured images? (Refer to the report for these values). What are some ways in which you could improve the accuracy or minimize the errors if you were to repeat this exercise?

Q3 One of the GCPs is a bit far from the orthomosiac image. If you remove this particular GCP from the `15March2018_GCP.csv`, how do you think it would affect the stitching and orthomosaic generation?

DISCUSSION AND SYNTHESIS QUESTIONS

In this chapter, you were introduced to the basics of image stitching, including some general considerations for improving the overall quality of stitched images. Having prior knowledge of the proposed study, including needed ground sampling distance to achieve the study objectives, can help balance accuracy with time during data collection and processing. You were also introduced to the role of tie points and GCPs in creating a high-quality stitched image. You used Agisoft Metashape software to align photos and add GCPs for assigning the stitched image a ground reference. Finally, you learned how to export the orthomosaic from Metashape in a GeoTiff format that can be visualized and manipulated in GIS software.

S1 What are the landscape characteristics that may improve image stitching quality and should be considered during the mission planning stage for a flight? How does the spatial extent (i.e., size and shape) of the landscape factor into the mission planning process?

S2 How does the ground sampling distance (GSD) relate to the flying altitude of a drone and the calculation of image overlap? Refer to Chapter 4 for a refresher on the relationships between these factors if needed.

S3 Often, the landscapes being surveyed with a drone are visually homogenous (e.g., croplands with very little variability in the rows of crops). What are some factors to consider if you were planning a mission to capture drone data for the purpose of creating an orthomosaic in such an area? What would you do if the study area under investigation was covered by mature corn crops (> 5 ft tall) hiding potential markers on the ground?

S4 If images for a landscape with minimum variability (i.e., a few tie points or distinguishable features) have already been captured, how could you restructure your image stitching workflow to develop a higher quality seamless image for the area?

S5 How might the accuracy of the stitched image change if the number of GCPs was increased or decreased?

ACKNOWLEDGMENTS

We are grateful to PrecisionHawk (www.precisionhawk.com) for providing the drone-captured images used in the exercise. We also thank Madeline Fetterman, Head of Project Management at PrecisionHawk, for the technical support that improved the chapter.

REFERENCES

Brown, M., & Lowe, D.G. (2007). Automatic panoramic image stitching using invariant features. *International Journal of Computer Vision*, 74, 59–73.

Capel, D., & Zisserman, A. (1998). *Automated mosaicing with super-resolution zoom*. In, *Proceedings 1998 IEEE Computer Society Conference on Computer Vision and Pattern Recognition* (Cat. No. 98CB36231) (pp. 885–891): IEEE.

de Cesare, C., Rendas, M.-J., Allais, A.-G., & Perrier, M. (2008). *Low overlap image registration based on both entropy and mutual information measures*. In, *OCEANS 2008* (pp. 1–9): IEEE.

Ghosh, D., & Kaabouch, N. (2016). A survey on image mosaicing techniques. *Journal of Visual Communication and Image Representation*, 34, 1–11.

Liqian, D., & Yuehui, J. (2010). *Moon landform images fusion and Mosaic based on SIFT method*. In, *2010 International Conference on Computer and Information Application* (pp. 29–32): IEEE.

Lowe, D.G. (2004). Distinctive image features from scale-invariant keypoints. *International Journal Of Computer Vision*, 60, 91–110.

Moussa, A., & El-Sheimy, N. (2016). A fast approach for stitching of aerial images. International Archives of the Photogrammetry, Remote Sensing & Spatial *Information Sciences*, 41, 769–774.

Singh, K.K., & Frazier, A.E. (2018). A meta-analysis and review of unmanned aircraft system (UAS) imagery for terrestrial applications. *International Journal of Remote Sensing*, 39, 5078–5098.

Su, L., Huang, Y., Gibeaut, J., & Li, L. (2016). The index array approach and the dual tiled similarity algorithm for UAS hyper-spatial image processing. *GeoInformatica*, 20, 859–878.

Szeliski, R. (2006). Image alignment and stitching: A tutorial. *Foundations and Trends® in Computer Graphics and Vision*, 2, 1–104.

Zhao, F., Huang, Q., & Gao, W. (2006). *Image matching by normalized cross-correlation*. In, *2006 IEEE International Conference on Acoustics Speech and Signal Processing Proceedings* (pp. II–II): IEEE.

Zoghlami, I., Faugeras, O., & Deriche, R. (1997). *Using geometric corners to build a 2D mosaic from a set of images*. In, *Proceedings of IEEE Computer Society Conference on Computer Vision and Pattern Recognition* (pp. 420–425): IEEE.

10 Counting Wildlife from Drone-Captured Imagery Using Visual and Semi-Automated Techniques

Kunwar K. Singh, Katherine Markham, Amy E. Frazier, and Jarrod C. Hodgson

CONTENTS

LEARNING OBJECTIVES

After completing this chapter, you will be able to:

1. Use visual interpretation techniques to count wildlife using data captured from a drone at varying altitudes.
2. Apply a semi-automated detection method to count wildlife
3. Assess the accuracy of counts and compare results from the visual interpretation and semi-automated detection methods

SOFTWARE AND HARDWARE REQUIREMENTS

This exercise requires ArcGIS 10.4 or higher. This exercise can also be completed using ArcGIS Pro.

INTRODUCTION

Accurate and reliable measurements of wildlife populations are required to achieve a diverse range of management and conservation goals. For example, local stakeholders may desire population counts to determine how much land to put aside for conservation purposes; or managers

might need estimates of a game population to inform the number of seasonal hunting permits to sell. Accurate and reliable population numbers are especially needed for threatened and endangered species (Cristescu et al. 2015). In order to understand the impacts of stressors such as climate change and human activities on wildlife populations, they must be monitored regularly and systematically (Smyser et al. 2016). Scientists and wildlife managers employ a range of methods to estimate population numbers and densities, such as capture-mark-recapture methods, scat counts, mist-netting birds, standardized visual searches in the field, playback calls, aerial surveys, and many others (see Table 10.1 for common methods).

TABLE 10.1

Common Methods for Counting Wildlife with Potential Benefits and Limitations along with Example Studies

Method	Description	Benefits	Limitations	Selected Studies
Camera traps	Stationary cameras record photos or video of movement	• Potentially inexpensive • Monitor over extended period • Minimally invasive • Reanalysis possible • Low number of field workers required • Unaffected by weather	• Number & location of camera traps • Battery life • Memory card storage • Equipment disturbed by animals/humans • Processing images can require intense effort	(Karanth 1995; Newey et al. 2015)
Capture-mark-recapture	Capture set number of individuals, mark them, recapture individuals, and determine population by ratio of marked to unmarked	• Unaffected by weather • Other survival parameters can be estimated	• Permits required • Highly invasive • Expensive • Can require considerable field labor • Requires intense effort and logistics (dependent on habitat) • Reanalysis not possible	(Moore and Vigilant 2014)
Indirect counts	Indicators of presence such as nests or fecal matter are counted to estimate abundance	• Inexpensive • Minimally invasive • Unaffected by weather	• Requires considerable field labor • Requires intense effort and logistics • Reanalysis not possible	(Mowry et al. 2011; Stephens et al. 2006)
Playback calls	Wildlife calls are played in habitat to elicit response calls	• Potentially inexpensive • Low number of field workers required • Reanalysis possible if answering calls recorded	• Number & location of playbacks • Low detectability in noisy environments • Affected by weather	(Bolton et al. 2010; Dacier et al. 2011)
Acoustic surveys	Audio recording devices record wildlife that make calls	• Potentially inexpensive • Minimally invasive • Reanalysis possible • Requires minimal field labor • Unaffected by weather	• Number & location of recording devices • Battery life • Memory card storage • Wildlife must vocalize predictably • Low detectability in noisy environments	(Milchram et al. 2020; Thompson et al. 2010)

(Continued)

TABLE 10.1 (*Continued*)

Common Methods for Counting Wildlife with Potential Benefits and Limitations along with Example Studies

Method	Description	Benefits	Limitations	Selected Studies
Single observer count line transect survey	Single observer walks line transect and records wildlife and distance to observation	• Inexpensive • Precise estimates if individuals are identified • Access to areas where aircraft cannot reach or obtain imagery • Unaffected by weather	• Number & location of lines • Intense effort and logistics • Requires considerable field labor • Only wildlife within line of sight detected • Reanalysis not possible	(Marques 2001)
Double observer count method	Two observers walk a line transect or plot to record wildlife and distance to observation	• Inexpensive • Precise estimates if individuals are identified • Access to areas where aircraft cannot reach or obtain imagery • Unaffected by weather	• Number & location of lines or survey plots • Intense effort and logistics • Requires considerable field labor • Reanalysis not possible	(Lubow and Ransom 2016)

Note: Benefits and limitations are generalizations and are not meant to encompass all studies and circumstances.

Wildlife biologists face challenges when monitoring wildlife abundance and density, including obtaining permits if individuals are to be captured or handled and working safely in remote and rugged areas (Witmer 2005). A key issue in estimating wildlife population abundance is that large and remote areas cannot typically be covered solely by ground surveys (Gaston and Fuller 2009; Royle and Nichols 2003). Certain habitats may also be inaccessible due to physical barriers (e.g., presence of water bodies, rugged terrain, etc.), further complicating attempts to conduct ground surveys (Croxall et al. 2002; Zahratka and Shenk 2008). Other factors such as lack of roads, steep slopes, cold weather, unstable terrain, heavy precipitation, dense vegetation, and other environmental and geographical variables may all complicate monitoring efforts.

Wildlife monitoring using remote sensing methods can eliminate many of above-mentioned limitations and challenges linked to handling individuals. Reliable data can be obtained without the need for permits while reducing the risk of disease transmission or injury to wildlife or humans. Ecologists and conservation biologists are increasingly using remote methods, particularly those that rely on earth observation data (Kerr and Ostrovsky 2003; Pettorelli et al. 2014). For example, Fretwell et al. (2012) used very high-resolution satellite imagery to estimate penguin population size in Antarctica. The spatial and temporal resolutions of remotely sensed satellite imagery can limit their effectiveness for producing accurate and reliable population estimates. According to O'Neill et al. (1996), the grain (spatial resolution) of the imagery needs to be 2–5 times smaller than the features being detected. Therefore, freely accessible Landsat imagery with 30-m spatial resolution (i.e., 900 m^2) or Sentinel-2 imagery with 10-m spatial resolution (i.e., 100 m^2) is insufficient to count most wildlife species. The limitations of satellite imagery necessitate using data products with spatial resolutions in centimeters or inches, such as drone-captured images (Hodgson et al. 2018).

Over the last decade, drones or unmanned aircraft systems (UAS) have been increasingly adopted for wildlife counting in a variety of habitats (Linchant et al. 2015; Wang et al. 2019). Drone-captured data products have been used to detect koalas (Corcoran et al. 2019), monitor birds (Hodgson et al. 2018), elephants (Vermeulen et al. 2013), crocodiles (Evans et al. 2016),

and marine mammals (Durban et al. 2015; Hodgson et al. 2013). They have been launched from boats to monitor killer whales (Durban et al. 2015) and have been used to monitor and map a highly sensitive breeding colony of waterbird (*Aechmophorus occidentalis*) at a resolution not otherwise possible (Lachman et al. 2020). While drones are not always the answer—for example, a study comparing the detectability of chimpanzee nests using drone imagery and ground surveys by human observers found that, on average, only 10% of nests identified on the ground were detected by drones (Bonnin et al. 2018)—they are often capable of bridging the gap between satellite imagery and in-situ observations for wildlife population monitoring.

When compared to satellite and conventional aircraft, drones allow for capturing images at finer spatial and temporal resolutions that are better suited for ecological monitoring (Anderson and Gaston 2013; Hodgson et al. 2017; Singh and Frazier 2018). Unlike satellite imagery, which is often collected at regular intervals, drones can be deployed immediately following a disaster or disturbance by a wildlife manager to perform population monitoring. In addition to the fine spatial and temporal resolution imagery, counting wildlife with drone-acquired data adds substantial safety and accuracy benefits in comparison to other methods (see Table 10.1) For instance, counts of seabirds using drone imagery were found to be more accurate than ground-based surveys by humans (Hodgson et al. 2018). The physiological and behavioral responses of wildlife to drones appear to be limited and in some cases nonexistent (Brunton et al. 2019; Ditmer et al. 2015; Hodgson et al. 2017; Linchant et al. 2015; Scholten et al. 2020), while physiological responses of animals may decline with habituation (Ditmer et al. 2019).

METHODS FOR COMPUTER-AIDED IMAGE INTERPRETATION

Visual, or manual, interpretation of images is a widely used and accessible technique. The observer uses image elements such as size, shape, shadow, color/tone, texture, association, and pattern to interpret an image. Visual image interpretation is a labor-intensive process and detection can be influenced by the observer's training, experience, and bias. The observer also must have at least some knowledge of the object(s) under analysis. Thus, visual image interpretation by an expert observer is time consuming but often results in very accurate and precise results. A visual analysis identifying a large mammal, such as an elephant, from aerial photography could use the size of the object in relation to other objects in the scene, the shape of the object as seen from the air, and even the proximity (association) to food or water sources. Patterns such as the spatial arrangement of individuals or textures such as the coloration of the wildlife against the background can also help observers count species (Laliberte et al. 2011; Laliberte and Ripple 2003).

A variety of semi- to fully automated detection methods have been developed to overcome the challenges associated with visual image interpretation. These digital image processing methods streamline object detection, mapping, and counting efforts, allowing users to preprocess, enhance, transform, and analyze data in a manner that is replicable and reproducible. Subtracting one image from another is a simple form of digital image processing. Classifying land-cover types based on pixel values is another, more complicated form of digital image processing. Automating image processing enables users to conduct multiple functions on one or more images over a shorter time period, reducing the likelihood of user error and further harnessing the power of computer programs.

In this chapter, you will perform wildlife counts with drone-captured imagery using two methods: visual image interpretation and semi-automated detection method. During visual image interpretation, you will identify wildlife based on the shape, size, position, tone, and other elements of image interpretation. During semi-automated detection, you will count wildlife based on an image segmentation technique.

STUDY AREA AND DATA

Drone images of simulated seabird colonies were captured along a beach near Port Willunga, south of Adelaide, Australia (Figure 10.1). Life-sized, plastic duck decoys (25.5 × 11.3 cm; 185/cm² footprint) representative of the greater crested tern (*Thalasseus bergii*) were arranged on the beach to simulate a seabird colony. The decoys were placed in an area with little topographic variation, above the high-water mark, and with little to no vegetation to simulate nesting conditions. Additional details on these colonies can be found in (Hodgson et al. 2016; Hodgson et al. 2018). The beach was generally free of rocks but did contain natural debris. The beach sloped gently from the high-water mark to a naturally vegetated embankment. Sand color ranged from off white to golden.

Images were collected using a 3D Robotics Iris+ quadcopter equipped with a Sony Cyber-shot RX 100 III camera with a base resolution of 5472 by 3648 pixels, a CMOS sensor size 13.2 × 8.8 mm, and a ZEISS Vario-Sonnar T lens. The camera was mounted facing downwards with a custom vibration dampening plate, and photos were captured in jpeg format at a focal length of 8.8 mm.

Images of the colony were captured at four altitudes: 30, 60, 90, and 120 m above ground level (AGL). The images were then processed and mosaicked. Each mosaic was georeferenced using Google Earth Pro. Ground sample distances (GSD) for the four altitudes were initially 0.82, 1.64, 2.47, and 3.29 cm, respectively but changed during image processing to 1.5, 3.0, 4.5, and 6.0 cm, respectively (Figure 10.2).

WORKFLOW AND EXERCISES

In the following exercises, you will use the drone-captured, georeferenced images to count seabirds using visual interpretation and semi-automated detection methods. In Exercise 1, you will use visual interpretation techniques for detecting and digitizing seabirds. In Exercise 2, you will use **image segmentation** and a **binary threshold method** for detecting and mapping seabirds. In Exercise 3, you will compare the outcomes from both methods. By the end of this chapter, you

FIGURE 10.1 The study area located along a beach near Port Willunga, Adelaide, Australia.

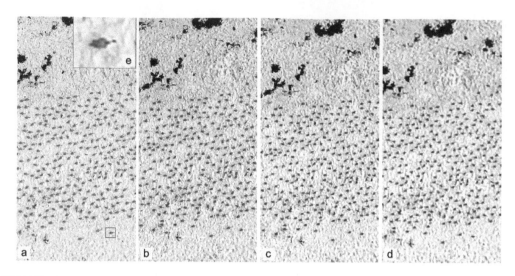

FIGURE 10.2 Images of the replica seabird colony captured using a drone-mounted camera at flying altitudes of (a) 30 m, (b) 60 m, (c) 90 m, and (d) 120 m. Inset on upper left (e) represents an individual bird decoy at 30-m altitude.

will understand how to process and view drone imagery for counting wildlife manually and using automated techniques along with the benefits and limitations of each method.

The workflow will be completed in ArcGIS and will leverage many of the built-in functions of that software (Figure 10.3), including image enhancement, digitization, and editing shapefiles.

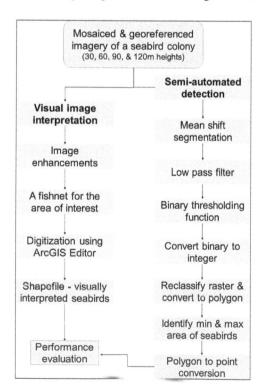

FIGURE 10.3 Workflow to perform the visual interpretation and semi-automated detection of seabirds from a simulated seabird colony.

Exercise 1: Visually Interpreting Drone Images for Counting Greater Crested Terns

1. Open ArcMap. Activate the **Spatial Analyst** extension by going to **Customize** on the ArcMap main menu > **Extensions** and check the box next to **Spatial Analyst**. This extension is required to perform various basic operations on vector and raster data.

2. Click on **File** located on the upper left corner of ArcMap, and then click on **Save** to save the project as "VisInter" in the `wildlifeCount` folder.

3. Navigate to the working folder (e.g., `wildlifeCount`) in your drive to add the drone-captured images. You can add data two ways: 1) Click on the **Add Data** button located on the menu bar, and then navigate to the `droneData` folder in the `wildlifeCount` folder, or 2) Activate ArcCatalog in ArcMap, go to **Windows**, and click on **Catalog**. ArcCatalog will be added to the right of ArcMap. Now, add all drone-captured images (i.e., `30m_Colony3_prj`, etc.) to the **Table of Contents** (Figure 10.4). Toggle between the four images to see the differences in resolution.

Q1 How does the altitude at which the drone captured the images impact image quality? What are some visual interpretation elements that might help you to identify objects in each of the different images? Do the visual interpretation elements that you would use change based on the resolution of the imagery?

4. Create an empty shapefile and add it to the **Table of Contents**. To do this, first create a folder within `wildlifeCount` and name it "visualAnalysis." Right-click on the newly created folder, go to **New > Shapefile**. Once the **Create New Shapefile** window opens,

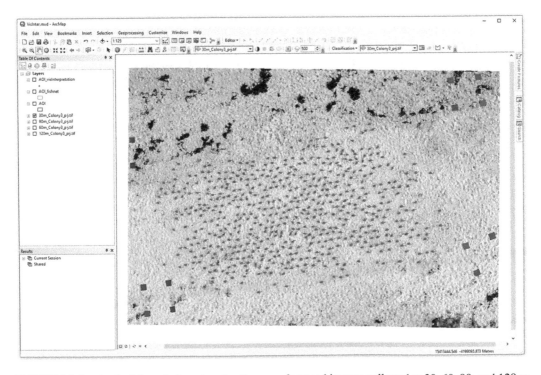

FIGURE 10.4 An ArcMap window showing the georeferenced images collected at 30, 60, 90, and 120 m altitudes in the Table of Contents. The image of the simulated seabird colony is visible in the main window.

name the new shapefile "AOI" (i.e., area of interest), select **Polygon** from the dropdown located next to **Feature Type**, click on the **Edit** button, and select **Import** from the drop-down located next to **Add Coordinate System**. Navigate to the drone-captured images in the `droneData` folder and select any image to import the coordinate system. Once you click **Add**, a coordinate system (WGS 1984 Web Mercator Auxiliary Sphere) will be added to the **Current coordinate system** window. Finally, click **OK**, and **OK** again to complete the procedure. This procedure will add an empty polygon shapefile to the **Table of Contents**.

5. Draw a polygon in the `AOI` shapefile covering the entire extent of the image. If needed, add the Editor toolbar to ArcMap by clicking **Customize > Toolbars > Editor** toolbar. Go to the **Editor** toolbar and click on the down arrow immediately next to Editor and select **Start Editing**. When you **Start Editing**, it will activate various functions located on the **Editor** toolbar, including **Create Features**. Click on **Create Features**; this will open a **Create Features** window. To activate **Construction Tools**, click on `AOI` located below **Create Features**. Select the **Rectangle** construction tool and click on the upper left corner of the image, then click on the upper right corner, and finally click on the lower right corner of image to complete the AOI polygon. To complete the process, go to the **Editor** dropdown menu again, click **Save Edits** and then **Stop Editing**. This will add a polygon covering the entire image to the `AOI` shapefile.

Next, you will create a "fishnet" of regular grid cells to aid in visual interpretation. The grid helps focus your counts to a smaller area where you can then create a point (i.e., digitization) for each bird within each cell and repeat this process until all individuals in each cell have been digitized. The `AOI` shapefile from the previous step will be used to set the coordinate system of the output in the **Template Extent** of the **Create Fishnet** tool.

6. Open the **Create Fishnet** tool (Figure 10.5). You can find this tool by either searching for it using the **Search** window or through the **Data Management Toolbox**. Under **Output Feature Class**, navigate to the folder where you are saving data (i.e., visualAnalysis), and name the Output Feature Class "AOI_fishnet." The output feature class will contain the fishnet of rectangular cells. You can set the coordinate system of the output by entering the layer (i.e., AOI) in the Template Extent parameter. Set the **Number of Rows** to 20 and the **Number of Columns** to 30. This will create a fishnet of 600 rectangular cells. Finally, uncheck the **Create Label Points** parameter, select **Polygon** from the dropdown **Geometry Type**, and click **OK**. This will create a fishnet of rectangular cells as a polygon feature and add it to the **Table of Contents**. It may take some time to build the fishnet, so be patient.

7. Create an empty point shapefile called "AOI_visInterpretation" following the same procedure you followed in Step 4. This time select **Point** instead of **Polygon** from the dropdown located next to **Feature Type**.

You will next use visual interpretation elements (e.g., size, shape, shadow, color, texture, association, and pattern) to interpret the image and detect seabirds. Since the greater crested terns (i.e., the objects of interest) are quite distinct from the rest of the background in the image, object identification is straightforward. You can use the zoom-in functionality in ArcMap to get a better look if needed. You will digitize the seabirds in the 30-m imagery as points using the `AOI_visInterpretation` shapefile.

8. First, order the layers in the **Table of Contents** with `AOI_visInterpreation` on top followed by `AOI_fishnet`, and then `30m_Colony3_prj`. Un-check the 60, 90, and 120 m imagery layers; you will only use the 30-m imagery for this step. Change the display

FIGURE 10.5 Window to create a fishnet of rectangular cells using the ArcGIS Create Fishnet tool.

of AOI_fishnet so that it is hollow by right-clicking the AOI_fishnet layer in the
Table of Contents > Properties, go to the **Symbology** tab, then double click on the colored
symbol box to pop up the **Symbol Selector** window and choose the Hollow option. Click
OK twice. Next, go to **Editor** (on the Editor Toolbar) > **Start Editing**. This will activate
various functions located on the **Editor** toolbar, including **Create Features**. Click on
Create Features; this will open a **Create Features** window. To activate **Construction
Tools**, click on AOI_visInterpretation located below **Create Features**.

9. Select the **Point** construction tool and click on the first object (seabird) in the upper left-
hand grid cell of the fishnet. If you make a mistake, note that you can use the **Undo Create**
button. Move through the grid systematically either row-by-row or column-by-column,
making sure that you have digitized every bird in the cell before moving on to the next cell.
*Note: If a bird falls on the line of the fishnet, this is fine. Just be consistent in where you
place the point.* The fishnet is there as a guide. Save your edits (**Editor > Save edits**) regu-
larly as you go (Figure 10.6). Once you have digitized seabirds in every cell, go to **Editor
> Save Edits** and then **Stop Editing**.

FIGURE 10.6 (a) The mosaicked imagery of the simulated seabird colony captured at 30 m altitude with the fishnet overlay, and (b) visually interpreted, detected, and digitized seabirds (the red dots) along with a zoomed out inset to show the outcome.

Q2 How many objects (i.e., seabirds) did you digitize in the 30 m image?

Image enhancement techniques can augment visual interpretation. Image enhancement is the process of improving the interpretability of the original image by adjusting pixel values in ways that make it easier to identify key features. You can apply enhancement techniques to modify images permanently or render pixel values temporarily to improve the brightness and contrast of images. In the next steps, you will apply image enhancement techniques to the drone-captured images temporarily to aid visual interpretation.

10. Right-click on 30m_Colony3_prj > **Properties** > **Symbology** tab and under **Stretch** examine the different stretch options for each band by clicking on the **Histograms** button located next to **Stretch Type** (Figure 10.7). Select the **Standard Deviations** method from the dropdown and click **Apply.** You will notice a change in the visual quality of the image, notably greater contrast between the greater crested terns and the background. Next, apply the **Histogram Equalize**, **Minimum-Maximum**, and **Percent Clip** stretches from the dropdown menu and observe how the image brightness and contrast change.

11. You can achieve similar effects using the **Image Analysis** tool. Go to **Windows** > **Image Analysis** to activate the tool. The Image Analysis window offers slider options to change contrast, brightness, and transparency that can quickly improve the appearance of the selected image. Changes made using the Image Analysis tools are temporary, but permanent layers can be created by exporting the changes to a saved file. Experiment with the sliders to enhance the contrast and brightness of the image to make visual interpretation of the seabirds easier (Figure 10.8).

Note: you must select the image you want to change by clicking it, so it is then selected in blue before the tool allows you to make changes to the brightness slider, etc.

FIGURE 10.7 Layer properties window shows the image stretch option to temporarily enhance the image for the visual interpretation. You can examine each band (i.e., red, green, and blue) by clicking on the Histograms button in the Stretch portion.

Note: while image enhancements aid in visual interpretation, it is essential to avoid altering the original image permanently if you intend to subsequently perform digital image processing for detection and mapping of objects!

Q3 Which image stretching method offered the best visual contrast between greater crested terns and the background? Did you observe similar effects from the different image enhancement methods for the images captured from the different altitudes?

FIGURE 10.8 Examples of different image enhancements to facilitate identification of key features. (a) The 30m_Colony3_Prj image was enhanced using (b) standard deviations (c) histogram equalize, and (d) and minimum-maximum methods.

Q4 Which elements of visual interpretation (e.g., size, shape, shadow, color, texture, association, and pattern) were improved through digital image enhancement?

12. Repeat Exercise 1 using the 120 m imagery and answer the two questions below.

Q5 How many objects (i.e., seabirds) did you digitize in the 120-m image? If there was a difference between the number you digitized at 30 m and the number at 120 m, explain what might be the reason for that difference.

Q6 How were the elements of visual interpretation (e.g., size, shape, color, texture, association, and pattern) that you used to identify birds in the 120-m image different from those you used for identifying birds in the 30-m image? Why did you need to rely on different cues at the different resolutions?

Exercise 2: Semi-automated Wildlife Counting

You will now use an image segmentation approach to semi-automate the counting. **Image segmentation** is the process of partitioning a digital image into segments, or sets of contiguous pixels, that represent objects. The image segmentation technique in ArcGIS is based on the **Mean Shift** approach. This technique uses a moving window to calculate an average pixel value for determining which pixels should be included in each segment (Comaniciu and Meer 2002). Pixels with similar spectral characteristics are grouped into segmented objects.

1. Create a folder called "digitalAnalysis" in the wildlifeCount folder. Open the **Segment Mean Shift** tool. You can find this tool through the **Search** window in ArcMap. Navigate to the droneData folder to add the 30m_Colony3_prj.tif raster dataset (Figure 10.9a) as the **Input Raster** for the segmentation and specify a name for the **Output Raster Dataset** along with an extension ("30m_Colony3_prj_segMean.tif"). The output location of this file will be the digitalAnalysis folder. Set the **Spectral Differences** of features to 16, the Spatial Details (the proximity between features) to 15, **Minimum**

FIGURE 10.9 An example of (a) the original and (b) the segmented image.

> **Segment Size** in pixels to 5, and click **OK**. The output raster (Figure 10.9b) will be added to the **Table of Contents**.

With segmentation, you can control the amount of spatial and spectral smoothing to derive features of interest. Higher spectral detail helps to distinguish between objects. Higher spatial detail is beneficial for an image where objects of interest are small or clustered together.

2. To smooth the segmented image and reduce abnormal pixels, you can apply a low pass filter (Figure 10.10a). Open the **Filter** tool (**Spatial Analysis** toolbar). The input raster is 30m_ Colony3_prj_segMean.tif. Specify a name for the **Output Raster** along with an extension ("30m_Colony3_prj_segMean_filtLow.tif"). The output location of this file will be the digitalAnalysis folder. Select **LOW** from the **Filter type** dropdown menu, check **Ignore NoData** in calculation, and click **OK** to execute the tool.

The **Binary Thresholding** function will be used to divide the smoothed, segmented drone image into two different classes (i.e., seabirds and other). The algorithm uses the Otsu method to distinguish background and foreground (i.e., object of interest) in imagery by creating two classes with minimal intra-class variance (Otsu 1979).

3. To apply the Binary Thresholding function, open the **Image Analysis** tool (**Windows > Image Analysis**) and select 30m_Colony3_prj_segMean_filtLow.tif in the top window so that it is highlighted. This is the image that you will divide into two classes (i.e., 0 and 1). Click the **Add Function** icon under **Processing**. A **Function Template Editor** window will open. Right-click on **Identity Function > Insert Function > Binary Thresholding Function**. A Raster Function Properties window will open that will contain the image you selected earlier (i.e., 30m_Colony3_prj_segMean_filtLow.tif). Click **OK**, and **OK** again to run the process. The Func_30m_Colony3_prj_segMean_filtLow.tif layer (Figure 10.10b) will be added to the **Table of Contents**.

4. Right-click on Func_30m_Colony3_prj_segMean_filtLow.tif in the **Table of Contents > Data > Export Data**. Save as "30m_Colony3_prj_segMean_filtLow_binaryThres.tif" to the digitalAnalysis folder. A layer will be added to the **Table of Contents**. Display it as **Unique Values** through **Properties > Symbology**.

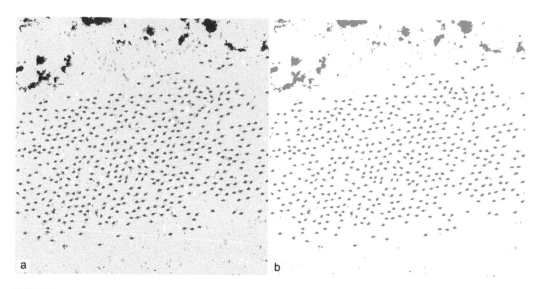

FIGURE 10.10 Example of (a) smoothed, segmented image using a low pass filter (3-by-3) designed to reduce the presence of irregular cells, and (b) a raster output with two distinct classes using the Binary Thresholding function.

5. The `30m_Colony3_prj_segMean_filtLow_binaryThres.tif` layer is in float pixel type, but you will need to convert it to integer format using the **Int** tool. Open the **Int** function through the **Search** window. The Input Raster is the binary thresholding data you created in the previous step. Specify the path to the `digitalAnalysis` folder and a name for the **Output Raster** along with an extension (i.e., "30m_Colony3_prj_segMean_filtLow_binaryThres_int.tif"). Click **OK** to run the function. This will add a layer to the **Table of Contents**.

6. The next step is to reclassify the binary integer data to convert foreground to class "1" and background to **NoData**. This process will help you to retain only segments that represent the objects of interest (seabirds). Open the **Reclassify** tool and add the binary integer data (`30m_Colony3_prj_segMean_filtLow_binaryThres_int.tif`) as the **Input Raster**. Select **Value** for the **Reclass field**, assign 1 to 0, which represents the object of interest and **NoData** to 1 under **New values** column. The goal is to convert any segment that is not a seabird to NoData. Specify a name for the **Output raster** ("30m_Colony3_prj_segMean_filtLow_binaryThres_int_reclass.tif") to the `digitalAnalysis` folder and click **OK**. The layer will be added to the **Table of Contents**.

In the next three steps, you will convert the reclassified, segmented data into polygons, add an area column to the attribute table, and use the **Select by Attributes** function to identify polygons that match the size of the objects of interest.

7. Open the **Raster to Polygon** tool and add the reclassified raster as the **Input Raster**. Select **Value** from the dropdown menu under **Field**. Specify a name for the **Output Polygon Features** along with an extension. Check the **Simplify polygons** box and click **OK** to run the tool. A polygon shapefile layer will be added to the **Table of Contents**.

8. To compute the area of each polygon object, you first need to add a new field to the attribute table. Right-click on the polygon shapefile you just added to the **Table of Contents > Open Attribute Table**. Go to the **Table Options** located in the upper left corner, and click **Add**

Field. The **Add Field** window will open where you will specify a name (i.e., areaSqM), choose **Double** from the **Type** dropdown menu, and click **OK**. A new field is added to the attribute table. Right-click on the heading of this field > **Calculate Geometry**. This will open a window that will ask you "Do you wish to continue?," click **Yes**. You will use the Coordinate System of your data source to calculate the area of each object in **square meters**. When you are finished entering these parameters, click **OK** and **Yes**, which will calculate the area for each polygon and add the value to the attribute table.

9. In this step, you will remove unwanted polygons. This step requires you to identify a minimum and maximum area value for the object of interest. You can accomplish this step in many ways, but to keep it simple, you will check a few polygons by overlaying the polygon shapefile on the `30m_Colony3_prj` imagery. The minimum size of a bird object in the 30-m imagery is 0.03 m², and the maximum size is 0.065 m². Click **Selection** on the menu bar and open the **Select by Attributes** function. The layer is the polygon shapefile you created in Step 7. In the **Select From** window, add `"areaSqM"` (double click) `>0.03 AND "areaSqM" <0.065`. Click **Apply** when you have the expression entered. *Note: if you have any typos in your expression, you will receive an error so make sure your expression matches word for word.* Several polygons will be highlighted. Export these polygons by right-clicking on the polygon shapefile > **Data** > **Export Data**. Specify a name ("30m_Colony3_SelPoly.shp"), and click **Save** to the `digitalAnalysis` folder, and **OK**. A shapefile containing selected polygons will be added to the **Table of Contents**.

10. Overlay the shapefile containing the selected polygons on the drone imagery (i.e., `30m_Colony3_prj`) and remove any polygons located outside the bird colony using the **Editor** tool. Go to **Editor** > **Start Editing** and select the shapefile (`30m_Coloney3_SelPoly.shp`) and click **OK** to start editing. Remove polygons by selecting them, right-clicking, and then selecting **Delete**. Once you finish removing unwanted polygons, go to **Editor** > **Save Edits** and then **Stop Editing**. The saved shapefile should look like Figure 10.11. Remember that no seabirds were placed in vegetated areas on the beach. This

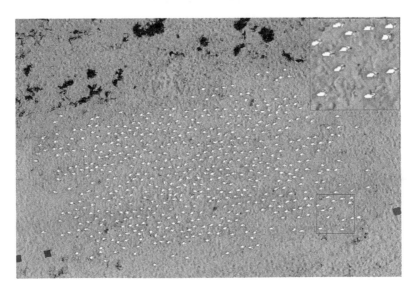

FIGURE 10.11 Distribution of detected seabirds from images collected at 30 m altitude using the Mean Shift segmentation and Binary Thresholding functions. Inset shows the shape and size of the segmented raster representing seabirds.

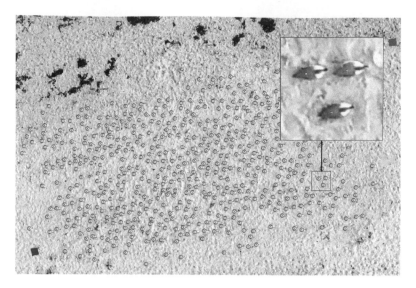

FIGURE 10.12 Distribution of mapped seabirds in point format from images collected at 30 m altitude. Inset shows the location of seabirds in the image.

process improves accuracy by removing polygons misclassified as seabirds, but it may not have captured every single decoy. If you wanted, you could mark any decoys that were missed during the process after Step 11.

11. In the final step, you will convert the polygons to points to estimate the number of seabirds in the colony. You will use the **Feature to Point** tool for this purpose. Open the **Feature to Point** tool, add the shapefile with the refined polygons, specify a file name for the output ("30m_Coloney3_count.shp"), save to the `digitalAnalysis` folder, and click **OK**. This will add a point shapefile to the **Table of Contents** (Figure 10.12).

12. Repeat Exercise 2 for **all three** of the remaining altitudes (60, 90, and 120 m).

Q7 How do the spatial and spectral values in the Mean Shift segmentation process affect the segmentation results? How can you identify an optimal value for both the spatial and spectral values for the Mean Shift function?

Q8 Why is it important to find a minimum segment size when working with high-resolution images such as those captured from drones? What are some of the ways you can determine the minimum segment size?

Q9 The Binary Thresholding function creates a raster with two distinct classes. Can you directly convert a segmented image to a polygon without applying a smoothing filter and the Binary Thresholding function? If not, what are the reasons?

Q10 What is the advantage of estimating the area of each polygon prior to converting them into a point shapefile?

Exercise 3: Evaluating Performance and Accuracy

You will now compare the results of your analyses to assess performance and accuracy. There are multiple ways to assess the accuracy and performance; however, to keep the procedure simple, you will use the **Near** function. The **Near** function calculates distance between the input features

(e.g., features detected using a semi-automated method) and the closest feature in another feature class (e.g., a ground reference dataset).

Since the length of the seabirds ranges roughly between 0.17 m and ~0.27 m, if a visually detected seabird (provided with the chapter) and a seabird detected through the semi-automated method (Exercise 2) are within this distance of one another, the semi-automated detected seabird is assumed to be correctly identified (Figure 10.13). You will use visually interpreted counts

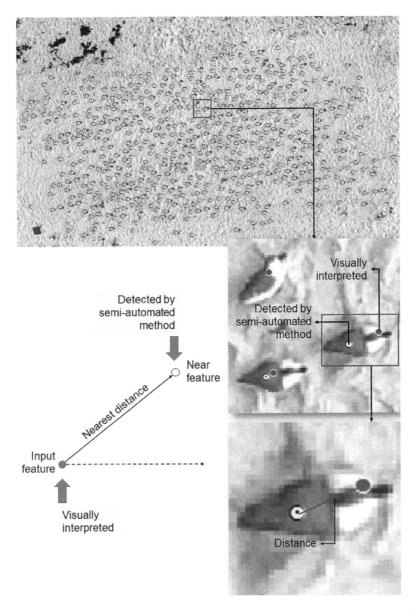

FIGURE 10.13 Distribution of mapped seabirds using both visual interpretation (ground reference) and the semi-automated methods in point format from images collected at 30 m altitude. Insets show the location of both ground reference (yellow with black outline) and detected (purple) points along with the concept of Near function.

(30m_colony3_visInterpretation) provided with the chapter in the countData folder as the ground reference data to check the accuracy of your semi-automated counts.

1. Use the **Search** window to find the **Near** (**Analysis**) tool and open it. Add the visually interpreted data (30m_colony3_visInterpretation) located in the countData folder as the **Input Features** and the layer you created through the semi-automated method as the **Near Features**. Type 0.27 into the **Search Radius** box, select **PLANAR** from the dropdown menu under Method, and click **OK**. *Note: if you are in an editing session (i.e., you saved your edits but did not stop editing), this tool will not run. You must first Stop Editing and they try running the tool again.*

The Near function will add several fields to the Input layer, including NEAR_FID and NEAR_DIST fields. NEAR_FID column will contain the object ID of the closest near feature. If no feature is found within 0.27 m of the input, the value will be −1. The NEAR_DIST column will contain the distance between the input and near feature.

2. Once the process is complete, right-click the **Input Layer** (aoi_30m_colony3_visInterpretation) > **Open Attribute Table**. Right-click on the NEAR_FID heading > **Sort Ascending** to organize the observations in ascending order. Select all rows with a value of −1 by highlighting them. The points that were not detected by the semi-automated method will be highlighted (Figure 10.14).

3. Repeat Exercise 3 for **all three** of the remaining altitudes, (60, 90, and 120 m).

Q11 How many seabirds were not detected using the semi-automated method from the image collected at 30 m altitude? What percentage of the total population was not detected with this method from the images collected at each of the four altitudes? At which of the four altitudes is there the greatest decline in accuracy? Based on a comparison of the accuracy at

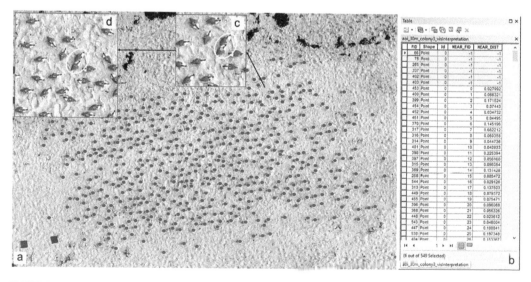

FIGURE 10.14 Outcome from the Near function analysis: (a) highlighted visually interpreted seabirds that were not detected by the semi-automated method, (b) Attribute Table with the selected rows (six total) with −1 values, and (c and d), insets with yellow boxes showing seabirds not detected by the semi-automated method.

the different altitudes, which altitude would you recommend for future flights over the colony given that time and money are also a concern?

Q12 Why do you think these particular seabirds were not detected with the semi-automated method? What could you have done differently during the image processing to workflow to ensure these seabirds were detected?

DISCUSSION AND SYNTHESIS QUESTIONS

In this chapter, you applied computer-aided visual interpretation and semi-automated detection methods to detect, map, and count a wildlife population from drone imagery. You learned a variety of spatial functions/tools (e.g., image segmentation, binary thresholding, image smoothening, etc.) that you can apply to count wildlife. You also explored how the flight altitude of the drone can change the spatial resolution of images, impacting seabird population detection and mapping. Lastly, you learned to assess the performance of these two methods. The following questions will further help your learning through discussion and aid the development of your research ideas.

S1 Under what conditions might using a drone for counting wildlife be challenging or even impossible? Think specifically about ecology, habitat types, and climates.

S2 Counting individuals from a drone potentially allows researchers to survey a much larger area than would be possible using ground-based methods, but how should you determine what area is appropriate or too big? What factors affecting the drone need to be considered? What factors affecting the wildlife need to be considered?

S3 A local park contacts you and wants to use a drone to monitor seabird nests regularly over the next five years. They ask you to design a protocol they can use to collect such data. What types of variables, parameters, and metrics would you need to consider? What type of information would you need from the park?

S4 How might wildlife behavior, vigilance for example, dictate how wildlife population counts are conducted? What types of wildlife are well-suited to drone-based counts? What types of wildlife may not be suited for drone-based counts?

S5 If semi-automated counts are faster than visual image counts, what is the benefit of using visual image counts? What are the benefits of this method and under what circumstances might it be preferred or necessary?

S6 What are the ethical implications of studying wildlife using a drone? You may wish to discuss cost barriers of drone, training barriers of drone, stress responses of endangered species, wildlife habituation to drone, etc.

S7 Can you apply a High pass filter to smooth the image? How would this impact the outcomes from the Binary Thresholding function?

S8 Community (or citizen) science programs, where the public collects data for a scientific purpose with minimal scientific training, can be used to survey wildlife. For example, the Great Backyard Bird Count has invited the public across the globe to identify and count birds in their yards since 1998. How might a drone be implemented into community science projects? What are the benefits and limitations of creating a community science program counting wildlife using drones?

ACKNOWLEDGMENTS

The analyses in this paper are based on data collected and described in Hodgson et al. (2018). We gratefully acknowledge the authors of that study. Data and the pre-registered experimental design for this exercise were acquired from the Dryad Digital Repository: https://doi. org/10.5061/dryad.rd736. You can find more about the count data, scenes, semi-automated aerial image counting approach source code and dataset, and r script from the repository (Hodgson et al. 2018).

REFERENCES

Anderson, K., & Gaston, K.J. (2013). Lightweight unmanned aerial vehicles will revolutionize spatial ecology. *Frontiers in Ecology and the Environment*, 11, 138–146.

Bolton, M., Brown, J., Moncrieff, H., Ratcliffe, N., & Okill, J. (2010). Playback re-survey and demographic modelling indicate a substantial increase in breeding European Storm-petrels *Hydrobates pelagicus* at the largest UK colony, Mousa, Shetland. *Seabird*, 23, 14–24.

Bonnin, N., Van Andel, A.C., Kerby, J.T., Piel, A.K., Pintea, L., & Wich, S.A. (2018). Assessment of chimpanzee nest detectability in drone-acquired images. *Drones*, 2, 17.

Brunton, E., Bolin, J., Leon, J., & Burnett, S. (2019). Fright or flight? Behavioural responses of kangaroos to drone-based monitoring. *Drones*, 3, 41.

Comaniciu, D., & Meer, P. (2002). Mean shift: A robust approach toward feature space analysis. *IEEE Transactions on Pattern Analysis and Machine Intelligence*, 24, 603–619.

Corcoran, E., Denman, S., Hanger, J., Wilson, B., & Hamilton, G. (2019). Automated detection of koalas using low-level aerial surveillance and machine learning. *Scientific Reports*, 9, 1–9.

Cristescu, R.H., Foley, E., Markula, A., Jackson, G., Jones, D., & Frere, C. (2015). Accuracy and efficiency of detection dogs: a powerful new tool for koala conservation and management. *Scientific Reports*, 5, 8349.

Croxall, J.P., Trathan, P., & Murphy, E. (2002). Environmental change and Antarctic seabird populations. *Science*, 297, 1510–1514.

Dacier, A., de Luna, A.G., Fernandez-Duque, E., & Di Fiore, A. (2011). Estimating population density of Amazonian titi monkeys (*Callicebus discolor*) via playback point counts. *Biotropica*, 135–140.

Ditmer, M.A., Vincent, J.B., Werden, L.K., Tanner, J.C., Laske, T.G., Iaizzo, P.A., Garshelis, D.L., & Fieberg, J.R. (2015). Bears show a physiological but limited behavioral response to unmanned aerial vehicles. *Current Biology*, 25, 2278–2283.

Ditmer, M.A., Werden, L.K., Tanner, J.C., Vincent, J.B., Callahan, P., Iaizzo, P.A., Laske, T.G., & Garshelis, D.L. (2019). Bears habituate to the repeated exposure of a novel stimulus, unmanned aircraft systems. *Conservation Physiology*, 7, coy067.

Durban, J.W., Fearnbach, H., Barrett-Lennard, L., Perryman, W., & Leroi, D. (2015). Photogrammetry of killer whales using a small hexacopter launched at sea. *Journal of Unmanned Vehicle Systems*, 3, 131–135.

Evans, L.J., Jones, T.H., Pang, K., Saimin, S., & Goossens, B. (2016). Spatial ecology of estuarine crocodile (*Crocodylus porosus*) nesting in a fragmented landscape. *Sensors*, 16, 1527.

Fretwell, P.T., LaRue, M.A., Morin, P., Kooyman, G.L., Wienecke, B., Ratcliffe, N., Fox, A.J., Fleming, A.H., Porter, C., & Trathan, P.N. (2012). An emperor penguin population estimate: the first global, synoptic survey of a species from space. *PloS One*, 7, e33751.

Gaston, K.J., & Fuller, R.A. (2009). The sizes of species' geographic ranges. *Journal of Applied Ecology*, 46, 1–9.

Hodgson, A., Kelly, N., & Peel, D. (2013). Unmanned aerial vehicles (UAVs) for surveying marine fauna: a dugong case study. *PloS One*, 8, e79556.

Hodgson, A., Peel, D., & Kelly, N. (2017). Unmanned aerial vehicles for surveying marine fauna: assessing detection probability. *Ecological Applications*, 27, 1253–1267.

Hodgson, J., Baylis, S., Mott, R., & Koh, L. (2016). A comparison of the accuracy of simulated animal counts using traditional and UAV-assisted methods. *Open Science Framework*.

Hodgson, J.C., Mott, R., Baylis, S.M., Pham, T.T., Wotherspoon, S., Kilpatrick, A.D., Raja Segaran, R., Reid, I., Terauds, A., & Koh, L.P. (2018). Drones count wildlife more accurately and precisely than humans. *Methods in Ecology and Evolution*, 9, 1160–1167.

Karanth, K.U. (1995). Estimating tiger *Panthera tigris* populations from camera-trap data using capture—recapture models. *Biological Conservation*, 71, 333–338.

Kerr, J.T., & Ostrovsky, M. (2003). From space to species: ecological applications for remote sensing. *Trends in Ecology & Evolution*, 18, 299–305.

Lachman, D., Conway, C., Vierling, K., & Matthews, T. (2020). Drones provide a better method to find nests and estimate nest survival for colonial waterbirds: a demonstration with Western Grebes. *Wetlands Ecology and Management*, 28, 837–845.

Laliberte, A.S., Goforth, M.A., Steele, C.M., & Rango, A. (2011). Multispectral remote sensing from unmanned aircraft: image processing workflows and applications for rangeland environments. *Remote Sensing*, 3, 2529–2551.

Laliberte, A.S., & Ripple, W.J. (2003). Automated wildlife counts from remotely sensed imagery. *Wildlife Society Bulletin*, 31, 362–371.

Linchant, J., Lisein, J., Semeki, J., Lejeune, P., & Vermeulen, C. (2015). Are Unmanned Aircraft Systems (UASs) the future of wildlife monitoring? A review of accomplishments and challenges. *Mammal Review*, 45, 239–252.

Lubow, B.C., & Ransom, J.I. (2016). Practical bias correction in aerial surveys of large mammals: Validation of hybrid double-observer with sightability method against known abundance of feral horse (*Equus caballus*) populations. *PLoS One*, 11, e0154902.

Marques, F.F. (2001). *Estimating wildlife distribution and abundance from line transect surveys conducted from platforms of opportunity*. In: University of St Andrews: Scotland.

Milchram, M., Suarez-Rubio, M., Schröder, A., & Bruckner, A. (2020). Estimating population density of insectivorous bats based on stationary acoustic detectors: A case study. *Ecology And Evolution*, 10, 1135–1144.

Moore, D.L., & Vigilant, L. (2014). A population estimate of chimpanzees (*Pan troglodytes schweinfurthii*) in the Ugalla region using standard and spatially explicit genetic capture–recapture methods. *American Journal of Primatology*, 76, 335–346.

Mowry, R.A., Gompper, M.E., Beringer, J., & Eggert, L.S. (2011). River otter population size estimation using noninvasive latrine surveys. *The Journal of Wildlife Management*, 75, 1625–1636.

Newey, S., Davidson, P., Nazir, S., Fairhurst, G., Verdicchio, F., Irvine, R.J., & van der Wal, R. (2015). Limitations of recreational camera traps for wildlife management and conservation research: A practitioner's perspective. *Ambio*, 44, 624–635.

O'neill, R., Hunsaker, C., Timmins, S.P., Jackson, B., Jones, K., Riitters, K.H., & Wickham, J.D. (1996). Scale problems in reporting landscape pattern at the regional scale. *Landscape Ecology*, 11, 169–180.

Otsu, N. (1979). A threshold selection method from gray-level histograms. *IEEE Transactions On Systems, Man, And Cybernetics*, 9, 62–66.

Pettorelli, N., Laurance, W.F., O'Brien, T.G., Wegmann, M., Nagendra, H., & Turner, W. (2014). Satellite remote sensing for applied ecologists: opportunities and challenges. *Journal of Applied Ecology*, 51, 839–848.

Royle, J.A., & Nichols, J.D. (2003). Estimating abundance from repeated presence–absence data or point counts. *Ecology*, 84, 777–790.

Scholten, B.D., Beard, A.R., Choi, H., Baker, D.M., Caulfield, M.E., & Proppe, D.S. (2020). Short-term exposure to unmanned aerial vehicles does not alter stress responses in breeding tree swallows. *Conservation Physiology*, 8, coaa080.

Singh, K.K., & Frazier, A.E. (2018). A meta-analysis and review of unmanned aircraft system (UAS) imagery for terrestrial applications. *International Journal of Remote Sensing*, 39, 5078–5098.

Smyser, T.J., Guenzel, R.J., Jacques, C.N., & Garton, E.O. (2016). Double-observer evaluation of pronghorn aerial line-transect surveys. *Wildlife Research*, 43, 474–481.

Stephens, P., Zaumyslova, O.Y., Miquelle, D., Myslenkov, A., & Hayward, G. (2006). Estimating population density from indirect sign: track counts and the Formozov–Malyshev–Pereleshin formula. *Animal Conservation*, 9, 339–348.

Thompson, M.E., Schwager, S.J., Payne, K.B., & Turkalo, A.K. (2010). Acoustic estimation of wildlife abundance: methodology for vocal mammals in forested habitats. *African Journal of Ecology*, 48, 654–661.

Vermeulen, C., Lejeune, P., Lisein, J., Sawadogo, P., & Bouché, P. (2013). Unmanned aerial survey of elephants. *PloS One*, 8, e54700.

Wang, D., Shao, Q., & Yue, H. (2019). Surveying wild animals from satellites, manned aircraft and unmanned aerial systems (UASs): A review. *Remote Sensing*, 11, 1308.

Witmer, G.W. (2005). Wildlife population monitoring: some practical considerations. *Wildlife Research*, 32, 259–263.

Zahratka, J.L., & Shenk, T.M. (2008). Population estimates of snowshoe hares in the southern Rocky Mountains. *The Journal of Wildlife Management*, 72, 906–912.

11 Terrain and Surface Modeling of Vegetation Height Using Simple Linear Regression

Jennifer L.R. Jensen and Adam J. Mathews

CONTENTS

LEARNING OBJECTIVES

After completing this chapter, you will be able to:

1. Create data products from aerial images using SfM processing techniques.
2. Create a DEM by filtering the SfM-produced 3D points.
3. Generate heights for non-ground 3D points and calculate regression predictor variables.
4. Build a regression model to estimate plot-level vegetation canopy heights.
5. Map vegetation canopy heights.

HARDWARE AND SOFTWARE REQUIREMENTS

Part 1 requires:

1. Agisoft Metashape Professional. Instructions and screenshots use the Metashape "Classic" interface, which can be changed in the software via the Tools dropdown > Preferences > General tab > Theme (change to Classic)

Part 2 requires:

1. ArcMap 10.x or ArcGIS Pro
2. Spreadsheet software (e.g., Microsoft Excel)

DATASETS

The `Part1_Data.zip` folder contains 417 drone-collected, geotagged aerial photos that you will use in Part 1. The `Part2_Data.zip` folder contains a set of vector, raster, and text files that you will need for Part 2.

INTRODUCTION

Central to forest, wildlife, and natural resource management is the accurate evaluation of vegetation composition and structure on the landscape. **Vegetation composition** refers to the assemblage of plant species on the landscape, while **vegetation structure** is defined as the quantification of dimensional measurements (e.g., height, canopy cover, etc.) associated with vegetation. Vegetation structure measurements are particularly significant because they aid land managers with determining wildlife habitat requirements, forest inventory monitoring, wildfire risk management, conservation planning, etc. Measurement, inventory, and monitoring of vegetation structure aids in land management decisions and provides valuable information for subsequent analyses since vegetation plays a critical role in ecological processes such as heat transfer, gaseous exchange between the atmosphere and terrestrial surface, and light regimes.

A common vegetation structure measurement is **vegetation height**, which is generally defined as the total perpendicular distance from the soil at the plant base to the topmost foliage component. For vegetated landscapes, the vegetation canopy is equivalent to vegetation height, although other definitions of vegetation height may be applied depending on the study objectives (e.g., height from soil to live foliage or height of only live foliage not including the ground). Vegetation height is significant across a range of disciplines and applications. For example, vegetation height is used in models to calculate aboveground biomass, identify wildlife habitat suitability, and model hydrologic regimes among other applications. Thus, accurate characterization of vegetation height is a fundamental measurement to relate to overall vegetation structure.

Traditional methods to measure vegetation height involve direct observations in the field using a ruler, tape measure, relascope, clinometer, laser rangefinder, or a combination of equipment depending on the height and density of the vegetation. However, a challenge with measuring vegetation height solely with field-based measurements is that it is both costly and time consuming as well as inexhaustive. It is not reasonable to measure height for every tree in a forest because that would take too long. As such, remote sensing is an important source of data to measure vegetation height for large areas. Historically, photogrammetry was used to obtain 3D measurements from overlapping stereoscopic pairs of aerial photographs; however, in the early 2000s, Light Detection and Ranging (lidar) became the leading technology to collect 3D data, including

FIGURE 11.1 Location of the study area near San Marcos, Texas, USA

vegetation heights. While lidar continues to be a top choice for both topographic (Mongus and Žalik 2012) and vegetation surveys (Okuda et al. 2019; Wolf et al. 2016), lidar data acquisition and processing can be very costly, and repeat acquisitions are uncommon.

Since 2013, SfM techniques have gained traction to generate image-based 3D point clouds much like traditional photogrammetric and more recent lidar datasets. Researchers continue to explore the potential of SfM to characterize landscapes for a variety of applications including vegetation structure (De Souza et al. 2017; Jensen and Mathews 2016; van Iersel et al. 2018). Regardless of whether you use photogrammetric, lidar, or SfM point cloud data to estimate vegetation height, two intermediate data products are required. The first data product is a digital elevation model (DEM), which is a continuous spatial dataset that represents the Earth surface. A bare-earth DEM that does not include vegetation, buildings, or other objects is also referred to as a digital terrain model (DTM). The second product is a spatial dataset of features (e.g., points) that are above the DEM surface (i.e., non-ground points). By subtracting the elevation value of the DEM from the elevation value of the features above the ground surface, you can calculate an estimate of vegetation height.

This chapter presents a method to process UAS imagery to generate 3D data, create a DEM, perform simple linear regression to estimate vegetation height, and then map vegetation height across the study area located near San Marcos, Texas (Figure 11.1). While the UAS data processing methods are relatively new for vegetation structure modeling, the geoprocessing and statistical framework for estimating vegetation height from 3D data is well documented in lidar-based literature.

The chapter is divided into two parts that are designed to be completed in sequence. In Part 1, you will develop a DEM from UAS-acquired imagery. It is a time and process-intensive activity that will introduce you to the SfM workflow and data filtering process to generate a DEM. In Part 2, you will use a DEM and 3D data from an SfM point cloud to generate a vegetation canopy height map. You will learn how to process and extract data to calculate independent variables that will be used in a simple linear regression analysis to identify a suitable model of vegetation canopy height. You will then use the regression model to map canopy height across the study area.

PART 1: DEVELOPING A DIGITAL ELEVATION MODEL (DEM)

A digital terrain model (DTM) is a specific type of DEM that includes only the bare Earth. DEMs represent the Earth's surface topography and remain one of the most commonly utilized datasets for geospatial analyses (e.g., site suitability analyses, viewshed modeling, etc.). Traditionally, DEMs were generated by direct survey of the landscape, however, DEM generation has evolved with technological advances, primarily using photogrammetry, then radar and lidar, and most recently Structure from Motion-Multi-View Stereo (SfM-MVS, simply SfM) photogrammetry using UAS-collected aerial images. While each of these options for developing a DEM presents advantages and disadvantages, the most recent addition of UAS-SfM has considerably reduced the cost of creating highly detailed terrain and surface information with the potential to extend data collection efforts to a broader audience compared to government and/or private mapping agencies (Carrivick et al. 2016). Further, DEMs generated from SfM have been reported to be more accurate and are created using data with significantly higher point densities than lidar (Fonstad et al. 2013).

The creation of a DEM from point cloud data (SfM or lidar) involves assigning the X, Y, and Z points into ground and non-ground classes. Once ground points are identified and attributed, a raster DEM can be created using the Z (height) information from the ground points. A major challenge of generating a DEM over vegetated surfaces with UAS-SfM is that unlike lidar pulses, which can penetrate canopy gaps, travel to the ground, and be reflected back to the sensor, UAS-imagery only captures the energy reflected from the first surface light encounters. For landscapes with dense vegetation that covers or obscures the ground, UAS-SfM may not be a suitable method to generate a DEM. A few studies have explored vegetation conditions for which DEM generation is possible (Jensen and Mathews 2016).

EXERCISE 1.1: BUILDING THE SfM POINT CLOUD

The `Part1_Data.zip` file contains 417 aerial photos of a portion of the Freeman Center, a 3500-acre site located in San Marcos, Texas, USA and managed by Texas State University for farming, ranching, game management, educational, and experimental purposes. The Freeman Center lies within the biogeographically unique region of the Texas Hill Country and is characterized by prairie, savanna, and desert biomes. The images used in this exercise were collected using two Canon PowerShot A800 point-and-shoot digital cameras mounted on a fixed-wing (kite-wing) UAS platform. Images were captured around 10:00 am local time (UTC-6) on 14 August 2013. Two cameras were used for data collection to ensure enough high-quality images for SfM processing.

1. Open Agisoft Metashape (be sure you are in "Classic" mode for the interface) and add the 417 photos to Chunk 1 by clicking **Workflow > Add Photos**.

2. Save your Metashape project as a new project file (**File > Save**).

3. From the Workflow menu, build your SfM workflow as a **Batch Process** using the parameters in Table 11.1.

 a. Click **Workflow > Batch Process** and a new window will appear

 b. Click **Add** to add a processing step. Under Job Type: select the first step (Align Photos) and set the properties following Table 11.1. To change the values, double-click them in the window and type in new values. Click **OK**.

 c. Add the remaining two processing steps by clicking **Add** and assigning parameters according to values in Table 11.1

TABLE 11.1

Processing Steps and Parameters for Batch Processing the SfM Workflow

Processing Step	Parameters
Align Photos	Accuracy: Medium Generic preselection: Yes Reference preselection: Yes Leave all other parameters as the default
Optimize Alignment	Leave all parameters as the default
Build Dense Cloud	Quality: Low Leave all other parameters as the default

Note: SfM requires considerable computational resources in terms of both storage space and processing ability through CPU and GPU. Be sure to plan enough time for this exercise according to the processing power of your machine.

FIGURE 11.2 Dense point cloud generated in Agisoft Metashape Professional using structure from motion (SfM).

 d. Be sure to check the box next to **Save project after each step** before running.

 e. Click **OK** when you are ready to run this workflow. *Note: this step may take several minutes to run*

Upon completion of Step 3, some photos may not have aligned during the SfM process (e.g., 416 of the 417 images were aligned in Figure 11.2). If these issues occur, you should examine the specific photos that are not aligned. Often these issues result from poor image-to-image overlap or blurriness within images.

 4. The outputs displayed in the model may include blue tiles that represent the estimated camera positions during image acquisition. You can turn camera positions off/on by clicking **Model > Show/Hide Items > Cameras**.

5. Display the sparse point cloud by clicking **Model > View Mode > Point cloud** and navigate the model window. You can navigate in Metashape using these mouse combinations:

 a. Scroll wheel – zooms in and out of point cloud

 b. Left mouse button – rotate the point cloud

 c. Right mouse button – shift the point cloud up or down

 d. Left and right mouse buttons held at the same time will shift the point cloud within the bounding box.

 e. You can also examine the point cloud from predefined views by clicking Model > Predefined Views and making a selection.

6. Now display the dense point cloud by clicking **Model > View > Dense Cloud** and navigate the model window.

Q1 Examine the sparse and dense point clouds you produced. What are the primary differences between the sparse and dense point clouds in terms of your ability to discern specific landscape features?

Agisoft automatically georeferenced the SfM model using the image geotags. Ideally, ground reference data would also be collected and incorporated into the workflow to improve and/or assess the horizontal and vertical accuracy of the resulting point clouds.

EXERCISE 1.2: CLASSIFYING GROUND POINTS FOR THE SfM POINT CLOUD

Prior to point classification, it is necessary to fully examine the point cloud for erroneous points (noise). Erroneous points include points that are well above the surface of the earth (i.e., in the sky) or well below the generalized ground surface. Removing points below the visible ground surface will help produce a more accurate DEM later on.

1. With the dense point cloud in the model window, tilt the point cloud so the visible ground surface is level and you can see points above and below the visible surface. You should notice several points that are well below the ground.

2. Click **Model > Rectangle Selection** and draw a box around points obviously below the surface by holding down the left mouse button and dragging the mouse to create a box around the noisy points. Release the mouse button to finish the selection. Press **Delete** on the keyboard to delete the points. If you want to reset your selection, press **Esc** on the keyboard or use the selection tool anywhere in the model window that does not contain any point. If you accidentally delete points, you can click **Edit > Undo** to recover them.

3. Navigate through the point cloud to select and delete points that are well below the ground surface. You also can try some of the other selection tools (i.e., Circle and Free-Form Selection) in the Model menu to select points. You can reset any model selection tool back to the navigation arrow by pressing the spacebar on your keyboard.

Note: Manual point cloud editing can be a time-consuming process, and it is often difficult to determine which points should be deleted. For the purposes of this exercise, only remove points that are obviously well below the ground surface (refer to Figure 11.3)

4. Once you have completed cleaning the point cloud, it is ready to be classified. While there are many possible classes to which the points can be assigned, in this exercise your focus is to classify ground points so you can generate a DEM. The software can do this

FIGURE 11.3 Example of noisy points well below the ground surface indicated by the black arrows.

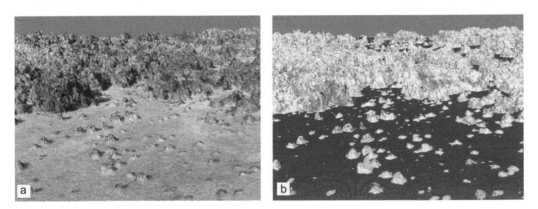

FIGURE 11.4 (a) The SfM-generated dense point cloud, and (b) the point cloud classification with ground points shown in brown and non-ground points in gray.

automatically (Figure 11.4). To classify ground points in the SfM point cloud click **Tools > Dense Cloud > Classify Ground Points**.

5. Run the **Classify Ground Points** tool with the default parameters. To view the results of the classification, click Model > View Mode > Dense Cloud Classes. By default, ground points are displayed in brown, non-ground points are displayed in gray, and low points (noise) are displayed in pink (Figure 11.4b).

6. The default point cloud parameters may not be ideal for the dataset given the topography and vegetation present on the landscape. Often the parameters need to be adjusted to obtain the best ground point classification for a specific study area. Next, you will re-run the classification using different parameters. Click **Tools > Dense Cloud > Reset Classification** and repeat the classify ground points process, but this time select different parameters than the default. Parameter definitions are:

 a. Max angle (degree): determines the maximum angle, in degrees, of a line drawn between the elevation/ terrain model and the candidate ground point.

 b. Max distance (meters): determines the maximum distance between the elevation/ terrain model and the candidate ground point.

 c. Cell size (meters): determines the cell size for which the point cloud will be divided in to in the classification process. Cell size selection can be guided by estimating or measuring the maximum area in the point cloud that does not contain any ground points.

7. To visually assess the point classification quality, you can toggle between viewing the dense cloud and the dense cloud classes by clicking **Model > View Mode** and making a selection. You may also view the points by filtering points to display a single class. This is a helpful way to determine if ground points are classified as non-ground and vice versa. To view only ground points, click **Tools > Dense Cloud > Filter by Class** and deselect all classes except Ground.

The ability of automated classifiers, such as the one you just used, to correctly classify all ground points is limited. Often, manual adjustments are required to assign some points to the correct class. For example, if you notice that some low-lying vegetation is incorrectly classified as ground, you may manually adjust the point class to Created (never classified).

8. To manually assign points to a specific class, select the points you want to reassign by using the selection tools (e.g., Model > Rectangle Tool), then click **Tools > Dense Cloud > Assign Points**. If you selected points that were incorrectly classified as ground points: select From: Ground and To: Created (never classified) and click **OK**. Adjust the "From" and "To" classes based on your specific class assignment need.

Another tool to assist with assessing the quality of the ground point classification is a mesh. A **mesh** is a polygonal model or wireframe of the ground points that will help you visualize the ground surface based on your classification. The quality of the classification becomes apparent when you create a mesh surface because you will be able to see a generalized surface model of the terrain.

9. To build a mesh, click **Workflow > Build Mesh**. Set the parameters as follows:

 a. Source data: Dense cloud

 b. Surface type: Height Field (used when modeling terrains based on aerial photography)

 c. Face count: Medium.

 d. Click the arrow next to Advanced and set Interpolation: Enabled.

 e. Click **Select** and deselect all classes except Ground.

10. Leave all other defaults, and click **OK** to build the mesh. To display the mesh output, double-click on the 3D Model item in the Workspace pane.

If you are satisfied with your ground point classification, proceed to the next section. If your mesh resulted in an unrealistic ground surface (i.e., obvious above-ground features are included as ground; see Figure 11.3), you can right-click the 3D model item and select **Remove Model**. Repeat Steps 6, 7, 8, or 9 until you are satisfied with your ground point classification.

Note: You have the option to export the different point classes from the classified point cloud. In this case, you have Ground and Created (never classified) classes. It may be desirable to export

which is why it is important to spend time selecting the right parameters during the point cloud classification step. There will likely be differences between DEM datasets created by different users based on the classification parameters in addition to any manual edits applied to the point cloud. In Part 2, you will use a provided classified SfM point cloud and DEM raster.

PART 2: MAPPING VEGETATION HEIGHT USING 3D DATA

There are two basic workflows that can be used to calculate the height of features in a 3D dataset, such as an SfM point cloud. The first method involves subtracting the DEM from all points that are classified as non-ground. This method results in a height above ground attribute for all non-ground points in the point cloud, and this height field can be used for additional modeling or analysis. The second method involves generating a digital surface model or DSM (a raster model that includes the largest z value, or highest recorded point, per raster cell). Subtracting a DEM from a DSM (i.e., DSM − DEM) will also result in a height above ground value, but unlike the first method where there was a height value for each point, in the second method there is only one height value per pixel. In this part of the exercise, you will use the first method to calculate different height values associated with fixed areas on the ground and store the values as an attribute in the point cloud shapefile.

Many studies that use 3D point data to estimate vegetation structure (e.g., vegetation height) rely on field-measured data to identify an empirical relationship between the characteristics of the point cloud height data and the vegetation measured in the field. Most often, the relationship between the two datasets can be modeled using **linear regression** (Equation 11.1). In its basic form, linear regression is used to examine if a set of independent measurements can be used to predict an outcome. Simple linear regression uses one variable as the independent measurement and takes the form:

$$\hat{y} = \beta_0 + \beta_1 x \qquad (11.1)$$

where \hat{y} is the predicted outcome, β_0 is the y-intercept, β_1 is the coefficient in the model that modifies x to best predict y (i.e., the slope of the line), and x is the independent measurement (i.e., a variable) used to predict \hat{y}.

To perform linear regression, you need two sets of data: the independent measurements (x) and the dependent measurements (y). For this part of the exercise, you will use height values calculated using the SfM point cloud and DEM for your independent measurements (x) and field measured vegetation heights as your dependent variable (y). By modeling the relationship between SfM heights and on-the-ground heights through linear regression, it is possible to then apply that relationship (i.e., the regression equation) to the remainder of the points in the SfM model t⁄ compute accurate height values.

The field measured vegetation heights used for this exercise were collected in Septembⁱ consisted of vegetation height measurements captured within sixteen, 20 m × 20 m plotʳ uted within a subsection of Freeman Center. Plot boundaries were established by reʳ center point coordinates of each plot with a high accuracy GPS unit and extending ₐ from the center point 20 m in each cardinal direction. The heights to the uppermⁱ trees located within each plot boundary were measured using a TruPulse 360ᶠ The mean vegetation height for each plot was calculated by summing all ⁱʳ within the plot and dividing by the number of trees in the plot. Median ₐⁱ heights were calculated as the middle and maximum heights measureʳ

Using linear regression to predict vegetation height is a useful ʳ identify a model where x (i.e., SfM-based height) does a good ⁱⁱ you measured in the field), you can then apply that model to a laₓ in the field. This is possible because you have SfM-based heights tᵤ. can use those heights to predict the vegetation heights in the field.

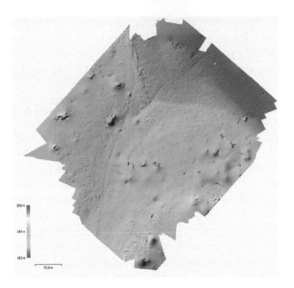

FIGURE 11.5 DEM raster created using ground points with default parameters.

ground points so they can be used in different geoprocessing environment to generate a DEM. Additionally, you can export the Created (never classified) points, which represent non-ground points. Non-ground points can be used to develop a different type of digital surface introduced in Part 2 of this exercise. To export points, click **File > Export > Export Points**. *Select the point class you want to export and the data type (i.e., txt, las, etc.). This step is not necessary for this exercise but is presented as an option for future analyses.*

Q2 Which classification parameters (i.e., max angle, max distance, and cell size) did you use to classify the point cloud? How did you determine which values provided acceptable results? Provide screenshots of the classified point cloud to help justify your answer.

EXERCISE 1.3: CREATING A DEM USING CLASSIFIED GROUND POINTS

In this exercise, you will create a DEM based on your classified ground points.

1. To create a DEM, click **Workflow > Build DEM** and use the following parameters:

 a. Source data: Dense cloud

 b. Interpolation: Enabled

 c. Point classes > click Select, and deselect all classes except ground

 d. Accept all other defaults and click **OK** to create the DEM.

 To view the DEM, double-click on the DEM item in the Workspace pane. To export your DEM, right-click the DEM item select **Export DEM > Export TIFF/BIL/XYZ**. Accept he default parameters, and click **OK** to save your DEM. See Figure 11.5 for an example of ·w the DEM should appear.

 is the spatial resolution of the DEM?

 w classified the SfM point cloud and used the ground points to generate a DEM. The 'assification process determines how the final DEM will look as well as the accuracy,

FIGURE 11.6 Example for importing *XY* data in ArcGIS.

Exercise 2.1: Importing SfM Points into a GIS and Calculating Their Height above Ground

Note: The steps below use ArcMap Desktop software. ArcGIS Pro or another GIS software (e.g., QGIS) can also be used for this portion of the exercise, but the interface and tools will be slightly different.

1. Open ArcMap and add the provided `SfM_DTM.tif` raster from the Part 2 Data Folder.

2. Add the `non_ground_points.txt` file to the map. Right-click on the file in the Table of Contents pane and select **Display XY data**. Specify the following in the dialog box (see Figure 11.6 for an example):

 a. X Field: Longitude

 b. Y Field: Latitude

 c. Z Field: Elevation

 d. For the Coordinate System of Input Coordinates, click Edit and select the XY Coordinate System tab. Click Projected Coordinate Systems > UTM > NAD 1983 > NAD 1983 UTM Zone 14N. Click **OK**

 e. Click **OK** in the Display XY Data window to run the process (this may take several minutes).

RASTERVALU	Height
211.001	-6.29056
211.001	-6.29056
211.001	-6.29056
211.001	-6.29056
211.004	-6.12911
211.004	-6.12911
211.004	-6.12911

FIGURE 11.7 Example of negative height values present in the attribute table.

3. After the data are imported, a layer named `non_ground_points.txt` is added to the Table of Contents. Right-click the layer, and select **Data > Export Data** and save the points as `non_ground_points.shp`.

The first step to calculate the height above ground of a non-ground point is to determine what the underlying DTM value is and then subtract that value from the Z values of the non-ground points. To do this, you will use the **Extract Values to Points** tool.

4. Go to **Spatial Analyst Tools > Extraction > Extract Values to Points**

5. Specify the following parameters:
 a. Input point features: `non_ground_points.shp`

 b. Input raster: `SfM_DTM.tif`

 c. Output point features: `point_heights.shp`

 d. Run the process. *Note: This may take several minutes since there are over 1 million values to extract.*

Once processing completes, you can calculate the height above ground of the non-ground points in the feature attribute table:

6. Right-click `point_heights.shp` in the Table of Contents window > **Open Attribute Table**.

 a. Click the Table Options icon at the top left and select **Add Field**. Add a new field named "Height" with a Float data type. Click **OK**.

 b. Right-click the new Height field and select **Field Calculator** (Calculate Field in Pro) and enter the expression:

    ```
    Height = Elevation - RASTERVALU.
    ```

 c. Click **OK** to calculate the height values.

7. Right-click on the Height field and sort the values in ascending order. You will notice some of the heights are negative (Figure 11.7). You do not want to include negative heights in your analysis, so you need to create a new selection containing only records with positive heights and then export those records to a new output shapefile. You will also notice that some of the values are –9999, which is the number ArcGIS uses for No Data. You do not want to include No Data values in your analysis, so you will also need to remove these records. To do this, you will use a **Select By Attribute** query.

8. Click the Table Options icon > **Select By Attributes**. Build a query to select points with heights greater than or equal to zero and Rastervalu not equal to -9999. Your query should resemble the one below (it may be slightly different if you are working in a different GIS software).

<div align="center">

`"Height" >= 0 AND "RASTERVALU" <> -9999`

</div>

9. Click **OK** to run the query. Check to make sure only points with positive height values are selected and points with the No Data signifier in RASTERVALU (-9999) are not selected.

10. Save the selected points to a new file by right-clicking the `point_heights.shp` layer in the Table of Contents and selecting **Data > Export Features**. Name the output file `point_heights_filtered.shp` and click **OK**.

Q4 Why do you think negative height values occurred in the dataset?

Q5 What processing steps can you take to minimize negative heights?

EXERCISE 2.2: ASSOCIATING PLOT ID WITH SfM POINTS AND CALCULATING HEIGHT METRICS

The plot center points collected with a high accuracy GPS unit and described in the introduction of Part 2 were used to create plot envelopes (i.e., a square buffer). Plot envelopes were created by first buffering the GPS-collected plot center points by 10 m and then using the **Feature Envelope to Polygon** tool to create square features that corresponded to the geometry of plot measurements in the field. After the plot envelopes were created, three new fields were added to the attribute table, and the mean, maximum, and median heights of the field-measured data were entered manually for each plot (denoted by PLOT_ID). The plot envelopes with vegetation height attributes allow you to associate the point heights from the SfM data with the actual height values measured in the field.

1. Add the file `plot_envelopes_with_field_data.shp` to ArcMap.

2. Open **Analysis Tools > Overlay > Intersect**. The Intersect tool computes the geometric intersection of the input features and writes the attributes of all features to the output. In this case, you will have an output that associates the Plot ID with every height record. Specify the following parameters in the Geoprocessing window:

 a. Input features: `point_heights_filtered.shp` and `plot_envelopes_with_field_data.shp`

 b. Output feature class: `heights_by_plot.shp`

 c. Output type: POINT

 d. Accept all other defaults and click **OK** to run the process

3. Open the `heights_by_plot.shp` attribute table and export it as "heights_by_plot.csv".

Q6 The SfM-based heights that you calculated earlier now have an attribute called Plot ID. Why do the point heights need to be associated with the field measured heights for each plot?

You are now ready to prepare the data in a spreadsheet to calculate height-based metrics that you will use as independent variables in a simple linear regression. The steps here are based on

FIGURE 11.8 Example of pivot table field designations.

Microsoft Excel, but this portion of the analysis can be completed in any spreadsheet software program.

4. Import `heights_by_plot.csv` into Microsoft Excel (or another spreadsheet software). You may need to specify a delimiter to parse the data into their respective columns (e.g., comma delimiter). Once you import the data, you can delete all columns except Height, PLOT_ID, FIELD_MEAN, FIELD_MAX, and FIELD_MED. Once the columns are deleted, save the file as a workbook (i.e., .xls, .xlxs, or similar).

5. The height records need to be organized by Plot ID to calculate height-based metrics. There are several methods to do this, but for this exercise, you will create a pivot table and calculate basic height metrics that you can assume are reasonably associated with the field measurements (e.g., maximum SfM height with maximum field measured height).

6. Click **Insert > PivotTable** and select the entire range of data. Specify a new worksheet for the output pivot table and click **OK**. Rename the worksheet to "PivotTable."

7. Click the tab for your new **PivotTable** worksheet. In the PivotTable fields window, click PLOT_ID and drag it to the Rows window. Now select the Height field and drag it to the Values window.

8. Your values window may say, *Sum of Height*. Click the drop-down arrow in the Values window and select *Value Field Settings*. Select *Summarize Values by Average* and click **OK**.

9. Repeat this process with the following settings (Figure 11.8):

 a. Drag Height to the Values window and summarize by Max.

 b. Drag FIELD_MEAN to the Values window and summarize by Mean.

 c. Drag FIELD_MAX to the Values window and summarize by Max.

10. Your final pivot table should have five columns, Row Labels (i.e., plot IDs), Max of Height, Mean of Height, Mean of MED_HT, and Max of MAX_HT. Copy and paste the data in the pivot table to a new worksheet. Rename the worksheet "Height Estimates."

Q7 Why do you think height metrics such as SfM-mean, and SfM-maximum can be reasonably correlated to vegetation height values measured in the field?

Q8 What other SfM-based height metrics could be calculated and used as independent variables in the regression model to improve the ability of the model to estimate height?

Exercise 2.3: Performing Simple Linear Regression and Applying Height Estimate Models to the Entire Study Area

1. Select the data in the Max of Height column (this is the maximum height for each plot in from your SfM data) and the data in the Max of FIELD_MAX column (this is the maximum height for each plot based on field measurements). With the data selected, click **Insert > Insert Scatter XY chart**.

2. Your chart is a scatterplot with the SfM-based height metric (the independent variable) on the *X*-axis and the field measured maximum height (the dependent variable) on the *Y*-axis. Place the cursor on one of the data points in the chart, right-click and select **Add Trendline**.

3. In the Format Trendline window, check the two boxes for **Display Equation** on chart and **Display R-squared value** on chart.

4. Rename your chart "Model for Maximum Height" and label the axes.

5. Repeat Steps 1–4, except this time select *Average of Height* and *Average of FIELD_MEAN* as the data columns. Name the chart "Model for Mean Height."

6. You now have two regression equations that can be used to predict height estimates across the entire study area. Write down the model equations for Maximum Height and Mean Height and return to ArcMap.

7. In ArcMap, go to **Spatial Analyst Tools > Neighborhood > Point Statistics**, enter the following parameters and then click OK to run the process:

 a) Input point features: `point_heights_filtered.shp`

 b) Field: Height

 c) Output raster: `maximum_height_metric.tif`

 d) Output cells size: 20 m

 e) Neighborhood: 20 x 20 rectangle

 f) Statistics type: Maximum

 g) Units type: Map

8. Repeat Step 7 to generate a `mean_height_metric.tif` raster. Use the same settings except select Statistics type as **Mean** instead of Maximum.

9. Now that you have two height metric layers, you can use the Raster Calculator to estimate mean and maximum heights for the entire study area. In Spatial Analyst Tools, click **Map**

maximum_height_estimate.tif

Value
- 16.9495
- 9.91644
- 2.88339

FIGURE 11.9 Example raster output of maximum height model.

Algebra > Raster Calculator, enter the model expression from the simple linear regression for Maximum Height (e.g., `0.4792 * max_height_metric.tif + 2.2061`), specify the output raster as `maximum_height_estimate.tif`, and click **OK** to run the process. See Figure 11.9 for an example of how the output should appear.

10. Repeat Step 9, but this time enter the model expression for Mean Height and specify the output raster as `mean_height_estimate.tif`.

Q9 What were the model equations and R^2 values for the mean and maximum height models?

DISCUSSION AND SYNTHESIS QUESTIONS

S1 Before generating SfM models, you should always inspect the individual aerial photos for overlap and angles. Are there any areas of the study area that are not well covered? Are there any other issues you have noticed with this dataset and modeling effort? Use the Agisoft Metashape report that can be generated through **File > Export > Generate Report** to support your answer.

S2 The UAS-collected aerial images were not captured in a systematic fashion (you can turn on cameras in Agisoft Metashape to view camera locations). Discuss the advantages and disadvantages of capturing images in a systematic flight pattern.

S3 Now that you have examined the SfM model results in this densely vegetated study area, discuss some of the difficulties of modeling vegetation using the UAS-SfM approach.

S4 Consider and discuss the pros and cons of the SfM processing workflow (e.g., what features were originally intended to be modeled with SfM). Provide screenshots of specific problem areas in the resulting point cloud to illustrate your points.

S5 A DTM should be smooth and represent only the bare Earth surface. Discuss any problems with automatically generating a bare-Earth DEM/ DTM from a UAS-SfM generated point cloud in a moderate- to densely vegetated area (see Figure 11.4 as an example).

S6 Some studies use height metrics that are calculated above a specified height threshold (e.g., 1.0 m). Explain how setting such a threshold might influence the height metrics you calculated and in what situations this might be useful.

S7 How does DEM/DTM accuracy affect both height metrics and the final model estimates? Discuss how the height estimates you mapped for the study area can be validated.

ACKNOWLEDGMENTS

The images used in this chapter were originally collected for research conducted by the authors (Jensen and Mathews 2016). Readers are directed to this publication to learn more about vegetation canopy analyses using the UAS-SfM approach. The authors thank John Klier for help acquiring the aerial images as well as Ethan Roberts and Caleb Jensen for assistance with field-based vegetation data collection.

REFERENCES

Carrivick, J.L., Smith, M.W., & Quincey, D.J. (2016). *Structure from Motion in the Geosciences.* Chichester, UK: Wiley-Blackwell.

De Souza, C.H.W., Lamparelli, R.A.C., Rocha, J.V., & Magalhães, P.S.G. (2017). Height estimation of sugarcane using an unmanned aerial system (UAS) based on structure from motion (SfM) point clouds. *International Journal of Remote Sensing*, 38, 2218–2230.

Fonstad, M.A., Dietrich, J.T., Courville, B.C., Jensen, J.L., & Carbonneau, P.E. (2013). Topographic structure from motion: a new development in photogrammetric measurement. *Earth Surface Processes and Landforms*, 38, 421–430.

Jensen, J.L., & Mathews, A.J. (2016). Assessment of image-based point cloud products to generate a bare earth surface and estimate canopy heights in a woodland ecosystem. *Remote Sensing*, 8, 50.

Mongus, D., & Žalik, B. (2012). Parameter-free ground filtering of LiDAR data for automatic DTM generation. *ISPRS Journal of Photogrammetry and Remote Sensing*, 67, 1–12.

Okuda, T., Yamada, T., Hosaka, T., Miyasaku, N., Hashim, M., Lau, A.M.S., & Saw, L.G. (2019). Canopy height recovery after selective logging in a lowland tropical rain forest. *Forest Ecology and Management*, 442, 117–123.

van Iersel, W., Straatsma, M., Addink, E., & Middelkoop, H. (2018). Monitoring height and greenness of non-woody floodplain vegetation with UAV time series. *ISPRS Journal of Photogrammetry and Remote Sensing*, 141, 112–123.

Wolf, J., Brocard, G., Willenbring, J., Porder, S., & Uriarte, M. (2016). Abrupt change in forest height along a tropical elevation gradient detected using airborne lidar. *Remote Sensing*, 8, 864.

12 Assessing the Accuracy of Digital Surface Models of an Earthen Dam Derived from SfM Techniques

Gil Gonçalves, José Juan Arranz Justel, Sorin Herban, Petr Dvorak, and Salvatore Manfreda

CONTENTS

LEARNING OBJECTIVES

Unmanned aircraft systems (UAS) equipped with an optical camera are a cost-effective strategy for topographic surveys. These low-cost UAS can provide useful information for three-dimensional (3D) reconstruction even if they are equipped with a low-quality navigation system. To ensure the production of high-quality topographic models, careful consideration of the flight mode and proper distribution of ground control points (GCPs) are required.

This exercise explores the influence of the spatial distribution and number of GCPs and flight configuration on the accuracy of the Digital Surface Model (DSM) of an earthen dam derived from UAS imagery. A commercial UAS was used to capture data over a small earthen dam using different combinations of flight configurations and by adopting a variable number of GCPs. After completing this chapter, you will be able to:

1. Understand how the optimization of both the choice and combination of flight plans can reduce the error of a 3D model to less than 2 m without using GCPs.

2. Evaluate the use of GCPs for improving the quality of the 3D model to reduce error to the order of a few centimeters.

3. Demonstrate how the combined use of images extracted from two flights, one with a camera mounted at nadir and the second with the camera tilted at an angle can be beneficial for increasing the overall and vertical accuracy of a 3D model.

HARDWARE AND SOFTWARE REQUIREMENTS

1. Spreadsheet software (e.g., Microsoft Excel, Google Sheets, or open-source Calc)
2. Agisoft Metashape Professional
3. Either QGIS (open-source GIS software) or ArcGIS
4. The data folder for this chapter, which includes:
 - `Flight1` folder with 63 images
 - `Flight2` folder with 77 images
 - `Flight3` folder with 86 images
 - GCPs folder containing a CSV file `PISCHIA_orthometric.csv` with projected coordinates of the GCPs and an image `plan.pdf` with the spatial locations of the GCPs
 - A python script `add_altitude_to_reference.py` to adjust the flight altitude values in the images.
 - A shapefile `CheckPoints.shp` of the GCPs
 - `Readme` file with additional details on the datasets

INTRODUCTION

Digital surface models (DSMs) have traditionally been generated using terrestrial or aerial surveys (e.g., aerial photogrammetry and laser scanning), which can be time-consuming, difficult to plan and process, and costly (Cook et al. 2013). Advances in GPS and digital camera technologies have reduced costs and increased efficiency for using aerial photogrammetry, which has significantly improved the quality of DSMs (Kraus and Waldhausl 1993; Luhmann et al. 2006; Mikhail et al. 2001). Furthermore, technological miniaturization, in general, has further reduced the costs of aerial photogrammetry and derived products with the introduction of UAS, which are becoming increasingly popular for mapping and surveying (Manfreda et al. 2018). UAS equipped with GPS and optical cameras are low-cost alternatives to traditional manned aerial photogrammetry, especially for short- and close-range applications (Nex and Remondino 2014).

The introduction of Structure-from-Motion (SfM; see Chapter 6 for an overview) has led to a significant revolution in the field, where any researcher or user can afford high-resolution topographic reconstruction for even low-budget research and applications (Westoby et al. 2012). The SfM workflow can produce high-quality orthoimagery and surface models (e.g., DSM, DEM, etc.) at high spatial resolution – on the order of centimeters (Colomina and Molina 2014; Whitehead et al. 2014), which is crucial for many applications, especially for change detection studies (Clapuyt et al. 2016; Lucieer et al. 2014). One of the main benefits of SfM and multi-view stereo (SfM-MVS) algorithms is that they allow high-resolution DSMs and orthomosaics to be created without prior information on camera parameters, such as focal length or radial distortion. Software to implement these algorithms is relatively inexpensive as well, allowing for a flexible and low-cost alternative to traditional photogrammetric methods and enabling high temporal frequency and optimal timing of the missions (Kraus et al. 1997; Westoby et al. 2012).

A drawback of using SfM-MVS methods is that the accuracy of the derived DSMs can be highly variable, and the causes of this variation are still not fully understood (Smith and Vericat 2015). A number of factors affect the precision and accuracy of UAS-derived orthoimagery and surface models, such as flight parameters (e.g., elevation above ground level [AGL]), flight speed, flight direction, camera orientation, the focal length of the camera), image quality, processing software, the morphology of the studied area, and the type of UAS platform (i.e., fixed or rotary wing). For instance, short focal length lenses used for low altitude flights can introduce considerable geometric distortion into UAS-derived imagery, compromising the accuracy of products derived from the images. Studies suggest that appropriate settings can reduce the positioning error of SfM-MVS products (James et al. 2017), but processing workflows and accuracy assessment methodologies need to be optimized and standardized (Carrivick et al. 2016; Ridolfi et al. 2017; Tmušić et al. 2020).

In this context, ground control points (GCPs) are commonly used to increase the precision of SfM-MVS products, even though their placement and collection can be one of the most laborious and time-intensive parts of a UAS data collection campaign. At a minimum, three GCPs are necessary to allow the SfM-MVS algorithms to take advantage of the positioning information they provide. However, the optimal number of GCPs needed to generate a surface model with a specific level of quality is still uncertain.

The literature offers a wide range of choices for the number and spatial distribution of GCPs used to support SfM-MVS algorithms. For example, James et al. (2017) recommend a minimum of four to five GCPs and emphasize accurate camera calibration. They showed that a high Root Mean Square Error (RMSE) when using three GCPs decreased markedly with six GCPs, especially when considering the vertical component. Singh and Frazier (2018) analyzed approximately 66 studies that reported the use of GCPs and were not able to identify a discernible relationship

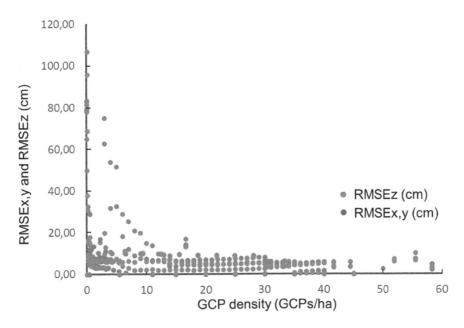

FIGURE 12.1 Horizontal and vertical accuracies of digital surface models (DSMs) in root mean squared error (RMSE) as a function of the ground control point (GCP) density. This figure was developed using data extracted from the literature referenced above. [Adapted from Manfreda et al. 2019].

between the number of GCPs and the size of the study areas selected. They did identify a weak, negative relationship between the number of GCPs collected per hectare and the RMSE, but with considerable variation. A selection of several publications dealing with the impact of GCPs, in terms of configurations and numbers, on DSM quality is reported in Manfreda et al. (2019).

By extracting the data contained in a set of studies (Aguera-Vega et al. 2017; Cryderman et al. 2014; Gómez-Candón et al. 2014; Hugenholtz et al. 2013; James and Robson 2014; Koci et al. 2017; Küng et al. 2011; Lucieer et al. 2014; Mancini et al. 2013; Oniga et al. 2018; Rock et al. 2011; Tahar 2013; Uysal et al. 2015), we charted the relationship between the measured planar and vertical RMSE as a function of the GCP density (Figure 12.1). The graph shows a clear trend whereby DSM accuracy tends to increase with the number of GCPs until an asymptotic relationship is reached. In most cases, the errors observed for vertical precision are higher compared to horizontal precision. The horizontal errors tend to stabilize after reaching 5 GCPs/ha, whereas 10–15 GCPs/ha are needed to reach the same accuracy for vertical precision. This review offers useful information about optimizing the number of GCPs. However, the synergic effects of their number and spatial arrangement, as well as flight characteristics, are not yet fully understood (Clapuyt et al. 2016; Gómez-Candón et al. 2014; Küng et al. 2011). Optimizing UAS campaigns is therefore an important step toward improving the effectiveness and reliability of UAS-derived products.

In this exercise, you will explore the impact of both UAS flight characteristics (e.g., altitude, camera tilt, and flight plan) and GCP density on the accuracy of 3D surface models of an earthen dam. The analyses you will perform are intended to demonstrate how you can increase the reliability of DSMs, which provide critical information in many applications including environmental and hydrological science. The exercises are based on the recent outcomes from work by Manfreda et al. (2019).

STUDY AREA AND DATA COLLECTION

The survey will be executed in an area with an earthen dam next to a village called Pişchia, located 20 km northwest of Timisoara in Western Romania (Figure 12.2). The Pişchia dam,

FIGURE 12.2 Study area location in Pişchia village, which is located about 20 km northwest of Timisoara in Western Romania.

managed by the Romanian National Water Administration, has a volume of approximately 500,000 m³, which is used to supply drinking water and for recreational activities. The retention basin formed by the earthen dam has a trapezoidal cross-section with a side slope of 1:3 and a maximum elevation of about 10 m. The surrounding area is characterized by agricultural land with gentle slopes.

The data used in this exercise are described below. If you would like to capture your own data, follow the parameters detailed here for a study site of your choosing. It is best if the study area has some relief, such as a steep hill or other topographic gradient.

Flights were performed with a DJI Phantom 4 Pro quadcopter, featuring a gimbaled, 1-inch 20-megapixel CMOS sensor with a mechanical shutter. The lens focal length was 24 mm (full-frame equivalent). The data were stored in 24-bit JPG format, and the pixel size was 2.41 μm. The camera sensitivity was set to ISO100 for all images, with the aperture ranging from 4 to 5.6 and the shutter times ranging between 1/120 and 1/500s. All images were georeferenced with an on-board GPS. The WGS84 coordinates were stored in JPG EXIF. Mission planning was executed in Pix4Dcapture, which enabled control of the camera tilt. All six flights were performed on April 4, 2018, between 10:00 a.m. and 1:00 p.m. UTC. Flight missions were planned with a front and side overlap of 80% and 60%, respectively.

The GCP positions were determined using a Leica 1200 system RTK (Real-Time Kinematic) GNSS (Global Navigation Satellite System) rover (Leica Geosystems AG, Heerbrugg, Switzerland) and a precise Leica 1201 Total Station to achieve a precision better than 3 mm for all GCPs. To determine a geodetic base, corrections were acquired from the Romanian Position Determination System (ROMPOS) network of GNSS permanent stations. The study area where determinations were realized is located approximately 18 km from the TIM1 reference station (http://rompos.ro/index.php/en/).

To explore the impact of mission planning on the overall accuracy of UAS-derived DSM, the data were collected with different flight plans that included changing the flight trajectories, camera tilt, and flight elevation. Flight characteristics are summarized in Table 12.1. Other parameters, such as camera settings and additional mission flight settings (e.g., overlap), were kept constant according to the details provided above. The reference elevation in Table 12.1 refers to the elevation at the take-off location, which was about 14 m AGL.

Flights covered an area of approximately 100 m × 270 m (Figure 12.3). For this exercise, only a portion of the dam will be studied using the 16 GCPs distributed along the main structure of the dam and in the adjacent agricultural areas (Figure 12.3a). The GCPs were placed along five

TABLE 12.1
Characteristics of the Three Different Flight Surveys Carried Out for the Study Area

Flight	Flight Plan	Take-off AGL (m)	Average AGL (m)	Camera Tilt (degree)	Average GSD (cm/pix)	Number of Images
1		60	74	0	1.9	63
2		60	74	0	1.9	77
3		60	74	20	2.0	86

FIGURE 12.3 (a) Distribution of the ground control points (GCPs) throughout the study area, represented by the red boundary, and (b) UAS-derived DSM of the area showing the elevational gradient. [Adapted from Manfreda et al. 2019].

FIGURE 12.4 Orthomosaic and images of the central part of the dam acquired during flight. (a) 16 GCPs overlaid on the orthomosaic. The same area is shown for (b) Flight 1, (c) Flight 2, (d) Flight 3. (e)–(g) A ground control point (GCP #1) is magnified in each image. [Adapted from Manfreda et al. 2019].

longitudinal alignments to capture the full range of elevation changes in the dam. The maximum vertical variation of the GCP positions was about 10.6 m.

Examples of the images obtained by different configurations are shown in Figure 12.4. The same feature is shown in all six photos, but the flight plans and camera angles are different. The outlet tower and spillway of the dam can be identified from these images.

PART 1: EVALUATING 3D MODEL ACCURACY USING ONLY THE GEOTAGGED IMAGES

In Part 1, you will focus on using only the geotagged images, without GCPs, to create a DSM. The measured GCPs will be adopted only as checkpoints to validate the results. Elaboration without the GCPs will allow you to better understand the role of the flight mode and the combination of different flights on the resulting DSM. This is completed by first exploring DSM accuracy using imagery extracted from a single flight and then by combining images from multiple flights. The resulting combinations will display a wide variability in the precision of planar coordinates and elevation. This preliminary analysis will allow you to identify the best performing flight configuration and the benefits of combining flight patterns for accuracy.

Exercise 1.1: Evaluate the Accuracy of a 3D Model Derived from Flight 1

1. Open Agisoft Metashape and add all of the images taken during Flight 1 (located in the `Flight1` folder) to Chunk 1 by clicking **Workflow > Add Photos**.

2. Switch from the Workspace panel to the Reference panel (tabs are at the bottom) and click the Import Reference icon (the first icon under Reference that looks like a spreadsheet with folder). Navigate to where your data are stored and open the GCP file `PISCHIA_ orthometric.csv` (located in the folder called `GCPs`). The values in the .csv file are delimited with a semicolon. When prompted, select Semicolon under **Delimiter** (you can also select Other and type in ";"). Under **Coordinate System**, type 3844, which is the EPSG code corresponding to the Pulkovo 1942(58)/ Stereo 70 map coordinate system. Leave all other options as the default and click **OK**. When prompted to create new markers, click **Yes to All**.

3. Navigate back to the Workspace window. Right click on **Chunk 1 > Reference Settings**. Set the three coordinate systems in the following manner, and click **OK** when you are finished.

 a. Coordinate System as EPSG::3844
 b. Camera reference as EPSG::4326
 c. Marker reference as EPSG::3844

4. Open the **Tools menu > Run Script**. Navigate to the dataset folder and select the Python file `add_altitude_to_reference.py`. Leave the Arguments field blank if prompted, and click **OK**. If the script fails to run, see the note below. Otherwise, a new menu item called "Custom menu" is added to the toolbar at the top of your Metashape screen.

Note: If the Run Script fails, it is likely because the Metashape version you have installed does not match the compatible version in the script. If this happens, open the `add_altitude_to_ reference.py` *script with a text editor and change the* `compatible_major_version = "1.6"` *to the major version of Metashape you have downloaded. You can check the Metashape version under Help.*

5. Go to **Custom Menu > Add reference altitude** and type in "70" as the height to be added. This script will shift the altitudes of the geotagged images by a constant value of 70 m. The reason for this shift is because the Romanian vertical system and corresponding geoid "Sistem de altitudini Marea Neagra 1975" (Black Sea 1975) is not available in Metashape. Therefore, it is necessary to add a vertical shift (about 70 m) to the altitudes geotagged by the DJI Phantom 4 pro. This vertical shift will compensate for the differences between the vertical datums of the two coordinate systems (EPSG::4326 and EPSG::3844) and for the fact that DJI Phantom 4 Pro recorded uncalibrated barometric altitudes.

6. Next, align the images (**Workflow > Align Photos**) using the following parameters:

 a. Accuracy: Medium
 b. Generic preselection: checked
 c. Reference preselection: checked (select Source)

 Under Advanced (click the dropdown arrow):

 d. Key point limit: 40,000
 e. Tie point limit: 4,000
 f. If Adaptive camera model fitting is checked, uncheck it.
 Click **OK** when you are finished. This step may take a few moments.

7. Next, build the dense cloud (**Workflow > Build Dense Cloud**). Metashape uses the estimated camera positions, obtained in the previous step, to compute the depth maps of each image. These depth maps will be filtered and then combined into a single dense cloud.

 a. Accuracy/Quality: Medium
 b. Under Advanced: Depth filtering = Aggressive
 c. Uncheck Calculate point colors. You do not need a colored 3D point cloud

Note: This step can take quite a bit of time (depending on your CPU), so be sure to plan accordingly. Make sure that you have activated your GPU if necessary.

8. Build the DSM (**Workflow > Build DEM**) using a Geographic Projection (EPSG::3844) and accept the default parameters:

 a. Projection: Geographic (EPSG::3844)
 b. Source data: Dense cloud
 c. Interpolation: Enabled
 d. Point classes: All

Q1 What is the spatial resolution of the DEM?

9. Build the Orthomosaic (**Workflow > Build Orthomosaic**)

 a. Surface: DEM
 b. Blending mode: Mosaic (default)
 c. Check Enable hole filling

10. Export the DSM to a geotiff file (**File > Export > Export DEM > Export TIFF**). Use a pixel size of 0.075 m, and leave all the other defaults.

11. Export the Orthomosaic to a geotiff file (**File > Export > Export Orthomosaic > Export JPG/TIFF**). Use a pixel size of 0.05 m, and leave all the other defaults.

The DEM and orthomosaic you just created were generated without any ground control reference. You will now add ground control information by geotagging three of the Ground Control Points (GCPs) in the image block. This process requires some patience but is a useful skill.

12. Locate the GCPs labeled 1, 19, and 24 in the model window. Right-click on the first GCP (#1) and select **Filter Photos by Marker**. This command filters the photos in the **Photos** window to only show those containing the corresponding GCP.

13. Double-click on a photo to display it in the main window. Move the marker to the center of the GCP target by clicking and dragging it into position. You may need to zoom in considerably to see the target. The further in you zoom, the more accurate your georeferencing will be.

14. Repeat the above step for at least 10 images, but the more images on which you move/ verify the marker the better your results will be. Either double-click on the images or use the Page Up and Page Down keys to move between photos. After geotagging a point in an image, update the Bundle Block Adjustment using the **Update Transform** button in the Reference panel (it looks like a refresh icon). When you are finished editing the markers for GCP #1, move to the next marker. Repeat the process for all three of the GCPs (#1, #19, #24) in the image block. If you are having trouble selecting a GCP, you can try highlighting it in the Reference window instead of the Model window. Be sure to click the **Update Transform** button in the Reference panel after each.

Q2 Why do some of the targets in the images appear smaller than others even though all of the targets are the same size?

15. Since you will not be using the GCPs to georeference the model in this part of the exercise, uncheck all of the GCPs in the Reference Panel. *Note: The three GCPs you tagged will still be used as Checkpoints (CPs) and can still be used to measure model accuracy, they just are not being used to georeference the model.* Update the Markers reference table by clicking the **Update Transform** button on the Reference pane toolbar. You will notice that the Error values of the three GCPs changed.

16. Go to **File > Export > Generate Report** to save a report that contains the basic parameters of the project, processing results, and accuracy evaluations. Save the report in a location you can access, open the report, and find the **Ground Control Points** section. Copy Table 5, which reports the errors for the three checkpoints (1, 19, and 24), into a spreadsheet.

The horizontal accuracy of the model expresses the absolute DSM accuracy in the X and Y dimensions and can be measured through root mean square error (RMSE) based on the three checkpoints where:

$$RMSE_{X,Y} = \sqrt{RMSE_X^2 + RMSE_Y^2}$$

The vertical accuracy ($RMSE_Z$) expresses the absolute vertical DSM accuracy. The total (horizontal + vertical) error can be computed as the total RMSE of the model:

$$RMSE_{Total} = \sqrt{RMSE_{X,Y}^2 + RMSE_Z^2}$$

Q3 Compute the horizontal RMSE (X, Y error) and vertical RMSE (Z error) accuracies for the 3D Model you just generated using the values found in Table 5 of the report. It is recommended you copy the values from Table 5 into Excel or another spreadsheet software and set up your calculations there. Having the spreadsheet set up will make it easier to perform a similar step later on in the chapter. You can check your answers against the values reported in Table 4 to ensure your calculations ran correctly.

Q4 Compute the *relative* vertical accuracy of the 3D Model. To do this, copy the absolute values from the Z error column in Table 5 into a spreadsheet software. Subtract the minimum Z value from each value in the Z error column, sum the values, and divide by the number of rows (i.e., the number of checkpoints).

Q5 Compute the Total error ($RMSE_{Total}$) for the 3D model derived from Flight 1 in your spreadsheet. You can check your answers against the value reported in Table 4.

17. Save the Metashape project file, and save your spreadsheet file. You will need these later on.

EXERCISE 1.2: EVALUATE THE ACCURACY OF A 3D MODEL DERIVED FROM FLIGHT 2 AND FLIGHT 3

1. Open a new Agisoft Metashape project

2. Repeat the steps from Exercise 1.1, but this time use the images taken during Flight 2 and Flight 3 (add all photos from the `Flight2` and `Flight3` folders into one project). You do *not* need to answer Q1–Q5 for this exercise. When you are finished processing, move on to Q6.

Note: This step can take quite a bit of time (depending on your CPU and GPU), so be sure to plan accordingly.

Q6 Compute and report the horizontal, vertical, relative vertical, and total accuracy of the 3D model derived from the model created by combining the Flight 2 and Flight 3 images.

Q7 Create a bar plot comparing the RMSE values (horizontal, vertical, relative vertical, and total) for the two different flight combinations (Flight 1 vs. Flights 2 & 3) you processed above. Which model had the highest horizontal accuracy? Vertical accuracy? Total accuracy? Discuss how flight configuration influenced model accuracy in the absence of GCPs. Refer back to Table 12.1 for the flight configurations.

PART 2: EVALUATING THE IMPACT OF GCP DENSITY AND DISTRIBUTION ON DSM ACCURACY

GCPs can be incorporated into the 3D model creation process to improve quality during the Bundle Block Adjustment step of SfM-MVS processing. The optimal number and distribution of GCPs per unit study area is not universally agreed in the literature, as highlighted in the introduction (Oniga et al. 2018; Singh and Frazier 2018). However, the number of GCPs necessary for the survey will be influenced by the aim of the survey, extent of the study area, topography, camera, and internal GPS precision.

In the next exercise, you will analyze the combined Flights 2 and 3 to evaluate how GCP density and distribution impact DSM accuracy. For this analysis, the 16 GCPs will be split into different sets that will be used for georeferencing and testing the accuracy of the model. This analysis is useful for understanding the benefits of combining flight images and well-designed GCP distribution. Proper use of the two can enhance the quality of DSMs generated through SfM-MVS algorithms.

EXERCISE 2: EVALUATE THE VERTICAL ACCURACY OF THE DSM GENERATED USING FLIGHTS 2 AND 3 WITH A VARIABLE NUMBER OF GCPS

1. Open the Metashape project from Exercise 1.2 (Flights 2+3).

2. Go to the reference panel and check the boxes next to markers #1, #19, and #24 as GCPs. Update the project.

3. Rebuild the Dense point cloud with "Medium Quality" and "Aggressive Depth filtering." *Note: It is worth noting that this step is only needed if the camera optimization step has also not been taken.*

4. Rebuild the DSM using a Geographic Projection (EPSG::3844) and the default parameters:

 a. Source data: Dense cloud
 b. Interpolation: Enabled
 c. Point classes: All

5. Export the DSM as a GeoTIFF file called "DSM1" and use a pixel size of 0.075 m.

Next, you will re-build the DSM using a different set of five GCPs.

6. Duplicate the Chunk (right-click on the **Chunk > Duplicate**) and copy only the Key Points and Depth Maps. Make the new Chunk active by double-clicking it.

7. Repeat Steps 12–14 from Exercise 1.1, but this time geotag GCPs #3 and #23. Remember to update the Bundle Block Adjustment using the **Update Transform** button in the Reference panel (looks like a refresh icon).

8. In the **Reference** panel, mark points #1, #3, #19, #23, and #24 as GCPs.

9. Rebuild the Dense point cloud with "Medium Quality" and "Aggressive Depth filtering."

10. Rebuild the DSM using a Geographic Projection (EPSG::3844) and the same default parameters as before:

 a. Source data: Dense cloud
 b. Interpolation: Enabled
 c. Point classes: All

11. Export the DSM as a GeoTIFF file called "DSM2" and use a pixel size of 0.075 m.

This time, you will re-build the DSM using a different set of seven GCPs.

12. **Duplicate** the Chunk and copy only the Key Points and Depth Maps. Make the new Chunk active by double clicking it.

13. Repeat Steps 12–14 from Exercise 1.1, but this time geotag points #6 and #25. Remember to update the bundle block adjustment using the Update Transform button in the Reference panel (looks like a refresh icon).

14. Go to the **Reference** panel, and this time mark 1, 3, 6, 19, 23, 24, and 25 as GCPs.

15. Rebuild the DSM using a Geographic Projection (EPSG::3844) and the same default parameters:

 a. Source data: Dense cloud
 b. Interpolation: Enabled
 c. Point classes: All

16. Export the DSM as a GeoTIFF file called "DSM3" and use a pixel size of 0.075 m.

17. Save the project in Agisoft Metashape.

18. Open a GIS software program (e.g., QGIS or ArcGIS) and load in the three DSMs you created in this Exercise. You will extract the height values from the DSMs to the checkpoints so that you can compute vertical errors on your own. Detailed instructions for doing this in ArcGIS and QGIS are below.

In ArcGIS:

a. Load the three DSMs you generated and the `CheckPoints.shp` file from the data folder

b. Use the **Extract Values to Points** tool to extract the height values from the first DSM to the `CheckPoints.shp` points

c. The output feature class will have a new field added to the Attribute Table called RASTERVALU. You need to rename this field otherwise the next time you run the tool for the second DSM the values will be overwritten. ArcGIS does not have a straightforward way to rename a field. Instead, add a new field, name it "DSM1," and use the **Field Calculator** (right-click column heading) to copy the values from RASTERVALU to the new field (the new values = RASTERVALU).

d. Repeat this process for the remaining two DSMs. At the end, you should have three additional columns in your `CheckPoints.shp` attribute table: DSM1, DSM2, DSM3

e. Export the attribute table to an Excel file (or other spreadsheet software).

In QGIS:

a. Install the Point sampling tool in QGIS (Plugins > Manage and Install Plugins > All > Point sampling tool)

b. Create a new project and import the DSM

c. Import the CSV file containing all the GCPs (Layer > Add Layer > Add Delimited Text Layer). Be sure to configure correctly the **X Field**, **Y Field**, and the **CRS** entries.

d. Interpolate the DSM heights of the new point layer created in the previous step. To do that go to **Plugins > Analyses > Point Sampling Tool**. Choose the DSM raster file to interpolate the Z values. In order to get the point number and the correct Z value (i.e., the orthometric height obtained by the GNSS survey) in the attribute table it is necessary to choose the field_1 and field_4, respectively.

e. Export the attribute table to an Excel file. Open the attribute table of the geopackage point layer created in the previous step. Select the table and paste the contents to a new empty Excel file (or other spreadsheet software).

19. Compute the error for each checkpoint in each DSM by subtracting the DSM height from the checkpoint height (`Z_Value`). You will have three new columns of data representing the difference (Z error) between the checkpoint heights and the DSM heights.

Q8 For each of the three DSMs, Compute the $RMSE_Z$ using the equation below, where Z_{error} is the difference in value between the height of the DSM and the height of the checkpoint. You

will square each Z error value and sum the squares across all of the checkpoints. *Note: Use only the points that were NOT used to georeferenced the model (e.g., for DSM1, do NOT include 1, 19, and 24 in your RMSE calculation; for DSM2, do NOT include 1, 3, 19, 23, and 24; for DSM3, do NOT include 1, 3, 6, 19, 23, 24, and 25)*

$$RMSE_Z = \sqrt{\frac{\sum_{i=1}^{n} \left(Z_{error}\right)^2}{n}}$$

Q9 In a GIS software program, explore the spatial distribution of the different combinations of GCPs (e.g., 1-19-24, 1-3-19-23-24, and 1-3-6-19-23-24-25). Based on their spatial distribution, why do you think these particular GCPs were selected to georeference the model?

Q10 How did the number and configuration of GCPs impact the vertical accuracy of the DSM? If you were to add additional GCPs in the field, where would you add them and why?

SUMMARY AND WRAP-UP

UAS-derived surface models provide a new strategy for monitoring land surfaces with an extremely high level of detail. There are a wide range of applications for the operational use of UASs for 3D model reconstruction using SfM-MVS algorithms, offering different strategies aimed at minimizing the errors of surface models. A review of these studies enabled the identification of the control exerted by GCP density on the planar and vertical accuracy of DSMs. The planar accuracy of SfM-MVS outputs is generally higher than the vertical accuracy. Therefore, the number of GCPs needed to produce stable results is generally lower for planar coordinates. On average, five GCPs/ha are enough to produce a good performance on the plane, but doubled density is needed for elevation (Figure 12.1). The final result is highly influenced by other factors such as flight pattern and configuration, camera quality, and local morphological complexity. In this chapter, you focused on optimizing the accuracy of a 3D model derived from UAS images by exploiting different combinations of flight configurations and GCP numbers/configurations.

DISCUSSION AND SYNTHESIS QUESTIONS

S1 As you can see from your results, mission planning is a critical step that can significantly affect your model accuracy. Why do you think the model created using the combination of images from Flight 2 and Flight 3 outperformed the models created with images from only a single flight?

S2 SfM-MVS algorithms work best when the number of observations of each individual point across the study area is maximized. What are some strategies that you could employ either through the flight plan or the camera to increase the number images in which a particular point in the study area is captured during a flight?

S3 High horizontal accuracy can be obtained with a relatively small number of GCPs that are well spread in space. While achieving high vertical accuracy requires a larger number of GCPs, their distribution in space may be less important. If you were designing a study, what factors should you consider in determining whether horizontal or vertical accuracy is more important? How would you decide where to place the GCPs?

S4 The prescriptions you followed in this exercise are not exhaustive. What are some other factors that were not taken into account in this exercise that might be important or useful for improving the vertical accuracy of UAS-derived DSMs? How would you design a study to test whether these new factors influence accuracy?

S5 The 3D model accuracy is calculated by using the 3D coordinates of the checkpoints obtained by photogrammetric intersection. In turn, this intersection is computed by using the alignment parameters, that is the exterior and interior (camera calibration) orientation parameters, obtained in the alignment step. Which parameters do you expect to most influence the final accuracy (horizontal and vertical) of the DSM?

Collecting the Data Yourself (Optional)

If you are collecting images yourself, you may want to take into account these additional considerations. First, flights should be scheduled for maximum solar elevation in order to reduce the shadows and allow good (if possible, uniform) scene illumination. Cumulus clouds should be particularly avoided as they are a source of strong contrasting shadows. Slightly overcast conditions are allowable if clear-sky weather is scarce. These conditions are known to produce a stable shadow-free environment but at the price of reduced image contrast. Care should be taken to select appropriate exposure parameters in order to attain maximum quality aerial imagery. Ideally, the aperture should be selected to exploit the maximum optical performance of the lens used. A rule of thumb is that the maximum performance is 2EV (stops) lower than the maximum aperture of the lens. This is not always possible if illumination of the scene is not sufficient. Exposure time (shutter speed) should be set to prevent motion blur of the image. This depends on the focal length of the lens used, flight speed of the aerial platform as well as on the air turbulence encountered during the flight. Some flight planning tools (such as APM Mission Planner) provide guidance on the minimum recommended shutter speed for a given configuration. Sensitivity of the camera should be held low in order to minimize digital noise in the imagery. Flight parameters such as flight speed should balance the requirements for area covered, overlaps (>75% recommended), camera repetition rate, and motion blurring of the imagery. interesting guidelines for UAS-based macan be found in the recent work by Tmušić et al. (2020).

ACKNOWLEDGMENTS

This exercise is derived from the field activities carried out within the COST Action CA16219 "HARMONIOUS – Harmonization of UAS techniques for agricultural and natural ecosystems monitoring." Users are directed to the published work (Manfreda et al. 2019) to see the complete results of the original study that included six flights. Gil Gonçalves acknowledges the financial support received from Fundação para a Ciência e Tecnologia (FCT, Portugal) through the strategic project UIDB//00308/2020 granted to INESC-Coimbra and by the research project UAS4Litter (PTDC/EAM-REM/30324/2017). Petr Dvorak was supported by LTC18007 and by the MEYS under the National Sustainability Programme I (Project LO1202).

REFERENCES

Aguera-Vega, F., Carvajal-Ramirez, F., & Martinez-Carricondo, P. (2017). Assessment of photogrammetric mapping accuracy based on variation ground control points number using unmanned aerial vehicle. *Measurement*, 98, 221–227.

Black Sea (1975). *IAG National Report on Geodetic and Geophysical Activities 2007-2010, XXVth IUGG General Assembly*, Melbourne, 28 June–7 July 2011 https://www.iag-aig.org/doc/5d8dd33cc57a7.pdf.

Carrivick, J.L., Smith, M.W., & Quincey, D.J. (2016). *Structure from Motion in the Geosciences*. Oxford, UK: Wiley-Blackwell; p. 208.

Clapuyt, F., Vanacker, V., & Van Oost, K. (2016). Reproducibility of UAV-based earth topography reconstructions based on Structure-from-Motion algorithms. *Geomorphology*, 260, 4–15.

Colomina, I., & Molina, P. (2014). Unmanned aerial systems for photogrammetry and remote sensing: A review. *ISPRS Journal of Photogrammetry and Remote Sensing*, 92, 79–97.

Cook, S.J., Clarke, L.E., & Nield, J.M.E. (2013). *Geomorphological Techniques* (Online Edition). London: British Society for Geomorphology.

Cryderman, C., Mah, S.B., & Shufletoski, A. (2014). Evaluation of UAV photogrammetric accuracy for mapping and earthworks computations. *Geomatica*, 68, 309–317.

Gómez-Candón, D., De Castro, A., & López-Granados, F. (2014). Assessing the accuracy of mosaics from unmanned aerial vehicle (UAV) imagery for precision agriculture purposes in wheat. *Precision Agriculture*, 15, 44–56.

Hugenholtz, C.H., Whitehead, K., Brown, O.W., Barchyn, T.E., Moorman, B.J., LeClair, A., Riddell, K., & Hamilton, T. (2013). Geomorphological mapping with a small unmanned aircraft system (sUAS): Feature detection and accuracy assessment of a photogrammetrically-derived digital terrain model. *Geomorphology*, 194, 16–24.

James, M.R., & Robson, S. (2014). Mitigating systematic error in topographic models derived from UAV and ground-based image networks. *Earth Surface Processes and Landforms*, 39, 1413–1420.

James, M.R., Robson, S., d'Oleire-Oltmanns, S., & Niethammer, U. (2017). Optimising UAV topographic surveys processed with structure-from-motion: Ground control quality, quantity and bundle adjustment. *Geomorphology*, 280, 51–66.

Koci, J., Jarihani, B., Leon, J.X., Sidle, R.C., Wilkinson, S.N., & Bartley, R. (2017). Assessment of UAV and ground-based structure from motion with multi-view stereo photogrammetry in a gullied savanna catchment. *ISPRS International Journal of Geo-Information*, 6, 328.

Kraus, K., & Waldhausl, P. (1993). *Photogrammetry. Fundamentals and standard processes*. Bonn: Ferd. Dummler.

Kraus, K., Jansa, J., & Kager, H. (1997). Photogrammetry. *Advanced methods and applications*. Bonn: Dümmler.

Küng, O., Strecha, C., Beyeler, A., Zufferey, J.-C., Floreano, D., Fua, P., & Gervaix, F. (2011). *The accuracy of automatic photogrammetric techniques on ultra-light UAV imagery*. In *IAPRS, Proceedings of the International Conference on Unmanned Aerial Vehicle in Geomatics (UAV-g)*, Zurich, Switzerland, 14–16 September 2011; 38.

Lucieer, A., de Jong, S.M., & Turner, D. (2014). Mapping landslide displacements using Structure from Motion (SfM) and image correlation of multi-temporal UAV photography. *Progress in Physical Geography*, 38, 97–116.

Luhmann, T., Robson, S., Kyle, S., & Harley, I. (2006). *Close range photogrammetry*. Caithness: Whittles.

Mancini, F., Dubbini, M., Gattelli, M., Stecchi, F., Fabbri, S., & Gabbianelli, G. (2013). Using unmanned aerial vehicles (UAV) for high-resolution reconstruction of topography: The structure from motion approach on coastal environments. *Remote sensing*, 5, 6880–6898.

Manfreda, S., McCabe, M.F., Miller, P.E., Lucas, R., Pajuelo Madrigal, V., Mallinis, G., Ben Dor, E., Helman, D., Estes, L., & Ciraolo, G. (2018). On the use of unmanned aerial systems for environmental monitoring. *Remote Sensing*, 10, 641.

Manfreda, S., Dvorak, P., Mullerova, J., Herban, S., Vuono, P., Arranz Justel, J.J., & Perks, M. (2019). Assessing the accuracy of digital surface models derived from optical imagery acquired with unmanned aerial systems. *Drones*, 3, 15.

Mikhail, E.M., Bethel, J.S., & McGlone, J.C. (2001). *Introduction to modern photogrammetry*. New York: John Wiley & Sons, Inc., 19.

Nex, F., & Remondino, F. (2014). UAV for 3D mapping applications: a review. *Applied Geomatics*, 6, 1–15.

Oniga, V.-E., Breaban, A.-I., & Statescu, F. (2018). Determining the optimum number of ground control points for obtaining high precision results based on UAS images. *Proceedings*, 2(7):352. https://doi.org/10.3390/ecrs-2-05165.

Ridolfi, E., Buffi, G., Venturi, S., & Manciola, P. (2017). Accuracy analysis of a dam model from drone surveys. *Sensors*, 17, 1777.

Rock, G., Ries, J., & Udelhoven, T. (2011). *Sensitivity analysis of UAV-photogrammetry for creating digital elevation models (DEM)*. In, *Proceedings of the Conference on Unmanned Aerial Vehicle in Geomatics*, Zurich, Switzerland.

Singh, K.K., & Frazier, A.E. (2018). A meta-analysis and review of unmanned aircraft system (UAS) imagery for terrestrial applications. *International Journal of Remote Sensing*, 39, 5078–5098.

Smith, M.W., & Vericat, D. (2015). From experimental plots to experimental landscapes: topography, erosion and deposition in sub-humid badlands from Structure-from-Motion photogrammetry. *Earth Surface Processes and Landforms*, 40, 1656–1671.

Tahar, K. (2013). An evaluation on different number of ground control points in unmanned aerial vehicle photogrammetric block. *ISPAR*, 93–98.

Tmušić, G., Manfreda, S., Aasen, H., James, M.R., Gonçalves, G., Ben-Dor, E., Brook, A., Polinova, M., Arranz, J.J., & Mészáros, J. (2020). Current practices in UAS-based environmental monitoring. *Remote Sensing*, 12, 1001.

Uysal, M., Toprak, A.S., & Polat, N. (2015). DEM generation with UAV Photogrammetry and accuracy analysis in Sahitler hill. *Measurement*, 73, 539–543.

Westoby, M.J., Brasington, J., Glasser, N.F., Hambrey, M.J., & Reynolds, J.M. (2012). "Structure-from-Motion" photogrammetry: A low-cost, effective tool for geoscience applications. *Geomorphology*, 179, 300–314.

Whitehead, K., Hugenholtz, C.H., Myshak, S., Brown, O., LeClair, A., Tamminga, A., Barchyn, T.E., Moorman, B., & Eaton, B. (2014). Remote sensing of the environment with small unmanned aircraft systems (UASs), part 2: Scientific and commercial applications. *Journal of unmanned vehicle systems*, 2, 86–102.

13 Estimating Forage Mass from Unmanned Aircraft Systems in Rangelands

Humberto L. Perotto-Baldivieso, Michael T. Page,
Alexandria M. DiMaggio, Jose de la Luz Martinez,
and J. Alfonso Ortega-S.

CONTENTS

LEARNING OBJECTIVES

After completing this chapter, you will be able to:

1. Create data products from UAS captured images using structure from motion (SfM) approaches in Pix4D software
2. Generate height data from 3D databases
3. Develop a simple linear regression prediction equation
4. Estimate forage mass in rangelands.

HARDWARE AND SOFTWARE REQUIREMENTS

1. Pix4Dmapper software
2. ArcMap Desktop version 10.X
3. Excel or another spreadsheet software

INTRODUCTION

Forage mass estimation is crucial to **carrying capacity** in rangelands. **Forage mass** refers to "the total dry weight of forage per unit area of land above a defined reference level, usually ground level, at a specific time" (Allen et al. 2011). Field-based forage mass estimation is time intensive and sometimes requires work during extreme conditions (Byrne et al. 2011). **Carrying capacity** is defined as "the maximum stocking rate that will achieve a target level of animal performance in a specified grazing system that can be applied over a defined time without deterioration of the grazing land" (Allen et al. 2011). Ranchers, range managers, extension agents, and other stakeholders use forage estimation to inform their ecological and management decisions (Brummer et al. 1994; DiMaggio et al. 2020).

There are several field-based approaches to estimate forage mass in rangelands. One of the most common methods involves clipping, drying, and weighing samples from several small representative areas to obtain average values for forage mass estimation. A Daubenmire frame is a 25 × 50-centimeter (cm) frame made from rebar or PVC that can be placed in a patch of vegetation to systematically sample an area (Daubenmire 1968). A less destructive method, the double sampling technique, uses a small number of clipped samples along with visual estimations to develop a prediction equation using linear regression (Bonham 2013; Montalvo et al. 2020). A large number of visual estimations are collected in the targeted area, and the average visual estimation is used in a prediction equation to estimate pasture-scale forage mass. These methods often require long hours in the field and skilled workers. Additionally, rangelands may have large areas that are difficult to access, making extensive fieldwork impractical and often economically infeasible.

The use of unmanned aircraft systems (UAS) in natural resource management has increased exponentially in recent years (Gillan et al. 2020). Models derived from UAS-captured images have been used to calculate canopy height and vertical structure for crops and woody vegetation. The use of 3D models can be applied to estimate forage mass in rangelands. For example, digital surface models (DSM) and digital elevation models (DEM) have been used in rangelands to estimate forage mass (Cunliffe et al. 2016; Gillan et al. 2019) across the extent of the UAS captured imagery. UAS provide an easy and flexible approach to obtain imagery for frequent estimations of forage mass and potentially more precise estimates that can be used for calculating carrying capacity and adjusting stocking rates.

DiMaggio et al. (2020) developed a UAS-based methodology that supports approaches that rangeland practitioners (e.g., ranch managers, landowners, rangeland specialists) regularly perform in the field. First, 20 quadrats (0.5 m × 0.5 m) were identified in the field and painted with orange paint (Figure 13.1). The *X* and *Y* coordinates of each quadrant were registered with a GPS unit (Junto T41, 1 m resolution) to easily identify the location of each quadrat. Within each quadrat, percent cover for each vegetation species was recorded by visual estimation. Next, six ground control points (GCPs) were located across the entire study area using bullseye aerial targets. Coordinates of the target centers were acquired with a Trimble GeoXH 6000 GPS unit (10 cm accuracy). A UAS was flown at an altitude of 50 m above ground level (AGL) to capture images across the study area. After the UAS flight mission was complete, the vegetation within the quadrats was clipped, and total **green forage mass** was weighed for each quadrat (Figure 13.1). Subsamples (100 g) for each plot were dried, and dry matter percentage was determined for each sample. The dry matter percentage was used to estimate dry **forage mass** for each sample clipped.

This chapter presents the UAS-based methodology for estimating forage mass developed by DiMaggio et al. (2020). You will process the UAS imagery captured over the study area in Pix4Dmapper software to generate a DSM and an orthomosaic. You will then use the orthomosaic to delineate the 20 quadrats and extract the volume of biomass within each quadrat from the DSM. Using the forage mass estimations measured by the authors, you will perform a linear regression to develop a prediction equation to estimate forage mass from the DSM volumes.

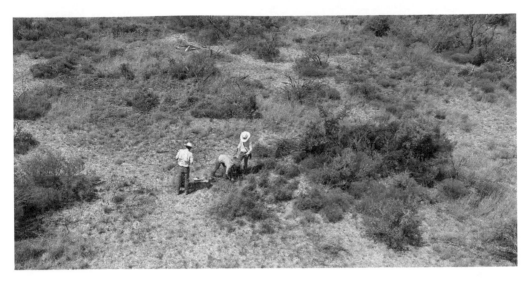

FIGURE 13.1 Aerial view of fieldwork and data collection where quadrats are set for painting prior to the UAS flight mission.

Finally, using data captured from 100 random points along six transects, you will replicate the traditional method of visual estimations and measure volumes for each quadrat.

The chapter is divided into three sections: Part 1 will walk you through processing UAS imagery with Pix4Dmapper photogrammetry software to generate a DSM and orthomosaic. In Part 2, you will extract height data from the orthomosaic and DSM and perform a linear regression to develop the prediction equation. You will complete this section using ArcMap™ and a spreadsheet software like Excel. Finally, in Part 3, you will estimate forage mass using the traditional method of visual estimations using ArcMap and Excel.

STUDY AREA

The flights were conducted at a ranch located in Duval County, Texas (27.79194°, –98.73612) in the South Texas Plains ecoregion (Texas Parks and Wildlife 2018) (Figure 13.2). The ecoregion has a hot semi-arid climate (Beck et al. 2018) with a mean annual precipitation of 659 mm, a mean high temperature of 28.5°C, and a mean low temperature of 15.3°C for the period 1981–2010 (US climate data 2018). There was no rainfall for eight weeks prior to the flights, and temperatures were above 35°C (DiMaggio et al. 2020). Soils are 75% Salco fine sandy loam soils with sandy clay loam soils comprising the remaining 25% of the study area (Web Soil Survey 2020). The study area is located within the Gray Sandy Loam ecological site (Ecological Site Description Catalog, 2019). The dominant grasses in the study area include pink pappusgrass (*Pappophorum bicolor* Fourn.), plains bristlegrass (*Setaria leucopila* (Scribn. and Merr.) K. Schum), tanglehead (*Heteropogon contortus* (L.) P. Beauv. ex Roem. & Schult.), silver bluestem (*Bothriochloa laguroides* (DC.) Herter), hooded windmillgrass (*Chloris cucullata* Bisch.), and multiflowered false rhodesgrass (*Trichloris pluriflora* Fourn.). The main woody species are mottes of honey mesquite (*Prosopis glandulosa* Torr.) accompanied mainly with scattered brasil (*Condalia hookeri* M.C. Johnst.), blackbrush acacia (*Acacia rigidula* Benth.), cenizo (*Leucophyllum frutescens* (Berl.) I.M. Johnst.), elbowbush (*Forestiera angustifolia* Torr.), and granjeno (*Celtis pallida* (Torr.) (Ecological Site Description Catalog, 2019).

FIGURE 13.2　The location of the study area near Freer, Texas in the South Texas Plains ecoregion.

PART 1: PROCESSING UAS IMAGERY INTO A DSM AND ORTHOMOSAIC

The `data_50m` folder contains 159 aerial photos acquired using a DJI Phantom IV Pro UAS. The aerial photos were captured between 10:50 AM and 11:00 AM Central standard time (UTC-6) on 31 August 2018. Pix4Dcapture™ with a double grid flight pattern was used to obtain the desired overlap and convergent angles for the aerial photographs. The UAS unit uses an integrated GPS/GLONASS system to get more precise satellite acquisition location during flights. Natural color aerial images (red, green, blue bands) were acquired using the camera integrated with the DJI Phantom IV Pro (a 2.5 cm, 1-inch 20-megapixel CMOS sensor), which was mounted to a gimbal to stabilize the camera with respect to the movement of the UAS (DiMaggio et al. 2020).

1. Unzip the data folder onto a disk unit with enough space (50–100GB) to allow for data storage.

2. Open Pix4Dmapper and click **Project > New Project**.

3. In the **New Project Wizard**, name your project "Forage" and choose a directory where you will save your new project. (*Note: it is common practice to save the project in the same folder that contains the aerial imagery*). Click **Next**.

4. Click on **Add Images** and select all the images in the `data_50m` folder. Alternatively, you can also click **Add Directories** and select the folder to add images. Ensure that 159 images have been selected. Click **Next**.

5. The **Image Properties** window provides information on the coordinate system, geolocation and orientation, and the camera specifications. For this exercise, all the parameters identified by Pix4D are obtained from the aerial photography metadata. You should see the following information:

 a. Datum: World Geodetic System 1984

 b. Coordinate system: WGS84 (EGM96 Geoid)

 c. Geolocation and orientation: Geolocated images: 159 out of 159

 d. Geolocation accuracy: The radial next to "Standard" should be checked

 e. Selected camera model: FC6310_8.8_5472×3648 (RGB)

Once you have verified the window matches the information above, click **Next**.

6. The **Select Output Coordinate System** window shows the selected coordinate system. For this exercise, you will use WGS84 / UTM Zone 14N (EGM 96 Geoid) coordinate system. Under the **Output/GCP coordinate system**, the radial next to Auto Detected: WGS84 / UTM Zone 14N should be checked. Click **Next**.

7. The **Processing Options Template** window has three options (Standard, Rapid, and Advanced). Click on each of the processing options to get an idea of how Pix4D processes aerial photos. For this exercise, you will choose the 3D models option under **Standard**. Click on **3D Models** and click **Finish**.

8. The **Map View** window will open, and you should see an aerial map with the center of each aerial photograph shown by a red dot. Go to the bottom left of the application window and click on **Processing Options**.

9. In the **Processing Options** menu, you can select the outputs and change the parameters of the model. Check the box next to **Advanced** at the bottom left of this window. Next, make sure that all three processing options are checked on the left pane (1. Initial Processing; 2. Point Cloud and Mesh; and 3. DSM, orthomosaic, and index).

10. Click on **3. DSM, orthomosaic, and index**, and three tabs will show on the right pane (DSM and Orthomosaic, Additional Outputs, and Index Calculator). Go to the **DSM and orthomosaic** tab and make sure the following options are checked:

 a. Under Resolution:

 • Radial next to Automatic should be checked

 b. Under DSM Filters:

 • Use Noise Filtering option should be checked

 • Use Surface Smoothing option should be checked

 • Type: Sharp

 c. Under Raster DSM:

 • GeoTIFF option should be checked

 • Method: Inverse distance weighting

 • Merge Tiles option should be checked

 d. Under Orthomosaic:

 • GeoTIFF option should be checked

 • Merge Tiles option should be checked

 • All other options should be unchecked

11. *Optional:* You can save these options as a template on the bottom left of the window (**Save Template**) if you plan to work on several projects with similar processing options. This will create a new processing option in the main Processing Options window. If you do not want to save a Template at this time, just click **OK**.

12. Before you start processing the imagery, you need to add the GCPs. A text file called GCPs.csv with six ground control points has been provided in the data folder. To add these to your project, go to the main menu at the top of the Pix4D application and click **Project > GCP / MTP Manager**.

13. In the **GCP/MTP Manager** window, you should see the following GCP coordinate system: World Geodetic System 1984; WGS84 / UTM Zone 14N (EGM 96 Geoid). The GCPs have been processed in ArcMap to meet these projection parameters. Click on **Import GCPs** (right side of the window), browse to the folder where your project data are stored, and select GCPs.csv. Six GCPs will appear in the window. Click **OK**. You will see the locations of these six GCPs added to the map.

14. Below the map you will see a Processing window. In this window, you will see the three processing steps: 1. Initial Processing; 2. Point Cloud and Mesh; and 3. DSM, Orthomosaic and Index. Make sure only **1. Initial Processing** is checked (uncheck the other two), and click **Start**. Once the initial processing is completed, a report is generated that provides very useful information on the quality of the image processing you just prepared.

Note: This step may take a while (up to several hours) depending on the processing power of your machine.

Q1 Scroll through the report and locate the 2D keypoints Table. Keypoints are objects or points found in overlapping images. What was the median number of 2D keypoints per image? What was the median number of matched 2D keypoints per image?

Q2 Find the Geolocation Details in the processing report. What was the mean Geolocation error for *X* and *Y* coordinates? What are the units of these errors?

Close the report when you are finished answering the questions. You will notice a new 3D figure (the rayCloud) in the display window and a list of layers (e.g., Cameras, Rays, Tie Points, etc.). Toggle these layers on and off to view them in the figure. Review the layers to make sure the GCPs are visible. If you cannot see the GCPs, you may need to repeat Step 13–14.

15. Expand the dropdown next to GCPs / MTPs. Click on the first GCP (p1). The GCP properties will appear in the **Properties** window on the right side of your screen.

Q3 What are the *X*, *Y*, and *Z* positions [m] of the p1 GCP?

The bottom half of that screen shows the images with the location of the GCP and the bullseye.

Note: You may need to scroll down to see this area of the window. You can collapse the Selection window by clicking on the triangle, which will give you more room to view the Images if needed.

16. Find the GCP in the first image. It is a target on the ground that looks like a little square with an "X." You will likely need to zoom out to find the ground target. Refer to Figure 13.3 to see where each GCP is located. Drag the cursor into the image, and place the crosshairs on the center of the X. Click on the X. This will place a bullseye on the image, moving the GCP to the bullseye location. Zoom in closely on the GCP to make sure the bullseye is exactly in the center. When you have the bullseye in the correct position, move to the next image and repeat the process. Click **Apply** to apply the changes (this button is in the Selection Area that you may have collapsed).

FIGURE 13.3 The six numbered ground control points.

Note: This step can be tricky! In some images, you may see more than one ground target. Use Figure 13.3 to reference the GCPs. If it is not clear which target is the match, skip that image and come back to it later! Be sure to scroll out to the entire extent to make sure you are selecting the correct target. You may also have to skip some points to start if they do not have enough images associated with them. You may have to move back and forth between the six GCPs before you have amassed enough matches.

17. Continue matching GCPs until you have matched <u>at least 10 GCPs</u> for each point. The number of matches is in parentheses next to the point number. The more you match, the higher the accuracy of your products will be. But only match GCPs to targets for which you are certain.

18. Once the matching process is complete, you will rerun the **1. Initial Processing step, 2. Point cloud and mesh**, and **3. DSM, orthomosaic and index**. Check the boxes next to all three processing steps and click **Start**. Because you are re-running the initial process again, Pix4D will ask if you want to overwrite the previous results. Click **OK** to overwrite and start the processing.

Note: This step may take several hours to complete depending on the processing power of your machine.

19. Once the process is completed, go to your working directory and you will find the following folders and data products:

 a. `3_DSM_Ortho > 1_DSM`: Digital Surface Model

 b. `3_DSM_Ortho > 2_mosaic`: orthomosaic

 c. `1_initial > report`: report (PDF)

 d. `1_initial > report`: report in html format.

Q4 Open the pdf report and look for the quality check. Look at the Georeferencing/Geolocation details. What is the value of the mean RMS error? What does this value mean? Can you provide an explanation for this value? Can you think of any ways to improve this value? If so, how?

TABLE 13.1
Volume Estimation for Each Quadrat

1	2	3	4	5	6
FID	Quadrat	Sum (mm)	Sum (cm)	Volume (cm³)	Forage Mass (kg/ha)
0	1	90,031	9,003.1	19,854	2,225
1	2				840
2	3				7,388
3	4				3,474
4	5				4,971
5	6				1,784
6	7				1,135
7	8				1,560
8	9				1,825
9	10				2,219
10	11				1,054
11	12				4,252
12	13				1,335
13	14				2,813
14	15				2,398
15	16				741
16	17				2,257
17	18				3,048
18	19				1,282
19	20				130

PART 2: LINEAR REGRESSION: VOLUMES AND FORAGE MASS

In the second part of this exercise, you will extract information from the orthomosaic and DSM to estimate forage biomass using a simple linear regression. The purpose of this analysis is to develop a relationship between the *forage mass* that was measured directly from the field samples (i.e., the vegetation from each quadrat that was cut, dried, and weighed) and the *volume* of vegetation that can be derived from the DSM developed using the UAS images. For this exercise you will use the field data that was collected by DiMaggio et al. (2020). The data are located in Table 13.1 column 6 (Forage mass kg/ha). By developing a relationship between these two quantities (mass and volume) using a linear regression, it is possible to estimate forage mass across the entire study area using just the DSM without having to clip, dry, and weight all of the vegetation in the study area, which would mean it would no longer be available to the cattle!

You will complete this section using ArcMap and Microsoft Excel, or another spreadsheet software. You will need the orthoimagery, which is located in the 3_DSM_Ortho > 2_mosaic folder, and the Quadrat_locations.shp shapefile that came with this exercise. Before you start, create a folder called "Shapefiles" in your working directory where you will store the shapefiles you create in this part of the exercise.

1. Open ArcMap and create a new project. Go to **Customize > Extensions** and check the **Spatial Analyst** extension. If this extension is not available, contact the ESRI representative in your organization.

2. Click **Add Data** and navigate to the `3_DSM_Ortho > 2_mosaic` folder within your working directory. Click on the orthomosaic file you created called `Forage_trans-parent_mosaic_group1.TIF`. Click **Add**. If you are asked if you want to build pyramid layers, click **Yes**.

3. Click the **Add Data** button on the ArcMap toolbar, and load the `Quadrat_locations.shp`. You may receive a notice that the layers are in different projections. The orthomosaic is in a Projected Coordinate System (UTM Zone 14; WGS 84,) and the quadrat locations are in a Geographic Coordinate System (WGS84). ArcMap performs a projection on the fly to resolve conflicts when your data are in different coordinate systems. For the purposes of this exercise, you do not need to reproject any of the datasets.

4. The `Quadrat_locations` are in point format, but to compute the forage volume for each quadrat, you will need the quadrats to be polygons. You will draw polygons around each point based on markings on the ground in the orthomosaic. First, you will need to create an empty polygon shapefile that will eventually hold the polygons for each quadrat. To do this, click on the **Catalog** tab and navigate to the `Shapefiles` folder you created. Right-click on `Shapefiles` > **New** > **Shapefile**.

5. The **Create New Shapefile** window opens. Input the following information:

 a. Name: Quadrat_areas

 b. Feature type: Polygon

 c. Spatial reference: Go to **Edit** and click the **Add Coordinate System** Tab. Click on **Import** so you can choose the projection from another spatial data layer. Navigate to the directory where your orthomosaic is located and select the `Forage_transparent_mosaic_group1.TIF` file. This step will assign the same projection of the orthomosaic to the new shapefile to ensure they match. Click **Add** and verify that the projection is UTM zone 14 WGS84. Click **OK**, and **OK** again.

 d. The shapefile for your polygons has now been created. **Add** this file to ArcMap.

6. In ArcMap, go to the main menu, click **Customize > Toolbars**. Look for the **Editor** toolbar and check it. The Editor toolbar will show on your screen.

7. On the Editor toolbar, go to **Editor > Start Editing**. If you receive a message indicating that the `Quadrat_locations.shp` is in a different projection, click **Continue**.

8. In the **Create Features** pane, click on the `Quadrat_areas` polygon shapefile you just created. At the bottom of the pane, the **Construction Tools** window will become activated.

9. In the Table of Contents, right-click on `Quadrat_locations.shp` and **Open Attribute Table**. The attribute table for the 20 points will open. You want to make sure that when you draw the polygons, you do so in the same order as the `Quadrat_locations` shapefile. Click on the gray box to the left of the FID for the first point. This will highlight the first point. Find the highlighted point in the map, and zoom to that location.

Note: The GPS location and the painted quadrat on the ground should be within 2 m of each other. Use the GPS points to help find the quadrat, but you will digitize your polygons based on the orange painted rectangle.

10. Locate the quadrat for the first point, which has been painted orange, and draw a polygon just inside the orange boundary (see Figure 13.4). To do this, make sure you click on `Quadrat_areas` in the **Create Features** window. Go to the **Construction tools** >

FIGURE 13.4 Quadrat delineation in ArcMap. The yellow point is the approximate GPS location. The quadrat can be seen from the orthoimagery and the cyan boundary is the delineated polygon.

Polygon. Drag your cursor into the map area and draw a polygon inside the orange area. Repeat Steps 9-10 for all 20 points. It is a good idea to save frequently (Editor > Save Edits) as you go.

11. Once you finish digitizing all 20 quadrats, go to **Editor > Stop Editing**. If prompted to **Save edits?** click **Yes**.

12. Using the digitized `Quadrat_areas` polygons, you will next clip the DSM so that you have 20 mini DSMs, one for each quadrat. You will then calculate the volume of vegetation within each quadrat based on the DSM. Click **Add Data** and browse to the directory 3_ DSM_Ortho > 1_DSM. Select the `Forage_dsm.tif` file and add it to the map.

13. Press Ctrl+F (or go to Windows > Search) to open the search pane in ArcMap. Type "Split Raster" into the search box and select the option **Split Raster (Data Management)**. Input the following information into the tool window, and click OK when you are finished:

 a. Input raster: Forage_DSM.TIF

 b. Output folder: create a new directory called "DSM_Clips" where all the clips will be stored

 c. Output base name: "clips50m" (you may want to create a folder with the same name to store these clips when browsing for the directory.)

 d. Split method: POLYGON_FEATURES

 e. Output format: TIFF

 f. Resampling technique: Nearest

 g. Split polygon feature class (optional): quadrat_areas.shp

Before continuing to the next steps, you can remove the DSM, polygon shapefile, and point location from the Table of Contents in ArcMap. You no longer need these layers. The output clips

from the Splitting operation will be numbered starting with 0. This value corresponds to the FID of the polygon layer. Therefore, `Clip50m0` corresponds to Quadrat 1, which has an FID of 0. `Clip50m1` corresponds to Quadrat 2, and so on.

14. Click **Add Data**. Select your first clip (i.e., clip ending in 0), and add it to the map. The layer symbology on the **Table of Contents** pane shows the range of elevation values for each pixel in the clipped raster. The lowest value corresponds to the elevation of the ground.

15. Open ArcToolbox, and select **Spatial Analysis Tools > Map Algebra > Raster Calculator**. In the Raster Calculator expression box, input the following formula:

 `Int(("Clip50m0.TIF" - [the lowest value in the DSM])*1000)`

Where `Int` is the expression for an integer value, `Clip50m0.TIF` is the DSM clipped to the first quadrat polygon, `the lowest value in the DSM` is unique to each clip and is determined from the elevation values in the **Table of Contents**, and `1000` is the transformation from meters to millimeters. An example is shown below for a clip in which the lowest value is `151.155`. Your equation should look similar, but you may have a different lowest value.

 `Int(("Clip50m0.TIF"- 151.155)*1000)`

Save the output raster (e.g., "Clip50m0_LV") in the same directory as the clipped rasters.

16. The new raster has the vegetation heights in millimeters (mm). To calculate the sum of all vegetation heights within the quadrat, you will use the **Zonal Statistics as Table** tool. Open **Spatial Analysis Tool > Zonal > Zonal Statistics as Table**:

 a. Input raster or feature zone data: vegetation height raster in mm (e.g., Clip50m_0)

 b. Zone field: Value

 c. Input value raster: vegetation height raster in mm (e.g., Clip50m_0)

 d. Output table: "Clip50M_0_sum"

 e. Make sure that **Ignore NoData in Calculations (Optional)** is checked.

 f. Statistics type: Sum

 g. Click OK

17. The new table contains the sum of the pixel values (heights) for each quadrat. Open the table and right-click on the Sum field. Click statistics and record the total (sum) value in mm next to the appropriate Quadrat in Column 3 of Table 13.1. Convert this value to centimeters (cm) by dividing by 10, and input the value into Column 4 of Table 13.1.

Next, you will compute and record the volume of forage in each quadrat in Table 13.1. To do this, you need to multiply the total height (in cm) of the vegetation in each cell (Column 4) by the area of each cell. The size of each pixel in the DSM raster is 0.01485 m x 0.01485 m (1.485 cm x 1.485 cm). To determine this information on your own, you can right-click on any DSM raster from this exercise and go to Properties > Source > Cell Size (X, Y). Cell size is given in meters because the projection is UTM Zone 14N (WGS84).

18. Compute the volume of vegetation biomass in each quadrat by multiplying the total (sum) height of the vegetation in cm (Column 4) by the cell area. Quadrat 1 is filled in for you as an example. The last column in Table 13.1 contains forge mass (kg/ha) for each quadrat. You will use this information in Part 3.

19. Repeat steps 15–18 for the remaining 19 polygons. Do not forget to adjust the minimum value of the DSM for each polygon in the raster calculator equation in Step 15. Fill in Table 13.1 as you go.

Once you have estimated forage volume from the DSM for all 20 quadrats, you can perform a linear regression to determine the relationship between volume and forage mass. Studies that use 3D data derived from UAS to estimate vegetation structure (e.g., biomass) often use **linear regression** to establish an empirical relationship between the 3D model (DSM) and the vegetation measured in the field (Equation 13.1). In its basic form, linear regression can be used to examine if a set of independent measurements can predict the outcome for a dependent variable. Simple linear regression takes the form:

$$\hat{y} = \beta_0 + \beta_1 x \tag{13.1}$$

where \hat{y} is the predicted outcome (dependent variable), β_0 is the y-intercept, β_1 is the coefficient in the model that modifies x to best predict y (i.e., the slope of the line), and x is the independent measurement (i.e., a variable) used to predict \hat{y}. In this case, the independent variable (x) is the vegetation volume (cm³) measured through the DSM, and the dependent variable (y) is the forage mass measured through the field samples.

Steps for running a linear regression analysis in Excel are provided below, but you may use any software program you choose (e.g., R, SPSS, SAS, etc.).

20. In Excel, go to the **Data tab > Analysis group >** click the **Data Analysis** button. You may need to activate the **Data Analysis** tool by going to **File > Options > Add-ins**. In the Manage box, select **Excel Add-ins** and click **Go**. Make sure the **Analysis ToolPak** option is checked and click **OK**.

21. Select **Regression** in the **Data Analysis** window, and click **OK**. In the **Regression dialog box**, configure the following settings:

 a. Input *Y* range: This is your dependent variable - the forage mass estimates (Column 6 of Table 13.1)

 b. Input *X* range: This is your independent variable - the volume (cm³) estimates (Column 5 of Table 13.1)

 c. Keep all of the other default settings and Click **OK**. Check the results.

Q5 Report your regression equation. This equation is important as it establishes the relationship between forage mass, which was determined from field samples and vegetation volume, which was determined from the DSM derived from the UAS images. You will use this equation in Part 3.

Q6 What is the R^2 value of the regression analysis? Based on the R^2 value, do you think there is a strong relationship between the DSM volume and the vegetation biomass measured in the quadrats?

PART 3: FORAGE MASS ESTIMATION

The third part of this exercise involves using the relationship you established in Part 2 between DSM volume and forage mass to estimate forage mass across the entire study area. The data you will use in this part were derived from six transects placed across the study area. Each transect is 25 m in length, and a series of small quadrats (0.25 m²) have been placed along each transect. To avoid confusion with the quadrats used above, these smaller quadrats will be

referred to as "frames" throughout the rest of the chapter. A total of 100 frames were located along the six transects.

The rationale for this "double sampling" technique of larger quadrats and smaller frames is to use a smaller number of larger quadrats to gain an understanding of the relationships between actual biomass and the volume estimated from the DSM (DiMaggio et al. 2020). That relationship can then be applied to a much larger number of smaller frames to more fully represent land cover across the study area. You will use the regression equation you developed in Part 2 to estimate forage mass in each of the 100 transect frames. You can read more about this double sampling technique in DiMaggio et al. (2020).

1. Open **ArcMap** and click **Add Data**. Add the **DSM** raster from the directory 3_DSM_Ortho > 1_DSM. From the data folder that accompanied this chapter, add the shapefile called `transects`, which contains the six transect lines from the field, and the six polygon shapefiles named `transect#_frames.shp`. Transects 2 and 4 correspond to the area on the road, and Transects 1, 3, 5, and 6 correspond to an area that was treated with an herbicide to control brush to increase forage production (see Figure 13.3).

2. Create a directory/folder for the DSM clips of the Transect 1 frames (e.g., "clips_transect1").

3. Follow Steps 13–19 in Part 2 to calculate the volume for each frame, and record the volume for each frame in Table 13.2.

Note: The transects have varying numbers of frames. Transects 1, 2, 3, and 5 have 16 frames each, while transects 4 and 6 have 18 frames each. There are a total of 100 frames.

TABLE 13.2
Forage Mass Estimation for Each Frame in Transect 1

FID	Quadrat	Sum (mm)	Sum (cm)	Volume (cm³)	Forage Mass (kg/ha)
0	1				
1	2				
2	3				
3	4				
4	5				
5	6				
6	7				
7	8				
8	9				
9	10				
10	11				
11	12				
12	13				
13	14				
14	15				
15	16				
16	17				
17	18				

Where a = and b = (complete with the data from Exercise 2)
Average Forage mass for transect 1 (kg/ha)

TABLE 13.3

Average Volume and Forage Mass Estimates for the Road Area and Treated Areas from DiMaggio et al. (2020)

Road Area (Transects 2 and 4)		Treated Area (Transects 1, 3, 5, and 6)	
Average Volume (cm³)	Forage Mass (kg/ha)	Average Volume (cm³)	Forage Mass (kg/ha)
3520	1479	5293	1890

4. Once you have completed the volume calculations for all Transect 1 frames, use the regression equation you developed in Part 2 to estimate the average forage mass for each frame. Then, average the forage mass estimations across the 16 frames to compute a transect-level estimate of the amount of forage mass.

$$FM = a \times Vol\left(cm^3\right) + b \qquad (13.2)$$

where *FM* is the independent variable - the forage mass you are estimating; *Vol* (*cm³*) is the dependent variable – the volume you computed for each frame measured in cubic centimeters; *a* is the multiplicative coefficient, and *b* is the additive coefficient. These values come from your regression equation in Part 2.

5. Repeat Steps 2–4 for the remaining five transects. You will need to create a new table for each Transect. At the end, you will have six tables, each of which includes a single estimate of the average forage mass for the transect.

Q7 Which transects had the highest estimated forage mass? Which transects had the lowest estimated forage mass? Include your six tables as part of your response.

Q8 Estimate the mean forage value for the treated area (take of average of Transects 1, 3, 5, and 6) and the road area (take the average of Transects 2 and 4). Compare your results to the values in Table 13.3. How similar or different are your average volume and forage mass values compared to the values obtained by DiMaggio et al. (2020)? If you did not obtain the same (or very similar) values, what might be some reasons?

DISCUSSION AND SYNTHESIS QUESTIONS

S1 What other approaches could you use to estimate vegetation height from the DSM?

S2 How can you streamline the workflow presented in this exercise? Can you build a model using the model builder functionality in ArcMAP? What other methods could you use?

S3 How could you scale up this approach to estimate forage mass in a 3000-ha pasture?

S4 What are some ways to improve horizontal and vertical accuracy for the estimation of forage mass?

ACKNOWLEDGMENTS

The images used in this chapter were collected at the Duval County Ranch by the authors. The authors are very grateful to Duval County Ranch for the access to their property. Funding for this research was provided by the Ken Leonard Fund for Cattle Wildlife Interactions. The authors

would also want to thank Chase Walther and Karelys Labrador-Rodriguez for their assistance in the field and with Pix4D.

REFERENCES

Allen, V.G., Batello, C., Berretta, E., Hodgson, J., Kothmann, M., Li, X., McIvor, J., Milne, J., Morris, C., & Peeters, A. (2011). An international terminology for grazing lands and grazing animals. *Grass and Forage Science*, 66, 2.

Beck, H.E., Zimmermann, N.E., McVicar, T.R., Vergopolan, N., Berg, A., & Wood, E.F. (2018). Present and future Köppen-Geiger climate classification maps at 1-km resolution. *Scientific Data*, 5, 180214.

Bonham, C.D. (2013). *Measurements for terrestrial vegetation*. Oxford, UK: John Wiley & Sons.

Brummer, J.E., Nichols, J.T., Engel, R.K., & Eskridge, K.M. (1994). Efficiency of different quadrat sizes and shapes for sampling standing crop. *Rangeland Ecology & Management/Journal of Range Management Archives*, 47, 84–89.

Byrne, K.M., Lauenroth, W.K., Adler, P.B., & Byrne, C.M. (2011). Estimating aboveground net primary production in grasslands: a comparison of nondestructive methods. *Rangeland Ecology & Management*, 64, 498–505.

Cunliffe, A.M., Brazier, R.E., & Anderson, K. (2016). Ultra-fine grain landscape-scale quantification of dryland vegetation structure with drone-acquired structure-from-motion photogrammetry. *Remote Sensing of Environment*, 183, 129–143.

Daubenmire, R. (1968). *Plant communities. A textbook of plant synecology*. New York: Harper & Row.

DiMaggio, A.M., Perotto-Baldivieso, H.L., Walther, C., Labrador-Rodriquez, K.N., Page, M.T., Martinez, J.d.l.L., Rideout-Hanzak, S., Hedquist, B.C., & Wester, D.B. (2020). A Pilot Study to Estimate Forage Mass from Unmanned Aerial Vehicles in a Semi-Arid Rangeland. *Remote Sensing*, 12, 2431.

Gillan, J.K., Karl, J.W., & van Leeuwen, W.J. (2020). Integrating drone imagery with existing rangeland monitoring programs. *Environmental Monitoring and Assessment*, 192, 1–20.

Gillan, J.K., McClaran, M.P., Swetnam, T.L., & Heilman, P. (2019). Estimating forage utilization with drone-based photogrammetric point clouds. *Rangeland Ecology & Management*, 72, 575–585.

Montalvo, A., Snelgrove, T., Riojas, G., Schofield, L., & Campbell, T.A. (2020). Cattle Ranching in the "Wild Horse Desert" – Stocking Rate, Rainfall, and Forage Responses. *Rangelands*, 42, 31–42.

OTHER RESOURCES

Ecological Site Description Catalog. 2019. Ecological site R083CY019TX Gray Sandy Loam. Available online: https://edit.jornada.nmsu.edu/page?content=class&catalog=3&spatial=163&class=8418 (accessed on 19 June 2020).

Texas Parks and Wildlife. 2018. Ecoregions of Texas. Available online: https://tpwd.texas.gov/education/hunter-education/online-course/wildlife-conservation/texas-ecoregions (accessed on 6 Oct 2018).

U.S. Climate Data. 2018. Climate Freer-Texas. Available online: https://www.usclimatedata.com/climate/freer/texas/united-states/ustx0589 (accessed on 4 October 2018).

Web Soil Survey.2020. Duval County, Texas. Available online: https://websoilsurvey.sc.egov.usda.gov/App/WebSoilSurvey.aspx (accessed on 19 June 2020).

14 Applications of UAS-Derived Terrain Data for Hydrology and Flood Hazard Modeling

Wing H. Cheung and Jochen E. Schubert

CONTENTS

LEARNING OBJECTIVES

This exercise demonstrates how data captured by UAS can be used to analyze the hydrology of a watershed and perform flood hazard modeling. This chapter is divided into two parts, which should be completed sequentially. After completing this chapter, you will be able to:

1. Understand the differences between a UAS-derived digital surface model (DSM), digital terrain model (DTM), and digital height model (DHM) for hydrological studies
2. Analyze terrain data captured via UAS to derive channel locations using GIS tools
3. Predict surface water flow properties using 3D surface data with hydraulic modeling

The first part, **Getting to know the terrain and hydrology of the study area**, will introduce you to terrain and surface water features using the spatial analysis tools in ArcGIS Pro (Esri, Redlands, CA). You will visualize and compute the average elevation of the study area based on a digital surface model (DSM) and digital terrain model (DTM) to understand the differences between the

two types of models. You will then take the difference between the DSM and the DTM to create a digital height model (DHM), which can be used to identify any surface features that may influence flood hazards (e.g., vegetation or buildings that may block water flow). Finally, you will use the built-in neighborhood functions in ArcGIS Pro and the DTM to identify surface water features, such as channel network locations, and analyze slope and hillshade to better understand the terrain and hydrology of the study area.

The second part, **Applications of drone data in hydraulic modeling**, will introduce you to basic hydraulic modeling using the HEC-RAS (Hydrologic Engineering Centre – River Analysis System) software for flood hazard analysis. HEC-RAS is a freely available, widely used, and well-established open channel flow analysis software tool developed by the Hydrologic Engineering Center, an organization within the U.S. Army Corps of Engineers (USACE). It allows users to use DTMs derived from drone data to perform simulations of flow, sediment transport, and water quality analysis.

HARDWARE AND SOFTWARE REQUIREMENTS

1. A computer running Microsoft Windows
2. ArcGIS Pro with the Spatial Analyst extension and familiarity with ArcGIS Pro
3. HEC-RAS 5.0.X software (https://www.hec.usace.army.mil/software/hec-ras/download.aspx)
4. The data files that accompany this chapter include:
 - A polygon shapefile depicting the study area extent,
 - A UAS-derived raster Orthoimage for the site (`Ciruelito_Orthoimage.jp2`),
 - A UAS-derived raster DSM for the site (`Ciruelito_DSM.tif`),
 - A UAS-derived raster DTM for the site (`Ciruelito_DTM.tif`),
 - A geographic projection file for the site (`Mexican Datum 1993 UTM Zone 12N.prj`).
 - UAS images if you would like to generate your own DSM, DTM, and orthomosaic (`El_Ciruelito_UAS_Imagery.zip`)

PART 1: GETTING TO KNOW THE TERRAIN AND HYDROLOGY OF THE STUDY AREA

INTRODUCTION

Coastal and inland watersheds are subject to rapid changes in their topography, land cover, and hydrologic behavior due to natural hazards, sediment dynamics, climate variability, and anthropogenic influence (Berger 2008; Parker 1995). For populated floodplains, these changes mean evolving exposure to flooding, economic damages and, in the worst case, loss of life. In an effort to assess the vulnerability of communities in light of these rapid changes, there has been growing interest among researchers and policymakers to monitor regional hydrology and anticipate potential flood hazards (Hashemi-Beni et al. 2018; Heimhuber et al. 2015; Heintz et al. 2012).

Both DTMs and DSMs are widely used to visualize and analyze the surface topography (Orengo and Petrie 2018) (Figure 14.1). While the generation of the DSM only requires the interpolation of surface elevation values, the generation of the DTM requires one to first identify elevation values associated with the ground/terrain and then interpolate those values into a raster

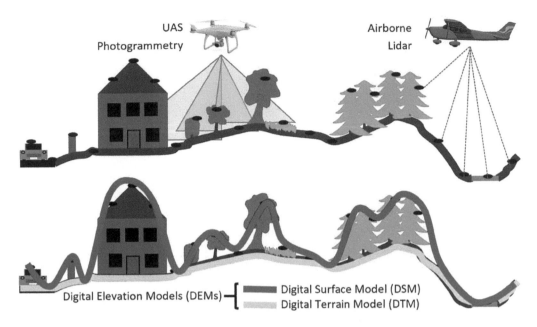

FIGURE 14.1 (Top) A comparison of UAS photogrammetry and airborne lidar. (Bottom) A comparison of the digital surface model (DSM) and the digital terrain model (DTM).

surface (Dong and Chen 2018). In the fields of hydrology and hydraulic modeling, the DTM provides crucial information about terrain geometries such as the location, slope, and flow capacity of different stream channels (or channels), which influence stream flow, whereas the DSM takes into account surface obstacles or manmade objects such as bridges, roads, walls, and structures that may also alter the flow direction of streams or other water features. Specifically, taking the difference between the DSM and the DTM produces a **digital height model** (DHM) (Dong and Chen 2018) that represents the heights of buildings, canopy, and objects such as tires, sandbags, or infrastructure. In other words, the DHM represents the difference between, for example, the building roof elevation stored in the DSM and the ground elevation stored in the DTM.

As shown in Figure 14.1, it is worth noting that DSM values in a given location should theoretically always be greater than or equal to the DTM values. However, as you will see, when you subtract a DTM from a DSM to obtain a DHM, you may occasionally have negative values in some areas due to artefacts (e.g., random noise in the point clouds used to create the DSM and DTM), the quality of the DTM and DSM, and the interpolation processes (Dong and Chen 2018; Parrot and Núñez 2016). As these negative DHM values have minimal impacts on the analyses in this lab, you will ignore them while taking note of their existence and considering their potential impacts on other applications.

STUDY AREA

The study area for the exercise is located in a rural canyon near the village of El Ciruelito, 35 km southeast of the Municipality of La Paz, Baja California Sur, Mexico (Figure 14.2). Climatically, La Paz is situated in an arid, desert-like environment, characterized by droughts, hurricanes, and

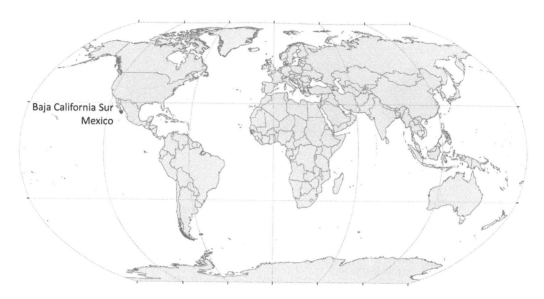

FIGURE 14.2 The study area location near the village of El Ciruelito, 35 km southeast of the unicipality of La Paz, Baja California Sur, Mexico.

intense rainfall events during the summer season. Limited water supply has especially restricted the city's expansion of industry and agriculture, while frequent flash flooding contributes to infrastructure and monetary damages and often loss of life. La Paz is hit by a hurricane on average every 2.85 years, and regional climate change predictions indicate that cyclones are likely to increase in intensity and frequency in the future (Ivanova and Bermudez-Contreras 2014; GeoAdaptive, LLC, 2015). The El Ciruelito canyon, which is situated approximately 100 km northwest of the city of La Paz, is a test site for various stormwater control measures designed to retain rainfall-runoff. The purpose of the stormwater control measures is twofold: (1) reduce flash flooding in La Paz by retaining precipitation runoff in the upper watershed, and (2) replenish groundwater aquifers with rainfall runoff to reduce water shortages.

Exercise 1.1: Visualize and Examine Digital Elevation Models of the Study Area

1. Open ArcGIS Pro, and start a new map. Add the `Ciruelito_DSM.tif` and `Ciruelito_DTM.tif` raster layers, and the `StudyArea.shp` shapefile. If you are asked if you would like to build pyramids, click Yes.

In the following steps, you will use the **Zonal Statistics** tool in ArcGIS to calculate the average elevation within the study area based on the DTM cell values. The Zonal Statistics tool is used to compute a single output statistical value for each zone, which is defined by a zone dataset. In this case, the zone dataset is `StudyArea.shp`, and the statistic you are computing is the average elevation. After computing the zonal statistic for the DTM, you will repeat the process to compute the average height of the features and objects within the study area based on the DSM cell values.

2. Go to the **Analysis** tab on the main menu, and click on **Tools**. In the **Geoprocessing** panel, type "Zonal Statistics (Spatial Analyst Tool)," and open the **Zonal Statistics** tool.

3. In the **Zonal Statistics** tool pane, enter the following and then click **Run**:

 a. Input raster of feature zone data: StudyArea.shp

 b. Zone field: Id

 c. Input value raster: Ciruelito_DTM

 d. Output raster: AvgDTM

 e. Statistics type: Mean

 f. Leave the Ignore NoData in calculations option checked

Q1 What is the average/mean elevation of the study area according to the DTM?

4. Repeat Step 3, but this time change the Input raster to `Ciruelito_DSM`, and change the output raster name to `AvgDSM`. This operation will compute the average elevation of the features and objects in the study area according to the DSM.

Q2 What is the average elevation of the study area according to the DSM?

Note: the average elevation according to the DTM may not be considerably different from the average elevation according to the DSM in this exercise, because the study area has very few non-ground features, and those that do exist (e.g., trees, buildings) are not particularly tall. However, in urban environments with many tall, non-ground structures (e.g., buildings, towers), the elevation values in the DSM may be significantly greater than the values in the DTM.

5. You will now use the **Raster Calculator** tool to create a DHM by differencing the DSM and DTM. Go to **Analysis** tab > **Tools**. In the **Geoprocessing** search bar, type "Raster Calculator (Spatial Analyst Tool)" and click the corresponding result to open the tool.

6. In **Raster Calculator**, double click-on `Ciruelito_DSM` in the Rasters section to add it to your expression. Next, double-click on the minus sign (-) in the **Tools** section. Lastly, double-click on `Ciruelito_DTM` in the Rasters section to finish the expression. Your expression should read:

   ```
   Ciruelito_DSM.tif - Ciruelito_DTM.tif
   ```

 Name the **Output raster** "Cirulito_DHM.tif," and click **Run**.

Q3 What are the summary statistics (average, minimum, and maximum values) of the created DHM? *Hint: Right click on the Cirulito_DHM in the* **Contents** *pane, and select* **Properties** *to view the layer's properties. Within the Layer Properties window, select* **Source** *and expand the* **Statistics** *section to find this information.*

Q4 What is a possible reason for having a negative height value in the created DHM?

To get a rough visualization of what obstacles may potentially disrupt the normal drainage/runoff in the study area, you can display the orthoimage in three-dimensions and overlay the height values from the DHM (Figure 14.3).

7. Add the `Ciruelito_Orthoimage.jp2` raster layer to your map. This layer was also pre-processed from the drone data. Turn off all other layers in the map. Go to **View** > **Convert** > **To Local Scene**.

FIGURE 14.3 (a) A three-dimensional view of the study area. (b) The digital height model superimposed on the study area. The digital height model reveals some relatively tall dwelling structures in the lower left and taller trees in the upper right, but the study area is mostly barren with minimal surface features. The coloring and number of classes in your GIS interface may vary based on the number of classes and color scheme that you have chosen.

8. In the **Contents** pane, right-click `Ciruelito_Orthoimage.jp2` > **Symbology**. In the background section (Mask tab) of the Symbology pane, check the box for Display background value. This enables you to display the cells with no data values as transparent, thereby essentially excluding them from the display.

9. In the **Contents** pane, scroll to the bottom of the list and uncheck the "WorldElevation3D/Terrain3D" layer (under Elevation Surfaces).

10. Right-click on **Ground** (under Elevation Surfaces) > **Add Elevation Source**. In the **Add Elevation Source** window, navigate to the DHM file (`Cirulito_DHM.tif`) and click **OK**.

11. Turn the `Cirulito_DHM.tif` layer back on in the contents pane. Adjust the DHM appearance by selecting the DHM layer in the **Contents** pane, navigate to the **Appearance** tab, and click **Symbology**. Within the Symbology pane, select **Classify** from the **Primary symbology** dropdown list, then click the hamburger button (the three lines in the upper right) and select **Advanced**. Under **Data exclusion** enter "–2.5–0.1" to prevent low ground feature heights from being displayed.

Q5 Explain why the non-ground features (e.g., trees) in the three-dimensional view of the DHM appear distorted and blocky.

EXERCISE 1.2: ANALYZE TERRAIN WITH NEIGHBORHOOD FUNCTIONS

1. Within ArcGIS Pro, start a new map.

2. Add in the `Ciruelito_DTM.tif` raster layer and the `StudyArea.shp` polygon vector layer.

3. In the following steps, you will use the **Surface analysis** tool to analyze the terrain of the study area by calculating slope values and creating a hillshaded elevation model based on the DTM. Slope values play an important role in flood hazard modeling as higher slope values represent steeper slopes, which can directly impact the discharge velocity or how fast water flows in the study area. Slope can be measured as the change in local elevation along a user-defined length, which can be expressed in degrees or by calculating:

$$slope = \frac{rise}{run}$$

4. Go to **Analysis** tab > **Tools**. In the **Geoprocessing** window search bar type "Slope (Spatial Analyst Tool)" and click on the corresponding result.

5. In the **Slope** tool pane, enter the following and then click **Run**:

 a. Input raster: Ciruelito_DTM.tif

 b. Output raster: Ciruelito_Slope

 c. Output measurement: Degree

 d. Method: Planar

 e. Z factor: 1

6. Repeat Step 3 from Exercise 1.1 and use the **Zonal Statistics** tool to compute the average slope for the `Ciruelito_Slope` raster. Change the Input value raster to `Ciruelito_Slope` and the output raster name to "AvgSlope."

Q6 What is the average slope[1] (in degrees) of the study area?

7. A hillshade is a 3D representation of the surface topography that takes into account the relative position of the sun for shading the image (Figure 14.4). This 3D representation

FIGURE 14.4 Hillshade of the study area generated from the digital terrain model.

can also help you approximate the location of channel networks in the study area. To create a shaded relief model, go to **Analysis** tab > **Tools**. In the **Geoprocessing** search box type "Hillshade (Spatial Analyst Tool)," and click on the corresponding result to open the tool.

8. In the **Hillshade** tool pane, enter the following and click **Run**:

 f. Input raster: Ciruelito_DTM

 g. Output raster: Ciruelito_Hillshade

 h. Azimuth[2]: 130.44

 i. Altitude: 24.36

 j. (check the Model shadows box)

 k. Z factor: 1

Q7 Add the `Ciruelito_Orthoimage.jp2` raster layer to your map and compare it with the `Ciruelito_Hillshade` raster layer to differentiate between manmade (e.g., road networks) and natural features (e.g., stream channel network). Describe how geometric properties such as pattern, shape, size, and texture vary between manmade and natural features in the hillshade raster. See Figure 14.4 for an example of the Hillshade raster.

EXERCISE 1.3: INVESTIGATE THE HYDROLOGY OF THE STUDY AREA

1. Within ArcGIS Pro, start a new map.

2. Add in the `Ciruelito_DTM.tif` raster layer.

In the following steps, you will use some of the built-in **Hydrology** tools in ArcGIS to identify channel networks in the study area. You will first "fill" any sinks in the DEM to remove small imperfections in the data or depressions in the raster where water might get "stuck" in a hydrological analysis. Filling sinks can assist with the identification of channels.

3. Go to **Analysis > Tools**. In the **Geoprocessing** search box, type "Fill (Spatial Analyst Tool)," and open the corresponding tool.

4. In the **Fill** tool, enter the following and click **Run**:
 a. Input raster: Ciruelito_DTM

 b. Output raster: Fill_DTM

Next, you will compute the **Flow Direction** to determine the direction of water flow from every cell in the DEM raster. The nominal values assigned to each cell in the output raster correspond to the direction in which the water in a specific cell will flow. For example, for all cells in the output raster with a value of 16, water will travel in a westward direction out of the cell, and for cells with a value of 1, water will travel in an eastward direction. For all cells in the output raster with a value of 64, water will travel in a northward direction out of the cell, and for cells with a value of 4, water will travel in a southward direction.

5. Go to **Analysis > Tools**. In the **Geoprocessing** search box, type "Flow Direction (Spatial Analyst Tool)" and open the corresponding tool.

6. In the **Flow Direction** tool, enter the following and click **Run**:
 a. Input raster: Fill_DTM

 b. Output raster: Flow_Direction

 c. Flow direction type: D8

Note: The D8 flow method models flow direction from each cell to its steepest downslope neighbor (Esri, 2016).

You will now use the **Flow Accumulation** tool to calculate the number of cells that are contributing water flow to each cell in the output raster. The cells with higher values in the output raster receive flow from a larger number of cells and are therefore more likely to be part of a major hydrology channel network.

7. Go to **Analysis > Tools**. In the **Geoprocessing** search box, type "Flow Accumulation (Spatial Analyst Tool)," and open the corresponding tool.

8. In the **Flow Accumulation** tool, enter the following and click **Run**:
 a. Input flow direction raster: Flow_Direction

 b. Output accumulation raster: Flow_Accumulation

 c. Output data type: Float

 d. Input flow direction type: D8

In order to identify channels in the study area, you will use the **Raster Calculator** to identify cells in the Flow Accumulation raster with large flow accumulation values. These are cells that are receiving concentrated water flow and are likely to be components of the stream channel network.

9. Go to **Analysis > Tools**. In the **Geoprocessing** search box type "Raster Calculator (Spatial Analyst Tool)," and open the corresponding tool.

10. In the **Raster Calculator** window, type in the below expression to reassign a value of 1 to any cells in the Flow Accumulation raster with a value of greater than 50,000 (i.e., cells that are receiving flow from more than 50,000 cells). Cells with a value of less than or equal to 50,000 will be classified as NoData and excluded from subsequent operations.

```
Con("Flow_Accumulation">50000, 1)
```

11. Name the output "Stream_Raster.tif," and click **Run**.

You will next classify the cells in `Stream_Raster.tif` using the **Stream Order** tool and the Strahler method of stream ordering. The **Strahler method** is a system that was devised to characterize the confluence of smaller stream channels into larger ones in a watershed. All streams without any tributaries are considered first-order. Stream order increases when two first-order streams intersect to form a second-order stream. Similarly, the confluence of two second-order streams produces a third-order stream. It is important to note that the unification of a lower order stream (e.g., first-order) with a higher order stream (e.g., second-order stream) does not result in an increase in stream order (e.g., third order).

12. Go to **Analysis > Tools**. In the **Geoprocessing** search box, type "Stream Order (Spatial Analyst Tool)," and open the corresponding tool.

FIGURE 14.5 Hillshaded terrain model with superimposed stream vector lines symbolized with different colors by their order.

13. In the **Stream Order** tool pane, enter the following and click **Run**:

 a. Input stream raster: Stream_Raster

 b. Input flow direction raster: Flow_Direction

 c. Output raster: Stream_Order

 d. Method of stream ordering: Strahler

 Open the attribute table for the `Stream_Order` layer. The stream order assigned to each cell is listed under the **Value** field. Answer the following questions based on the attribute table:

Q8 How many cells were classified as part of a first-order stream? How many cells were part of a second-order stream? How many cells were part of a third-order stream?

14. You can visualize the output from the stream order operation as vector polylines (see Figure 14.5). To convert the stream raster dataset to polyline features, go to **Analysis > Tools**. In the **Geoprocessing** search box type "Raster to Polyline (Conversion Tools)" and open the corresponding tool.

15. In the **Raster to Polyline** tool pane, enter the following and click **Run**:

 a. Input raster: Stream_Order

 b. Field: Value

 c. Output polyline features: Stream_Order_Lines

 d. Background value: Zero

 e. Minimum dangle length: 0

 f. Keep simplify polylines checked

16. You can play with the layer's Symbology to change the display of the Stream Order Lines vector by colorizing each line segment based on its stream order. To do so, select the

`Stream_Order_Lines` layer in the **Contents** pane and click on **Symbology** in the **Appearance** tab. Select Graduated Colors as the **Primary symbology** method in the **Symbology** pane, and choose "grid_code" as the value for Field 1. You can also pick a different color scheme to increase the contrast between lines with different grid_code values (i.e., stream order values).

Q9 In step 10 of this section, you classified cells in the Flow_Accumulation raster with a value exceeding the threshold of 50,000 as part of the channel network. Hypothesize and investigate the impacts of specifying a lower threshold value. Be sure to discuss how this change will affect the number of cells classified into each stream order category, and the number of stream channel polylines delineated for the study area.

PART 2: MODELING FLOOD HAZARD WITH DRONE DATA

Topographic data, such as DTMs, form the basis of a hydraulic model as they provide a description of the channel networks, floodplain features, and geographical knowledge about the surrounding catchment. Hydraulic model simulations are heavily influenced by the characteristics of the terrain (Sanders 2007), therefore it is recommended to use recent, fine resolution, and accurate terrain data. In two-dimensional (2D) hydraulic models, topographic representation of floodplains must be very detailed for accurate results, and typically aerial laser scanning (i.e., LiDAR – light detection and ranging) is favored where available. Recent advances in the field of UAS offer new opportunities for the low-cost deployment of sensors for the collection of topographic data, either through direct measurement such as LiDAR, or indirect through structure-from-motion (SfM) photogrammetry. The following exercise uses terrain data developed from drone-collected aerial imagery using SfM techniques to perform flood hazard analysis. You will use HEC-RAS (Hydrologic Engineering Centre – River Analysis System) software for flood hazard analysis.

Exercise 2.1: Load UAS Terrain Data into HEC-RAS

1. Download HEC-RAS 5.X at https://www.hec.usace.army.mil/software/hec-ras/download. aspx and run the installation program to install the software. You can also review the release notes for additional information about the software. Once HEC-RAS is installed, launch the program.

2. On the HEC-RAS user interface, navigate to **File > New Project**. In the right window, select the folder where you would like to save your project. Under **Title**, type an appropriate title for your project.

3. Ensure that the name in the **File Name** box matches the **Title** box. When you have selected the project name and folder, click **OK** in the bottom left corner. Click **OK** on the RAS system message.

4. On the main HEC-RAS user interface, navigate to **Options > Unit System** and select **System International**. Click **OK** and accept any warning message from the program. *Note: This step is very important since the data you are using for this exercise is in metric units.*

5. Save the project (**File > Save Project**).

6. Terrain data can now be added to HEC-RAS. From the HEC-RAS user interface, click **RAS Mapper** (refer to Figure 14.6 if you need help identifying the tool).

7. The first step is to define the project's coordinate system. Within **RAS Mapper** click **Tools > Set Projection for Project**. Click the folder icon and navigate to the `Mexican Datum`

Geometry Editor Unsteady flow model setup RAS mapper

Project file names Run unsteady flow model Model units

FIGURE 14.6 HEC-RAS 5.0 user interface shows the locations for the tools that you will use in this exercise. Interface connects various hydraulic analysis components, data storage and management capabilities, and graphics reporting facilities.

1993 UTM Zone 12N.prj file within the data folder for this exercise. Once the projection file has been selected, click **OK** to return to the RAS Mapper window.

Q10 As the name of the projection file suggests, the study area is located within the Universal Transverse Mercator (UTM) Zone 12 North. Perform an internet search to determine the range of longitude degrees in Zone 12 North. Report those values here.

8. Navigate to **Tools** and select **New Terrain**. In the **New Terrain Layer** window, click the "+" icon and navigate to your terrain dataset (DTM). Under **Rounding (Precision)** select **1/100**. The units are in meters, so this value will ensure that elevation values are entered with 1-centimeter precision. For **Filename**, click the folder icon and enter an appropriate name describing the current terrain dataset (this could, for example, match the name of the original terrain file). Once all settings have been entered, click **Create**. When processing is complete, click **Close** on the **Creating Terrain** dialog window.

Q11 The terrain data for this project uses metric units. However, if the data were in the imperial unit system, what rounding would you have to choose to attain the same precision as above?

9. At this point, the terrain data have been added to HEC-RAS. Initially, it may not be visible in RAS Mapper. Ensure the box next to the **Terrains** layer is checked and click the globe icon (see red boxes in Figure 14.7).

10. RAS Mapper offers the ability to zoom in and out using the scroll wheel on the mouse or using the **Zoom** buttons (see Figure 14.7). To measure distances in the terrain dataset units, use the **Measure** tool (see Figure 14.7). To retrieve terrain elevation information, ensure the **Terrains** layer is highlighted (the layer name will turn pink) in the left-hand side window and hover your mouse over the terrain map. Right-clicking on the name you assigned to your terrain in Step 8 (e.g., "Ciruelito_15cm_DTM_GCP_ground" in Figure 14.7) will open a context menu with various options for assisting with terrain data visualization. Select **Image display properties…**

11. The **Layer Properties** window opens, giving access to several features that can be adjusted to enhance terrain data visualization (see Figure 14.8). For example, the color transparency can be changed on the **Transparency** slider bar, contour lines can be plotted based on a list of possible contour intervals, and terrain features can be exaggerated to highlight small channels or landform features by increasing the **Z Factor**. When you are finished exploring the terrain model, return to the main HEC-RAS user interface and save the project.

Zoom in/out buttons Measure tool

FIGURE 14.7 Displaying terrain data in RAS Mapper.

FIGURE 14.8 HEC-RAS Layer Properties window.

Q12 Based on the elevation values in the terrain layer, in which direction do you think water will flow within the study area?

EXERCISE 2.2: MODEL FLOW AREA SETUP

With the terrain data successfully imported into HEC-RAS, you are now able to start setting up the hydraulic model. For this exercise, you will focus on the two-dimensional (2D) application of HEC-RAS for hydraulic modeling. The first step of setting up a hydraulic model is to define the extent of the modeling domain over which the software will compute flow. In HEC-RAS this is done using a **2D flow Area**.

1. Open the **Geometry Editor** (refer back to Figure 14.6 if you need help identifying the tool). Within the Geometry Editor, **Tools** are aligned horizontally at the top of the window, while **Editors** are aligned vertically on the left-hand side of the window. The modeling process requires you first create geometries using the **Tools**. Then, the geometries can be edited using the **Editors**. From **Tools**, select **2D Flow Area**. Drag the cursor into the map area, and draw a polygon that roughly approximates the catchment boundary shown by the magenta line in Figure 14.9. Make sure that the ending point of your polygon sketch reasonably coincides with the starting point of the sketch. Double-click to finish the polygon and give it a name. For now, you can ignore the circular magenta outline, which will be addressed in the next step.

The extent of the polygon you drew defines the area where HEC-RAS will perform flow calculations over. Flow calculations are carried out over so-called computational cells, which have to be spread across the **2D Flow Area**.

FIGURE 14.9 Manual digitizing the 2D flow area along a catchment boundary.

2. To create the mesh, click on the drawn polygon to select it. Once selected, it will be highlighted in magenta, and enclosed within a large circle (see Figure 14.9). Then click the **2D Flow Area editor** on the left-hand side of the **Geometry Editor** window. In the **2D Flow Area editor** window, change the **Default Manning's** *n* value to 0.04. The Manning coefficient represents the type of surface in your modeling domain. A value of 0.04 m$1^{/3}$/s represents light brush and trees, which is the predominant landcover in our study area (Chow 1973). Then click the **Generate Computation Points on Regular Interval with All Breaklines** button. Under **Computation Point Spacing**, enter a mesh cell size of 3x3 meters. The cell size needs to be small enough to capture the size of features in the modeling domain but large enough to prevent the model from taking too long to run.

3. Once you have entered the **Computation Point Spacing**, click the **Generate Points in 2D Flow Area** button (see Figure 14.10). Select **Force Mesh Recomputation** in the **2D Flow Area editor** window to output the finished mesh of computational cells. You will see square cells appearing in the digitized 2D flow area, and the 2D Flow Area editor window will provide statistics on the generated mesh (see Figure 14.11).

Note: Generating meshes with many hundreds of thousands or even millions of cells can require many hours of computation and is only recommended for high performance desktops or computing clusters.

4. Before continuing, save the geometry data you just created. In the **Geometry Editor** click **File > Save Geometry Data As**. Under **Title**, enter an appropriate name for your geometry data. For example, since you are currently setting up a model to simulate streamflow from the model boundary, you could name the geometry data "Geometry_streamflow." Do not

FIGURE 14.10　Generating points for model mesh creation.

FIGURE 14.11 Mesh statistics generated.

worry if your terrain layer disappears after saving your geometry data; that will be addressed in the following steps.

5. Another necessary setup task is to associate the terrain data to the generated mesh so that terrain elevations can be assigned to the cells within the mesh. From the main HEC-RAS user interface, open **RAS Mapper** (refer to Figure 14.6 if you need help identifying the tool). At this point you will see that a number of geometry layers have been added in the left-hand panel (expand the **Geometries** item by clicking on the plus sign, if needed). Right click on the **Geometries** layer header, and select **Manage Geometry Associations** from the context menu (see Figure 14.12). In the Manage Geometry Associations window, ensure that under **Terrain**, the terrain data that you previously imported is selected, and click **Close**. Check the box for 2D Flow Areas under **Geometries** in the left-hand panel to see your 2D flow area polygon superimposed on the terrain layer (see Figure 14.12).

6. With the geometry data saved and terrain associated, you will proceed with setting up the boundary conditions for streamflow. Boundary conditions are used to define the locations where streamflow will be forced into the model and where flow is allowed to leave the model. Open the **Geometry Editor**. Since you associated the terrain layer with your 2D flow area in the previous step, you should now be able to see the terrain data in your **Geometry Editor** window. If not, try zooming in and out by using the scroll wheel of your mouse, and the terrain data should appear. Within the **Geometry Editor** tools button bar (along the top of the window), select the **SA/2D Area BC Lines** tool to draw the boundary conditions. Boundary conditions that allow flow to enter the model (also known as inflow boundary conditions) should be located across stream channels. Zoom to an upstream channel location at the 2D Flow Area boundary where you want streamflow to enter the model

FIGURE 14.12 Terrain association with geometry data.

(e.g., see the small pink circle in Figure 14.15 if you need assistance locating this point). Draw a polyline along the outer boundary of the border (without touching the boundary or crossing the boundary line) approximately across the width of the stream channel (see Figure 14.13), and double-click to finish drawing the polyline. When prompted, enter a name for the boundary condition (e.g., "BC_inflow"). Several boundary conditions can be added to the same mesh, therefore label your boundary conditions appropriately. Click **OK** after entering each boundary condition name.

7. The boundary condition you drew will appear as a dashed black and red line, and the name will be shown within a label next to the boundary condition. Save the geometry data in the **Geometry Editor** by going to **File > Save Geometry Data**.

Since you linked the geometry data to the terrain layer in a previous step, you can explore what the local terrain looks like at the boundary condition, and check if the boundary condition actually falls on a stream channel.

8. In the **Geometry Editor**, click on the boundary condition polyline that you just drew. A context menu opens with various options. Select **Plot Terrain Profile under BC Line**. A plot opens showing the elevation of the terrain (*y*-axis) along the distance of the boundary condition line (*x*-axis) (see Figure 14.14).

Q13 Include a screenshot of your boundary condition profile plot. What is the lowest elevation in your profile plot? This is the *thalweg* value – the line of lowest elevation in a channel – at the cross-section represented by your boundary condition polyline.

9. Close the terrain profile plot and add a second boundary condition, but this time add it at the downstream end of the terrain data (see Figure 14.15 for where to draw this line).

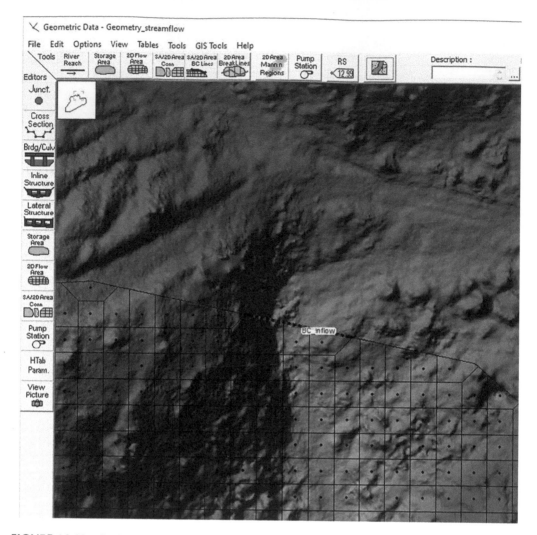

FIGURE 14.13 Setting up a boundary condition.

Defining a downstream boundary condition is very important, since without this condition, all flow that enters the 2D Flow Area from the upstream boundary condition would remain stuck in the 2D Flow Area, like a clogged bathtub. The downstream boundary condition will act as a drain, allowing flow to pass through the 2D Flow Area. Draw the downstream boundary condition along the outer border of the 2D flow area (without touching the boundary or crossing the boundary line) and name the second boundary condition (e.g., "BC_outflow"), making it explicit that this represents the downstream condition or the outflow of the model.

10. At this point, your geometry data setup for this model is complete. Click on the **2D Flow Area** polygon that you drew previously (not the icon in the Editors or Tools menu), select **Edit 2D Flow Area** from the context menu, and click **Force Mesh Recomputation** to ensure that the boundary conditions are correctly linked to the 2D flow area. Then exit the **2D Flow Areas** window, save the geometry data in the **Geometry Editor**, and close the **Geometry Editor** window.

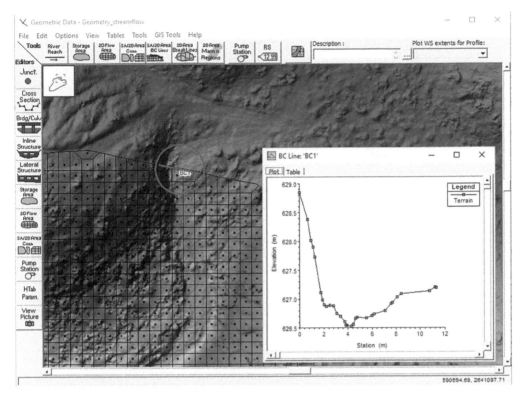

FIGURE 14.14 Exploring terrain profile at boundary condition location.

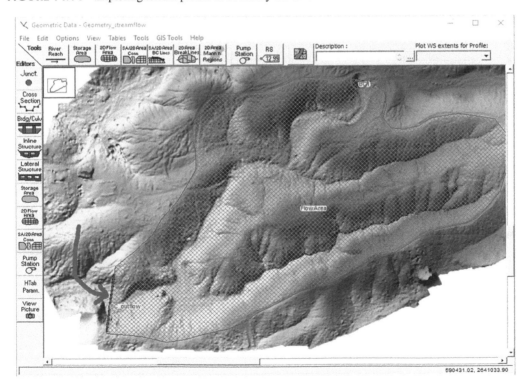

FIGURE 14.15 Defining the location of the downstream boundary condition.

EXERCISE 2.3: MODELING UNSTEADY FLOW

1. From the HEC-RAS user interface, save the project.

2. Open the **Unsteady Flow Model Setup** tool (refer back to Figure 14.6 if you need help identifying the tool). The setup tool window will open, giving you access to options to define the amount of flow to enter the model.

3. Under **Storage/2D Flow Areas**, select the downstream boundary conditions (i.e., BC_outflow). Then, from the various **Boundary Condition Types** in the list toward the top of the window, select **Normal Depth**. By selecting **Normal Depth**, you are telling HEC-RAS to solve an equation at the downstream boundary condition called the Manning formula. Manning's equation relates water flow velocity (from the upstream boundary) and stream channel geometry (from the terrain data) to flow depth. To solve Manning's equation, at the downstream boundary, HEC-RAS needs to know the *friction slope*, which can be approximated using the terrain slope at the downstream boundary condition. Given the example data, enter 0.033 m/m as the **Friction Slope**, then click **OK**.

4. Next, select the upstream boundary condition (i.e., BC_inflow) from the list and select **Flow Hydrograph** from the various **Boundary Condition Types**. The **Flow Hydrograph** window will open. Under **Data time interval** select **30 Minute**. Then, under the **Hydrograph Data – Flow** column, enter all the values as shown in Figure 14.16 (ignore the default values in the Date column). These values represent the (volumetric flow) rate of water entering the 2D flow area reported every 30 minutes throughout the hypothetical rain event that you will be simulating in this exercise. Finally, enter 0.06 m/m as the **EG Slope** in the bottom right-hand corner. This value represents the terrain slope at the upstream boundary condition and is once again used to calculate an initial flow depth using Manning's equation.

5. Click the **Plot Data** button, and HEC-RAS will display the upstream flow data as defined by the numbers you entered into the **Hydrograph Data** table. In this case, you are forcing

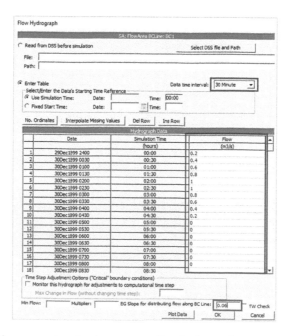

FIGURE 14.16 Defining parameters for the upstream flow hydrograph.

flow into the model at the upstream boundary location using a triangular-shaped hydrograph. Triangular hydrographs are a simplified form of hydrograph, and they are helpful for modeling peak flows of flood events.

Note that for sites where gauge data are available, it is preferred to use measured flow data to force flow in a hydraulic model. However, in the absence of gauge data, values have been provided for you.

Q14 Referring to the hydrograph data table and plot, at approximately what time can you expect peak flow (maximum flow) at the upstream boundary? What flow rate was reported at those times?

6. Click **OK** on the **Flow Hydrograph** window and return to the **Unsteady Flow Setup** window. At this point, your boundary condition setup is complete, and the **Unsteady Flow Setup** window should look similar to Figure 14.17.

7. Within the **Unsteady Flow Setup** window go to **File > Save Unsteady Flow Data As**. Assign an appropriate name to the unsteady flow data. Exit the **Unsteady Flow Setup** window, return to the main HEC-RAS user interface, and save the project.

8. With geometry and flow data defined for your hydraulic model, you next need to provide HEC-RAS instructions on how to run the model. As shown in Figure 14.6, open the **Perform Unsteady Flow Model** tool. Enter a Short ID name (e.g., "1cms" to represent the peak flow conditions). Under **Programs to Run**, select the **Geometry Preprocessor**, **Unsteady Flow Simulation**, and the **Post Processor** options. Use the calendar icons to enter today's date as the Starting Date and Ending Date. Under **Starting Time** enter 00:00, under **Ending Time** enter 06:00 (the time you want your simulation to run until). *Note: the end time can be shorter than the hydrograph duration, but not longer.* Finally, under **Computation Settings** adjust the intervals as shown in Figure 14.18.

FIGURE 14.17 Completed boundary conditions setup.

FIGURE 14.18 Unsteady Flow setup

Note: the computation interval is very important for successfully running a model. Entering too large a value will result in the model becoming unstable and crashing, producing erroneous results. Entering too small of a value will result in the model requiring a very long time to run. Therefore, often the correct value will be obtained by trial and error. It is important to remember that the Mapping, Hydrograph, and Detailed Output Intervals do not influence the model computation; but the Computation Interval can make or break your model.

9. Within the **Unsteady Flow Analysis** window, click **Options-Calculation Options and Tolerances**. Under the **2D Flow Options** tab set the **#6 Equation Set** for your 2D flow area (right column) as **Full Momentum** (see Figure 14.19). This setup enables the full shallow water flow equations, which provide greater accuracy during flow computation compared to the *Diffusion Wave* equations. While HEC-RAS might run slower when using the *Full Momentum* equations, it will provide better results, especially for hydraulic models with fast moving flow over steep terrain. Click **OK** to exit the **Options and Tolerances** window.

10. In the **Unsteady Flow Analysis** window, navigate to **File > Save Plan As**. Enter an appropriate **Plan** name to store your model run settings.

11. At this point, you have completed all of the necessary setup steps for your hydraulic model. Save the project on the main HEC-RAS user interface, and then click the **Compute** button on the **Unsteady Flow Analysis** window.

Note: This process can take several minutes. The HEC-RAS **Computations** *window (see Figure 14.20) will open, providing a step-by-step account of what HEC-RAS is doing while running your model.*

Errors are encountered when HEC-RAS is not able to optimize the flow convergence and a large water surface elevation error is detected. The error is shown in the *ERROR* column, while the modeled water surface elevation and the model cell where the error is occurring are shown in the

FIGURE 14.19 Setting HEC-RAS to run the Full Momentum equations.

FIGURE 14.20 Running the HEC-RAS model computation.

WSEL and *Cell* columns, respectively. If the *ERROR* value becomes too large, the model may become unstable and the program will crash. If this happens, you will need to reduce the *Computation Interval* in the *Unsteady Flow Analysis* window.

EXERCISE 2.4: VISUALIZING THE MODELING RESULTS

The final step is to visually check that the simulation ran correctly and that the modeled flow matches your expectations. Any mistakes that may have been made during model setup or in the choice of model execution parameters usually become evident when visualizing the simulation results.

In HEC-RAS, the simulation results are displayed within **RAS Mapper**, which was initially used to import model terrain data into HEC-RAS. After model execution, HEC-RAS processes the model outputs and displays them with the initially imported terrain data. From there, various modeled flow properties can be visualized, an animation of the modeled flow can be viewed, localized analysis on flow properties can be carried out, and the modeling results can be exported to be used in other software (e.g., ArcGIS Pro).

1. From the main HEC-RAS user interface, open **RAS Mapper**. To visualize the extent of the modeling domain (which you drew in Exercise 2.2), expand the **Geometries** item by clicking on the plus sign, and turn on **2D Flow Areas**.

2. To visualize the model results, expand the **Results** item by clicking on the plus sign, and turn on the **Depth**, **Velocity**, and **WSE** (Water Surface Elevation) layers. You may also need to turn off a layer to see other layers that are listed under it.

 Note that when you select each layer's name, it becomes selected, and its name is highlighted in a magenta color. For example, click on the Depth layer's name, then press the **Play animation button** in the time selection and animation menu (see Figure 14.21) to see

FIGURE 14.21 An overview of important RAS Mapper functionalities and tools.

FIGURE 14.22 (Left) Layer Properties. (Right) Editing layer coloring.

an animation of water depth changes during the study period. You can also select a time instance by adjusting the **Time selection slider** (see Figure 14.21), and hovering the cursor over the flood depth data in your map. The depth at the cursor location at a specific time will be displayed.

3. You can also change the way results are contoured during display or animation in **RAS Mapper**. When a layer is turned on (checked), a color bar will appear next to the layer name. Double-clicking the layer name opens the **Layer Properties** window for that layer (see Figure 14.22).

4. Under **Surface**, click **Edit** to access the **Select Surface Fill** editor. Here you can change the way **RAS Mapper** symbolizes the data inside the results layer, which is helpful to highlight specific properties. For example, if you want to differentiate between various levels of shallow flows, you can limit the *Max* surface value and increase the *number of values (No. Values)* to be colored (see Figure 14.22). Once you are happy with the layer colors, click **Create**, then **Apply** and close the **Layer Properties** window.

Q15 Submit four screenshot graphics of your completed project as follows:

- A graphic showing only your 2D flow area superimposed on the terrain data
- A graphic showing only your Depth (Max) layer superimposed on the terrain data
- A graphic showing only your Velocity (Max) layer superimposed on the terrain data
- A graphic showing only your WSE layer superimposed on the terrain data

FIGURE 14.23 DJI's Phantom 4 unmanned aircraft (drone) used in the collection of data for this chapter.

DISCUSSION AND SYNTHESIS QUESTIONS

S1 Produce hillshade layers of the study area using the DSM and the DTM. Discuss your observations and the causes for any differences in the two hillshade layers. Hypothesize how the flood extent and flow velocity may change if you used the DSM instead of the DTM as your terrain data.

S2 Set up a second flow simulation using the DSM for terrain instead of the DTM. You can do so by importing the DSM into RAS Mapper (see Exercise 2.1, Step 8), then associate the new terrain to the project Geometries (see Exercise 2.2, Step 5). After, you can re-run your previous flow scenario and the new results will appear in RAS Mapper. Once completed, make a graphic (e.g., using your computer's print screen/screenshot function) to compare the flood extents and depths for each scenario (i.e., DTM & DSM) (see Exercise 2.4, Step 4 to tailor the depth contouring to highlight flow depth differences). Describe where and why you see differences in the simulation results.

S3 List the advantages and disadvantages of using drones to gather terrain data used in flood hazard modeling. Be sure to consider issues such as safety, efficiency, resolution (e.g., spatial, temporal), and accuracy.

S4 Research the principles behind UAS LiDAR (light detection and ranging) technology and explain how it may enable researchers to derive terrain data that are more accurate than terrain data derived from photogrammetry, such as the ones used in this chapter's exercises.

S5 One of the main challenges in flood hazard modeling is finding suitable terrain data for model setup. Using the USGS's Explorer tool, find other types of freely available digital

elevation data for the Ciruelito site (Lat: 23.8774, Lon: –110.1102; radius = 500 m), describe their source/method of data collection and data product attributes. Download the data (free USGS account required) and compare how they represent the stream network relative to the UAS data.

S6 Give some examples of social and hydrological parameters that you did not specify in the HEC-RAS exercise (Part 2) in this chapter but that may potentially impact the flood extent, flood velocity, and flood depths within the study area.

S7 Discuss the real-world applications of model outputs such as those produced in this chapter for urban planners, policymakers, emergency responders, and other community stakeholders.

COLLECTING THE DATA YOURSELF (OPTIONAL)

The data used in this chapter were collected using a DJI Phantom 4 drone with a built-in 12.4MP RGB camera (Figure 14.23) and processed using DroneDeploy – a third-party cloud-based UAS data processing and flight planning application software. Once the flight is completed, you can upload the collected images directly to the DroneDeploy website, where the images are automatically processed using the Structure from Motion (SfM) photogrammetry technique. You can download the raw drone images from the data folder provided for this chapter if you would like to build the orthoimage, DSM, and DTM used in this chapter yourself. You can sign up for a trial account on the DroneDeploy website or use another software program.

ACKNOWLEDGMENTS

This material is based upon work supported by the National Science Foundation under Grant No. 1700496, 1700552. Any opinions, findings, and conclusions or recommendations expressed in this material are those of the author(s) and do not necessarily reflect the views of the National Science Foundation.

NOTES

1 To contextualize slope, consider a home with a pitched roof typically has a minimum of 10 degree slope. For more information on how slopes angles are calculated, see https://www.e-education.psu.edu/natureofgeoinfo/book/export/html/1837.
2 The Azimuth is the sun's relative position along the horizon (degrees), and the altitude is the sun's angle of elevation above the horizon (degrees) (Esri, 2016).The sample Azimuth (Solar Azimuth) and Altitude (Solar Elevation) values for the study area are based on November 29, 2019 at 10:00 AM. You can explore Azimuth and Altitude values for other locations by visiting the NOAA ESRL Solar Position Calculator: https://www.esrl.noaa.gov/gmd/grad/solcalc/azel.html.

REFERENCES

Berger, A.R. (2008). Rapid landscape changes, their causes, and how they affect human history and culture. *Northern Review*, 28, 15–26.
Chow, V.T. (1973). *Open-channel hydraulics* (International ed.). Singapore: McGraw-Hill.
Dong, P., & Chen, Q. (2018). *LiDAR remote sensing and applications*. Boca Raton, FL: CRC Press.
Esri. (2016). Hillshade function – Help I ArcGIS for Desktop. *Arcgis.Com*. http://desktop.arcgis.com/en/arcmap/10.3/manage-data/raster-and-images/hillshade-function.htm.
GeoAdaptive, LLC (2015). *Evaluación Técnica-Intervenciones Estratégicas Hacia un Futuro Resiliente, La Paz, BCS, México*. Boston, MA: GeoAdaptive LLC.

Hashemi-Beni, L.; Jones, J.; Thompson, G.; Johnson, C.; Gebrehiwot, A. Challenges and Opportunities for UAV-Based Digital Elevation Model Generation for Flood-Risk Management: A Case of Princeville, North Carolina, *Sensors* 2018, 18, 3843. https://doi.org/10.3390/s18113843.

Heimhuber, V.; Hannemann, J.-C.; Rieger, W. Flood Risk Management in Remote and Impoverished Areas—A Case Study of Onaville, Haiti. *Water* 2015, 7, 3832–3860. https://doi.org/10.3390/w7073832.

Heintz, M.D., Hagemeier-Klose, M., & Wagner, K. (2012). Towards a risk governance culture in flood policy – Findings from the implementation of the "floods directive" in Germany. *Water*, 4, 135–156.

Ivanova, A., & Bermudez-Contreras, A. (2014). Climate Action Plan for the City of La Paz, BCS, Mexico: a tool for public policy in a Coastal City. *Current Urban Studies*, 2, 249.

Orengo, H.A., & Petrie, C.A. (2018). Multi-scale relief model (MSRM): a new algorithm for the visualization of subtle topographic change of variable size in digital elevation models. *Earth Surface Processes and Landforms*, 43, 1361–1369.

Parker, D.J. (1995). Floods in cities: Increasing exposure and rising impact potential. *Built Environment (1978-)*, 21, 114–125.

Parrot, J.-F., & Núñez, C.R. (2016). LiDAR DTM: artifacts, and correction for river altitudes. *Investigaciones Geográficas, Boletín del Instituto de Geografía*, 2016, 28–39

Sanders, B.F. (2007). Evaluation of on-line DEMs for flood inundation modeling. *Advances in Water Resources*, 30, 1831–1843.

15 Comparing UAS and Terrestrial Laser Scanning Methods for Change Detection in Coastal Landscapes

Ian J. Walker, Craig Turner, and Zach Hilgendorf

CONTENTS

LEARNING OBJECTIVES

After completing this chapter, you will be able to:

1. Understand how unmanned/uncrewed aircraft systems (UAS) imagery can be used to create high-resolution digital surface models (DSMs) and digital elevation model (DEM) of a dynamic, vegetated coastal dune landscape
2. Assess various logistical considerations and constraints associated with using UAS and terrestrial laser scanning (TLS) datasets of the same location for characterizing change in vegetated terrain
3. Conduct a geomorphic change detection (GCD) analysis using basic surface differencing and a more advanced spatial statistical approach
4. Interpret spatial-temporal (4D) morphodynamics of a coastal dune landscape using change surfaces and derived sediment volumetric changes

HARDWARE AND SOFTWARE REQUIREMENTS

The required materials for the exercises include:

1. A computer that can run Agisoft Metashape. Requirements can be found at Agisoft's system requirements webpage: https://www.agisoft.com/downloads/system-requirements/)
2. Agisoft Metashape Professional software
3. Esri ArcMap Desktop 10.4 or higher
4. GCD 7 AddIn for ArcGIS 10.4 or higher. The AddIn download and installation details are available on the Geomorphic Change Detection (GCD) software website: http://gcd.river-scapes.xyz/Download/[1]
5. The data included for download with this chapter

Post-processing of the data was conducted in the photogrammetric software Agisoft Metashape Professional.

OBJECTIVES AND KEY CONCEPTS

Many of Earth's landscapes are dynamic and change on timescales perceptible to humans, often with important implications for our activities, economies, and communities. **Geomorphology** is the study of landforms and their formative processes. Geomorphic processes such as river flooding, erosion by wind, water, or ice, and mass wasting by gravity involve exchanges of matter (e.g., soil, sediment, rock, water, etc.) that require various forms of energy (e.g., potential, kinetic, thermodynamic) be converted and expended over space and time. As such, landforms are considered **process-response systems** wherein exchanges of matter and energy via Earth surface processes give rise to distinct landforms and landscapes. The term **morphodynamics** is used to describe changes in process-response system function and form over space and/or time. Geomorphic processes occur naturally, but their frequency, magnitude, and geomorphic responses can also be exacerbated directly (e.g., slope oversteepening) or indirectly (e.g., climate change) by human activities.

Coastal landscapes are inherently dynamic, complex systems, and ongoing processes of erosion, sedimentation, flooding, and sea-level rise will accelerate in many regions with future climatic variability and change (Ranasinghe 2016). Combined with the effects of increasing

populations and development pressures, managing change in coastal areas will require enhanced response plans by communities, engineers, and land managers to mitigate and/or adapt to ongoing and future changes. Such responses include erosion and flood control measures (e.g., beach nourishment, dune rebuilding, dyke construction), beach-dune ecosystem restoration, infrastructure upgrades or relocation, or other engineering and planning efforts. These efforts require methods of detecting and quantifying coastal change and associated hazards to inform mitigation, restoration, and adaptation strategies.

High-resolution, remotely sensed data offer improved detection, measurement, and interpretation of geomorphic processes, and their use has expanded recently from largely land surveying applications and scientific inquiry to include natural hazards management, land-use planning, civil and environmental engineering, and development of climate change adaptation strategies. Recent advances and improved availability of **close-range remote sensing** methods (non-orbital platforms that are close to, or on, Earth's surface), have allowed for much higher resolution (spatial and temporal) characterization of geomorphic processes and change than traditional satellite platforms. In particular, the generation of DSMs, which include other objects such as vegetation and buildings, and "bare-earth" DEMs (also referred to as digital terrain models, DTMs) that only include ground surface data (Figure 15.1), has enabled detailed examination of landscapes and change. These models are often interpolated as raster or vector datasets from highly dense, three-dimensional point clouds. Resulting DSMs and DEMs are usually provided as a raster product with a resolution, or ground sampling distance (GSD), that is effectively the distance between pixel centers.

FIGURE 15.1 UAS-derived orthophoto mosaic, DSM, and DEM products. a) Plan view of the digital orthomosaic showing various non-ground features (e.g., vehicles, trees). b) Oblique view of the orthomosaic at the same location showing minor distortion under the crown of a tree. c) Plan view of the UAS-derived point cloud that includes vegetation and vehicles, depicted as black points. d) DSM constructed with the point cloud from (c) with white coloration indicating areas of high elevation. e) Point cloud from (c) with vegetation and vehicles removed to leave only ground points. f) DEM constructed with the point cloud from (e). Areas where points have been removed appear as smooth surfaces, wherein the points along the edge of these gaps are used to interpolate the surface.

FIGURE 15.2 a) Fixed-wing UAS with vertical takeoff and landing capability. This platform can operate with longer flight times (~55 min) and at higher elevations than many multi-rotor platforms, making it ideal for mapping larger study areas. b) Quadcopter UAS system with a more limited flight time (up to 30 min) and lower elevation required for equivalent GSD resolution. Over larger study areas, this quadcopter platform requires multiple flights to acquire the same data coverage, but its ability to hover and compensate for flight attitude, particularly in stronger winds, is advantageous for some situations. c) TLS system integrated with an onboard, Trimble R10 GNSS system and RGB camera. This platform is much more time intensive to operate but is capable of higher resolution ground mapping, and the data can be classified with greater precision to remove vegetation with higher accuracy compared to a UAS-derived point cloud.

Monitoring campaigns using UAS or light detection and ranging (LiDAR) products, including those from terrestrial laser scanning (TLS), are now used often to improve natural hazard detection and mitigation, land-use management, and longer-term decision-making for change in dynamic landscapes (Figure 15.2) such as river floodplains (Tamminga et al. 2015), hillslope systems (Kasprak et al. 2019), glacial valleys (Westoby et al. 2012), and coastal environments (Guisado-Pintado et al. 2019). In comparison to traditional satellite imagery or aerial LiDAR, UAS and TLS enable collection of higher resolution (spatial and temporal) data products useful for observing and interpreting processes of landscape change. Using georeferenced ground control points (GCPs), temporary targets, or known survey monuments occupied with GNSS receivers, UAS and TLS can provide rapid, georeferenced imagery (UAS only) and point clouds that allow for quantification of cm-scale changes at broader landform (10–100s m) to landscape (100–1000s m) scales. As such, UAS and TLS have emerged as feasible and relatively affordable tools for assessing landscape change.

Complementing the use of traditional two-dimensional aerial photographs for interpreting landscapes and generating topographic maps, the examination of high-resolution DSMs and DEMs over time has emerged as a common method for **geomorphic change detection** (GCD) (Bishop et al. 2012; Wheaton et al. 2010). GCD is a technique that uses repeat, topographic surveys to infer changes in landforms or landscapes. The method involves mathematical comparison of digital surfaces over successive time intervals to detect patterns and quantities of change through time. Geomorphologists are typically most interested in patterns of vertical elevation change (increase = accretion, decrease = erosion) of sediment, soil, or rock from the Earth's surface. Such patterns yield important information on the nature and rates of geomorphic processes

responsible for observed changes and can yield insights on contributing factors, trends, and future states of landscapes that are useful for both modelling and management.

This chapter and exercise explore the use of repeat, high-resolution UAS imagery for detecting, quantifying, and interpreting spatial-temporal changes in a dynamic coastal landscape. Comparison of UAS data to TLS data for the same landscape is used to highlight differences between datasets and interpretation capabilities from a passive aerial sensor (e.g., onboard a UAS) and an active, on-the-ground sensor (e.g., TLS). From these comparisons, implications for DEM generation, geomorphic change detection, and interpreting morphodynamics in vegetated landscapes are discussed.

INTRODUCTION

Close-range remote sensing methods, including UAS and TLS, are now used widely to provide repeat, high-resolution datasets for detecting and interpreting changes in dynamic coastal landscapes. Various spatial-temporal statistical methods have emerged to query such datasets and provide robust means for identifying and quantifying important patterns of change (Bishop et al. 2012; Wheaton et al. 2010). In turn, this improves understanding of driving processes of change and related implications for managing dynamic landscapes and enhancing their resilience to various land-use activities or climate change impacts.

Until recently, aerial LiDAR and TLS systems were the predominant means for capturing ultra-high-resolution DEMs of landscapes. Over the past decade, however, significant advances in digital photogrammetry, notably Structure-from-Motion Multi-View Stereo (SfM-MVS) methods (Westoby et al. 2012), have enabled creation of DSMs and DEMs of landscapes from UAS imagery on desktop computing platforms. These methods are now embedded within adept post-processing software (e.g., Pix4D, Agisoft Metashape) that enables detecting and interpreting landscape changes more efficiently and effectively than traditional land surveys or aerial photogrammetry.

UAS and TLS systems entail different advantages and limitations for mapping complex terrain, as discussed below and in Table 15.1. The exercise explores these differences by comparison of UAS- and TLS-derived datasets from the same landscape to highlight logistical considerations and interpretation capabilities of each for detecting and quantifying change in vegetated terrain. Figure 15.2 depicts two common UAS flight platforms and a Riegl VZ400i TLS system that were deployed to collect the datasets used in this assignment.

COASTAL FOREDUNE SYSTEMS

The coastal margin is one of the most dynamic landscapes on Earth, and landforms such as beaches, spits, bluffs, and dunes reflect the complex interplay between marine, atmospheric, terrestrial, and biological processes. The landscape chosen for this assignment is a **coastal foredune** (Figure 15.3) – a shore-parallel sand ridge that develops on the upper beach by deposition of windblown (aeolian) sand in vegetation (Hesp 2002). Foredunes are not formed by wave action or tidal processes, but they are linked to coastal (littoral) processes like wave swash, runup, or storm surges that can supply and/or erode sand to/from beaches. Foredunes are thus highly dynamic and offer the added complexity of grassy to shrubby vegetation that obscures some of the underlying sand surface.

Foredunes can be continuous ridges or discontinuous, hummocky features, depending on vegetation type, wind regime, sand supply, and climate (Hesp and Walker 2013). The large, continuous ridge shown in Figure 15.3 is the "established" active foredune. Established

TABLE 15.1

Key Attributes and Differences between Common Close-Range Remote Sensing Platforms Used in Geomorphology Research, Including Kite/Balloon Aerial Photogrammetry (KAP/BAP), Uncrewed Aircraft Systems (UAS), and Terrestrial Laser Scanning (TLS)

Criteria	KAP/BAP	UAS	TLS
Capital costs	Very low	Low	Moderate
Ease of deployment and data acquisition	Very easy	Easy[+]	Moderate[*]
Spatial coverage	Small to moderate (1×10^{1}-10^{4} m²)[#]	Small to extensive (1×10^{2}–10^{6} m²)[#,**]	Small to extensive (1×10^{2}–10^{6} m²)[*]
Spatial resolution (pts/m³)	~300-700[^]	~300-700[^]	~1500+[*]
Post-processing	Moderate[@]	Moderate[@]	Significant[*]
Primary and secondary data products	Primary: DI and V Secondary: OM, PC, DSM, and DEM[@]	Primary: DI and V Secondary: OM, PC, DSM, and DEM[@]	Primary: PC Secondary: DSM, and DEM
Accuracy (m)	±0.15-0.30	±0.12	±0.03

DI = Digital orthoimagery, V = Video, OM = Orthomosaics, PC = Point clouds, DEM = Digital elevation model, and DSM = Digital surface model

~ Varies with contractor

+ Depends on flight restrictions and compliance issues

^ Depends on flight elevation, camera resolution, and attitude

* Depends on the mode of deployment (tripod vs. mobile mount)

Depends on flight platform and/or battery life

@ Depends on software and computing hardware capabilities

** Based on a 20-minute flight at 60m AGL with a DJI Phantom 4 Pro

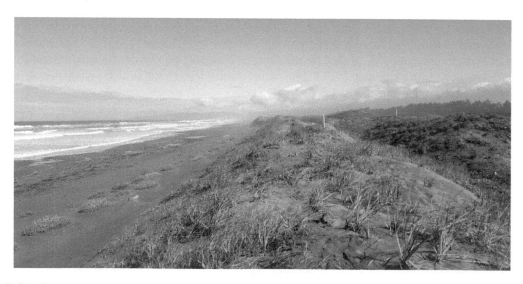

FIGURE 15.3 A 10-m high established foredune formed by deposition of windblown (aeolian) sand in vegetation at the Lanphere Dunes, Arcata, California. The foredune is vegetated predominantly with native *Elymus mollis* grass and a low forb assemblage. Landward is a stabilized foredune that receives little sand delivery from the beach. Seaward is a low, discontinuous, hummocky incipient foredune forming on the upper beach by deposition in clusters of a pioneer species, *Cakile edentula* (American searocket).

FIGURE 15.4 Study area near Arcata, California. This site has been monitored since 2014 as part of a restoration project.

foredunes host a variety of intermediate, sometimes woody, plant species and tend to have greater morphological complexity, height, width, age, and a seaward-most position (Hesp 2002). Here, the foredune is vegetated predominantly with native *Elymus mollis* grass and a low "dune mat" forb assemblage. Landward of this is a "relict" or stabilized foredune that has become isolated from the beach and related depositional or erosional processes due to the formation of the younger established foredune. Seaward of the established foredune is a smaller, new "incipient" foredune that is developing from aeolian sand deposition within clusters of *Cakile edentula* (American searocket) on the upper beach. Incipient foredunes are often ephemeral and can be removed by high water levels and wave attack. Over time, however, if the incipient dune persists and continues to grow, it can develop into an established foredune. Foredunes can also be highly dynamic, and changes in their form can reflect seasonal patterns in tides, storms, and winds. For example, on the west coast of North America, El Niño-related climate patterns, and stronger storm surges often result in erosion along much of the coast. This trend changes over the late spring and summer months, where deposition and beach-dune rebuilding often occur with a reduction in storm waves and high-water levels.

This exercise will show you how to use UAS- and TLS-derived data products for visualizing, quantifying, and interpreting the morphodynamics and sediment budget of this foredune system. This site, located in northern California, has been monitored since 2014 as part of a restoration project that removed a dense invasive grass (*Ammophila arenaria*) and replanted the native dune grass and forb species (Figure 15.4). Over this time, the foredune experienced both natural storm erosion and aeolian rebuilding, as well as changes related to vegetation removal and replanting. As such, the site provides readily detectable changes in beach-dune morphology and sand surface elevations (or volumes) with a relatively simple vegetation cover (vs. forest canopies). Exercise questions will explore both the logistics of capturing and creating DSMs and DEMs using UAS and TLS in this type of environment, as well as interpretation of how and what the resulting change maps and quantities tell us about foredune morphodynamics and changing vegetation cover at this site.

Using UAS SfM-MVS and TLS Datasets for Terrain Mapping

Emergence of UAS platforms with high-quality digital cameras, combined with the development of adept SfM-MVS software, has opened the door for high-resolution terrain mapping in ways that were previously only attainable by traditional, costly fixed-wing or helicopter aerial photogrammetry or LiDAR from commercial contractors or government agencies. Although UAS platforms do not yet offer the same range of coverage as conventional aircraft, there are a suite of other considerations such as cost, ease of deployment, acquisition planning, training requirements, and quality of data products that distinguish UAS and other close-range remote sensing technologies from traditional methods. For comparison, TLS can provide very high-resolution point cloud data with attributes that are useful for DEM generation, although costs and logistical demands could be prohibitive for some applications or users. Table 15.1 compares various aspects of common close-range remote sensing platforms, including UAS, TLS, and more affordable kite or balloon aerial photogrammetry (KAP or BAP, respectively).

A multitude of UAS platforms exist that can be used for DSM/DEM generation. Quadcopters and fixed-wing systems are typically among the most utilized platforms (Figure 15.2a, b), although multi-rotor (6 or 8) systems are common for larger payloads, such as LiDAR units. Each platform has its own advantages and limitations. An example comparison of a common quadcopter and a fixed-wing UAS platform is shown in Table 15.2. Ultimately, the performance or suitability of one platform over another depends on a variety of factors, including (1) capital costs, (2) required data products, (3) project budget, (4) logistical constraints for data acquisition (e.g., ease of deployment, weather conditions, flight restrictions, crowd or traffic control, surface cover, remoteness), and (5) terrain and land cover conditions (e.g., steepness, rugosity, vegetation cover, accessibility or visibility restrictions).

Operationally, UAS and TLS systems are fundamentally distinct methods that involve very different logistical considerations. UAS uses a passive camera sensor to collect digital imagery that is rendered into orthomosaics and/or DSMs or DEMs with SfM-MVS software. TLS uses an

TABLE 15.2

Operational Characteristics of Quadcopter and Fixed-Wing UAS Platforms

	DJI Phantom 4 Pro	WingtraOne	
Platform	Quadcopter	Fixed wing	
Operational flight speed	~14 m/s	~16 m/s	
Camera	20MP, RGB	Sony QX1/15mm Voigtländer 20MP, RGB	Sony RX1RII/35mm Full-Frame Sensor, 42MP, RGB
GSD/height	1.77 cm/pix @ 60m 2.95 cm/pix @100m	1.70 cm/pix @60m 2.83 cm/pix @ 100m	0.77 cm/pix @60m 1.29 cm/pix @ 100m
Weight	~1400g	~4300g	~4300g
Wingspan	47 cm	125 cm	
Flight pattern	Double grid	Grid	
GPS	GPS/GLONASS	Double redundancy, using GPS, Glonass and ready for Galileo and Beidou *Optional post-processing kinematic (PPK)	
Max flight time	Up to 30 min (~9 hectares)	Up to 55 min (~400 hectares)	
Additional sensors	N/A	Micasense Rededge MX Flir Duo Pro R 640	

active laser sensor (typically in the near-infrared range) that is deployed on the ground and uses distance ranging to produce a highly dense point cloud of cartesian (x,y,z) points in the surrounding terrain. Generally, LiDAR is considered the "gold standard" for high-resolution terrain mapping. TLS has the ability to effectively capture and classify a range of land surface and cover types, with the exception of water, which absorbs near-infrared laser energy. Depending on their configuration, TLS systems also provide additional attribute data including multiple returns, RGB spectrum, and return intensity, which can be used to classify surface cover and/or vegetation types with greater accuracy and spatial resolution than UAS-derived datasets.

One of the main advantages of UAS over TLS is easier deployment and reduced acquisition time. TLS campaigns in complex terrain typically require the work of two or more people over several hours to capture the dozens of scan positions needed to provide data to render a DEM. For example, the larger site used for this exercise takes two people about 6-8 hours to capture 60-80 scan positions to cover approximately six hectares. By comparison, UAS can cover more extensive areas and, thus, map the same landscape in fewer deployments and over much shorter time periods than on-the-ground TLS campaigns. A quadcopter UAS campaign of the same area could be flown in about an hour with an additional hour or two for deployment of GCPs, georeferencing, and other flight preparations. A fixed-wing UAS campaign of the site would take approximately 30–40 minutes from start to finish with onboard georeferencing capabilities.

Georeferencing UAS and TLS data is required for accurate change detection, and very different procedures are involved for each platform. Most UAS have onboard GPS systems, but of varying accuracy – relatively few provide the survey-grade (cm-mm scale) resolution required for repeat change detection in coastal dune systems. Some UAS have post-processing kinematic (PPK) capabilities that offer additional time savings by eliminating the need for on-ground GCP deployment and georeferencing with differential GPS or total station surveys. GCPs must also be deployed strategically to ensure visibility, variable elevation coverage, and a semi-random (i.e., not gridded) spatial distribution across the site. Essentially, the size and topographic complexity of the site determines the number and deployment of GCPs (James et al. 2017).

Georeferencing TLS datasets requires either onboard GPS receivers to precisely locate each scan position or use of reflective targets that are referenced between scans and/or to known survey monuments. Most TLS have onboard GPS receivers of limited precision, and some accept survey-grade receivers (Figure 15.2c). With onboard georeferencing, the accuracy of a TLS point cloud is typically greater than that derived from UAS SfM-MVS (Table 15.1), particularly if collected with an integrated, survey-grade GPS system.

In terms of data acquisition, UAS and TLS are also fundamentally different. UAS can be flown autonomously using GIS-enabled mapping software that allows the pilot to specify flight parameters and camera settings to achieve desired coverage and resolution. Flight parameters vary depending on the UAS, site dimensions, and weather conditions. Not all UAS are equally capable for SfM-MVS mapping, however. Most are equipped with at least a 12-megapixel camera, which is sufficient for SfM-MVS, but not all have GPS chipsets and/or are capable of being piloted autonomously by mapping software. The limitation of camera resolution on GSD can be partly compensated for by flight altitude, but GPS positioning is essential for autonomous flight programming. Manually piloted UAS acquisitions are possible, but maintaining consistent altitude and flight path control to ensure sufficient image capture and overlap can be almost as challenging as BAP or KAP campaigns. TLS, on the other hand, requires careful manual on-ground deployments from multiple scan positions to map a site effectively, which can be labor intensive, depending on site size, topographic complexity, and presence of obstacles or vegetation that create "shadow zones" that contain limited TLS returns.

Post-processing time and computing hardware requirements also vary between UAS and TLS. TLS is typically processed by costly proprietary software (e.g., Riegl Riscan Pro, Leica Cyclone),

while UAS SfM-MVS can be processed in a number of different software packages (e.g., Agisoft Metashape, Pix4D) with limited proprietary restrictions. Post-processing hardware requirements are similar for UAS SfM-MVS and TLS point cloud processing as both require multiple core CPU and GPU systems for efficient processing with the time required defined by the size of acquisitions and input datasets (number of scan positions, number of images collected).

GEOMORPHIC CHANGE DETECTION (GCD)

Detecting and interpreting changes in landscapes requires detailed, repeat DEMs that are georeferenced with high accuracy. Traditional GPS- or LiDAR-derived (Figures 15.2c and 15.5) DEMs were most common until recently, and each of these methods entails a number of limitations (e.g., capital costs, coverage, ease of data acquisition, see also Table 15.1) (Kasprak et al. 2019; Westoby et al. 2012). In contrast, UAS SfM-MVS now enables comparatively fast and extensive acquisition of high-resolution orthomosaics, DSMs, and DEMs (Figures 15.1 and 15.6). Spatial statistics can then be used to compare DSMs or DEMs over time to detect and quantify resulting geomorphic and sediment volume changes.

The tradeoffs between UAS and TLS come down to various logistical considerations as well as the desired DEM resolution. These methods also differ in terms of their ability to capture and render DEMs in complex terrain. For instance, UAS SfM-MVS derived DEMs encounter limitations in rendering surfaces with vegetation. Figure 15.6 shows three-dimensional point clouds derived from SfM-MVS and TLS for the same location and demonstrates that the UAS-derived point cloud does not render the vegetation or underlying surfaces as well as the TLS dataset. This relates to two factors. First, the GSD of UAS imagery ultimately constrains the ability of SfM-MVS to render ground points in proximity to plants and, thus, UAS-derived DEMs are often inaccurate in vegetated areas (Westoby et al. 2012). Second, TLS can capture ground points within and around plant structures at resolutions higher than that obtained from UAS SfM-MVS.

FIGURE 15.5 a) DSM from a foredune in Arcata, California shown in Figure 15.3 derived from TLS. Circular plant clusters (*Cakile edentula*) are visible on the upper beach (left), while dune grasses and forbs cover the foredune and backdune (center and right). b) DEM of the same extent with vegetation largely removed. Some depositional patterns result on the upper beach formed within the plant clusters and there is little trace of the grassy vegetation on the foredune.

FIGURE 15.6 Extracted swaths of point clouds derived for the same location within the beach-foredune landscape in Figures 15.3 and 15.5 derived from UAS and TLS (upper and lower two swaths, respectively) showing complete DSM and bare-earth DEM only points for each method. A round clump of vegetation is visible on the seaward (left) side, and beach grass is evident on the landward foredune (right). Note that the UAS-derived cloud does not render the vegetation or underlying surfaces as well as the TLS dataset. The TLS DSM point cloud captures some of the plant structures including individual blades of grass.

Following classification and removal of vegetation points, remaining ground points are used to render the DEM. Both methods are optical, however, so as plant density increases to a point where the naked eye cannot see bare ground, even TLS will become limited in its ability to image underlying terrain.

Multi-temporal DSMs and isolated vegetation point clouds can also provide useful information to a GCD assessment in plant-covered terrain. Isolating plants and examining their spatial extent and height over time has value for interpreting biological and surficial processes that may control geomorphic change (as discussed above). For instance, both established and incipient foredunes owe their form and function to the presence of vegetation, which traps aeolian sand and which can change in cover type and density over time. Thus, depending on the objectives of a study, there is value in examining both bare ground and vegetation point clouds and/or DSMs as part of a GCD assessment.

The temporal resolution of DEMs or DSMs is another consideration that defines the utility of GCD for detecting and interpreting landscape change. For instance, if the goal is to detect changes in shoreline positions in response to sea-level rise, then annual DEMs would provide sufficient temporal resolution. However, if the goal is to characterize beach-dune sediment budgets and recovery from storms, then bi-annual to monthly DEMs might be desired. Or, if the focus is to assess how seasonal plant phenology affects aeolian sedimentation in a dune restoration project, then weekly to

monthly DSMs might be of interest. Generally, more dynamic processes or landscapes require higher temporal resolution datasets and some knowledge of key processes driving change.

In this exercise, you will learn how to detect and interpret landscape change using the GCD method. Essentially, you will generate DEMs of difference (DoD) from the same location over time. You will then use DoDs to highlight where, and of what magnitude, the surface has changed in elevation or volume (Bishop et al. 2012; Guisado-Pintado et al. 2019; Kasprak et al. 2019; Tamminga et al. 2015; Westoby et al. 2012; Wheaton et al. 2010). Once the statistical parameters and approach for detecting significant change is set, GCD is a fairly straightforward process provided DEM accuracy is high.

Figure 15.7 shows two DEMs separated by time within the beach-foredune landscape shown in Figure 15.3. GCD detects locations where statistically significant elevation

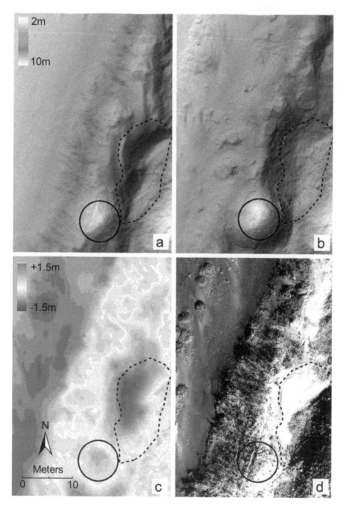

FIGURE 15.7 Recent (time 1, a) and later (time 2, b) DEMs from within the beach-foredune system shown in Figures 15.3 and 15.5. Notable depositional (dashed polygon) and erosional (solid circle) features on the foredune are indicated. The GCD result (c) is derived by subtracting coincident pixel value (elevation) changes between the older DEM (b) and the newer DEM (a) as defined by some threshold of accuracy and statistical significance. Notable erosion (red pixels) of up to 1.5 m occurred along the beach, while substantial deposition (blue pixels) on the same order of magnitude occurred landward of the foredune crest.

changes occurred and quantifies associated volumes of erosion (surface lowering) or deposition (surface rising). In this example, appreciable erosion (by as much as 1.5 m) occurred along the upper beach, while substantial deposition of the same order of magnitude took place landward of the foredune crest. These patterns, coupled with knowledge of geomorphic processes that control beach and foredune geomorphology, can then be used to infer why, how, and where sediment transfers might have occurred during this interval. For instance, lowering of the beach is most likely a response to fall and winter storm wave erosion. The steep rise of the foredune slope at the back of the beach limited the landward extent of this erosion process and defined transition from erosional (red) to depositional (blue) pixels that run diagonally from bottom left to top right of the DoD map (Figure 15.7c). Most of the deposition on the foredune results from aeolian sand transport and deposition in vegetation. As the dominant wind regime is from the NW, this implies onshore sand transport from the beach into the foredune over this time. Much sediment is deposited by wind in a deep hollow landward of the foredune crest (dashed), while some erosion is also evident on high points of the foredune (solid circle). This exercise will explore such patterns further in response to ongoing vegetation removal and replanting at this site as part of a dune restoration program.

Suggested readings to better understand content include:

1. Smith et al. (2016) for a comprehensive review of the applications of Structure from Motion (SfM) photogrammetry in physical geography.
2. Wheaton et al. (2010) for description of the GCD method and its use for improving quantification of sediment budgets and DEM uncertainty in dynamic floodplain landscapes.
3. Kasprak et al. (2019) for discussion of the effects of topographic surveying techniques and data resolution on the detection and interpretation of geomorphic change.

EXERCISE: TERRAIN MODELING AND GEOMORPHIC CHANGE DETECTION IN A DYNAMIC, VEGETATED COASTAL DUNE LANDSCAPE

Before you begin the exercise, consider the following questions:

1. What differences might you expect between a point cloud and DSM/DEM layers generated by a UAS platform and those generated by a TLS platform?
2. How might a beach-dune system differ over different timesteps (e.g., after a large storm; after a winter of erosion; and after a year of erosion and deposition)?
3. How might differences in elevation affect your ability to detect change in a landscape?

A flowchart of the process to perform a GCD analysis and generate results is shown in Figure 15.8. You would begin with an unfiltered point cloud (LAS format), complete steps to filter unwanted points and vegetation, and then generate a DEM that can be used to derive several other important layers. Repeating this process for several time steps would give you a set of DEMs from which you can execute the GCD comparison.

The dashed box highlights steps that are necessary to complete before you can begin GCD processing. These processing steps are covered in other chapters and are not repeated here. You will be given the processed, bare earth DEMs for different time steps to perform the GCD comparison.

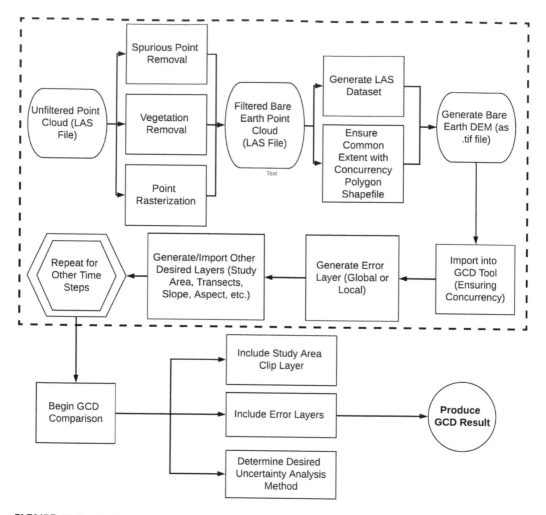

FIGURE 15.8 Basic steps in processing a point cloud and generating a raster dataset (in dotted box), and running a GCD comparison for use in ArcMap and the GCD Toolset (Riverscapes Consortium, 2019).

Before starting the exercises, ensure you have installed the GCD Riverscapes Add-In for ArcGIS (http://gcd.riverscapes.xyz/Download/). To confirm that you have successfully installed the Add-In, open ArcGIS, go to **Customize > Add-In Manager**. In the Add-Ins tab, you should see the **Geomorphic Change Detection** Add-In listed.

Exercise 1: Simple Geomorphic Change Detection Comparison Using UAS-Derived DSMs

1. Open ArcMap and load the GCD toolbar by going to the **Customize** tab, then navigating to the **Toolbars** dropdown menu. Find the option **Geomorphic Change Detection.** *Note: it may list the version number afterwards (e.g., Geomorphic Change Detection 7)*

2. On the GCD toolbar, click on the icon that looks like a small triangle to open the GCD Project Explorer Dockable Window. A new window will be added to ArcMap.

3. On the GCD toolbar, open the Exercise 1 project by clicking **Project > Open GCD Project**. Navigate to the Exercise 1 folder and select the `Exercise1.gcd` file. You should now see a file structure with several folders in the GCD Project Explorer window.

4. The first thing you will do is examine the two DSM layers from October 2018 and May 2019, which are contained within the **Inputs > Surveys** folder. Right-click on the DEM Surveys folder > **Add all DEM Survey to the map**. You may also want to add an Esri satellite base map (**File > Add Data > Add Basemap**) so you can better visualize the layout of the study area. In the Table of Contents in ArcMap, you will see the two DSMs have been added under Surveys: `Oct2018UASDSMCon` and `May2019UASDSMCon`.

Q1 Zoom into an area near the foredune, which runs parallel to the coast (a map scale of 1:150 is a good place to start) and toggle between the two DSMs (be sure to toggle the parent group so that both the colored DSM and the Hillshade layer turn off). What differences do you note between the two DSMs in this region?

5. Next, you will perform a change detection without incorporating error into the assessment. In the GCD Project Explorer window under the Analyses folder, right-click on **Change Detection > Add Change Detection**. A menu similar to the one shown in Figure 15.9 will open.

FIGURE 15.9 Right-clicking on **Change Detection** in the Analyses folder in the GCD Project Explorer and selecting **Add Change Detection** will bring up this menu to run the change detection tool in the GCD toolset. It is important to note that rasters must follow a consistent naming convention that ends in ".tif" to import into the GCD project file that has already been prepared for your exercise project files. A Study Area shapefile has also been included and will serve to narrow the area on which you will be focusing.

a. Name the analysis "Simple Detection"

b. Select the May 2019 DSM as the "new" and the Oct 2018 DSM as the "old" timesteps in the appropriate dropdown menus.

c. Under Area of Interest, select `StudyArea` (this shapefile has already been added to the GCD project).

d. Under the **Uncertainty Analysis Method**, select the option for **Simple minimum level of detection**. This option ignores potential error and instead includes only raster cells with change greater than the threshold value. Be sure the name of the analysis still says, "Simple Detection." Set the threshold to 0.05 m, and when you are finished, click **Create**. *Note: This option ignores any potential error and instead includes only raster cells with change greater than the threshold value.*

The "Change Detection Results" window will be automatically added to the display. A window will pop up with three tabs for **Tabular Results**, **Graphical Results**, and **Analysis Results**.

*Note: If you ever need to reopen this results window, simply right-click on the change detection result called "Simple Detection" in the Analyses folder and click **View change detection results**.*

Q2 Click on the Tabular Results tab. What percentage of the total area of interest reported a rise in elevation according to the *thresholded* results? What percentage of the total area of interest reported a lowering of elevation according to the thresholded results?

Q3 Click on the Graphical Results tab. The graph is a histogram showing the frequency (area) of different amounts of elevation change. Be sure the radial button next to **Area** is checked. Based on the uncertainty analysis parameters you entered in Step 5d above, what do you think the gray bars in the histogram represent?

6. Repeat Step 5, but this time, under **Uncertainty Analysis Method** select **Propagated Error**. Select `StudyArea` as the Area of Interest. Name the analysis "Detection with Propagated Error." When you are finished, click **Create**.

The uncertainty analysis will add the two error layers together and exclude any cells that fall within the threshold as insignificant change. These two error layers represent potential error inherent to collection (UAS accuracy, GPS accuracy), processing (SfM-MVS pixel error, point cloud alignment), and could even include perceived human error that is calculated for every input DSM separately. Propagating this error derives a potential error threshold value within the GCD comparison that is unique to the layers being compared. The result is a statistically significant DoD.

Q4 After running both the simple detection and detection with propagated error, where do you notice the biggest differences in cells that were removed from one to the other? (You may need to toggle each layer individually to view differences). Why do you think these differences exist?

7. Repeat Step 5 again, but this time select **Probabilistic thresholding** with a 0.95 confidence level under Uncertainty Analysis Method. Choose StudyArea as the Area of Interest. Name the analysis "Probabilistic Thresholding." When you are finished, click **Create**.

In these exercises, we assume that the data we are working with fit a normal distribution. So, the probability threshold you are applying is generated from a two-tailed Student's t-test that employs a confidence value of 0.95 (95%) to the data distribution, within two standard deviations of the mean of the population. Even though there is undoubtedly change that has occurred within the threshold value, it is necessary to consider compounding sources of error that may be impacting what you can realistically detect. Therefore, incorporating error layers and applying probability thresholding enhances the likelihood that the reported values represent significant and realistic change. For further discussion of the reasoning behind each uncertainty method, please refer to Wheaton et al. (2010), references therein, and the gcd.riverscapes.xyz tutorial resources.

8. Go back and re-examine the change detections you previously ran. Remember that if you need to reopen these results windows, simply right-click on the results in the Analyses folder (e.g., Simple Detection, Detection with Propagated Error, Probabilistic Thresholding) and click **View change detection results**.

Q5 According to each of the three Uncertainty Analysis Methods you utilized, what percentage of the study area saw detectable change (Thresholded) from October 2018 to May 2019? Which of the three methods do you think provides the most statistically significant representation of change? Explain your choice.

Q6 You may have noticed that there are large, red circular areas of erosion along the beach. If you toggle between the October 2018 and May 2019 DSMs, you will notice that these circular areas are present in October and disappear in May. What do you think these circular features are? Why do you think they are present in Fall but disappear in Spring? Add the two orthomosaic images found in the provided `Orthomosaics` folder (`Oct2018_UASOrtho.tif` and `May2019_UASOrtho.tif`) to see what the beach looked like during each survey.

Q7 Thinking about your answer to *Q6* and considering that you are working with DSMs, instead of DEMs, where in the study area do you think a DSM would give the most accurate result for measuring geomorphic change? Where do you think it would be less accurate? Explain your answer.

EXERCISE 2: EXAMINING GEOMORPHIC CHANGE DETECTION DIFFERENCES BETWEEN UAS AND TLS-DERIVED DATASETS

1. On the GCD toolbar, open the Exercise 2 project by clicking **Project > Open GCD Project**. Navigate to the Exercise 2 folder and select the `Exercise2.gcd` file.

You should see a set of files in the GCD Project Explorer window including a DEM from a terrestrial laser scan in October 2018 (`Oct2018_DEM_TLS`), a DSM from a terrestrial laser scan in October 2018 (`Oct2018_DSM_TLS`), and a DSM from the UAS survey in October 2018 (`Oct2018_DSM_UAS`). In this exercise, you will be working with point clouds that have already been classified and the vegetation has been removed (DEMs) and those that have not been classified for vegetation point removal (DSMs). As such, you will not be performing the removal process yourself, however there is an Agisoft Workflow at the end of this chapter if you would like to do this on your own.

2. Refer back to the steps from Exercise 1 and generate a GCD output that compares the two DSMs: `Oct2018DSM_UAS` and `Oct2018DSM_TLS`. Use the `StudyArea` file as your area of interest and a simple minimum level of detection with a 0.05 m threshold (to filter

out any minor differences). Use the TLS layer as the "New" timestep and the UAS layer as the "Old" timestep. Be sure to choose the TLS DSM data layer, not the DEM. Name this layer "TLS to UAS DSM Comparison."

3. You should notice an area of high deposition on the foredune, near the center of the study area (blue shading on the map). Explore this area on the map and consider what may be causing the difference in elevation between the two layers, which were both collected at the same time but using different methods (UAS vs. TLS). Refer back to the section on Coastal Foredune Systems above as you consider what may be causing this difference.

Q8 What is the difference in the percentage of area with detectable change between the UAS and TLS datasets? Based on what you learned in this chapter so far, why do you think differences exist between the two platforms (fixed-wing UAS and ground-based TLS)? You might also wish to consult the orthomosaics of the site to inform your answer.

Q9 Building on the previous question (*Q8*), what steps could you take to improve the quality of UAS-derived DSMs and minimize the differences between a UAS-derived DSM and a TLS-derived DSM?

4. Now, you will compute the difference between a DSM and DEM captured with the same platform. Utilize a simple minimum level of detection with a threshold of 0.05 m (to account for noise within the calculations). Select the Oct2018DSM_TLS as the new surface and Oct2018DEM_TLS as the old surface. Name the output "DEM and DSM Comparison."

Examine your results from Step 2. DSMs and DEMs can tell you different things about a landscape and what is on top of the surface.

Q10 What is the average net thickness of difference (m) between the two datasets of Step 4? Comparing the GCD output to the orthomosaic for 2018, did the TLS DSM capture all of the vegetation features in the study area? If not, what areas were missed?

EXERCISE 3: SPATIAL-TEMPORAL GEOMORPHIC CHANGE DETECTION USING REPEAT DEMS TO ANALYZE LANDSCAPE MORPHODYNAMICS

1. In this exercise, you will be using DEMs to conduct a change detection from three different campaigns (May 2019, October 2018, and May 2017). On the GCD toolbar, open the Exercise 3 project by clicking **Project > Open GCD Project**. Navigate to the Exercise 3 folder and select the `Exercise3.gcd` file. You should see a new set of files in the GCD Project Explorer window including a `May2017DEMCon`, `Oct2018DEMCon`, and `May2019DEMCon`.

2. Follow the procedures outlined in Exercise 1 to generate a GCD output that uses `StudyArea` as the area of interest, the necessary error layers, and Probabilistic Thresholding with a 0.95 threshold for the time steps: May 2019–October 2018 and October 2018–May 2017. You will need to perform two separate GCDs.

TABLE 15.3
Changes in the Beach, Stoss, and Lee between May 2019–October 2018 and October 2018–May 2017

	Beach		Stoss		Lee	
	Raising	Lowering	Raising	Lowering	Raising	Lowering
May 2019–Oct 2018						
Oct 2018–May 2017						

You can assess landscape change in terms of geomorphic units. For the landform you are focusing on here, a coastal foredune, there are generally three different, yet linked, geomorphic units of interest: the beach, stoss (seaward/windward) slope, and lee (landward) slope. Separating the landform into these three parts allows you to assess the movement of sediment into the system (from the beach) and over the crest (peak) of the foredune and better understand sediment transport patterns and resulting morphodynamics

You will find two extra layers in the Mask folder within the Exercise 3 GCD Project Explorer in ArcMap: Oct2018_GeomorphicUnits and May2017_GeomorphicUnits. These are the geomorphic units for the *earlier* time step in the GCD comparison. These features were digitized in ArcMap and represent features of the beach and dune that are of interest for sediment volume change analyses. You can add these masks to your Table of Contents by right-clicking > **Add Regular Mask to Map**.

3. In the GCD Project Explorer window, right-click on your GCD output for the May 2019 to October 2018 comparison and choose **Add Budget Segregation**, selecting the layer for the earlier timestep of the comparison (e.g., for May 2019–October 2018 you will utilize the Oct2018_GeomorphicUnits layer). The budget segregation calculates the volumetric differences within each distinct feature of the mask. *Note: if you receive a warning that "Both rasters must have the same vertical units," click OK.*

4. Explore the different tabs in the Budget Segregation Results.

5. Repeat Step 3 for the October 2018 to May 2017 comparison, this time choosing the May2017_GeomorphicUnits layer

Q11 Comparing the outputs from May 2019-October 2018 and October 2018-May 2017, which comparison yielded the greatest volume of change? Refer to the Thresholded column and Total Net Volume Difference (m^3) row to help you answer this question. Using the same two outputs for comparison, which geomorphic unit exhibited the greatest volume of change?

Q12 Explain the measured difference in volume on the lee slope between the two results. In doing so, provide some interpretations as to the probable processes at work during the compared intervals.

Q13 Fill in Table 15.3 using the "Thresholded" column and the "Average Depth of Surface Lowering (m)" and "Average Depth of Surface Raising" rows under "Vertical Averages" in the budget segregation results. *Note: not all cells have an associated value.*

Q14 During winter, it is common for storm waves and/or high water level events to create erosional scarps (low bluffs) in the lower seaward slope of the foredune. If a 1-meter scarp were to develop in the lower foredune stoss slope, what impacts might this have on the sediment budget of the foredune? Consider that healthy foredunes typically act as a "sink" or store of sediment delivered to, and over, the beach. Also consider the processes of sand delivery to, and movement over, the foredune. Consider your results, review the "Coastal Foredune Systems" section, and provide an explanation based on your answer.

DISCUSSION AND SYNTHESIS QUESTIONS

S1 Given what you have learned throughout this chapter, would you choose to use UAS or TLS for geomorphic change detection? Explain the rationale, benefits and limitations for both platforms.

 a. How does vegetation manifest itself in the datasets captured by each platform? How can the influence of vegetation be overcome to ensure accurate bare earth models?
 b. Why does a DEM offer a more appropriate dataset for conducting geomorphic change compared to a DSM?

S2 Do UAS platforms provide the necessary data to accurately conduct GCD analyses? What factors help or hinder this goal? What steps could be taken to improve an SfM-MVS dataset for the purposes of GCD?

S3 Describe and discuss factors you may have to consider when collecting SfM-MVS data to be used for a GCD comparison in:

 a. A natural beach-foredune system in a Mediterranean climate with cool, drier summers and rainy winters (e.g., northern California)
 b. A stream in an agricultural setting with a humid continental climate with warm summers and precipitation all year (e.g., the Midwestern United States)
 c. A small retention basin in a hot desert with summer monsoons (e.g., south-central Arizona)

S4 These exercises employ a "uniform" model to account for potential error in the DEMs. Discussed in (Wheaton et al. 2010), and built into the GCD Toolset, is a different error model called a Fuzzy Inference System (FIS). How do the uniform and FIS models differ, and which do you think accounts for error more accurately? Is there utility in incorporating more spatially constrained (localized) error patterns? What might cause such patterns. Refer to the "Methodological development" section (pgs. 142-145) in the Wheaton et al. article and consider your response to Q5, above.

COLLECTING THE DATA YOURSELF (OPTIONAL)

Due to the complexity and variability of terrain and the differencing in the desired outcome of the data set, the workflow will cover a general aerial survey. Keep in mind any logistical constraints that might be present.

1. UAS flight planning

 a. Plan out area of interest (AOI), consider any logistical constraints (i.e., federal regulations, battery life, site size).
 b. If using an RTK system, place GCPs among the entire region. Try not to have any method other than scattering them. Avoid straight lines and placing them too closely to each other.
 c. Using an automated mapping software, like Pix4D, plan out your acquisition flight. Depending on the type of camera on the UAS, a double grid pattern may be more favorable over a single grid pattern.
 d. Ensure that there is adequate power supply for the UAS to complete the flight mission. If the site is not able to be covered in one flight, additional planning and flights will be required in order to fly the entire AOI. This could present some complications if there are not enough batteries or if a power supply is not available. You would also need to relocate and obtain coordinates for your GCPs for each flight.

 e. Once the flying part is completed, the images are to be transferred to a computer from the UAS by removing the image storage device (i.e., SD card).

2. Agisoft metashape workflow

 a. Using Agisoft Metashape (previously Agisoft Photoscan), load the images using the workflow load photos.
 b. In the photos window, right click an image and estimate image quality to all the photos. Agisoft will run an algorithm that determines the overall quality of the photos. This can be a rather time-consuming process if there are a lot of images in the project. Typically, images that are under 0.5 in quality should be considered for removal of the project. The quality value can be viewed when changing the image view from small, medium or large to details.
 c. The next step is aligning the photos. Before aligning the photos, the image coordinate system must be changed in order to reflect that which the GCP's were taken in. Once the image coordinate system is changed, then use the Workflow Align Photos. Ideally the photos will be aligned using the high accuracy setting. The higher the accuracy, the more of the photo is used.
 d. There are times where the photos will not all align together. Typically, if there is moving water or waves, those images are not able to be aligned. If they are aligned it is a very low number of reprojections, these images should be removed from the project.
 e. At this point, there is an option to align multiple folders of photos by breaking them into chunks. These chunks will allow for the photos to be aligned and merged later on segmenting the project up. Chunks are ideal with larger projects.
 f. When the photos are aligned a sparse point cloud is generated.
 g. Disable the photo locations once the sparse point cloud is generated. This is a critical step that must not be overlooked. Leaving the locations of the photos open will cause poor accuracy and alignment results when assigning the GCP's. If GCP's are not being used the photo locations can be left on.
 h. Add the GCP's CSV file to the project. Ensure that it is imported into Agisoft using in the right projection.

 i. When assigning the GCP's their locations, make sure that the point is at the center of the GCP marker. After this is applied to 3 or more locations, the photos must be updated and optimized. Doing so will reduce the overall error and increase the project's accuracy.

Gradual Selection

Gradual selection is the process of removing the lowest quality points. These points could be points that contain a high amount of noise or have a high reprojection error. There are three steps to this process, and each should be done knowing that they will affect each other.

a. Model → Gradual Selection

b. Reprojection Error: Indicates poor localization of corresponding points and false matches

c. Reconstruction Uncertainty: These are points that do not match exactly where they should. High levels of reconstruction uncertainty are common and expected.

d. Projection Accuracy: Filters out points with relatively poor projections

e. After each gradual selection step is performed, the points must be deleted, then the steps repeated until there is no change in the numerical values. Ideally 10-15% of the points are eliminated per each step. After these three steps are finalized the cameras must be optimized and updated. The values entered in each gradual selection tool will change, so this process will be performed multiple times.

Tie Point Quality Control:

This is the process of checking and evaluating the accuracy in which the GCPs are located.

- Right click GCP Show info. This will bring up the pixel error values associated with the photo and GCP. Ideally this value should be 0.5 or less. High values are typically from radial distortion in the camera lens, blurry or overexposed photos. By addressing these issues, the overall accuracy of the project will be increased.

Weighing Observations

Weighing Observations is the process of adjusting the marker accuracy and tie point accuracy to the point cloud RMS and Max reprojection error. Marker accuracy is adjusted to the RMS reprojection error and the tie point accuracy is adjusted to the max reprojection error. Repeat this step until the change in value is less than 10%.

Outlier Observations of GCPs

For the model to be aligned properly the GCPs must be in the correct locations. Previously, the GCPs were placed close to the location where the RTK took the point. When performing an outlier observation, one must consider the radial distortion of the camera lens and the overall pix error value of the photo.

a. In the Reference menu, right click GCP marker > Show Info

b. A list of the photos associated with the GCP with show up along with pix error values

c. Remove the markers that are over 0.5

d. There are numerous reasons for high values but typically it can be overexposed images, radial distortion, or the GCP is on the edge of the image.

Build Dense Cloud

Prior to the dense cloud being constructed, it is important to ensure that the bounding box around the model is sized correctly.

a. Workflow → Build Dense Cloud
b. The dense cloud is generated by using a combination of the sparse point cloud and the photos from the project. There are quality level options for generating a dense cloud; Ultra-High, High, Medium and Low. With the Dense Cloud box open, the amount of depth filtering can be adjusted; Mild, Moderate, Aggressive and Disabled. It is recommended that if fine details are to be preserved, mild filtering is best to retain fine details but more computing intensive.
c. Determine the proper settings for the project and apply.

Ground Point and Vegetation Classification

a. Once the dense cloud is created the points can be assigned to their respectful nature. Metashape has options for ground, water; low, medium and high vegetation; roads, buildings and more. This is a tedious process. It should be determined beforehand if the result is a DEM, DSM or an orthomosaic photo. If the result is a DSM or a sole orthomosaic the points do not require classification.
b. Tools > Dense Cloud > Classify Ground Points from Unclassified. The overall parameter can be adjusted depending on the complexity of the site. Start with the preset parameters and adjust as needed.
c. It is possible to do a blanket classification on the ground points providing a good for classifying the other points in the model.
d. Select all the points in the model CTRL+Shift+C, No Class to ground class
e. Make sure there are no points "floating" above or below the model. If there are spurious points they can be removed from the project.

Build Mesh

Building mesh is the process of creating a polygon model out of the data that is collected. This is helpful if the project is not georeferenced and an orthomosaic image is still being produced.

- Workflow → Build Mesh → General Settings
 - Surface Type: Height Field
 - Source Data: Dense Cloud
 - Face Count: High (recommended for most data sets). This is also called the polygon count. It will decimate the model to the number of polygons listed.
 - In the Advanced Settings set Interpolation: Enable Agisoft Photoscan uses Triangulated Irregular Network (TIN) for interpolating the mesh. This cannot be modified at this time.
 - Point Classes: Ground

Build Texture

Texture is the color overlay of the point cloud.

- Workflow → Build Texture
 - Keep the default settings

Build Digital Elevation Model (DEM)

- Workflow → Build DEM
 - Set the coordinate projection
 - Source Data: Dense Cloud (this can also be set to use sparse cloud or mesh)
 - Interpolation: Enabled
 - Agisoft Metashape uses Inverse Distance Weighting (IDW) interpolation for building DEM, this cannot be modified at this time.
 - Point Classes: Use Ground Points (if creating a DSM use all points)

The resolution (m) and total size (pix) varies with the size of the project.

Build Orthomosaic

An orthomosaic is a single photo that is made up of all the photos in the project.

- Workflow → Build Orthomosaic
 - Keep the Default settings
 - You may choose a surface parameter; it is suggested to use DEM for any georeferenced data and the mesh for non-georeferenced data.
 - With the processing completed, each model can be exported as well as an Agisoft Report. The end result is dependent upon the desired outcome.

NOTE

1 Alternatively, the Riverscapes Consortium provides a standalone platform GCD 7. If you do not have access to ArcGIS, or would prefer not to use it, Riverscapes Consortium suggests using QGIS and the standalone GCD 7 (also found at http://gcd.riverscapes.xyz/Download/). If you choose this option, please follow the guidelines provided by Riverscapes Consortium provided in the link.

REFERENCES

Bishop, M.P., James, L.A., Shroder Jr, J.F., & Walsh, S.J. (2012). Geospatial technologies and digital geomorphological mapping: Concepts, issues and research. *Geomorphology*, 137, 5–26.

Guisado-Pintado, E., Jackson, D.W., & Rogers, D. (2019). 3D mapping efficacy of a drone and terrestrial laser scanner over a temperate beach-dune zone. *Geomorphology*, 328, 157–172.

Hesp, P. (2002). Foredunes and blowouts: initiation, geomorphology and dynamics. *Geomorphology*, 48, 245–268.

Hesp, P., & Walker, I. (2013). Fundamentals of Aeolian Sediment Transport: Coastal dunes. Ch. 11.17. In: Lancaster, N, Sherman, DJ, Baas, ACW (eds.), Vol. 11: Aeolian Geomorphology. pp. 328–355. In: *Treatise on Geomorphology*. Oxford: Elsevier. DOI: 10.1016/B978-0-12-374739-6.00310-9.

James, M.R., Robson, S., d'Oleire-Oltmanns, S., & Niethammer, U. (2017). Optimising UAV topographic surveys processed with structure-from-motion: Ground control quality, quantity and bundle adjustment. *Geomorphology*, 280, 51–66.

Kasprak, A., Bransky, N.D., Sankey, J.B., Caster, J., & Sankey, T.T. (2019). The effects of topographic surveying technique and data resolution on the detection and interpretation of geomorphic change. *Geomorphology*, 333, 1–15.

Ranasinghe, R. (2016). Assessing climate change impacts on open sandy coasts: A review. *Earth-Science Reviews*, 160, 320–332.

Smith, M., Carrivick, J., & Quincey, D. (2016). Structure from motion photogrammetry in physical geography. *Progress in Physical Geography*, 40, 247–275.

Tamminga, A.D., Eaton, B.C., & Hugenholtz, C.H. (2015). UAS-based remote sensing of fluvial change following an extreme flood event. *Earth Surface Processes and Landforms*, 40, 1464–1476.

Westoby, M.J., Brasington, J., Glasser, N.F., Hambrey, M.J., & Reynolds, J.M. (2012). "Structure-from-Motion" photogrammetry: A low-cost, effective tool for geoscience applications. *Geomorphology*, 179, 300–314.

Wheaton, J.M., Brasington, J., Darby, S.E., & Sear, D.A. (2010). Accounting for uncertainty in DEMs from repeat topographic surveys: improved sediment budgets. Earth surface processes and landforms: the journal of the British Geomorphological Research *Group*, 35, 136–156.

16 Digital Preservation of Historical Heritage Using 3D Models and Augmented Reality

Sergio Bernardes and Marguerite Madden

CONTENTS

LEARNING OBJECTIVES

After completing this chapter, you will be able to:

1. Understand the specifics of drone data acquisition for historical heritage preservation.
2. Process images collected by a drone and by a camera on the ground to generate point clouds, 3D models, and orthomosaics to represent a historically significant area and associated objects.
3. Georeference orthomosaics and 3D models for use in a Geographic Information System.
4. Integrate vector and structure from motion-derived datasets into a Geographic Information System for visualization and data exploration.

5. Create an augmented reality application for visualization and sharing of 3D models of historical significance.

HARDWARE AND SOFTWARE REQUIREMENTS

Part 1 requires:

1. Agisoft Metashape Professional: the chapter uses Metashape Professional running on a PC (Windows 10 operating system). Metashape Professional is also available for Mac OS and Linux. Alternatively, AliceVision Meshroom can be used to complete the Structure from Motion part of the exercise.
2. ArcGIS Pro (Esri)

Part 2 requires:

1. Spark AR Studio: instructions and screenshots shown in this chapter are based on Spark AR Studio version 96.0.0.18.226.
2. To visualize the AR application, the chapter uses the Spark AR Player app.

DATASETS

Accompanying material used by this tutorial includes multiple datasets, project files and ancillary data, as listed below:

1. `Drone_Images`: folder containing 280 images collected by a DJI Phantom 4 Pro quadcopter over the Old Athens Cemetery
2. `Ground_Images`: folder containing 61 images of a box tomb in the Old Athens Cemetery, collected by an iPad mini 4
3. `oac_gcps_cemetery.txt`: text file with five high positional accuracy ground control points collected at different locations at the Old Athens Cemetery to support the positioning of drone derived products
4. `oac_gcps_boxtomb.txt`: text file with four high positional accuracy ground control points collected at the base of a box tomb at the Old Athens Cemetery
5. `oac_monuments-XX.shp`: six vector files (point format) representing monuments at the Old Athens Cemetery with monument specific information. The six files include Box_Tombs, Fieldstone, Fragments, Headstone, Obelisk, and Slab.

INTRODUCTION

Preservation of historical heritage includes narratives that are directly or indirectly linked to objects, structures, places, and other physical or non-physical cultural resources. In particular, physical cultural resources, such as monuments, support historical context and can significantly contribute to detail-rich accounts, either as backdrop components or as key narrative players. As a result, historical heritage preservation benefits from efficient management of those cultural resources and often involves their rational use and the maintenance of their structural integrity and cultural connections. A main component of historical preservation involves assessing the condition of cultural resources and continuously compiling information on their physical status for making preservation decisions. The need for condition assessment is particularly relevant when restoration is involved and when access to cultural resources is restricted due to their rarity and fragility.

Assessing the condition of a cultural resource by physically manipulating the object can alter its integrity. Using a variety of recently developed non-contact technologies, including drones, 3D scanning, and object reconstruction, digital models of the cultural resources can be created to monitor and assess condition (Bernardes et al. 2019; Bernardes et al. 2018; Çöltekin et al. 2020). Often, those digital interactions unveil new properties or associations between resources, providing alternative ways to more fully explore, visualize, and experience them. In their most basic form, digital representations of resources can increase exposure to the resource by allowing more people to view and even interact with the model through immersive, game-like interactions.

Due to their ability to collect detailed images of objects on the surface of Earth, unmanned aircraft systems (UAS), or drones, have been incorporated into a variety of applications involving the representation of physical resources. Drone images and their derived products can also provide detailed representations of cultural areas and associated physical objects (Madden et al. 2019; Madden et al. 2015). Mosaics of drone images can be used to produce maps of large areas in 2D, which can support descriptions of conditions at a given point in time. These products can also be used to monitor changes over time.

In addition to the 2D or flat representation of areas and objects, images acquired by cameras can be used with computer vision techniques to recreate or "extract" the 3D structure of areas when collected under the right conditions. Techniques such as Structure from Motion (SfM, Agisoft 2020; Cotten et al. 2020) can be incorporated into cultural heritage preservation projects to generate 3D models from a series of images collected by drones or cameras on the ground. Those 3D models can be used for visualization and analysis, supporting interactions and integration with other technologies and products for feature-rich experiences.

This chapter explores how a combination of approaches, including SfM and augmented reality, can be used to create realistic digital representations of cultural objects with historical significance. In Part 1, you will manipulate images collected by a drone and a handheld camera using SfM to create an orthomosaic and 3D models of a cemetery. You will also create a photorealistic model of a monument (box tomb) in the cemetery. In Part 2, you will explore the models created in Part 1 and generate an augmented reality application that can enhance model visualization and exploration.

FIGURE 16.1 The location of the Old Athens Cemetery in Athens, Georgia.

The exercises presented in this chapter use data collected by the Athens: Layers of Time Project (https://athenslayersoftime.uga.edu/) at the main campus of the University of Georgia, in the state of Georgia, United States. The area under investigation is the Old Athens Cemetery (Figure 16.1), which is an exemplar for historical heritage preservation. The site is located within the University of Georgia campus, surrounded by university activities and many modern buildings.

CONSIDERATIONS WHEN CAPTURING DRONE IMAGERY FOR DIGITAL PRESERVATION

The success of digital preservation projects using drone images depends on factors affecting image acquisition and the quality of images. Several of these factors are directly related to the capabilities of the camera and drone platform. Other factors involve aspects associated with site access, site characteristics, and how those components affect data acquisition. Here, we briefly list several items that should be taken into consideration when incorporating drones into digital preservation efforts.

REGULATIONS AND SENSITIVITIES

When planning a flight mission over a historical site, the drone pilot and data collection team should be aware of what the site represents and any associated sensitivities, including historical, religious, spiritual, and/or emotional ties to the site, and the possibility that data acquisition at the site may be considered inappropriate or offensive. Data acquisition efforts must also take into consideration policies and regulations at the site, as well as the possibility that there will be visitors to the site or area, which may make flight operations more challenging.

REPRESENTATION OF AREA OF INTEREST

Mapping historical sites also requires consideration of how best to represent the area and objects of interest. Typically, one or more manual flights are conducted at a lower altitude to capture detail and multiple points of view to represent specific areas, monuments, statues, or other components of the site. Additionally, analyses often benefit from spatial context provided by images captured of the larger surrounding area of interest. However, these flights may not need to be flown at the same low altitude. Flight planners must work to balance the need for different perspectives and images with the costs associated with image processing time and increased data storage requirements.

TIME OF DATA ACQUISITION

The timing of data acquisition can significantly affect image quality and data outputs. Seasonal "leaf on" conditions can obstruct views of surface objects and produce hard shadows in images. Conversely, products derived from images collected during "leaf off" conditions may not capture branches in detail, leading to partially obstructed views of the surface. Depending on their location and orientation, the vertical faces of certain objects may be poorly illuminated during winter or certain times of the day when sun angles are lower. For instance, faces of objects oriented toward the east receive direct sunlight in the morning and may be poorly illuminated in the afternoon.

CAMERA ANGLE

The direction the camera faces during the flight also determines what products can be derived from images. Cameras can be set to look straight down (i.e., nadir view) or to capture images at an angle (i.e., oblique view). While nadir views can provide some representation of vertical faces (i.e., object sides), more complete imaging of vertical objects usually requires capturing images at oblique camera angles. Oblique imaging is particularly important when the project involves the representation of sides of buildings or other vertical structures and monuments.

HISTORICAL CONTEXT: THE OLD ATHENS CEMETERY

On November 17, 2015, human remains were discovered by construction workers excavating a parking lot for an addition to Baldwin Hall on the campus of the University of Georgia (UGA Today 2017). Built in 1938, Baldwin Hall is located on land adjacent to the Old Athens Cemetery that was established in 1801 as the original burial ground for the newly formed Clarke County and town of Athens (Morris 1923; Strahan 1893; Weeks 1999). The burial ground was located within the original tract of 633 acres purchased by Governor John Milledge and gifted as the site of the University of Georgia, which had been chartered by the Georgia Legislature and approved January 27, 1785, as a "public seat of learning" (Hull 1906). Cooper and McAninch (1984) state, "This old burial ground served the town of Athens from its beginning in 1801 into the late 1880s. The dead of all conditions and races were buried there." Although the University retained title, the burial ground was considered common property with no individual lots sold and "…all had the right to bury their dead here" (Cooper and McAninch 1984).

Although historical records indicated human remains were removed in the mid-1930s when Baldwin Hall was constructed (Shearer 2017), a total of 105 gravesites were identified between November 2015 and February 2016 by archaeologists from Southern Archaeological Services, Inc. working with bioarchaeologists of the UGA Anthropology Department (Parry 2017; Wilson Center DigiLab 2018a). Thirty gravesites contained sufficient remains for DNA testing, and the genetic ancestry of nearly all individuals whose DNA was sequenced was determined to be

FIGURE 16.2 Ground view of the Old Athens Cemetery in Athens, Georgia. Multiple monuments including box tombs (foreground), headstones (right), and an obelisk (back right) are visible in the shot.

African (Wilson Center DigiLab 2018b). Given the tenure of the Old Athens Cemetery and the fact that it closed in 1856, these individuals are assumed to have been enslaved during their lifetime. In light of the rediscovery of the extended boundary of the cemetery, researchers and students of the UGA Center for Geospatial Research within the Department of Geography received funding from the UGA Office of Research to collect historic maps, aerial photographs, UAS imagery, and satellite images documenting the environmental and land-use changes that might have been experienced by the enslaved people buried in the presumably segregated southern portion of the Old Athens Cemetery, in Athens Georgia (Figure 16.2). Local students were involved in compiling a geographic database of this area and exploring the use of emerging 3D geospatial techniques to record current and historic features of the cemetery and the surrounding town (Madden and Bernardes 2018).

PART 1: IMAGE COLLECTION AND GENERATION OF 3D MODELS AND ORTHOMOSAIC

Images were collected over the Old Athens Cemetery and the surrounding area around 12:00 pm local time on March 18, 2018 using the 20-megapixel RGB camera onboard a DJI Phantom 4 Pro drone. Flights followed a double-grid configuration with high image overlap: 80% forward lap and 80% sidelap) (Figure 16.3d). The drone flew at 46 meters (151 feet) above ground, resulting in pixel sizes of approximately 1.25 centimeters (0.5 inches). The camera was set to capture images using an oblique view (camera at 70-degree) in order to capture both the tops of the cemetery monuments (box tombs, headstones, etc.) as well as the vertical faces, or sides, of those monuments.

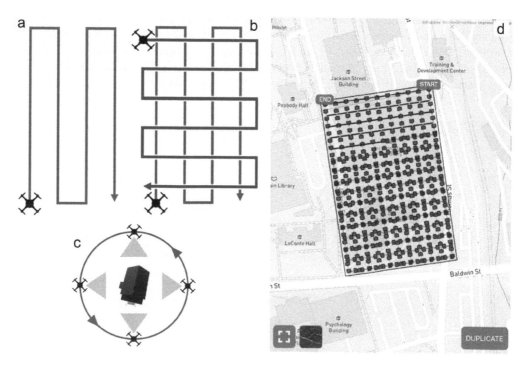

FIGURE 16.3 Drone flight configurations: (a) single grid, (b) double grid, (c) orbit, and (d) the interface of a flight mission planner for image acquisition over the Old Athens Cemetery historical site, showing a double grid configuration for a partially completed mission. Limits of the area flown are presented, including start and end of image acquisitions.

GROUND LEVEL IMAGE COLLECTION

Images captured by drones can be integrated with other types of data with complementary characteristics and captured at different scales to improve the representation and descriptive power of derived products. While drones are well suited for capturing images across an entire historical site, depending on the equipment used and data acquisition strategy, the captured images may lack the spatial resolution or detail needed for certain types of investigations. In addition to creating a digital representation of the Old Athens Cemetery, you will also create a detailed 3D model of one of the box tombs located in the cemetery. Images of the box tomb were collected on the ground using an 8-megapixel RGB camera (iPad Mini 4) by walking around the box tomb and taking 61 pictures from different perspectives, while guaranteeing overlap between adjacent pictures. This close-range image acquisition provides greater level of detail than a 20-megapixel camera flying 46 meters above ground.

EXERCISE 1.1: BUILDING A 3D MODEL OF A HISTORICAL LANDSCAPE

A single drone flight can produce hundreds or even thousands of images. Although visual analysis of these images can aid digital preservation projects, benefit is gained through generating orthomosaics, digital elevation models (DEMs), digital surface models (DSM), or other 3D models from the drone images. In this exercise, you will use Agisoft Metashape to generate an orthomosaic and 3D models of the Old Athens Cemetery using the main SfM steps.

1. Launch Agisoft Metashape.

2. Using Metashape's main menu, go to **Workflow > Add Photos**, navigate to the `Drone_Images` folder, select all 280 images, and click **Open**. The images will be added to your Photos pane, and spheres representing the approximate location where each image was captured will be added to the Model pane. The Workspace pane will show the number of images associated with a chunk. *Note: Metashape uses "Chunks" to group images that come from the same camera (same calibration parameters).*

3. Save your Metashape project by selecting **File > Save**. It is a good idea to save your project frequently, especially after major processing steps.

You will now perform camera alignment, and Metashape will identify common points on multiple images. During this process, the geometry of acquisition including the location of the camera, direction the camera was facing during image acquisition, and camera calibration parameters are calculated. The output of camera alignment includes the position of the camera at every location where an image was collected and a sparse point cloud.

4. Select **Workflow > Align Photos** from the main menu. Metashape will present a window with options for photo alignment. Select the following parameters and click **OK**:

 a. Accuracy: Medium

 b. Generic Pre-Selection: checked

 c. Key Point Limit: 40,000

 d. Tie Point Limit: 4,000.

Next you will georeference the sparse point cloud using ground control points collected in the field. Although GPS coordinates are added to images during drone flight, for this particular drone

platform, those coordinates are less accurate than coordinates collected in the field. Georeference your point cloud by following the steps below.

5. Switch to the **Reference** window by clicking the Reference tab. Select all images (you can use Ctrl+A), right click to open the context menu and click **Uncheck** to uncheck all cameras listed by the Reference tab.

6. Click the **Import Reference** icon (leftmost icon, just above the camera list), navigate to the data folder, and open the ground control points file called `oac_gcps_cemetery.txt`.

7. Inspect the Import CSV window and make sure the following parameters are correct:

 a. Coordinate system: WGS 84 (EPSG:4326)

 b. Delimiter: Tab

 c. Start import at row: 2

8. Click **OK** and click **Yes to All** when Metashape asks if it should create a new marker. Five GCPs will be loaded under **Markers** in the Reference tab.

Next, you will position the markers.

9. Right click the first GCP > **Filter Photos by Marker**. The Photos pane will display only photos with that GCP visible. Double-click the first photo to display it and use the cursor to drag the GCP to its correct location. (Locations for each GCP are shown in Figure 16.4. All GCP locations are at the corners of either the tomb or the concrete apron around the tomb.) When you reposition your GCP, a flag will be added to the GCP location and to the image thumbnail. Repeat this process for at least 10 photos. The more photos you mark, the higher your accuracy will be.

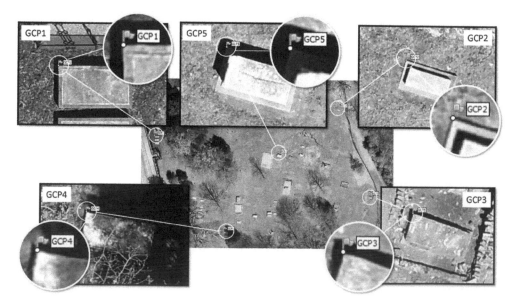

FIGURE 16.4 Location of the five ground control points used for georeferencing the images. The base of each flag (white dot) indicates the location where the GPS coordinates were captured. Each GCP is located at the corner of a monument.

10. Repeat the prior step for all five GCPs.

11. When you are done relocating the GCP markers, click the **Update Transform** icon on the **Reference** window. Metashape will calculate errors associated with the transformation. You can inspect the errors by scrolling across each marker section. If any GCP has an error greater than 0.25 m, you will need to reposition the markers associated with the GCP or position more GCPs in additional photos. After you are done editing the GCPs, click the **Workspace** tab to display the workspace used by your Metashape project.

12. You are now ready to generate a dense point cloud. To create the point cloud, go to **Workflow > Build Dense Cloud**. and select the following settings.

 a. Quality: Medium

 b. Depth filtering: Disabled

 c. Calculate point colors: checked

13. After the dense point cloud is generated, explore the results by rotating the point cloud to view different areas. Zoom in and out to examine how well different areas are represented with the points in terms of density.

Q1 What areas are represented well in the dense point cloud? Are there any areas where there are gaps in coverage? If so, where are these areas located?

14. Point clouds provide an adequate representation of the landscape features and objects. However, many applications benefit from generating a continuous surface, or mesh, in addition to point clouds. Generate a mesh by going to **Workflow > Build Mesh**. Select the following parameters:

 a. Source data: Depth maps

 b. Surface type: Arbitrary (3D)

 c. Face count: High

15. Inspect your mesh (3D Model) in terms of how well the details are represented.

Q2 How does the mesh compare to the dense point cloud in terms of coverage throughout the cemetery?

16. The mesh is displayed using colors derived from the original images, but at this point it does not yet have any image detail (texture) draped on it. Generate texture for the mesh by going to **Workflow > Build Texture**. Leave the default options and click **OK**. When the process is complete, load the textured mesh by going to **Model > View Mode > Model Textured** (see Figure 16.4, left) and navigate to multiple locations. Compare the textured mesh to the non-textured mesh.

The geometry of images collected by drones is affected by distortions resulting from the lens, camera angle (tilt), and changes in the distance between objects on the ground and the camera. If these geometric distortions are not corrected, they can impact the accuracy of mosaics created from those images. Orthorectification addresses these geometric inaccuracies and allows for the generation of orthomosaics that can be used as maps. The previous processing steps have already dealt with lens distortions and image acquisition geometry. In the next step, you will address changes in ground elevation and object heights.

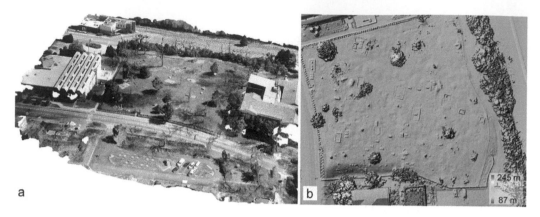

FIGURE 16.5 (a) 3D model of the Old Athens Cemetery, represented by a mesh with texture. (b) Color-coded digital surface model of the area. Context is provided by surrounding buildings, streets, and parking lot.

17. First, you need to create a DEM of the scene. Go to **Workflow > Build DEM**. Make sure the projection is set to WGS 84 (EPSG:4326) and the Source Data is set to **Dense Cloud**. Click **OK** to begin building the DEM.

18. Display the DEM by double-clicking its name. Notice that surface objects like trees and buildings are also visible in the DEM in addition to the ground surface (Figure 16.5). Zoom in and out of different areas of the cemetery, while keeping in mind that the Old Athens Cemetery has multiple areas that have been used as gravesites but that currently do not have monuments or marks. Because the DEM captures small changes in topography, you can use this product to locate these potential unmarked graves by identifying areas with indentations in the ground.

19. The visualization and navigation of detailed 3D models can be optimized by using a data format based on the hierarchical representation of the model, also known as a Tiled Model. Create a Tiled Model so your 3D model of the Old Athens Cemetery can be later exported to a format used by ArcGIS Pro. To create the model, go to **Workflow > Build Tiled Model**. For parameters, select:

 a. Source data: Depth maps

 b. Quality: high

 c. Face count: Low

 d. Under Advanced: make sure **Reuse depth maps** is checked.

20. Lastly, generate an orthorectified mosaic (orthomosaic) of the Old Athens Cemetery and surrounding area. Go to **Workflow > Build Orthomosaic**. Select DEM as the surface and leave all other defaults. Click **OK**.

You will export the products you created in a format that can be used in GIS and augmented reality (AR) programs.

21. Export the Tiled Model by right clicking the model name and selecting **Export Tile Model**. Using the **Save As** window, navigate to the folder where you want to save your model, choose **Scene Layer Package (*.slpk)** as **Save as type**, name your file "oac_cemetery.

slpk" , and click **Save**. Make sure the coordinate system is set to WGS84 (EPSG:4326) and click **OK**.

22. Export the DEM by right clicking the DEM name and selecting **Export DEM > Export TIFF/BIL/XYZ**. Make sure the coordinate system is set to WGS84 (EPSG:4326), accept all other defaults and click **Export**. Using the **Save As** window, navigate to the folder where you want to save your DEM, choose **TIFF/GeoTIFF (*.tif)** as **Save as type**, name your file "oac_DEM.tif" and click **Save**.

23. Export your orthomosaic by right-clicking the orthomosaic name and selecting **Export Orthomosaic > Export JPEG/TIFF/PNG**. Make sure the coordinate system is set to WGS84 (EPSG:4326), leave all other defaults, and click **Export**. Using the **Save As** window, navigate to the folder where you want to save your orthomosaic, choose **TIFF/GeoTIFF (*.tif)** as **Save as type**, name your file "oac_orthomosaic.tif" and click **Save**.

To facilitate importing the 3D model into the AR application, you will reduce the number of faces of the model by decimating its mesh.

24. First, create a duplicate of your 3D model so that you do not accidentally change the original model. Right-click the model name in the **Workspace** area and select **Duplicate**. Click **Yes** when asked if you want to duplicate the model. The duplicate model will be added in italics. Set the duplicate model as the default by right-clicking the model name and then selecting **Set as Default**. This will turn the other version to italics.

25. Next, you will decimate the mesh. Decimation is the process of reducing the number of faces used to represent features and 3D objects. To decimate the duplicate model, go to **Tools > Mesh > Decimate Mesh**. Make sure you have **200,000** for **Target face count**. Click **OK**. Click **Yes** when asked if you want to replace the default model.

26. Double-click on the 3D Model you just decimated to display it, and notice that the model does not have texture and looks blurry. To create texture for this model, go to **Workflow > Build Texture**. Accept the default options and click **OK**.

Exporting the model following a reset of the geometric transformation facilitates positioning of the 3D model using the AR application used in this chapter. To export your model, follow the steps below.

27. Right-click **Chunk 1> Duplicate**. When presented a window with options for items to copy, check **Models** and uncheck all other options. Click **OK**. The new chunk is added as **Copy of Chunk 1**. To activate this duplicate chunk, right-click the chunk name > **Set Active**.

28. To reset the transform for your active chunk, go to **Model > Transform Object > Reset Transform**. Click **Yes** when asked to confirm. If Metashape does not display your model following the transform reset, go to **View > Reset View**.

29. To export the model, expand Copy of Chunk 1, and right-click the 3D Model (be sure to choose the unitalicized version) > **Export Model**. Navigate to the folder where you want to save your model, and under **Save as Type**, choose **Binary glTF (*.glb)**. Name your file "oac_cemetery.glb" and click **Save**. When the **Export Model** window opens, make sure you have the **Export texture** option checked. Leave all other defaults and Click **OK** to export your model.

30. Save your project and close Metashape.

Q3 Now that you have seen some of the various products that can be generated from UAS images, what do you think are the important considerations when planning a flight mission to acquire high quality images of historical sites that have vertical structures, like the box tombs at the Old Athens Cemetery?

Q4 What is the purpose of the sparse point cloud you generated in Step 4, and why does it have fewer points than the dense point cloud you generated in Step 12?

EXERCISE 1.2: BUILDING A DETAILED 3D MODEL OF A HISTORICAL OBJECT

Sometimes, higher levels of detail are needed than can be obtained with aerial drone flights for assessing the condition of historical monuments or supporting digital interactions. When this is the case, a combined approach can be useful where drone-captured images are combined with high-resolution images captured on the ground. In this section, you will build on the models you developed in the previous exercise and use computer vision techniques to generate a 3D model showing detail of a box tomb in the Old Athens Cemetery.

1. Launch a new instance of Metashape.

2. Go to **Workflow > Add Photos** and navigate to the Ground_Images folder containing the box tomb images. Select all the images and click **Open**. The 61 images will be added to the Photos pane, and image names and icons representing image locations based on embedded coordinates will be added to the Model pane.

3. Save your project by going to **File > Save** (project name: "oac_metashape_boxtomb.psx").

4. Align photos by going to **Workflow > Align Photos**. During this step Metashape identifies matching points, estimates camera locations, and produces a sparse point cloud. Use the following parameters when aligning photos and click **OK** when you are done:

 a. Accuracy: Medium

 b. Check Generic preselection

 c. Under Advanced:
 i. Key point limit: 40,000
 ii. Tie point limit: 4,000

5. When Metashape finishes aligning the photos, click **View > Reset View**. The Model pane is updated to display a sparse point cloud (tie points) of the box tomb. Calculated image locations and the direction the camera was facing for each image are also displayed. Use Metashape's trackball to navigate and explore this sparse cloud. Notice that the Workspace pane has also been updated. Click the ">" symbol to the left of the chunk to display the number of aligned photos and the Tie Points layer.

6. Next, you will georeference the sparse point cloud using ground control points collected in the field. Switch to the **Reference** window by clicking the **Reference** tab. To ignore coordinates from images previously loaded and use a set of field coordinates, select all of the listed cameras (shortcut: Ctrl+A), then right-click over one of the camera names to open the context menu and click **Uncheck** to uncheck all cameras.

7. Click the **Import Reference** icon (leftmost icon, just above the camera list), navigate to the oac_gcps_boxtomb.txt file and click **Open**. *Note: the ground control point file has*

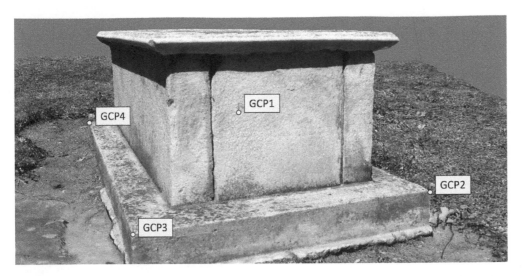

FIGURE 16.6 Location of ground control points to be used when positioning markers during georeferencing. Yellow dots indicate the location where ground control point coordinates were collected and where the marker should be placed. Note: although GCP1 is displayed above, this control point is in reality behind the box tomb, on the opposite corner of GCP3.

GPS coordinates of four corners of the base of this box tomb. The file includes longitude, latitude, and elevation for each point. Inspect the **Import CSV** window. Make sure the coordinate system is set to WGS 84 (EPSG:4326), the delimiter is set to **Tab**, and that **Start import at row** is set to 2. Click **OK** and click **Yes to All** when Metashape asks if it should create a new marker. Your GCPs will be loaded.

8. You now need to position each GCP in its correct location on the ground as you did in Exercise 1.1. Double-click an image thumbnail in Metashape's Photos pane to display the image. Using Figure 16.6 as a guide, right click on the bottom right corner of the base of the box tomb and select **Place Marker > Select Marker**. Select GCP2 from the list. You can zoom in and out of the image to assist with positioning the control points. You can reposition a control point by dragging and dropping it. If you cannot get a good view of the corner in an image, skip that image and move to the next. When you position your GCP, a flag will be added to the GCP location and to the image thumbnail. Identify GCP2 in at least 10 images. After you place a marker on the first few images, Metashape will automatically start suggesting a position in subsequent images. However, you still need to click on the point to set the marker in the image. The green flag on the thumbnail images will indicate which images have had a marker placed.

9. Repeat Step 8 for all four corners of the base of the box tomb, making sure you identify each GCP in at least 10 images. Metashape will indicate the number of images where control points have been identified by updating the Projections column associated with each control point. When you are done positioning markers, click the **Update Transform** icon on the **Reference** pane. Metashape will calculate errors associated with the transformation. Inspect the errors for each marker. After you finish editing the GCPs, click the **Workspace** tab to display the workspace used by your Metashape project.

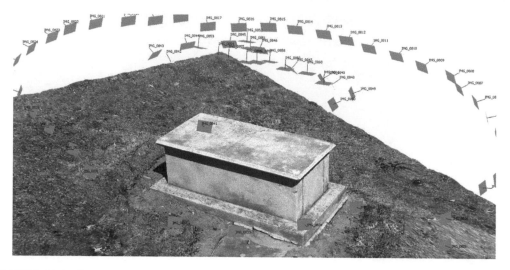

FIGURE 16.7 Texturized 3D model of a box tomb created from images collected from multiple perspectives. Location of the camera around the box tomb and direction the camera was facing during the image acquisition are shown as blue rectangles.

Q5 Report the accuracy of your four GCPs in meters.

10. Next, you will create a mesh to represent the box tomb, by going to **Workflow > Build Mesh**. Make sure the following parameters are selected and then click **OK**:

 a. Source data: Depth maps

 b. Quality: Medium

 c. Face count: High

11. During mesh creation, Metashape colors the mesh and creates a shaded version of the model. To create a more realistic model, you will use the original images to add texture to the mesh. Go to **Workflow > Build Texture**. Leaving the default options is sufficient to create a textured model that is of high enough quality for this exercise (Figure 16.7).

12. Create a Tiled Model, which you will later export to use in ArcGIS by going to **Workflow > Build Tiled Model**. For parameters, select the following:

 a. Source data: Depth maps

 b. Quality: Medium

 c. Face count: Medium

 d. Under Advanced: make sure Reuse depth maps is checked.

13. Make the Tiled Model active (double-click it in the workspace). Take a few moments to explore the different options Metashape provides to view the model. Use the **View Mode** icon on Metashape's toolbar or, alternatively, go to **Model > View Mode** and one-by-one select the point cloud, wireframe, solid, shaded, and textured options to display the 3D model.

Q6 Which of the five viewing options (point cloud, wireframe, solid, shaded, and textured) did you find most useful for representing the historical object (box tomb)? Why?

Q7 Which model representation would be most applicable for a project focusing on capturing and digitally preserving fine detail, indents, or engravings that are part of a historical object?

14. Export the Tiled Model by right-clicking the model name and selecting **Export Tile Model**. Using the **Save As** window, navigate to the folder where you want to save your model, choose **Scene Layer Package (*.slpk)** as **Save as type**, name your file "oac_boxtomb.slpk" and click **Save**. Make sure the coordinate system is set to WGS84 (EPSG:4326) and click **OK**.

To facilitate importing the 3D model into the augmented reality (AR) application, you will reduce the number of faces of the model by decimating its mesh.

15. First, create a duplicate of your 3D model by right-clicking the model name in the Workspace and selecting **Duplicate**. Click **Yes** if asked if you want to duplicate the model. Set the duplicate model as default by right-clicking the model name and then selecting **Set as Default**.

16. To decimate the duplicate model, go to **Tools > Mesh > Decimate Mesh**. Make sure you have 200,000 for **Target face count**. Click **OK**. Click **Yes** when asked if you want to replace the default model.

17. Notice that this decimated model does not have texture. To create texture for this model, go to **Workflow > Build Texture**. Accept the default options and click **OK**.

Exporting the model following a reset of the geometric transformation facilitates positioning of the 3D model using the AR application suggested by this chapter. To export your model, follow the steps below.

18. Create a duplicate of the Metashape chunk by right-clicking the chunk's name > **Duplicate**. When presented a window with options for items to copy, check **Models** and uncheck all other options. Click **OK**.

19. Be sure your duplicate chunk is set as active (right-click the chunk name > **Set Active**), then reset the transform by **Model > Transform Object > Reset Transform**. Click **Yes** when asked to confirm. If Metashape does not display your model following resetting the transform, go to **View > Reset View**.

20. Export the model by right-clicking 3D Model > **Export Model**. Navigate to the folder where you want to save your model, choose **Binary glTF (*.glb)** as **Save as type**, name your file (oac_boxtomb.glb), and click **Save**.

21. When the Export Model window opens, make sure the **Export texture** option is checked. Leave the other defaults and click **OK**. Save your project and close Metashape.

EXERCISE 1.3: PRODUCT INTEGRATION AND 3D MODEL VISUALIZATION USING A GEOGRAPHIC INFORMATION SYSTEM

Visualizing digital images and 3D representations of field sites or objects can be very informative, but if analyzed in isolation, these products can lack spatial context and may fail to represent important physical, social, and cultural connections. In the prior exercises, you used digital photogrammetry and computer vision techniques to create and explore products derived from images collected by a drone and by a camera on the ground. You will now integrate your results from those exercises in a Geographic Information System platform (ArcGIS Pro). Follow the steps

below to use ArcGIS Pro to create a multi-layer display of 2D products as maps. Image-derived products that store elevation information in addition to latitude and longitude will also be incorporated into the analysis using a 3D scene.

1. Launch ArcGIS Pro and create a new map project.

2. In the **Catalog** pane (**View > Catalog Pane**), right-click **Folders** and select **Add Folder Connection**. Navigate to the folder where datasets for this exercise are stored and click **OK**.

3. Add the `oac_orthomosaic.tif` image to your **Contents** pane by right-clicking the image name and selecting **Add To Current Map**. The image will be displayed on top of your basemap.

Zoom into different locations at the Old Athens Cemetery and explore details of the area, including types of monuments and site condition. Notice that multiple gaps exist around the edges of the orthomosaic. Incomplete edges and edge artifacts (anomalies) are normal in drone image processing and have flight planning and data acquisition implications.

4. On the ribbon menu, go to **Map > Basemap > Imagery** to change the basemap displayed by ArcGIS Pro. Then, select the `oac_orthomosaic` layer, and using the **Appearance** tab click the **Swipe** icon. Position the cursor in the main window, and swipe in different parts of the area to compare the orthomosaic from the drone flight to the basemap image.

Q8 Would it be possible to identify and map the box tombs in the cemetery using the basemap image in ArcGIS Pro? What features in the cemetery would you be able to map using the basemap imagery? What features would be missed?

5. From the **Catalog** pane, add the six vector files representing the monuments to your map from the data folder. These files are named `oac_monuments-Slab`, `oac_monuments-Obelisk`, etc. Symbolize the six monument layers according to their type: box tombs, field stones, fragments, headstones, obelisks, and slabs.

6. In addition to location, the provided monument layers contain information on the monument that can be used for exploration and historical resource management. Explore the information for each layer by right-clicking the layer name > **Attribute Table**. A database table with monument information will be presented. Explore specific monuments by double-clicking to the left of the FID number for each table row. Alternatively, you can use the menu ribbon to select the **Map** tab and click the **Explore** icon. Zoom to specific monuments and use the orthomosaic to assess monument conditions. Interact with the map and click the monument symbol to retrieve information associated with specific monuments such as who is buried there, when they died, and the inscription on the monument.

Q9 Find the slab for Sarah Frances Meriwether in the southern part of the Old Athens Cemetery. Based on the orthomosaic, what is the condition of this monument? What inscription and other historical information are associated with this slab monument?

You will now import the 3D models of the cemetery and box tomb you created in Metashape into ArcGIS Pro as Tiled Models, a format optimized for visualization at multiple scales.

7. Using the ribbon menu, click **Insert > New Map > New Local Scene**.

FIGURE 16.8 ArcGIS Pro interface showing a model of the Old Athens Cemetery created using drone imagery and a superimposed model of a box tomb derived from ground imagery.

8. Using **Catalog**, add the `oac_cemetery.slpk` file to your **Contents** pane. After the layer is added to the **Contents** pane, rename the layer from 3D model to **Old Athens Cemetery** (right-click > **Properties** > **General**). Also import the `oac_boxtomb.slpk` file and rename it **Box Tomb** (Figure 16.8).

You should now have a combined product that includes the 3D model of the cemetery displayed in ArcGIS Pro with a 3D model of the box tomb superimposed.

9. Use the 3D navigation capabilities of ArcGIS to explore different areas at the Old Athens Cemetery. To pan around the model, click, hold, and move (drag) the mouse. To zoom in and out, use the mouse wheel (middle button) or, alternatively, right-click, hold and drag the mouse. To rotate/tilt the model, click the mouse's middle button, hold and drag. As you explore the model, pay particular attention to the contribution of 3D objects to the description of the area.

Q10 Compare the 3D detail of the box tomb for which you created a separate 3D model from ground images (`oac_boxtomb.slpk`) with another box tomb in the cemetery that was only modeled using drone images. What are some of the differences you notice between the two? Can you make out the inscription on either box tomb?

10. To further explore the multiscale nature of this combined product, zoom into the box tomb area by right-clicking the box tomb layer name in the **Contents** pane > **Zoom To Layer**. Use the **Swipe** icon under the Appearance tab to explore how each layer affects the scene. *Note: you must zoom to the layer to reset the view in order for the Appearance tab to become active.*

Q11 Notice when you swipe how the `oac_cemetery.slpk` file "bulges" beyond the boundaries of the box tomb in the `oac_boxtomb.slpk` file. What do you think is causing this to happen?

11. Save your ArcGIS Pro project by selecting **File > Save**.

Optional activity 1: Use the image manipulation capabilities of ArcGIS to clip the edges of the orthomosaic. Use the clipped orthomosaic and symbolized vector data to create a layout for a map indicating the location of the monuments in the Old Athens Cemetery.

Optional activity 2: The DEM for the Old Athens Cemetery captures small changes in topography that can indicate unmarked graves, which are not marked with a monument. Load the DEM you exported from Metashape (`oac_DEM.tif`) into ArcGIS Pro, and overlay the monuments layers. Symbolize the DEM so that you can make out the outlines of the gravesites in the topography. You may have to play around a bit with the stretch type and parameters of the stretch in the Symbology window to see these details. Create a new polygon shapefile and digitize the outlines of potential unmarked graves. These will be areas where you can see an impression in the DEM but there is no monument marking the site.

Q12 How can integrating drone imagery and ground-based imagery be beneficial for historical preservation? Considering the current availability of technological solutions for imaging large areas and processing very high resolution drone images, what are some other activities that might benefit from digital preservation? What are some of the challenges associated with integrating ground-based images with drone-based images?

Q13 What should be considered during drone data collection to avoid or minimize the impacts of gaps along the edges of the scene and geometry artifacts on subsequent analyses?

Q14 The occurrence of shadows brings challenges when identifying objects and can limit information extraction. Shadows can also be informative though in terms of identifying features and objects. What important information can be derived from shadows for a scene such as a cemetery?

PART 2: USING AUGMENTED REALITY TO EXPLORE COMPUTER VISION-DERIVED 3D MODELS

The 3D models created in Part 1 can be visualized and shared using a variety of technologies and strategies. Among those, Augmented Reality (AR) has been receiving increasing attention due to its ability to represent digital objects by blending them with the physical/real world. In this part, you will it create two interactive AR applications to display your 3D models using Spark AR Studio software available through Facebook (https://sparkar.facebook.com/ar-studio/). Following the creation of the application, you will test using the Spark AR Player, running on a mobile device.

1. Launch Spark AR Studio and log into a Facebook account, as needed.

2. If you are new to Spark AR Studio, we recommend you take the **Interface Tour**, under **Help > Start Interface Tour**. Use the tour to familiarize yourself with interface components, including the viewport, the simulator, video controls, scene pane, assets pane, the AR library, the Inspector, test options, and publishing options. For more information on AR creation using Spark AR Studio, go to **Help > Documentation** and/or **Help > Tutorials**.

3. When the Spark AR Studio welcome screen opens, select **Create New**, and click the **World Object** template icon to create your application. Spark AR Studio will display your app creation window.

4. Save your AR project by going to **File > Save**.

You will use AR to visualize the non-georeferenced version of the texturized 3D model representing the box tomb created in Part 1. To create the AR application:

FIGURE 16.9 (a) Spark AR environment showing a texturized 3D model of a box tomb, including a preview of the application running on a simulated mobile device. (b) The same application is seen running on an iPad through Spark AR Player.

5. Add the non-georeferenced 3D model of the box tomb (`oac_boxtomb.glb`) to Spark AR Assets by clicking **Add Asset** under the **Asset** pane. Navigate to the file, select it, and click **Open**. Alternatively, you can drag and drop the file from your folder into the Assets pane. Spark AR may take a minute to add your model to the list of assets.

6. Click the triangle to the left of the `oac_boxtomb.glb` asset to expand that container. Click on **Texture 0**. The right pane will change to show texture properties. Under **Manual Compression**, check the option **No compression**.

7. Still using the container for your asset, add the 3D object part of the **oac_boxtomb** asset (this object is symbolized with a 3D cube) to the scene by dragging and dropping the object from the **Assets** pane to the **dragHere** area of the **Scene** (above the Assets area). You should now see your model rotating.

8. Stop the rotation by clicking the pause button on the video controls area of the screen (left side of the screen). At this point, you can also delete the **deleteMe** object to remove it from your scene.

9. Your model is displayed in shades of gray, as no image-based texture is being applied. To add a realistic texture to your model, click the **Default material** for the model under the **Asset** pane. Select **Standard** in the dropdown next to **Shader Type** in the Default Materials window.

10. Your model should be positioned so it is visible by the camera and should be displayed on the device simulator (Figure 16.9). If adjustments in size and position are necessary, you can click the model on the viewport to show a gizmo that allows for object manipulation using your mouse. Use buttons on the top part of the viewport to switch between position, rotation, or scale adjustments. If necessary, switch from **Local** to **Global** coordinate systems to facilitate object manipulation and placement.

11. You can test your AR application using the Spark AR Player on a mobile device (Figure 16.9). After preparing your device to communicate with Spark AR, connect the device to the computer you are using to develop your application and click the **Test on Device** icon. When the window opens listing your device, click **Send**.

12. After testing, and once you are satisfied with your AR implementation, you can upload the implementation to Spark AR Hub to start the publishing process. Spark AR Studio will check your app to make sure it meets system requirements, including size and capabilities of the platform (Figure 16.9).

Optional activity: create a new Spark AR project and use instructions similar to those presented above to create and explore an augmented reality application showing the 3D model of the Old Athens Cemetery and surrounding area.

Q15 Discuss the advantages and disadvantages of augmented reality for visualization and manipulation of historical objects. What are some ways in which the augmented reality experience can be improved for users?

DISCUSSION AND SYNTHESIS QUESTIONS

S1 What are some of the technical and non-technical aspects of a data collection mission that should be considered when planning to collect drone images over historical sites?

S2 What are some of the ways in which cultural heritage preservation programs can be improved or enhanced using the strategies and technologies introduced in this chapter? How do the methods presented by this chapter compare to traditional methods for cultural heritage preservation?

S3 Discuss the technical and/or non-technical challenges and limitations associated with the strategies and technologies used in this chapter? Provide a list and description of those challenges and limitations. How can the identified challenges be minimized and limitations be addressed?

S4 How is a visitor or user's experience of historical sites and objects affected by the use of these technologies, including drones and augmented reality? What opportunities do drones and augmented reality offer to enhance user experience? What disadvantages or limitations accompany these technologies?

S5 In addition to historical preservation, what other applications could benefit from the products and approaches implemented in this chapter? What adaptations (if any) to the strategies presented here would be required for use with other applications?

ACKNOWLEDGMENTS

Resources to collect and process images used by this chapter were made available through Learning Technologies Grants, by the Center for Teaching and Learning at the University of Georgia.

REFERENCES

Agisoft Metashape User Manual, Professional Edition, Version 1.6 (2020). Agisoft.
Bernardes, S. & Madden, M. (2019) *Athens: Layers of Time Story Map and Map Portal.* https://athenslayer-softime.uga.edu/
Bernardes, S., Madden, M., Knight, A., Neel, N., Morgan, N., Cameron, K., & Knox, J. (2018). A multi-component system for data acquisition and visualization in the geosciences based on UAVs, augmented and virtual reality. *International Archives of the Photogrammetry, Remote Sensing & Spatial Information Sciences*, XLII-4, 45–49.

Bernardes, S., Howard, A., Mendki, A., Walker, A., Bhanderi, D., Le, L., Tsao, A.L., & Rukangu, A. (2019). Innovative technologies in teaching and learning: Incorporating recent developments in virtual and augmented reality into active learning at the University of Georgia. AGUFM, 2019, ED11B-0873.

Çöltekin, A., Lochhead, I., Madden, M., Christophe, S., Devaux, A., Pettit, C., Lock, O., Shukla, S., Herman, L., & Stachoň, Z. (2020). Extended reality in spatial sciences: a review of research challenges and future directions. *ISPRS International Journal of Geo-Information*, 9, 439.

Cooper, P.I. & McAninch, G. (1984). *Map and historical sketch of the Old Athens Cemetery*, 2nd Ed. Athens, Georgia: Old Athens Cemetery Foundation, Inc., 35.

Cotten, D., Jordan, T., Madden, M. & Bernardes, S. (2020). Structure from motion and 3D reconstruction. In, Moran, S., Renslow, M. & Budge, A. (Ed). *Manual of Remote Sensing* (4th Edition). Bethesda, Maryland: American Society for Photogrammetry and Remote Sensing - ASPRS.

Hull, A.L. (1906). *Annals of Athens, Georgia: 1801-1901*. Athens, Georgia: Banner Job Office, 542.

Madden, M. & Bernardes, S. (2018). Dynamic time-series visualization of the cultural and natural landscape surrounding Baldwin Hall: 1800s to present, Final Report, Center for Geospatial Research, Department of Geography, University of Georgia, Athens, GA, 34p.

Madden, M., Jordan, T., Cotten, D., O'Hare, N., Pasqua, A. & Bernardes, S. (2015). *The future of unmanned aerial systems (UAS) for monitoring natural and cultural resources*. In Fritsch, D. (Ed.), *Proc. Photogramm. Week*, Stuttgart, Germany (pp. 369–385).

Madden, M., Jordan, T., Bernardes, S., Goetcheus, C., Olson, K., & Cotten, D. (2019). Small Unmanned Aerial Systems (sUAS) and structure from motion for identifying, documenting, and monitoring cultural and natural resources. In J.B. Sharma (Ed.), *Applications of Small Unmanned Aircraft Systems: Best Practices and Case Studies*, 185–201.

Morris, S. (1923). *Athens and Clarke County, In, H.J. Rowe, Publisher, History of Athens and Clarke County*. Athens, Georgia: The McGregor Company, 180.

Parry, M. (2017) Buried history: How far should a university go to face its slave history? *The Chronicle of Higher Education*, 25 May 2017, last accessed 30 October 2020. https://www.chronicle.com/article/Buried-History/240164.

Shearer, L. (2017) Sting of death: UGA's handling of the Baldwin Hall remains faces criticism, Online Athens - *Athens Banner Herald*, 11 March 2017. Last accessed 30 October 2020. http://www.onlineathens.com/local-news/2017-03-11/sting-death-uga-s-handling-baldwin-hall-remains-faces-criticism.

Strahan, C.M. (1893). *Clarke County, GA and the City of Athens*, Atlanta, Georgia: C.P. Byrd, 88.

UGA Today (2017) UGA to reinter remains of individuals discovered in Baldwin Hall construction, *Campus News*, March 8, 2017, last accessed 30 October 2020. https://news.uga.edu/uga-reinter-remains-discovered-baldwin-hall-construction/

Weeks, E.B. (1999) *Athens-Clarke County, Georgia, Cemeteries*. Athens, Georgia: Athens Historical Society, R.J. Taylor Jr. Foundation, 391.

Wilson Center DigiLab (2018a). Excavation of Baldwin Hall Cemetery, *Wilson Center Digital Humanities Lab*. https://digilab.libs.uga.edu/cemetery/baldwinplace.

Wilson Center DigiLab (2018b). Bioarchaeological Research at Old Athens Cemetery, *Wilson Center Digital Humanities Lab*. https://digilab.libs.uga.edu/cemetery/exhibits/show/baldwin.

17 Identifying Burial Mounds and Enclosures Using RGB and Multispectral Indices Derived from UAS Imagery

Agnes Schneider, Sebastian Richter,
and Christoph Reudenbach

CONTENTS

LEARNING OBJECTIVES

After completing this chapter, you will be able to:

1. Preprocess unmanned aircraft system (UAS)-captured imagery using Agisoft Metashape.
2. Enhance the quality of Agisoft-generated orthomosaics.
3. Process multispectral images and estimate vegetation indices in R/RStudio to detect underground archaeological features.

HARDWARE AND SOFTWARE REQUIREMENTS

1. Agisoft Metashape Professional
2. R and Rtools with GDAL installed
3. RStudio
4. QGIS version 3.x or higher (or ArcGIS)
5. The data folder containing the following files:
- `00_install_pacakges.R`
- `0_library_n_prep.R`
- `1_set_up_working_envrnmnt.R`
- `2_working_with_RGB_orthoimagery.R`
- `3_working_with_spectral_orthoimagery.R`
- `RGB_raw` (1 orthomosaic of Hohensolms)
- `Spect_raw` (4 spectral orthomosaics of Hohensolms)
- `RGB.zip` (RGB drone imagery)
- `RED.zip` (red spectral drone imagery)

INTRODUCTION

Satellite multispectral imaging provides key data inputs to spatial studies including ecological monitoring, physical geography, and archaeology, among many other applications. Advances in multispectral sensors for drones have led to a rapid growth in their use for capturing not only visible spectra (e.g., red, green, and blue bands, hereafter referred to as RGB) but also bands outside the visible spectra such as near-infrared (NIR) and red-edge (REG) channels (the red edge is located between the red and NIR portions of the electromagnetic spectrum). Multispectral sensors flown onboard UAS provide data that are spectrally similar to imagery captured from satellites and manned aircraft – putting a very powerful tool into the hands of users.

Off-the-shelf cameras are typically equipped with RGB imaging sensors covered by a blocking filter that allows only the visible portion of the electromagnetic (EM) spectrum to be transmitted (i.e., 400–700 nm). Multispectral imaging sensors, on the other hand, measure EM energy over a broader range of wavelengths, often including the NIR range. These sensors also usually capture reflectance measurements from more defined spectral channels compared to RGB sensors, providing more specific and spectrally higher resolution information of the surveyed area (Verhoeven and Sevara 2016). The at-sensor reflectance (i.e., radiance), which is the radiant flux received by the sensor, is a function of the surface radiance and the atmospheric disturbance between the surface and the sensor (Wang and Myint 2015). This can be

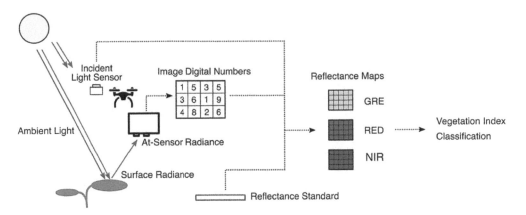

FIGURE 17.1 Schematics of the process for generating a reflectance map from a multispectral drone sensor. Assmann et al. 2018, Figure 1. (CC-BY 4.0, https://creativecommons.org/licenses/by/4.0/), drone symbol from the Noun Project (CC-BY, http://thenounproject.com).

calibrated by a reflectance standard to an absolute reflectance signature stored as numeric digital number (DN) values in the image (Figure 17.1). The output is a reflectance map/imagery with multiple bands (Assmann et al. 2018).

Reflectance maps can be used to calculate a variety of spectral indices. Spectral indices are a form of **image enhancement** where the bands are mathematically combined or transformed to permit better interpretation of the information in the image. Since the 1970s, many indices have been developed for different scientific purposes. The most common spectral indices are vegetation indices (VIs) that highlight the biophysical characteristics of the vegetation and are sensitive to photosynthetic activity, canopy structure, and vegetation composition. Examples of VIs include the normalized difference vegetation index (NDVI) and the enhanced vegetation index (EVI). NDVI can be used to establish vegetation phenology by identifying time steps when satellite or airborne remotely sensed data show the highest difference among vegetation types (Singh et al. 2018). Often, the sensors carried onboard a UAS do not have the ability to capture the bands needed to compute the most common VIs (e.g., the NIR band) thereby limiting their use and application.

One application of spectral indices is to use them to enhance imagery in order to detect hidden archaeological features that may be present underground. Burial mounds are human-constructed hills of earth and stones built over the remains of the dead. Enclosures are rectangular in shape and can be found together with burial mounds. The construction of burial mounds and enclosures alters the physical properties of the soil compared to the surrounding matrix, which in turn leads to differences in vegetation types and phenology (Figure 17.2). The presence of these features underground is expressed by changes in the typical phenological cycle of the vegetation (Luo et al. 2019), which can sometimes be identified using remote sensing spectral indices to aid in archaeological investigations.

This chapter will introduce a workflow for computing spectral indices using both RGB imagery captured from an off-the-shelf sensor along with multispectral imagery captured using a more sophisticated sensor for the purpose of enhancing imagery in order to locate underground features such as burial mounds and enclosures. The indices you will compute are designed to accentuate

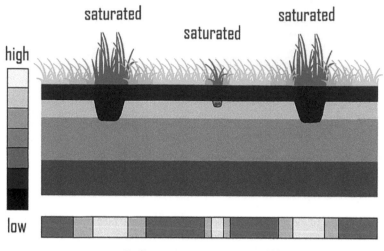

FIGURE 17.2 The variation in reflectance induced by a ditch. In this case the soil in the ditch nourishes the vegetation, allowing it to grow more vigorously than the surrounding vegetation. These differences result in higher reflectance of NIR radiation. After Lasaponara and Masini 2012, Fig. 1.1. Grass designed by www. Freepik.com.

these features of interest for the time of the acquisition of the orthoimagery (5 June 2018) during the crop phenological cycle in Hohensolms, Hessen, Germany.

INDICES COMPUTED FROM RGB IMAGERY

The **Visible Vegetation Index (VVI)** was developed by the Planetary Habitability Laboratory of the University of Puerto Rico at Arecibo to provide a measure of the amount of greenness using information from the visible spectrum (i.e., RGB Bands). The VVI offers an alternative to indices such as the NDVI that require a NIR band, which is not typically available in off-the-shelf sensors. VVI is computed as

$$VVI = \left(1 - \frac{Red - 30}{Red + 30}\right)\left(1 - \frac{Green - 50}{Green + 50}\right)\left(1 - \frac{Blue - 1}{Blue + 1}\right) \tag{17.1}$$

The **Redness Index (RI)** can also be computed from RGB bands and accounts for the soil redness intensity (Mathieu et al. 1998), which can be related to the soil properties such as mineral composition, water content, and even the soil particle size. RI is computed as

$$RI = \frac{Red^2}{Blue * Green^2} \tag{17.2}$$

The **Brightness Index (BI)** provides an overall measure of the combined magnitude of reflectance from all three RGB bands and is useful for differentiating bright soils from soils with higher organic matter (Mathieu et al. 1998):

$$BI = \frac{\sqrt{Red^2 + Green^2 + Blue^2}}{3} \tag{17.3}$$

INDICES COMPUTED FROM MULTISPECTRAL IMAGERY

The most well-known and commonly used multispectral index is the **NDVI**, which incorporates the NIR and Red bands to accentuate vegetation greenness. Healthy vegetation absorbs red light for photosynthesis and reflects NIR light. Differencing these two bands accentuates healthy, green vegetation in imagery. NDVI has become the standard multispectral index to measure vegetation vigor.

NDVI values are normalized, meaning pixel values range from −1 to +1. Values near zero typically correspond to barren rock, snow, or ice. Values between 0.6 and 0.9 correspond to dense vegetation or crops at their peak growth stage:

$$NDVI = \left(\frac{NIR - Red}{NIR + Red} \right) \tag{17.4}$$

Many versions and variations of NDVI have been created over the years by interchanging different bands to enhance the sensitivity of the index to chlorophyll concentration. For example, the Green NDVI, or GNDVI (Gitelson and Merzlyak 1998) uses reflectance from the Green band instead of the Red band and has been found to be more sensitive to chlorophyll in certain types of plants. Other variations reduce the sensitivity of the effects of soil color and enhance signals from the vegetation structure. For example, the Re-normalized Difference Vegetation Index (RDVI) (Roujean and Breon 1995), was developed to minimize the effects of soil background on vegetation identification. Other indices such as the Normalized Difference Red-edge Index (NDRE) (Barnes et al. 2000), have been created to incorporate the red-edge band since reflectance in this region shifts to slightly longer wavelengths as leaf chlorophyll content increases, making the index useful for detecting subtle differences between plants or areas. In the exercises that follow, you will compute several of these indices and compare the results.

The **Green Chlorophyll Index (GCI)** enhances images based on the leaf chlorophyll content of plants. GCI is computed as

$$GCI = \left(\frac{NIR}{GREEN} \right) - 1 \tag{17.5}$$

The Modified Simple Ratio (MSR) was developed based on the Simple Ratio (NIR/Red) to increase the sensitivity of the index to phenological parameters:

$$MSR = \frac{\left(\frac{NIR}{RED} \right) - 1}{\left(\sqrt{\frac{NIR}{RED}} \right) + 1} \tag{17.6}$$

In this chapter, you will complete a workflow designed to utilize these spectral indices to enhance imagery in order to identify and detect features hidden underground. The dataset you will work with is from a joint course held at Philipps-University of Marburg during Summer 2018. The course was developed by Dr. Christoph Reudenbach from the Department of Geography and Prof. Dr. Felix Teichner from the Archaeological Seminar. The dataset is from the Hohensolms area in Hessen, Germany (Figure 17.3) where possible archaeological structures such as burial mounds and enclosures possibly dating back to the late Iron Age or Early Roman period are visible on Google Earth (Figure 17.4).

FIGURE 17.3 Location of the study area in Hohensolms, Hesse, Germany.

FIGURE 17.4 Google Earth Image from 6/17/2015 clearly depicting the objects of interest.
Source: Google Earth 2020.

Images were captured using a Parrot Sequoia sensor mounted on a 3DR Solo Quadcopter. The Parrot Sequoia consists of an RGB camera along with four multispectral sensors: green (GRE), red (RED), NIR, and red-edge (REG). The resolution of the RGB camera is 16 megapixel (MP) (4608 by 3456 pixels). The resolution of the spectral (RED/NIR/RE) sensors is 1.2 MP (1280 × 960 pixels).

The chapter is divided in two parts that are designed to be completed in sequence. In Part 1, you will generate two orthomosaics, one from the RGB imagery and one from the RED band of the multispectral imagery. You will work through the differences in processing RGB and multispectral images and assess the pros and cons of each image type. In Part 2, you will set the spatial resolution and projection of the orthomosaics generated in Part 1 and crop them to the same spatial extent. You will then calculate a set of vegetation indices from RGB and multispectral orthomosaics and interpret the outputs.

PART 1: GENERATING AN ORTHOMOSAIC FROM UAS-DERIVED RGB IMAGERY

Most imagery for Earth observation applications is captured orthogonally, which means the sensor is pointed perpendicular to Earth, also known as **nadir**-facing. Satellites and other airborne sensors that are positioned high above the surface of the earth can easily capture large swaths of nadir-facing imagery because the field of view is large. However, close-range platforms like UAS have a much smaller field of view, so the images need to be mosaicked to create a single image of the study area. This stitched image is referred to as an **orthomosaic**.

You will use Agisoft Metashape software to generate orthomosaics for both the RGB and multispectral (RED) data sets. For the most part, the steps to produce the RGB and RED orthomosaics are the same. When the steps differ, the instructions will be divided into two parts: a) for RGB and b) for RED. It is recommended you work through the workflow for the RGB dataset first, and then repeat the workflow for the RED dataset.

EXERCISE 1.1: BUILDING A SPARSE POINT CLOUD AND MESH

The following steps will guide you through the process to generate a sparse point cloud from the images, which is needed to ultimately generate an orthomosaic. You will find two data folders: one containing the RGB imagery and the other containing the RED band imagery.

1. Unzip the RGB.zip and RED.zip files (located in the Agisoft folder) to extract the RGB and RED imagery. The name of the extracted image represents the "IMG_ymd_time_number_sensor," where "IMG" is the image type, "ymd" is the year-month-day the images were captured, "time" is the time the images were captured, "number" is the image number in the order the images were captured, and "sensor" is the sensor used to capture the images.

2. Open Agisoft Metashape and click **Workflow > Add Folder**. Browse to the folder containing:

 a) the RGB photos and click **OK**.

 b) the RED photos and click **OK**.

In the dialog, choose the **Single cameras** method, and click **OK**. You can see the key information about each completed step in this exercise by right-clicking on your chunk (RGB or RED) > **Show Info**. When loading images into Metashape, they will align along the pre-established flight track of the drone since the Parrot Sequoia sensor used to capture the photos also gathered geoinformation for each photo.

Q1 How many images were added from the RGB folder into Agisoft? How many images were added from the RED folder into Agisoft?

3. *Note: this step is only completed for the RED dataset*: Click **Tools > Camera calibration** to correct Black level. This setting adjusts the color contrast in the images. On the left side of the dialogue, choose the Sequoia Camera (if it is not already selected). Go to the main panel and choose the **Bands** tab. Change the Black level from 4819.9 to 0, and click **OK**.

4. Click **File > Save**, name your project "Multispectral_image_processing.psx" and save it in the `Agisoft` subfolder. In Agisoft, photos are organized in what are called "Chunks." You can find these chunks in the Workspace on the left side.

5. Rename your Chunks by right-clicking on **Chunk 1 > Rename**. Change the name of the RGB chunk (Chunk 1) to "RGB" and the RED chunk (Chunk 2) to "RED". Each chunk includes a sub-category **Cameras**, which contains a list of the loaded images. The chunks contain photos taken during the site survey as well as images captured during the ascent and the descent of the drone. You do not need the images from the ascent and descent.

6. To exclude images from the ascent and descent, you can manually select them from the list using the image numbers below and then right-click **Photos > Disable Camera**. You may note that some additional photos are disabled. These photos have also been excluded from the alignment.

 a. For **RGB**: select images 0005 to 0065 (ascent) and images 0180 to 0206 (descent).

 b. For **RED**: select images 0004 to 0022 (ascent) and images 0180 to 0192 (descent).

Q2 How many photos were disabled in total for the RGB? How many photos were disabled in total for the RED dataset?

Q3 Why do you think more images than just those from the ascent and descent were excluded from the chunk? What might be the reason these images are not suitable for processing and analysis?

Next, you will align the images, which will produce a sparse point cloud (Figure 17.5). This part of the workflow is somewhat explorative, and you can test out different parameters to see which ones provide optimal results. Use the basic settings below to get started.

7. Click on **Workflow > Align Photos** to align the photos.

 a. Accuracy:

 RGB: Low
 RED: Highest

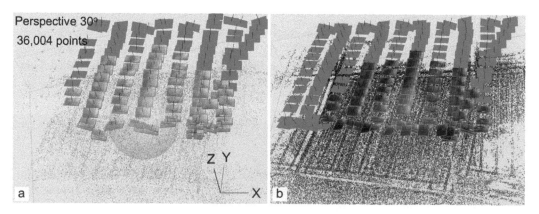

FIGURE 17.5 The sparse point clouds generated from the RGB (a) and RED (b) images in Agisoft Metashape. The light blue points represent the images that were disabled. *Note: the spatial position of the RGB images is more irregular compared to the RED images. The sparse point cloud for the RGB images is also less dense compared to the RED.*

 b. Generic Preselection: Yes

 c. Reference Preselection: Yes (drop-down at the right: source)

 d. Key point limit: 40,000

 e. Tie point limit: 4,000

 f. Adaptive camera model fitting (Advanced Settings): Yes

8. Click **File > Save** to save your project.

EXERCISE 1.2: OPTIMIZING THE SPARSE POINT CLOUD

The result of the alignment process is a sparse point cloud, which contains tie points of the aligned photos. **Tie points** are locations or objects that are visually recognizable in the overlap area between two or more images. The tie points contain three different measures of accuracy: reprojection error, reconstruction uncertainty, and projection accuracy. Detailed descriptions of these three parameters are provided in the Agisoft user manual (Agisoft 2018). For the purposes of this exercise, it is sufficient to know that Agisoft is able to calculate these three accuracy parameters, and you can optimize the sparse cloud by using the **Gradual Selection tool** to identify and delete points with high error according to the values of the accuracy parameters. You want to delete points with low **Reconstruction Uncertainty** values before moving on to the next steps. To do this:

1. Click **Model > Gradual Selection** to optimize the sparse cloud. In the dropdown menu, choose **Reconstruction Uncertainty**. You can decrease or increase the uncertainty value of the points by sliding the button from left to right. After clicking **OK**, you can zoom in and out of the point cloud to inspect the points and see which points have been highlighted as you change the level of reconstruction uncertainty (Figure 17.6). Set the levels as indicate below then click OK.:

 a) RGB: 16.0

 b) RED: 44.0

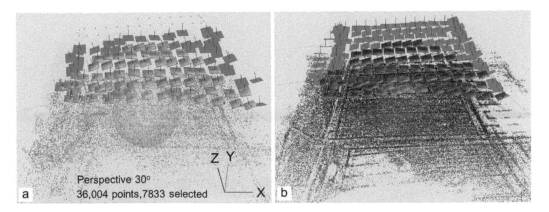

FIGURE 17.6 The sparse point cloud generated from the RGB (a) and RED (b) images in Agisoft Metashape. The points highlighted in pink have low quality reconstruction uncertainty and will be removed. *Note: the points are difficult to discern in the RED image. There are many more points with reconstruction uncertainty in the RGB point cloud.*

2. Click **Delete** on the keyboard to remove the selected points.

3. The last step is to adjust the camera positions and correct the point cloud. Click **Tools > Optimize Cameras**. Leave all settings as default and click **OK**.

4. Click **File > Save** to save your project

Q4 Why does reconstruction uncertainty occur in point clouds? What would happen if you set the reconstruction uncertainty value higher or lower?

Q5 Why are the number of tie points for the sparse cloud of the RGB images different from the number of tie points for the RED images? What are some potential reasons for the different number of tie points?

EXERCISE 1.3: BUILDING A 3D MODEL (MESH)

In this exercise, you will use the optimized sparse point cloud you created in Exercise 1.2 to build a 3D model (Mesh). A **mesh** is a 3D structure on which the photos are fitted to create an orthomosaic. You can imagine this process as putting paper mâché onto a wire model. The process works best when the surface of the mesh is smooth, without hard edges or gaps.

1. To develop a mesh, click **Workflow > Build Mesh**. Choose the following settings for a maximum number of faces (geometric parts forming the mesh surface), and then click **OK**. An example is shown in Figure 17.7.

 a. Source data: Sparse cloud

 b. Surface type: Arbitrary (3D)

 c. Face count: Custom > 0

 d. Interpolation: Enabled (default)

 e. Calculate vortex colors (Advanced settings): Yes

2. To create a smooth mesh, click **Tools > Mesh > Smooth Mesh** and input the following values, then click **OK**.

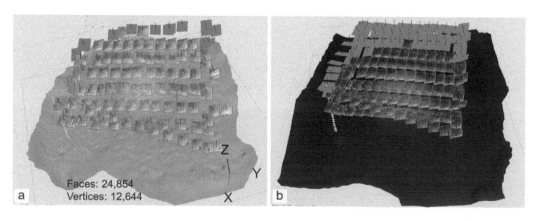

FIGURE 17.7 The mesh generated from the (a) RGB (b) and RED sparse point clouds before smoothing. Note that the RBG mesh has a much more irregular surface compared to the RED mesh.

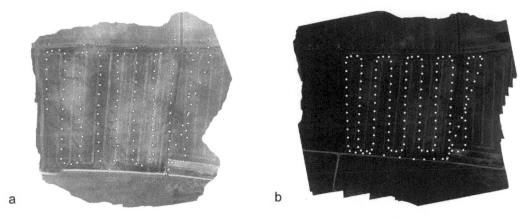

FIGURE 17.8 The orthomosaic generated from the (a) RGB and (b) RED mesh. The white dots represent the positions where the sensor captured an image.

 a. Strength: 15

 b. Fix borders (Advanced settings): Yes

 3. Save your project (**File > Save**)

Q6 What differences do you notice between the mesh for the RGB and RED data? Why is the RED mesh smoother than the RGB mesh, both before and after the smoothing step?

EXERCISE 1.4: GENERATING AN ORTHOMOSAIC

You will now generate an orthomosaic using the mesh you created above. See Figure 17.8 for an example.

 1. Go to **Workflow > Build Orthomosaic** and input the below settings, then click **OK**.

 a. Projection type: Geographic

 b. Projection: WGS 84 / UTM 32N (EPSG::32632)

 c. Surface: Mesh

 d. Blending mode: Mosaic

 e. Enable hole filling: Yes

 f. Pixel size: leave default setting

 2. Save your project (**File > Save**)

 3. To export your orthomosaic as a GeoTIFF file, click **File > Export > Export Orthomosaic > Export JPEG/TIFF/PNG**, name the files as follows and save them to the `raw_data` folder in the **Multispectral_Image_Processing** folder using the settings below:

 a) RGB: "Hohensolms_RGB"

 b) RED: "Hohensolms_RED"

Use the following settings:
 a. Projection type: Geographic

 b. Project: WGS 84 / UTM 32N (EPSG::32632)

 c. Pixel size: leave default settings

 d. Output file: Write big TIFF file

 4. You can generate a detailed PDF report of your results by clicking **File > Export > Generate report**.

Q7 You may have noticed a certain pattern in the alignment of the drone images. Why does this pattern occur and why might this particular alignment be advantageous or disadvantageous for creating 3D models?

Q8 How is the development of the RED orthomosaic different from the workflow for the RGB image processing? Identify parameters that are different in the two workflows.

Q9 What are the main differences between the two orthomosaics? You may want to review the report that was generated for each workflow to answer this question.

PART 2: GENERATING SPECTRAL INDICES FROM UAS-DERIVED ORTHOMOSAICS

The RGB sensor on the Parrot Sequoia is equipped with a rolling shutter while the multispectral sensors use a global shutter. These differences can impact the registration of the different bands, and cause geometric distortions. Additionally, the four spectral sensors are slightly offset from each other on the Parrot Sequoia, which leads to **band misregistration** (Jhan et al. 2017) and can affect the calculation of spectral indices by preventing the bands from being combined into an orthomosaic. To achieve optimal results, it is necessary to perform an extra step to align the bands when preprocessing spectral orthomosaics. For this part, you will use R and RStudio to compute vegetation indices and review your results in QGIS. The instructions and scripts needed for this part are contained in a github-wiki. The full address for the wiki page is https://github.com/kel-toskytoi/Multispectral_Image_Processing

EXERCISE 2.1: SETTING UP R & RSTUDIO

 1. Open RStudio

 2. Click on the Project drop-down menu in the upper right corner of the GUI (**File > Open Project**), navigate to where you stored the data for this exercise, and locate the `Multispectral_Image_Processing` folder. Open the `Multispectral_Image_Processing.Rproj` file. Once you load the project file, a completely empty working space will be visible.

 Four windows are visible in the RStudio GUI. The bottom right window displays multiple tabs. The first tab contains the files. Because you opened a project, you are automatically in the project folder, and you can see all of the R.files and folders of the project.

 3. Open the R.files with the numbers: `00_`, `0_`, `1_`, `2_` and `3` by doubleclicking on them one by one.

You will start with the R.file `00_install_packages.R` script, which will help you install the packages needed for the project.

4. Start by installing the `devtools` package, which is one of the most important packages as it helps to install the packages that are in the developmental phase. Installing the `devtools` package can take some time.

```
install.packages("devtools")
```

To execute a command, highlight line 4 with your cursor, and either click **Run** (upper right corner of the Code Editor window) or put the cursor at the beginning of the line and press **Ctrl + Enter**. Alternatively, you can always install packages by clicking the **Tools** drop-down **> Install Packages**. However, by typing in the code, you make your process more reproducible for future execution.

5. Install the following packages: `raster`, `rgdal`, `gdalUtils`, `mapview`, `sp`, `spData`, `sf`, `tools`, `RStoolbox`, `rgeos`, `lattice`, `ggplot2`, `RColorBrewer`, `signal`, and `rootSolve`. This step may take a few minutes. The code is below.

```
install.packages(c("raster", "rgdal", "gdalUtils", "mapview",
"sp", "spData", "sf", "tools", "RStoolbox", "rgeos", "lat-
tice", "ggplot2", "RColorBrewer", "signal", "rootSolve"))
```

6. Using devtools, install the packages `link2GI` and `uavRst` from the github link above.

```
devtools::install_github("r-spatial/link2GI", ref = "master",
dependencies = TRUE, force = TRUE)
devtools::install_github("gisma/uavRst", ref    =    "master",
dependencies = TRUE, force= TRUE)
```

7. In case there is a problem with the installation of uavRst from Github, please install the following packages from the archive:

```
devtools::install_url('http://cran.r-project.org/src/
contrib/Archive/spatial.tools/spatial.tools_1.6.2.tar.gz')
```

```
devtools::install_url('http://cran.r-project.org/src/
contrib/Archive/velox/velox_0.2.0.tar.gz')
```

If you run into further problems installing uavRst, please read the error messages carefully and follow the suggestions (e.g., install other missing packages) and/or consult the Github page for uavRst.

8. If the package `glcm` is not available on CRAN, you can install it from github. Before doing so, check in the bottom right window in the Packages tab to see if you already have `glcm` installed.

```
devtools::install_github("azvoleff/glcm")
```

Note: If R gives a warning at any given time that a package is missing, you can install packages by typing in the console `install.packages()` *or by clicking* **Tools > Install Packages** *as mentioned above.*

With the necessary packages installed, you can prepare R & RStudio by setting up the working environment for the chapter. Read the following paragraphs carefully before executing the next steps:

The R file you will be executing each time you open this R project is `1_set_up_working_envrnmnt.R`. This script cleans out the memory of R, reads the library (`0_library_n_prep.R`), and creates and sets a folder structure on your computer. Executing this script for the first time will set a folder structure for this project on your computer. Thus, you will have to change the path of the `projRootDir` to the file location where you placed the directory of this chapter. Example code to do this is below.

```
projRootDir <- "D:/Multispectral_Image_Processing/"
<-"your_path_on_the_computer/Multipsectral_Image_Processing"
```

The directory for this exercise contains the folders `RGB_raw` and `Spect_raw`. All the other folders will be set by executing this script for the first time.

```
paths<-link2GI::initProj(projRootDir = projRootDir, projFold-
ers = c("RGB_raw/", "Spect_raw/", "RGB_corr/", "Spect_corr/",
"RGB_crp/", "Spect_crp/", "indices_RGB/", "indices_spect/") ,
global = TRUE, path_prefix = "path_")
```

When executing this script anytime subsequently, it merely sets the previously created folder structure in the R project. When you close and reopen RStudio, your environment settings can be stored in memory. For this reason, you will be asked if you want to save your workspace image. However, it is better to start each session with a clean global environment, which is why it is recommended you run `rm(list=ls())` each time before you close, and then run the `1_set_up_envrnmnt.R` setup script each time you open RStudio.

Q10 Why might it be useful to work in projects and set the working environment in RStudio?

Exercise 2.2: Working with the RGB Orthomosaic

You will use the orthomosaics you generated in Part 1 to compute vegetation indices. First, you need to convert the orthomosaics to the same resolution and projection. Orthomosaics developed using Agisoft Metashape often have different spatial resolutions, extents, or missing pixels due to band misregistration and data processing complications. The best way to overcome these issues is to set all of the images to the same resolution, projection, and extent before computing indices. You will first work with the RGB orthomosaic before moving on to multiple single-band orthomosaics in the next exercise. You should have five scripts open in RStudio. You have also already set up the working environment. However, it is always good to start fresh to make sure everything is working properly.

1. Clean the working environment by typing in the command below. To execute, highlight the command and click **Run**, or put the cursor at the beginning of the line and click **Ctrl + Enter**.

```
rm(list=ls())
```

2. Close RStudio, and open it again. You will see that the **Global Environment** (upper right window in RStudio) is clear. You will already be in the `Multispectral_Image_Processing` project, and because you are working in a project, you will have files open in the exact order you left them.

3. If upon opening RStudio, you are not in the `Multispectral_Image_Processing` project, go to **File > Open Project**, locate the `Multispectral_Image_Processing` folder, and open the `Multispectral_Image_Processing.Rproj` file. Then, open the R.files with the numbers: 00_, 0_, 1_, 2_ and 3_.

4. Run the script `1_set_up_working_envntmt.R` to set up the working environment. In preparation for the next step, click on the script `2_working_with_RGB_orthoimagery.R` in RStudio.

Exercise 2.2.1: Convert the RGB Orthomosaic to the Desired Resolution and Projection

1. Read the RGB multiband orthomosaic into R from the folder where it is stored using the following command:

```
RGB_raw <- stack(paste0(path_RGB_raw, "Hohensolms_RGB.tif"))
```

2. Define the CRS/EPSG code of the desired projection.

```
Hohensolms_proj <- "+proj=utm +zone=32 +datum=WGS84 +units=m +no_defs"
```

3. Project the raster to the desired projection and a spatial resolution of 0.03 meters (3 cm) and save it to a variable. The function `res` defines the spatial resolution, therefore if you need to change resolution (as you will later on), you can replace 0.03 with a different number.

```
RGB_corr  <-  projectRaster(RGB_raw,  crs=Hohensolms_proj,
method = 'bilinear', res = 0.03)
```

4. Execute the code by highlighting the three steps and clicking **Run**.

*Note: Selecting codes and clicking Run is easy, but it is recommended that you type these codes in a new R script file (**File > New File > R script**). Typing these codes will also help you learn to code effectively. When you execute the code, you will see a red stop sign in the upper right corner of the **Console**. This sign indicates R is working, and the code is running. Once the calculations are complete, the red stop sign will disappear.*

5. To write the result to a file, select the following code or type it into the R script, and click Run.

```
writeRaster(RGB_corr, paste0(path_RGB_corr,
            "Hohensolms_RGB_res_prj.tif"),
            format="GTiff", overwrite=TRUE)
```

6. Check your results. Read the raster file you just exported and check if it still has three bands. Plot the file and check the resolution.

```
test <- stack(paste0(path_RGB_corr,
                     "Hohensolms_RGB_res_prj.tif"))
test
plot(test)
res(test)
```

Note: you can also visualize the results and inspect the properties of the raster in a software program like ArcGIS or QGIS by loading the RGB_corr *file from the* Multispectral_Image_ Processing *folder directly into that program.*

Q11 Rerun the analysis with a coarser spatial resolution (a larger pixel size, like 0.1 m) and compare the results. How does spatial resolution contribute to the data size of the files? What differences can you see in terms of the visual appearance of the images?

For the next exercise, make sure that all of the raster files created in Exercise 2.2.1 have the same resolution.

Exercise 2.2.2: Crop the RGB Orthomosaic to the Desired Extent

In this exercise, you will crop the RGB orthomosaics to a specific region of interest (ROI) and exclude areas with no pixels.

1. Create a mask for the ROI.

```
mask_Hohensolms<- as(extent
            (465996.9899999051121995,  466134.1799999050563201,
            5612216.0399723947048187, 5612299.3499723942950368),
            "SpatialPolygons")
```

2. Assign the projection of the RGB orthomosaic to the mask you just created:

```
proj4string(mask_Hohensolms) <- Hohensolms_proj
```

3. Crop the projected and resampled RGB raster you created in Step 3 of Exercise 2.2.1 using the mask.

```
Hohensolms_RGB_cropped <- crop(RGB_corr, mask_Hohensolms)
```

4. Export the cropped image to the folder RGB_crp.

```
writeRaster(Hohensolms_RGB_cropped, paste0(path_RGB_crp,
            "Hohensolms_RGB_res_prj_cr.tif"),
            format="GTiff", overwrite=TRUE)
```

5. Check your results. Read the raster file you just cropped back into R to ensure it still has three bands. Use the command below to plot the image, check its extent, and verify that it still has the same resolution. To make it easier for the next exercise, you will call the imported file RGB_Hohensolms. You can also complete this step in ArcGIS or QGIS.

```
RGB_Hohensolms <- stack(paste0(path_RGB_crp,
                          "Hohensolms_RGB_res_prj_cr.tif"))
RGB_Hohensolms
plot(RGB_Hohensolms)
extent(RGB_Hohensolms)
res(RGB_Hohensolms)
```

Exercise 2.2.3: Calculate Spectral Indices Using the RGB Orthomosaic

You will use the uavRst package to calculate several indices using the RGB orthomosaic.

1. First, separate the bands of the reprojected, resampled, and cropped RGB orthomosaic. *Note: you can access the different bands with double square brackets – [[]].*

```
red <- RGB_Hohensolms[[1]]
green <- RGB_Hohensolms[[2]]
blue <- RGB_Hohensolms[[3]]
```

2. Next, you will calculate three indices from RGB imagery using a single piece of code from the uavRst package. The three indices are the Visible Vegetation Index (VVI), the Redness Index (RI), and the Brightness Index (BI), which were introduced above.

```
indices_RGB <- uavRst::rgb_indices(red,
                          green,
                          blue,
                          rgbi = c("VVI", "RI",
                          "BI"))
```

3. Print the properties of the raster stack you just created and set the resolution, extent, crs (projection), and names.

```
indices_RGB
```

4. Export the calculated indices in separate geoTiffs into the folder indices_RGB.

```
writeRaster(indices_RGB, paste0(path_indices_RGB,
                          filename = names(indices_RGB),
                          "_RGB.tif"),
                          format="GTiff", bylayer=TRUE,
                          overwrite=TRUE)
```

5. Inspect your results in QGIS (or ArcGIS if you prefer). In QGIS, add a layer group for the RGB-derived indices by clicking on the subgroup symbol in the Layer tab in the bottom left tab. Add the RGB-derived indices to the RGB layer group (**Layer > Add Layer > Add Raster Layer**). Choose **File** as Source Type and navigate to the indices_RGB folder. Highlight all of the files, click open, and click **Add**. Alternatively, you can add your results to QGIS by navigating to the folder, highlighting all the files and pulling them all into the layer group. You can leave the indices grayscale or change them all to the same color ramp for a better comparison.

Q12 What objects or features do each of the three indices you computed (VVI, RI, and BI) enhance? Refer back to the introduction for an explanation of these if needed. Are there similarities or differences between the three indices in terms of which features are enhanced?

Q13 Why do you think these three indices were selected to highlight the features in these images? Refer back to the descriptions of the indices above to help frame your answer.

EXERCISE 2.3: WORKING WITH THE MULTISPECTRAL ORTHOMOSAICS

In this exercise, you will follow the same steps as you did with the RGB orthomosaics, but you will work with multiple orthomosaics at the same time. You will also address the issue of band-misregistration as explained above. You will set all of the orthomosaics to the same resolution, projection (Exercise 2.3.1), and extent (Exercise 2.3.2). You will then reset the origin of the spectral bands (Exercise 2.3.3), and then compute the indices (Exercise 2.3.4).

Your working environment is already up and running. If you experience that your computer is slow, run rm(list=ls()) (line 4 in the script 1_set_up_working_envntmt.R), to clear the Global Environment and also restart R (**Session > Restart R**). Then run the rest of the script 1_set_up_working_envntmt.R to set up the folder structure again.

Change to the script 3_working_with_spectral_orthoimagery.R in RStudio.

Exercise 2.3.1: Change the Multispectral Orthomosaics to the Desired Resolution and Projection

1. Put all spectral raster files that end in .tif from the folder Spect_raw in a list.

```
tiff_list = list.files(path_Spect_raw, full.names = TRUE,
                       pattern = glob2rx("*.tif"))
```

2. Define the CRS/EPSG code for the desired projection.

```
Hohensolms_proj <- "+proj=utm +zone=32 +datum=WGS84 +units=m
+no_defs"
```

3. Use a for-loop to iterate through each orthomosaic to set the output format, projection, projection method, and the desired resolution, and save the result in the folder Spect_corr.

```
for (i in 1:length(tiff_list)) {
```

```
        r <- raster(tiff_list[i])
        prj <- projectRaster(r, crs=Hohensolms_proj,
                        method = 'bilinear', res = 0.03,
                        filename = paste0(path_Spect_corr,
                        names(r), "_res_prj.tif"),
                        format="GTiff", overwrite=TRUE)
}
```

4. Check your results. Read one of the spectral orthomosaics you just reprojected and resampled to 3 centimeters (0.03 m). Plot it and check its resolution.

```
test2 <- stack(paste0(path_Spect_corr,
                "Hohensolms_REG_res_prj.tif"))
test2
plot(test2)
res(test2)
```

Exercise 2.3.2: Crop the Multispectral Orthomosaics to the Desired Extent

1. Put all spectral raster files that end in .tif from the folder Spect_corr in a list.

```
tiff_list = list.files(path_Spect_corr, full.names = TRUE,
                pattern = glob2rx("*.tif"))
```

2. Create a mask for the ROI (as you did for the RGB orthomosaic).

```
mask_Hohensolms<- as(extent
            (465996.9899999051121995, 466134.1799999050563201,
            5612216.0399723947048187, 5612299.3499723942950368),
            "SpatialPolygons")
```

3. Assign the same projection as the multispectral orthomosaics to the mask you just created:

```
proj4string(mask_Hohensolms) <- Hohensolms_proj
```

4. Use a for-loop to iterate through each orthomosaic to crop it to the size of the mask you defined before, and export the result in the folder Spect_crp.

```
for (i in 1:length(tiff_prj_list)){
    r <- raster(tiff_prj_list[i])
    cr <- crop(r, mask_Hohensolms,
            filename = paste0(path_Spect_crp, names(r),
            "_cr.tif"), format="GTiff", overwrite=TRUE)}
```

5. Check your results:

```
GREEN <- stack(paste0(path_Spect_crp,
                "Hohensolms_GRE_res_prj_cr.tif"))
GREEN
plot(GREEN)
extent(GREEN)
res(test2)
```

Exercise 2.3.3: Reset the Origin of the Multispectral Orthomosaics

Due to the different conditions under which the images were captured, the multispectral orthomosaics can each have different positions in space. You already preprojected, resampled and cropped each orthomosaic. The final step is to reset the origin of each , which is the point closest to (0, 0). Resetting the origin will force the cells from the different orthomosaics to overlap, allowing you to calculate indices.

1. Read the rest of the orthomosaics you just preprojected, resampled and cropped in the previous exercises.

```
NIR <- stack(paste0(path_Spect_crp,
                "Hohensolms_NIR_res_prj_cr.tif"))
REG <- stack(paste0(path_Spect_crp,
                "Hohensolms_REG_res_prj_cr.tif"))
GREEN <- stack(paste0(path_Spect_crp,
                "Hohensolms_GRE_res_prj_cr.tif"))
RED <- stack(paste0(path_Spect_crp,
                "Hohensolms_RED_res_prj_cr.tif"))
```

2. Check and reset the origin of the bands.

 a. Reset the origin of the GREEN band.

```
origin(GREEN)
#0.014068181 0.005929392
origin(GREEN) = c(0, 0)
origin(GREEN)
#0 0
```

 b. Reset the origin of the REG (red-edge) band.

```
origin(REG)
#-0.001655439  0.011503051
origin(REG) = c(0, 0)
origin(REG)
#0 0
```

 c. Reset the origin of the NIR band.

```
origin(NIR)
#0.007322282 -0.004446576
origin(NIR) = c(0, 0)
```

```
origin(NIR)
#0  0
```

d. Reset the origin of the RED band.

```
origin(NIR)
#0.004874268  0.014978494origin
(NIR) = c(0, 0)
origin(NIR)
#0  0
```

3. Check to ensure that the extent and the resolution of the raster files is the same.

Q14 When working with the RGB orthomosaic, you did not need to reset the origin of the spectral bands. Why was this step not necessary with the RGB orthomosaic but was needed with the multispectral orthomosaics?

Exercise 2.3.4: Calculate Indices from the Multispectral Orthomosaics

After the preprocessing steps are complete, you will calculate spectral indices starting with NDVI. You will also calculate the Renormalized Difference Vegetation Index (RDVI), the Green Normalized Difference Vegetation Index (GNDVI), the Normalized Difference Red Edge/Red (NDVI-REG), and the Normalized Difference NIR/REG Index (NDRE).

1. Calculate NDVI and save it to the folder `indices_spect`.

```
NDVI <- (NIR-RED)/(NIR+RED)
writeRaster(NDVI, paste0(path_indices_spect, "NDVI_spect.
tif"),
                    format= "GTiff", overwrite = TRUE)
```

2. Calculate and save additional indices:
 a. Calculate the Renormalized Difference Vegetation Index (RDVI) and save it to the `indices_spect` folder.

   ```
   RDVI <- (NIR - RED)/sqrt(NIR + RED)
   writeRaster(RDVI, paste0(path_indices_spect, "RDVI_spect.
   tif"),
                       format= "GTiff", overwrite = TRUE)
   ```

 b. Calculate the Green Normalized Difference Vegetation Index (GNDVI) and save it to the `indices_spect` folder.

   ```
   GNDVI <- (NIR-GREEN)/(NIR+GREEN)
   writeRaster(GNDVI, paste0(path_indices_spect, "GNDVI_
   spect.tif"),
                       format= "GTiff", overwrite = TRUE)
   ```

 c. Calculate the Normalized Difference Red Edge/Red Index (NDVI-REG) and save it to the `indices_spect` folder.

   ```
   NDVI_REG <- (REG-RED)/(REG+RED)
   writeRaster(NDVI_REG, paste0(path_indices_spect,
   ```

```
                                    "NDVI_REG_spect.tif"), format=
                                    "GTiff",
                                    overwrite = TRUE)
```

 d. Calculate the Normalized Difference NIR/REG Index (NDRE) and save it to the `indices_spect` folder.

```
NDRE <- (NIR-REG)/(NIR+REG)
writeRaster(NDRE, paste0(path_indices_spect, "NDRE_spect.
tif"),
                    format= "GTiff", overwrite = TRUE)
```

 e. Calculate the Green Chlorophyll Index (GCI) and save it to the `indices_spect` folder.

```
GCI <- (NIR/GREEN)-1
writeRaster(GCI, paste0(path_indices_spect, "GCI_spect.
tif"),
                    format= "GTiff", overwrite = TRUE)
```

 f. Calculate the Modified Simple Ratio (MSR) and save it to the `indices_spect` folder.

```
MSR <- ((NIR/RED)-1)/((sqrt(NIR/RED))+1)
writeRaster(MSR, paste0(path_indices_spect, "MSR_spect.
tif"),
                    format= "GTiff", overwrite = TRUE)
```

Open the previously created QGIS/ArcGIS project containing the RGB indices to visualize the results.

3. Add the spectral indices you computed for the multispectral orthomosaics to the spectral layer group **Layer > Add Layer > Add Raster Layer**. Choose **File** as **Source type** and navigate to the `indices_spect` folder. Highlight all, click **Open** and then click **Add**. Alternatively, you can navigate to the `indices_spect` folder, highlight all of the rasters, and drag and drop all in the layer group. Finally, you can investigate the indices in grayscale for a better comparison or set the same color ramp for all of them to be able to compare them.

Q15 Which index is most useful for identifying and locating the archaeological objects of interest in this chapter? Why do you think this index performed the best for this task? What components of the index (i.e., bands) may be contributing to its success and why?

Q16 Explain the differences you notice between the spectral indices that were developed to overcome some of the shortcomings of NDVI (i.e., GNDVI, RDVI, NDRE, GCI, MSR)? Do any of these indices highlight the archaeological objects better than NDVI? If so, what might that tell you about the vegetation or soil conditions at the location of the burial mounds?

DISCUSSION AND SYNTHESIS QUESTIONS

S1 What are the reasons why an analyst might choose to build a workflow based on a sparse cloud rather than a dense point cloud?

S2 The drone images utilized in this chapter were captured with 70% side and front overlap. Do you think a higher overlap would increase or decrease the quality of the developed orthomosaics and indices? Explain your answer.

S3 How does the flying altitude of the drone influence the volume of data needed to perform the workflow in this chapter?

S4 Apart from the sparse point cloud, what are other ways to generate an orthomosaic? What are the steps? What are the main differences compared to the process presented in this chapter?

S5 Having calculated orthomosaics from different sensors, compare the process to derive them. What were the biggest differences in how you processed the orthomosaics? You may wish to consult the reports you generated to help answer this question.

S6 Why is it necessary for the orthomosaics to all be of the same extent and resolution?

S7 Which bands enhance the vegetation the most effectively? Refer back to the orthomosaics in your QGIS/ArcGIS project.

S8 Compare the RGB and the spectral indices and discuss which are more effective to enhance archaeological objects? Which type of indices are more appropriate?

ACKNOWLEDGMENTS

We thank Prof. Dr. Teichner for his suggestion to study the area of Hohensolms. Seminar participants helped to capture drone imagery (Schneider et al. 2018). Christoph Reudenbach developed and created the `uavRst` and `link2GI` packages at the Environmental Informatics & GIS Laboratory at the Department of Geography, Philipps-Universität Marburg.

REFERENCES

Agisoft, L. (2018). Agisoft metashape user manual, Professional edition, Version 1.5. *Agisoft LLC*, St. Petersburg, Russia, from https://www.agisoft.com/pdf/metashape-pro_1_5_en.pdf, accessed June, 2, 2019.

Assmann, J.J., Kerby, J.T., Cunliffe, A.M., & Myers-Smith, I.H. (2018). Vegetation monitoring using multispectral sensors—Best practices and lessons learned from high latitudes. *Journal of Unmanned Vehicle Systems*, 7, 54–75.

Barnes, E., Clarke, T., Richards, S., Colaizzi, P., Haberland, J., Kostrzewski, M., Waller, P., Choi, C., Riley, E., & Thompson, T. (2000). Coincident detection of crop water stress, nitrogen status and canopy density using ground based multispectral data. In, *Proceedings of the Fifth International Conference on Precision Agriculture*, Bloomington, MN, USA.

Gitelson, A.A., & Merzlyak, M.N. (1998). Remote sensing of chlorophyll concentration in higher plant leaves. *Advances in Space Research*, 22, 689–692.

Jhan, J., Rau, J.-Y., Haala, N., & Cramer, M. (2017). Investigation of parallax issues for multi-lens multispectral camera band co-registration. *The International Archives of Photogrammetry, Remote Sensing and Spatial Information Sciences*, 42, 157.

Luo, L., Wang, X., Guo, H., Lasaponara, R., Zong, X., Masini, N., Wang, G., Shi, P., Khatteli, H., & Chen, F. (2019). Airborne and spaceborne remote sensing for archaeological and cultural heritage applications: A review of the century (1907–2017). *Remote Sensing of Environment*, 232, 111280.

Mathieu, R., Pouget, M., Cervelle, B., & Escadafal, R. (1998). Relationships between satellite-based radiometric indices simulated using laboratory reflectance data and typic soil color of an arid environment. *Remote Sensing of Environment*, 66, 17–28.

Roujean, J.-L., & Breon, F.-M. (1995). Estimating PAR absorbed by vegetation from bidirectional reflectance measurements. *Remote Sensing of Environment*, 51, 375–384.

Verhoeven, G., & Sevara, C. (2016). Trying to break new ground in aerial archaeology. *Remote Sensing*, 8, 918.

Wang, C., & Myint, S.W. (2015). A simplified empirical line method of radiometric calibration for small unmanned aircraft systems-based remote sensing. *IEEE Journal of Selected Topics in Applied Earth Observations and Remote Sensing*, 8, 1876–1885.

18 Detecting Scales of Drone-Based Atmospheric Measurements Using Semivariograms

Amy E. Frazier and Benjamin L. Hemingway

CONTENTS

LEARNING OBJECTIVES

After completing this chapter, you will be able to:

1. Understand the semivariogram and explain how it can be used to detect spatial scales of a geographic phenomenon
2. Apply semivariograms to one-dimensional, vertical profiles of atmospheric measurements captured by a drone
3. Analyze the components of the semivariogram to determine sampling scales
4. Evaluate the change in measurement scale that occurs throughout the morning atmospheric boundary layer transition

HARDWARE AND SOFTWARE REQUIREMENTS

This exercise requires R and RStudio with the gstat library installed

INTRODUCTION

The lowest portion of the Earth's atmosphere, known as the **atmospheric boundary layer (ABL)**, plays a key role in the formation of weather events (Stull 1988). The structure of the ABL – such as how temperature changes with altitude – dictates atmospheric dynamics and controls how weather develops near the surface of the earth. Simple meteorological measurements including temperature and relative humidity can provide the data needed to better understand this energy exchange, but conventional technologies used in the past to collect these data, such as weather balloons, weather towers, weather radar, and satellites, have not been able to capture data at the high spatial and temporal scales needed to monitor weather formation and events. Drone-based technologies are being developed to fill in these data sampling gaps and provide high-quality atmospheric measurements for enhanced meteorological studies (Jacob et al. 2018).

TRADITIONAL ATMOSPHERIC MEASUREMENT TECHNOLOGIES

Common meteorological sensing technologies used to gather data to inform weather forecasting include mesonets, weather radar, weather balloons, and satellites. **Mesonets** are networks of ground weather stations that have been constructed in many regions to observe mesoscale meteorological phenomena – events that occur at scales between 10 and 1000 km such as thunderstorms (Figure 18.1). These networks comprise weather towers that are typically about 10 m high and are equipped with a variety of atmospheric and meteorological sensors to capture measurements of pressure, temperature, humidity, wind velocity, and other environmental data (McPherson et al. 2007). The towers are usually spaced anywhere from 2 km to 40 km apart on the landscape, which allows measurements to be interpolated. Unfortunately, these towers can only sense up to a

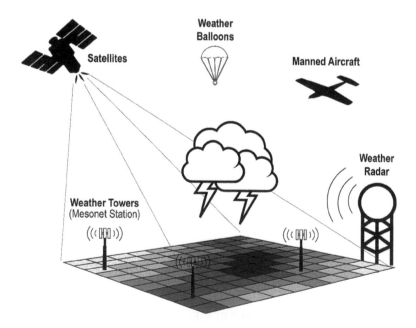

FIGURE 18.1 Illustration showing several common sensing technologies for monitoring weather including weather towers that are part of mesonets, weather radar, weather balloons, manned aircraft, and satellites.

limited height in the atmosphere (~10 m) and therefore are not able to collect data across the entire vertical extent of the ABL (Hemingway et al. 2017).

To overcome the vertical limitations of mesonet towers, sensors measuring meteorological variables are sometimes attached to **weather balloons**, which are released from the ground to gather data as they travel up through the atmosphere. A coordinated launch of weather balloons occurs twice daily, every single day of the year, from almost 900 locations around the world. However, because the path the balloon travels through the atmosphere cannot be controlled, these coordinated launches are not sufficient to capture data at the spatial and temporal scales needed to forecast local weather development. Additionally, the **radiosondes** – the sensor devices attached to the balloon to capture data – are difficult to recover and are designed to be expendable.

Another technology used for weather forecasting and storm tracking is weather surveillance **radar** (Doviak and Zrnic 2014). Weather radars send out pulses of microwave radiation and measure the signal that is scattered back to the tower by water droplets or ice particles. Weather radars are very useful for sensing precipitation, but they cannot measure thermodynamic variables such as temperature and humidity. They also have difficulty monitoring the ABL due to the Earth's curvature and obstructions like buildings or terrain (LaDue et al. 2010).

Manned aircraft can access areas of the atmosphere not easily sampled by weather radars and mesonet towers, but it is not always safe to deploy manned aircraft during severe weather events. Satellites are also used for weather monitoring and forecasting. A well-known satellite is the Geospatial Operational Environmental Satellite (GOES), operated by the U.S. National Oceanic and Atmospheric Association, which supports meteorology research, weather forecasting, and severe storm tracking such as during hurricanes. The limitation of satellite systems is that they usually collect data at coarse spatial resolutions (1 km), which is not sufficient to observe small scale weather phenomena (defined as being less than 1 km). In short, there are many technologies available for capturing measurements in the ABL, but most have key limitations that prevent them from providing high-quality atmospheric measurements over extended spatial and temporal domains needed for local forecasting.

Using Drones to Collect Atmospheric Measurements

Scientists have been exploring the potential for using drones to capture key atmospheric measurements. Because drones are highly maneuverable, especially at low altitudes, they are able to fill some of the spatial and temporal sampling gaps left by other weather monitoring technologies. For instance, small UAS are flexible enough to be flown in areas that are inaccessible to manned aircraft, such as near the ground or in the vicinity of severe weather like hurricanes. They can also be deployed rapidly in situations where weather patterns change quickly, such as during tornado outbreaks. Unlike weather balloons, the flight path of a drone can be controlled, and the sensors can be recovered, saving both time and money.

With the potential to use drones for weather monitoring, scientists need tools to turn these new data streams into usable information for weather forecasting. In particular, being able to monitor the structure of the atmosphere – how temperature changes with altitude – is key for understanding weather development. Most natural phenomena display **spatial autocorrelation**, that is, samples collected close to each other in space are more likely to be similar than samples captured at further distances from each other. Knowing the scales over which variables like temperature are correlated in the atmosphere can provide critical insights into how the ABL is structured. Semivariograms are one tool used by scientists to measure the size of these structures and make decisions about how to efficiently sample the atmosphere with drones. The following section introduces the concept of spatial dependence and the semivariogram and demonstrates how the semivariogram can be used to identify the spatial scales of structures in the atmosphere.

SPATIAL STATISTICS AND GEOSTATISTICS

Traditional statistics are based on the assumption that observations are independent (Getis 1999). However, most natural phenomena exhibit spatial autocorrelation, where nearby units are in some way associated with each other (Tobler 1979). In contrast, the fields of spatial statistics and geostatistics assume that observations collected in space are not independent but instead exhibit spatial autocorrelation. Geographers use spatial statistics to help find meaning in spatial data.

SPATIAL DEPENDENCE AND THE SEMIVARIOGRAM

In spatial statistics and geostatistics, the term **regionalized variable** is used to describe variables that are distributed in space. An important property of regionalized variables in the context of spatial statistics is spatial dependence. **Spatial dependence** in a variable means that the value measured at one location depends, in some way, on the value measured for that same variable at a different location. Spatial dependence allows information about one location to be inferred from information gathered at another location. A simple example related to this exercise is global temperatures. Temperatures near the equator are generally warmer than those near the poles, and at any given time, two locations near the equator are more likely to have similar temperatures than a location at the equator and one near the North Pole.

Sometimes spatial dependence is beneficial. For example, if you want to predict temperature at an unmeasured location, and you have temperature gauges positioned at several locations near the location you need to predict, you can use spatial dependence to your advantage to interpolate the temperature at the unknown location from the known locations. However, spatial dependence can also be disadvantageous because it means that samples may not satisfy standard statistical assumptions of independent observations (even if the samples were collected randomly).

The semivariogram is a tool used in spatial statistics and geostatistics to evaluate the scales of spatial dependence in a measured variable. The semivariogram can be used to identify the spatial scales of structures in the atmosphere or select sampling distances that are likely to minimize spatial dependence. The semivariogram is a graph that shows how semivariance changes as the distance between observations increases. The semivariogram is created by plotting the variance between sets of sample pairs that are separated by the same (or similar) distances, or **spatial lag**, where variance is the square of the standard deviation. Semivariance is simply half the variance and is calculated as:

$$\gamma(h) = \frac{1}{2N} \left\{ \sum_{i=1}^{n(h)} \left[z(i) - z(i+h) \right]^2 \right\} \qquad (18.1)$$

where γ is the semivariance for all samples separated by distance, h, N is the number of sample pairs, and z is the attribute value at location i.

Multiple pairs of points separated by similar separation distances (e.g., 5–10 m) are often binned together, and a single semivariance value representing the set of point pairs is plotted on the chart. This process is repeated until all sample pairs are represented on the graph. The graph of the plotted points is known as the **sample variogram** because it represents the raw semivariance values from the samples.

A **model variogram** can be fit to the graphed points using least-squares regression (Pardo-Igúzquiza 1999) in order to allow for more robust mathematical interpretations of the patterns. There are many different types of models that can be fit to the sample variogram (e.g.,

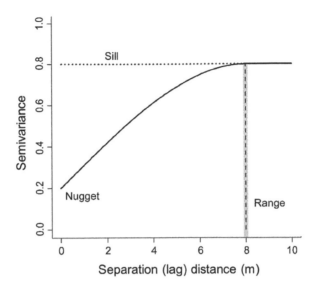

FIGURE 18.2 Diagram of an idealized model semivariogram showing the range, sill, and nugget

exponential, Gaussian, spherical, etc.). The specifics of each of these models is beyond the scope of this chapter, but interested readers are referred to Webster and Oliver (2007) for additional reading on this topic. Figure 18.2 shows a typical model variogram.

There are three key properties of a semivariogram: the sill, the range, and the nugget (Figure 18.2). The **range** represents the spatial lag (distance between samples) at which variance plateaus in the semivariogram. The range is important because it signals the separation distance between samples where point values are no longer spatially autocorrelated. At separation distances less than the range, the sample values have spatial dependence. At separation distances greater than the range, the samples do not have spatial dependence and are therefore valid for conventional statistics. The **sill** represents the semivariance value on the y-axis at the point where the range occurs.

In some situations, the variogram model may not pass through the origin but instead intersects the y-axis as a value greater than zero. Conceptually, this means that even at very small sample separation distances, there is still considerable variation between samples. This phenomenon is termed the **nugget effect** and stems from one of the earliest uses of variograms for gold mining where a sample containing a gold nugget can be found very close to a sample without any gold at all. The two samples were located near each other in geographic space but had considerable variation in the amount of gold they contained.

EXERCISES

In the following exercises, you will use variography and the semivariogram to determine the spatial structure of temperature measurements collected from a drone in the atmospheric boundary layer. The data you will use in this exercise were captured during two flights, one that occurred in the early morning and a second that occurred in the late morning. As part of the exercise, you will compare the structure of the atmosphere during the different times of the day. Instructions for collecting your own data for this exercise are provided at the end of the chapter.

FIGURE 18.3 The San Luis Valley study area located in south central Colorado, USA.

The data used in this exercise were captured in the San Luis Valley in south central Colorado (Figure 18.3) during an atmospheric sampling campaign. The San Luis Valley is a high-altitude depositional basin with an average elevation of 2,336 m above sea level. The valley is surrounded by the Sangre de Cristo Mountains and Great Sand Dunes National Park and Preserve to the east, with the San Juan Mountains to the west. In between, the valley is primarily flat and supports agricultural activities. The sampling campaign was completed as part of the Lower Atmospheric Process Studies at Elevation – a Remotely-piloted Aircraft Team Experiment (LAPSE-RATE), which is described in detail in de Boer et al. (2020) and Barbieri et al. (2019).

Data for this exercise were collected using a DJI Matrice 600 (DJI Shenzhen, Guangdong, China) rotary wing aircraft. The Matrice 600 is a hexacopter with a 7 kg payload capacity that can accommodate larger meteorological instruments. The platform was outfitted with a Young Model 81000 (R. M. Young Company, Traverse City, MI) ultrasonic anemometer, which was affixed to the aircraft using custom mounts (Figure 18.4a). Observations were logged at 32 Hz onto a Stabilis flight control module (Donnell et al. 2018). If users are looking for a more affordable option for capture similar data, small, meteorological sensors like the iMet XQ2 can be affixed to an inexpensive drone platform using low technology measures (e.g., zip ties or duct tape) as shown in Figure 18.4b). The key factor when assembling this lower-cost option is to make sure the sensor is not affected by the rotor downwash. More details are provided in the section at the end of this chapter called "Collecting the data yourself."

DATA AND CODE

The files you will need for this exercise include an R File called `code.R` that includes the code you will need to compute the sample variogram and fit a model variogram. The data includes two text documents called `profile_am` and `profile_pm` that each have six columns of data:

- Speed – wind speed

- Temp – temperature measurement in degrees Celsius

- Time – time the measurement was captured in Coordinated Universal Time (UTC)

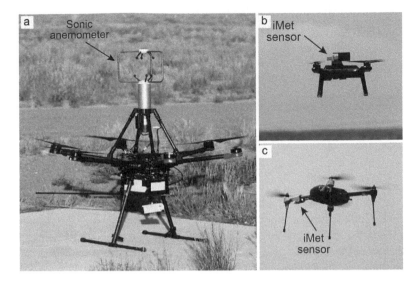

FIGURE 18.4 (a) DJI Matrice 600 platform with an RM Young 81000 sonic anemometer mounted on top. (b) 3DR Solo quadcopter with an iMet XQ2 sensor attached to the top in a 3D-printed mount (mount accommodates a fan to aspirate the sensor). (c) 3DR Iris platform with an iMet XQ2 sensor taped to the underside of the wing with the sensor pointing away from the rotor.

- Y – latitude where measurement was captured in decimal degrees

- X – longitude where measurement was captured in decimal degrees

- Z – height above ground where the measurement was captured in meters

EXERCISE 1: COMPUTING A SAMPLE VARIOGRAM AND FITTING A MODEL

1. Open RStudio. RStudio is a four-pane workspace for creating files containing R scripts, typing in R commands, viewing command histories, and viewing plots and more. The top left panel is the Code Editor.

2. Install the gstat package under **Tools > Install Packages**. The `gstat` package is a free software program for modeling geostatistical data that can be called from within R (Pebesma 2004).

3. Open the file `code.R` under **File > Open File** and navigating to the folder where you stored the data for this chapter.

The code is added to the **Code Editor** window of RStudio. The code is divided into seven sections that have been commented to facilitate interpretation of the different steps. To run a single line of code, you can place your cursor at the beginning of the line and click the **Run** icon. To run several lines of code, you can select them all and click **Code > Run Selected Line(s)**. To run the entire block of code, first click outside of the window to make sure the cursor is not on a single line, then click Run. The steps and questions below assume you are running the code one line at a time.

4. Load the gstat package by putting your cursor next to `library(gstat)` and clicking **Run**. This step ensures the package is loaded into the current project.

5. Next, set the working directory to wherever you downloaded and stored the data for this chapter. You can do this either through the `setwd()` code. *Note: R uses the forward slash.*

Or, you can click on **Session > Set Working Directory > Choose Directory**. If you choose to run the in-line code, be sure to change the text below to your working directory.

```
setwd("Path_to_your_working_directory_goes_here")
```

6. Read in the `profile_pm.txt` data table by putting the cursor next to this line of code and clicking **Run**. Be sure to replace the filepath with the path to where your data are stored (i.e., replace the ~/filepath in the code below with the path to your working directory).

```
data <- read.table("~/filepath/profile_pm.txt", header=TRUE)
```

7. An item called `data` is added to the **Global Environment** window, and a tab called data is added to the **Code Editor** window. Clicking the arrow next to `data` allows you to review the data. Clicking on the word `data` will load the table into the main RStudio window. You should see six fields: `speed`, `temp`, `time`, `X`, `Y`, `Z`. Clicking on the tab "data" will show you the entire table of data.

Q1 How many individual observations does this profile contain?

Q2 What are the minimum and maximum temperature measurements in the profile? What are the minimum and maximum wind speed measurements in the profile?

Q3 What is the maximum height above ground (z) at which measurements were captured? Note that measurements are in meters.

8. Click on the `code.R` tab and plot the temperature profile by placing your cursor at the start of the line of code below.

```
plot(data$temp, data$z, type="l")
```

This code plots temperature (`data$temp`) versus altitude (`data$z`). The type "l" in the code indicates it will be a line plot. The plot will appear in the plots and files window in the lower right of your RStudio interface. Examine the plot (a version has been included below in Figure 18.5) and answer the following questions.

Q4 In *general*, what is the relationship between temperature and height above ground (z) for the afternoon plot (`profile_pm`)? Include a copy of the plot with your answer. You can export the plot directly from RStudio.

9. Next, you will create a gstat object to hold all of the necessary information for computing the geostatistics. You can see from the next line of code that these pieces of information include the attribute (id), formula, locations, and data. Run this line of code to create the gstat object, g.

```
g <- gstat(id="temp", formula = temp~1, locations = ~x+y+z,
data = data)
```

10. After running this line of code, you will see g appear in the **Environment** window. If you click on g, you will see the entire set of data generated by the code for the object.

11. Next, you will compute the variogram for the `profile_pm` dataset. To create the variogram, you first need to set the **bin width**, which determines the range of separation

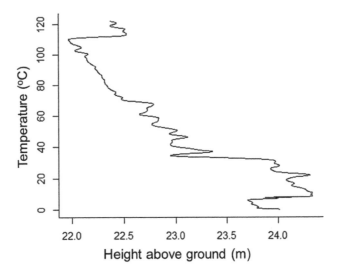

FIGURE 18.5 Example of the plot of temperature in degrees Celsius versus height above ground in meters.

distances that will be grouped together. Each **bin** will include all points separated by the distances within the bin width. You will also set the maximum separation distance (h in Equation 18.1) that will be considered. The settings provided in the code are for a bin width of 0.25 m and a maximum separation distance (cutoff) of 10 m. Run the line of the code to compute the variogram with these settings.

```
v <- variogram(g,width=1,cutoff=10)
```

12. Open the v table (you may need to click on v in the Environments window) and examine the results. Answer the questions below based on the information in the table.

Q5 How many data points (bins) were computed for the sample variogram (v)? How could you have determined this information without looking at the table?

Q6 The column np in the v table reports the number of points that were included in each bin. What is the maximum and minimum number of points in each bin? Sort the first column of table v in ascending order. Why do you think there are more points included in the first bins (e.g., 1–10), which represent shorter separation distances, compared to the latter bins (e.g., 30–40), which represent longer separation distances?

13. Next, plot v by running the next line of the code.

```
plot(v)
```

The plot will appear in the lower right window. The semivariance (gamma) computed within each bin is represented by a blue circle. Examine your plot, it should look similar to Figure 18.6.

Q7 Based on what you learned above about the range (and referring back to Figure 18.2 if needed), at what distance do you think the range is located based on the sample variogram? How did you come to this decision?

Q8 Based on the sample variogram, at what semivariance value do you think the sill and nugget are located?

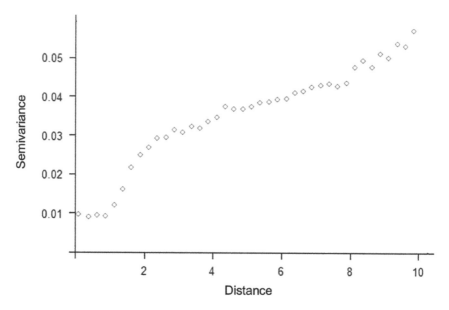

FIGURE 18.6 Plot of the semivariogram computed for the profile_pm datasets. The *x*-axis, distance, represents the separation distance between points. The *y*-axis, semivariance, is computed using Equation 18.1.

A model variogram can be fit to the sample variogram points to allow for more robust mathematical interpretations of the patterns and mathematically extract the range, sill, and nugget. The code for computing the model allows you to specify the partial sill (`psill`), the model type (`model`), the `range`, and the `nugget`. The partial sill is simply the sill minus the nugget (refer back to Figure 18.2 if you need a refresher on sill, nugget, and range). Based on the sample variogram you computed in the last step, you can estimate the values for `psill`, `range`, and `nugget`.

14. Run the last three lines of code in succession to fit a Gaussian model to the semivariogram and plot the model. A Gaussian model for a semivariogram approaches its sill asymptotically. Input a partial sill = 0.35, model = "Gau" (for Gaussian), range = 6, and nugget = 0.01. Your result should look similar to Figure 18.7.

```
model <- vgm(psill=0.35, model="Gau", range=6, nugget=0.01)

v.fit <- fit.variogram(v, model)

plot(v,v.fit)
```

Q9 In the Environment tab in the Global Environment settings, click the arrow next to `v.fit` to expand the results. Find `psill` in the list. The first number next to `psill` is the nugget, and the second is the `sill`. Now find `range` in the list. The number next to `range` is the range distance. Report these values. How are they different from the numbers for `nugget`, `sill`, and `range` that you entered into the code block?

Specifying values for psill, range, and nugget in the code gives R a starting point for fitting the model. R will iterate the code to get the best fit, which means slightly adjusting the values for the nugget, sill, and range.

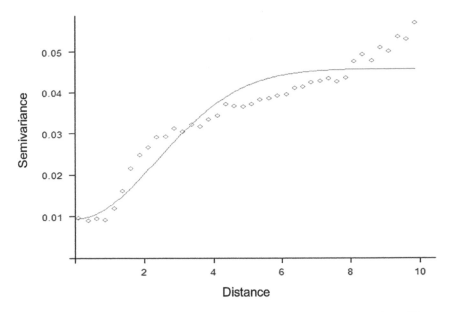

FIGURE 18.7 Model variogram (solid blue line) fit to the sample variogram (blue dots). The *x*-axis, distance, represents the separation distance between points. The *y*-axis, semivariance, is computed using Equation 18.1. A gaussian model was used to fit this model variogram.

Q10 Experiment with different values of psill, nugget, and range (within reason given your sample variogram). Do the values produced by the model (under v.fit in the Global Environment Settings) vary considerably?

The choice of model type will also influence your model variogram, particularly near the origin, where small changes in the shape of the curve can lead to big changes in prediction. Each model is designed to fit different types of phenomena more accurately. Aside from Gaussian models – the type you used to fit the model variogram – other common model types include Spherical, Exponential, and Matern models, among others.

15. Fit a model variogram using the same starting values for psill, range, and nugget as above, but this time use a Spherical (`"Sph"`) model instead of a Gaussian (`"Gau"`) model.

Q11 How did the model variogram change when you fit a spherical model? What are the values for psill, range, nugget under v.fit? Do you think the Spherical model fits the data better or worse than the Gaussian model? Explain your answer.

EXERCISE 2: ANALYZING SCALE CHANGES IN DIFFERENT ATMOSPHERIC SITUATIONS

The range value provides a good indication of the distance at which points are spatially independent, which is important when developing sampling schemes because you want your samples to be independent in order to run statistics. In this exercise, you will compare how the range distances can change based on different atmospheric conditions at different times of day. A shift in range distances means that sampling distances will also need to be adjusted during the day to ensure the data being captured are not spatially autocorrelated.

The ABL is diurnally dynamic, meaning that the stability and structure of the atmosphere changes throughout the day. During clear, calm nights, when the sun is not around to warm the surface of the Earth, the ground (and the air near the ground) cools. This cooling near Earth's surface triggers what is known as a **nocturnal inversion**, where warmer, less dense air sits on top of cooler, denser air. Turbulence is suppressed by the strong, thermal stratification. As the sun rises, the Earth's surface (and the air near the surface) begin to heat up. As the cooler air begins to warm, it starts mixing with the warmer air above. The stable conditions that were present over-night give way to a more turbulent atmosphere. This transition is referred to as the **morning boundary layer transition**.

Since the structure of the atmosphere changes throughout the day, different sampling frequencies may be warranted at different times during the day (or under different meteorological conditions). The flight profile you have been working with so far was captured during the early afternoon when conditions were more turbulent and less stable. In this exercise, you will examine a profile that was captured earlier in the morning when the atmosphere was more stable. You will compare how the range distance (i.e., the distance at which samples should be captured) changes with the atmospheric state.

By now, you should be familiar with the R code block for plotting data, creating a sample variogram, plotting the variogram, and fitting and plotting a model variogram. Refer back to the detailed steps from Exercise 1 if you get stuck.

1. Using the same RStudio code, load the `profile_am` data. This dataset is organized in exactly the same way as the `profile_pm` data table, with the same columns and headings.

Q12 What was the starting time of this flight (times listed in the table are Coordinated Universal Time [UTC], which is 6 hours ahead of local time at the study site)? Approximately how many hours before `profile_pm` was `profile_am` captured?

2. Plot the `profile_am` data.

Q13 Compare the plot for `profile_am` with the plot for `profile_pm` you created for Q4. What is the major difference in the relationship between temperature and height between these two plots? What do you think is the reason for this difference?

3. Plot the sample variogram for `profile_am`.

Q14 Describe the shape of the sample variogram for `profile_am`. How does the shape differ from the sample variogram for `profile_pm`?

Q15 Based on the sample variogram for `profile_am`, what would be appropriate starting values for the `psill`, `range`, and `nugget`? This should just be an eyeball guess for where you think these parameters are located. Do you think a Gaussian model or a Spherical model would be more appropriate to model the shape of this curve? Why?

The sample variogram for `profile_am` clearly does not follow the same structure as `profile_pm`. Whereas there was a clear nugget, range, and sill for `profile_pm`, these parameters are not as obvious for `profile_am`.

4. Fit a model variogram using the same parameters for the partial sill and range as above, but change the nugget to 0.00.

```
(psill=0.35, model="Gau", range=6, nugget=0.00)
```

Q16 What are the nugget, sill, and range values for the model variogram? How is the range different from `profile_pm`? Based on the difference in range values between the model variogram for the AM and PM profiles (be sure to only compare the ones created with a Gaussian model), how would you need to adjust your sampling scheme between the morning and afternoon?

Q17 Why do you think the range – or the distance between samples – needs to be shorter in the afternoon compared to the morning? What do you know about the stability of the boundary layer at different points during the day that might help you answer this question?

DISCUSSION AND SYNTHESIS QUESTIONS

In this exercise, you explored how the semivariogram can be used to identify the scales at which temperature measurements are autocorrelated in the atmospheric boundary layer. By applying semivariograms to vertical profiles of atmospheric measurements captured from a drone, you were able to analyze the various components of the sample variogram to create a model variogram from which to detect the appropriate scales of measurement. Lastly, you evaluated how spatial autocorrelation and measurements scales can change throughout the day as the boundary layer transitions from stable in the early morning to turbulent in the late morning and afternoon.

S1 Drones give researchers the ability to collect data at unprecedented spatial and temporal scales, and the sensors onboard are often able to capture measurements at very high frequencies. The data used in this exercise were captured at a rate of about 32 samples per second. What are some reasons why you might not want to collect data at such high frequencies? How can you determine the appropriate sampling frequency for capturing measurements via drone?

S2 What are some of the challenges of capturing measurements in the atmosphere that might not be present when collecting samples of, for instance, soil or vegetation? What additional factors might you need to consider when planning a drone mission to capture atmospheric data? What factors that need to be considered when capturing imagery with drones may not be relevant when capturing atmospheric data?

S3 What are some of the flight planning considerations that you might need to address for capturing atmospheric samples that differ from the flight planning process for capturing imagery?

COLLECTING THE DATA YOURSELF (OPTIONAL)

Platform and Sensor: To capture vertical profiles of atmospheric variables you will need a reliable VTOL UAS platform and a meteorological sensor. It is important to make sure the sensor is not placed in an area where measurements will be impacted by propeller wash. In the configuration in Figure 18.4a, the sensor is positioned well above the propellers. In the configuration in Figure 18.4c, the sensor is tucked under the arm and pointed away from the propeller to protect it from wash. As long as the sensor has reliable GPS, it does not need to be integrated with the platform. The flight paths for this exercise consisted of vertical profiles. The UAS should be flown at a constant velocity of no more than 1 m/s. Only measurements captured during the ascent of the flight should be used.

ACKNOWLEDGMENTS

Data for this exercise were collected as part of a U.S. National Science Foundation Grant IIA-1539070 "Unmanned Aircraft Systems for Atmospheric Physics" and 1842715 "Doctoral Dissertation Research: Spatial Structure of Turbulent Flows in the Atmospheric Boundary Layer." The exercise is based in part on computations provided in Hemingway et al. (2017)

REFERENCES

Barbieri, L., Kral, S.T., Bailey, S.C., Frazier, A.E., Jacob, J.D., Reuder, J., Brus, D., Chilson, P.B., Crick, C., & Detweiler, C. (2019). Intercomparison of small unmanned aircraft system (sUAS) measurements for atmospheric science during the LAPSE-RATE campaign. *Sensors*, 19, 2179.

de Boer, G., Diehl, C., Jacob, J., Houston, A., Smith, S.W., Chilson, P., Schmale III, Intrieri, D.G., Pinto, J., & Elston, J. (2020). Development of community, capabilities, and understanding through unmanned aircraft-based atmospheric research: The LAPSE-RATE campaign. *Bulletin of the American Meteorological Society*, 101, E684–E699.

Donnell, G.W., Feight, J.A., Lannan, N., & Jacob, J.D. (2018). *Wind characterization using onboard IMU of sUAS*. In, *2018 Atmospheric Flight Mechanics Conference*, Atlanta, Georgia, USA, 2986.

Doviak, R.J., & Zrnic, D.S. (2014). *Doppler Radar & Weather Observations*. Academic Press.

Getis, A. (1999). Spatial statistics. *Geographical Information Systems*, 1, 239–251.

Hemingway, B.L., Frazier, A.E., Elbing, B.R., & Jacob, J.D. (2017). Vertical Sampling Scales for Atmospheric Boundary Layer Measurements from Small Unmanned Aircraft Systems (sUAS). *Atmosphere*, 8, 176.

Jacob, J.D., Chilson, P.B., Houston, A.L., & Smith, S.W. (2018). Considerations for atmospheric measurements with small unmanned aircraft systems. *Atmosphere*, 9, 252.

LaDue, D.S., Heinselman, P.L., & Newman, J.F. (2010). Strengths and limitations of current radar systems for two stakeholder groups in the southern plains. *Bulletin of the American Meteorological Society*, 91, 899–910.

McPherson, R.A., Fiebrich, C.A., Crawford, K.C., Kilby, J.R., Grimsley, D.L., Martinez, J.E., Basara, J.B., Illston, B.G., Morris, D.A., & Kloesel, K.A. (2007). Statewide monitoring of the mesoscale environment: A technical update on the Oklahoma Mesonet. *Journal of Atmospheric and Oceanic Technology*, 24, 301–321.

Pardo-Igúzquiza, E. (1999). VARFIT: a fortran-77 program for fitting variogram models by weighted least squares. *Computers & Geosciences*, 25, 251–261.

Pebesma, E.J. (2004). Multivariable geostatistics in S: the gstat package. *Computers & Geosciences*, 30, 683–691.

Stull, R.B. (1988). *An Introduction to Boundary Layer Meteorology*. Dordrecht, The Netherlands: Kluwer Academic Publishers.

Tobler, W.R. (1979). Cellular geography. In *Philosophy in Geography* (Eds S. Gale and G. Olsson. Dordrecht, The Netherlands: Springer, (pp. 379–386).

Webster, R., & Oliver, M.A. (2007). *Geostatistics for environmental scientists*. West Sussex, England: John Wiley & Sons.

19 Assessing the Greenhouse Gas Carbon Dioxide in the Atmospheric Boundary Layer

Elinor Martin, Elizabeth Pillar-Little,
and Gustavo Britto Hupsel de Azevedo

CONTENTS

LEARNING OBJECTIVES

After completing this chapter, you should be able to:

1. Perform post-processing of atmospheric data collected with a sUAS
2. Explain how the meteorological state of the atmospheric boundary layer evolves over a day.
3. Understand how carbon dioxide concentrations vary with altitude in the atmospheric boundary layer and how that relates to the meteorology.
4. Predict how meteorological conditions affect carbon dioxide concentrations

HARDWARE AND SOFTWARE REQUIREMENTS

Processing for this exercise can be completed using any spreadsheet software such as Excel or programming language. The steps below are described using Visual Basic for Applications (VBA) for Excel language.

INTRODUCTION

Carbon is often referred to as the "central element" because of its critical role in creating and sustaining life. The planet's carbon cycle describes the movement of this vital resource between the hydrosphere, atmosphere, lithosphere, and biosphere. Organisms including trees, grasses, and plankton move carbon (in the form of carbon dioxide, or CO_2) from the atmosphere to the biosphere via photosynthesis. Overnight, the biosphere releases some of the CO_2 consumed during the day back into the atmosphere through respiration, while the rest is fixed into biomass.

When plants and animals die, their organic matter is incorporated into the lithosphere and compressed over time into rocks, such as shale, while some carbon is released back into the atmosphere during the decomposition process. Eventually, carbon is returned to the atmosphere from the lithosphere when carbonaceous rocks like shale, limestone, and dolomite are forced into the Earth's mantle and are subject to weathering and other processes. Sometimes, organic matter builds up in sediment or soil too quickly for it to completely decompose. This leads to the formation of organic rich mineral resources such as coal, peat, oil, and natural gas. Carbon trapped in these resources can be returned to the atmosphere through combustion.

One of the key components of the carbon cycle, carbon dioxide or CO_2, is of particular interest to climate and atmospheric scientists because it is a **greenhouse gas**. Greenhouse gases in the atmosphere, such as CO_2, methane, and water vapor can absorb energy emitted from the Earth and trap it in the atmosphere as heat. This phenomenon is called the greenhouse effect and has made Earth warm enough for habitation. However, as the carbon balance between the atmosphere, hydrosphere, and lithosphere has shifted due to human activity and emissions, increasing concentrations of CO_2 in the atmosphere have elevated global temperatures due to an amplified greenhouse effect. Existing carbon sinks (or removers of carbon, such as plants and the ocean) are able to absorb roughly half of the anthropogenically driven emissions; however, scientists do not have a good understanding of how the remaining carbon is partitioned between the Earth's reservoirs (e.g., atmosphere, ocean, biosphere, etc.) (Schimel 2007). Therefore, it is important to measure CO_2 concentration in the atmosphere to better understand changes in the carbon cycle over time.

The first regular measurements of CO_2 were started in 1958 at the Mauna Loa Observatory in Hawaii using flasks to capture gas samples (Keeling 1998; Keeling et al. 2001). Later, a tower system was erected at the same location, and this has become the reference standard for the international network of CO_2 towers. These tower networks have provided an excellent temporal CO_2 measurement record for specific locations. However, these points have poor spatial resolution and only extend up to a few hundred meters above the Earth's surface. The use of satellites to observe CO_2 has improved the availability of CO_2 in space (Hammerling et al. 2012). However, space-based measurements are temporally limited due to the type of satellite orbit. Studies have also shown that the total column CO_2 may not necessarily be representative of what is occurring in the troposphere – the lowest approximately 11 km of the atmosphere (Lan et al. 2017). Gas flasks have continued to be used to measure CO_2 concentrations, often deployed by manned aircraft where they are filled at various altitudes (Biraud et al. 2013). While this observational method has advantages, filling gas flasks is very resource intensive and still does not provide enough information in the lowest 1–2 km of the troposphere near the surface, which is also known as the **atmospheric boundary layer** (ABL).

The structure of the ABL is particularly dynamic due to daytime heating of the Earth by the sun. The ABL is deeper during the day and shallower during the night. After sunrise, solar radiation strikes the Earth's surface and causes the air nearest to the ground to warm first. This warmer air is unstable and begins to rise upward, generating vertical mixing and turbulence that moves heat, moisture, particulates, and gases away from the surface. In the ABL, the temperature decreases with height, and a decrease in temperature with height is measured by the **lapse rate**. The well-mixed turbulent zone increases in depth until it is prevented from increasing further by a stable layer that marks the top of the ABL during the day. The stable layer is marked by an increase in temperature with height – also known as an **inversion** and can "trap" pollutants and gases below it. As the sun sets, the turbulence decreases, leading to the development of stable conditions near the surface and a shallow boundary layer. We can observe this evolution of the boundary layer by capturing vertical **profiles** of meteorological measurements in the ABL with sUAS.

The ABL is also important for understanding how CO_2 concentrations are changing because this space serves as an interface between the land or water surface and the atmosphere. Most of the CO_2 emissions and sinks (e.g., vegetation) occur in the ABL. Consequently, there is a significant amount of heterogeneity in the spatial distribution of CO_2 in the lowest levels of the atmosphere (i.e., the ABL) depending on vegetation type, land use, and human emissions. Better understanding of this heterogeneity near the surface can help to differentiate global sources and sinks of CO_2 with additional detail, which is necessary to complete the carbon cycle budget and further understand and model the capabilities of the natural environment to remove CO_2 from the atmosphere (Armstrong et al. 2019; Saeki et al. 2013). Therefore, it is extremely important to characterize the daily, seasonal, and spatial variability of CO_2 in the ABL. However, there is currently a lack of ABL observations of both meteorological and chemical parameters due to the inability of conventional technologies (e.g., weather towers, manned aircraft, and satellites) to efficiently sample this dynamic region of the atmosphere. UAS have been proposed as a solution for ABL sampling because they can be operated in the lowest 1-2 kilometers of the atmosphere, are relatively inexpensive compared to other sampling methodologies, and can be deployed in a wide variety of conditions, terrains, and locations (Jacob et al. 2018).

The use of small UAS (sUAS) in atmospheric science has vastly expanded in the last decade as technologies have become more affordable, accurate, and available to sample a variety of atmospheric parameters, including temperature, relative humidity (RH), CO_2, and much more (Greene et al. 2019). The datasets used in this exercise were collected with a fixed-wing sUAS equipped with two CO_2 sensors and two RH and temperature sensors (Figure 19.1). Capturing duplicate datasets allows for quality control through comparisons between the different sensors and provides a backup in case a sensor malfunctions. The data for these exercises were collected at the Kessler Atmospheric and Ecological Field Station (KAEFS), a 360-acre environmental research and education facility located approximately 28 km southwest of the University of Oklahoma campus in Norman, Oklahoma, USA during May and June 2019 (Figure 19.2).

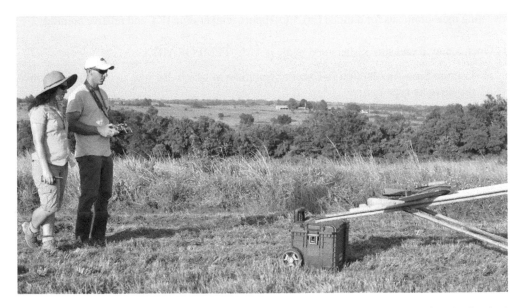

FIGURE 19.1 Authors Elizabeth Pillar-Little and Gustavo B. H. de Azevedo launching the fixed-wing sUAS to collect data at the Kessler Atmospheric and Ecological Field Station.

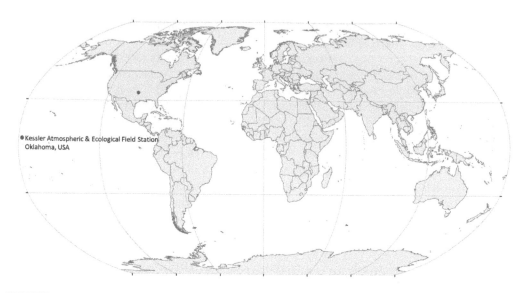

FIGURE 19.2 Data for the study were collected at the Kessler Atmospheric and Ecological Field Station (KAEFS), located approximately 28 km southwest of the University of Oklahoma campus in Norman, Oklahoma.

EXERCISE 1: POST-PROCESSING UAS ATMOSPHERIC DATA

In this exercise, you will take partially processed data from UAS flights and post-process the data into a combined CSV file. Processing can be completed using any programming language, but here the process will walk you through using the Visual Basic for Applications (VBA) for Excel language. Programs written in this language are often referred to as **macros**. The data files you will use in this exercise have been converted from the binary autopilot file (.bin) to .csv files with columns representing measurements for altitude (m), CO_2 (ppm), temperature (K), and relative humidity (%).

1. Open a new Excel spreadsheet and name it ALL_TEMPORARY.CSV.

 a. Use the **Save As** function in Excel to complete this step. Be sure to choose **CSV** under the **Save as type** option.

 b. You may receive a warning that "Some features in your workbook may be lost if you save it as a CSV," click Yes to keep using this format.

2. Open the CSV file `May30_1140_ALT.CSV` from the data folder. These data were collected during a flight on 30 May that began at 11:40 am local time. The first few lines of the spreadsheet are shown in Table 19.1.

3. Copy column A, labeled **timestamp**, from the file `May30_1140_ALT.CSV` and paste it into column A of the file `ALL_TEMPORARY.CSV`.

4. Copy column C, labeled **Alt**, from the file `May30_1140_ALT.CSV` and paste it into column B of the file `ALL_TEMPORARY.CSV`.

5. Open the file `May30_1140_CO2.CSV`, which includes carbon dioxide readings.

6. Copy column A, labeled **timestamp**, from the file `May30_1140_CO2.CSV` and paste it into column C of the file `ALL_TEMPORARY.CSV`.

7. Copy column C, labeled **co2Val0**, from the file `May30_1140_CO2.CSV` and paste it into column D of the file `ALL_TEMPORARY.CSV`.

TABLE 19.1

Example of the First Few Lines of the `May30_1140_ALT.CSV` **File**

Timestamp	TimeUS	Alt	Press	Temp	CRt	SMS	Offset	GndTemp
1559216486	579175565	−1.520271659	97487.28	37.05	0.514621615	579175	0	32.73276138
1559216487	579430768	−1.53710115	97487.48	37.05	−0.165470034	579430	0	32.73276138
1559216487	579530704	−1.61002934	97488.27	37.05	−0.696355641	579530	0	32.73276138
...

Note: Not all columns are needed for analysis. You will copy the necessary columns from several different spreadsheets and compile them into the CSV file you created.

8. Copy column E, labeled **co2Val1**, from the file `May30_1140_CO2.CSV` and paste it into column E of the file `ALL_TEMPORARY.CSV`.

9. Open the file `May30_1140_RH TEMP.CSV`, which includes relative humidity and temperature readings.

10. Copy column A, labeled **timestamp**, from the file `May30_1140_RH_TEMP.CSV` and paste it into column F of the file `ALL_TEMPORARY.CSV`.

11. Copy column E, labeled **Humi2**, from the file `May30_1140_1RH_TEMP.CSV` and paste it into column G of the file `ALL_TEMPORARY.CSV`.

12. Copy column F, labeled **Temp2**, from the file `May30_1140_RH_TEMP.CSV` and paste it into column H of the file `ALL_TEMPORARY.CSV`.

13. Copy column G, labeled **Humi3**, from the file `May30_1140_RH_TEMP.CSV` and paste it into column I of the file `ALL_TEMPORARY.CSV`.

14. Copy column H, labeled **Temp3**, from the file `May30_1140_RH_TEMP.CSV` and paste it into column J of the file `ALL_TEMPORARY.CSV`.

You should now have 10 columns in your `ALL_TEMPORARY.CSV` file. The timestamp of each measurement is recorded as the number of milliseconds (one thousandth of a second) since 1 January 1970 at UTC (Coordinated Universal Time). This **Unix Epoch** timestamp is common on many measurement acquisition and data-logging systems. Examining the timestamps in columns A, C, and F of `ALL_TEMPORARY.CSV`, you will see that altitude, CO_2, and temperature and relative humidity were often sampled at different times. However, the timestamps differ only by a millisecond. For this reason, it is necessary to post-process the data by averaging the measurements over each second. VBA code for a Microsoft Excel macro is provided to assist with converting the data in `ALL_TEMPORARY.CSV` to the desired, averaged format.

Note: the code was developed in Microsoft Excel version 16.0.11629.20238, 64-bit. As updates to Excel are released, this code may not function exactly as described here. A file called May30_1140_ALL_EXAMPLE.CSV is included in the data folder if you are unable to complete this processing step.

This macro uses a counter to determine the number of nonzero values per second, sums them, and divides by the number of values to get the one-second average. This post-processing step also effectively serves as a quality control by eliminating data gaps that may have been produced by a drop in communication between the sensor and autopilot system or other errors in data collection by the sensor.

15. To utilize the macro code, ensure that the **Developer** tab is displayed in the menu bar at the top of your CSV file. If it is not visible, go into **File > Options**, and click **Customize Ribbon** in the left-hand panel. On the right side, under **Main Tabs**, check the box next to **Developer** to make the developer tab visible. You should now see a tab called **Developer** in the menu bar at the top.

Note: Mac users, to get the **Developer** *tab to appear in your ribbon, select the* **customize quick access toolbar** *arrow (next to* **Save As** *button on the top bar of the window) go to* **More Commands** *and select* **Ribbon**. *Scroll down on the right side where it says* **Customize Ribbon***, and check* **Developer**.

16. Create a new sheet (Sheet2) in ALL_TEMPORARY.CSV where you will store the converted data. All of the data you copied over during Steps 1-14 should be in Sheet1.

17. Back in Sheet1, click on the **Developer** tab in the menu bar. In the Controls group, click **Insert**, and select Button (Form Controls) in the **Form Controls** area. *Note: Hover the mouse over the icons to see the names.*

18. Drag your cursor into Sheet1, and click and drag to draw a square to add the converter button. The **Assign Macro** dialog box will appear. On the **Assign Macro** dialog, click the **New** button to create a macro associated with the button. The macro development window will open.

19. Open the text file called macro in the Data folder, and copy and paste the code provided into the macro development window between the beginning (Sub) and end (End Sub) of your subroutine.

20. Save the macro and the worksheet by clicking the save icon or through **File > Save**.

21. Navigate back to the ALL_TEMPORARY.CSV file and click the button you created on Sheet1. This will populate Sheet2 with the one-second averaged data. Save Sheet2 to preserve your changes. Then Save Sheet2 as May30_1140_ALL.CSV by clicking **File > Save As** with Sheet2 active. Be sure to save it as a CSV.

22. On the new file (May30_1140_ALL.CSV), remove Sheet1, and keep Sheet2. For the remainder of the exercises, you will use this file. A file called May30_1140_ALL_EXAMPLE.CSV is included in the data folder for comparison if you would like to check to ensure the processing was completed correctly.

Q1 Using the May30_1140_ALL.CSV file, calculate how long the instruments were capturing measurements (i.e., the difference between the first timestamp and the last). Provide your answer in minutes.

Q2 What was the maximum altitude recorded by the UAS during this flight?

Q3 The negative heights (altitudes) are due to small atmospheric pressure fluctuations that occurred while the UAS was resting on the ground. How long (in seconds) were the instruments taking data before the UAS started to ascend?

Q4 Did the UAS take longer to ascend or descend?

EXERCISE 2: VISUALIZING METEOROLOGICAL AND CO_2 BOUNDARY LAYER DATA

In this exercise, you will visualize profile measurements captured in the ABL (temperature and relative humidity) and examine how the ABL impacts CO_2 using meteorological data and CO_2 measurements collected from UAS flights at the Kessler Field Station during May and June 2019.

You can complete this part using any spreadsheet software or programming language, but the steps below are designed for Excel.

1. Open `May30_1140_ALL.CSV` in Excel. Rename the sheet with the local time of the flight. During May and June, Oklahoma is 5 hours behind UTC so 1140 UTC is 6:40 am local time. Save the document as an Excel workbook (`May30.xlsx`).

2. Open the file containing the second flight of the day (`May30_1230_ALL.CSV`). Select all of the columns, copy, and paste the data into a new sheet in the May 30 Excel workbook (`May30.xlsx`). The first row should contain the column headings (e.g., TimeStamp, Altitude), and the TimeStamp should be in column A. Rename this sheet with the local time of the flight (i.e., 7.30 am).

3. Repeat Step 2 for the four remaining files containing data from flights on May 30 (1315, 1400, 1500, 1535). At the end, you should have one Excel workbook containing six labeled sheets (one for each flight).

4. For the first flight of the day (6.45 am), select column B (Altitude) and create a plot showing the altitude of the flight with time (Figure 19.3). Take note of the row when the altitude starts increasing (the ascent) and when the altitude begins to decrease (i.e., the descent begins). Label the figure and axes. Repeat to create a plot for each flight of the day.

5. Create a plot of carbon dioxide during only the *ascending* portion of the flight. Carbon dioxide concentration should be on the x-axis, and altitude on the y-axis. You will have two profiles of carbon dioxide from the two sensors in a single graph (CO2_1 in column C and CO2_2 in column D). Label the figure, axes, and add a legend for the two CO_2 profiles. You

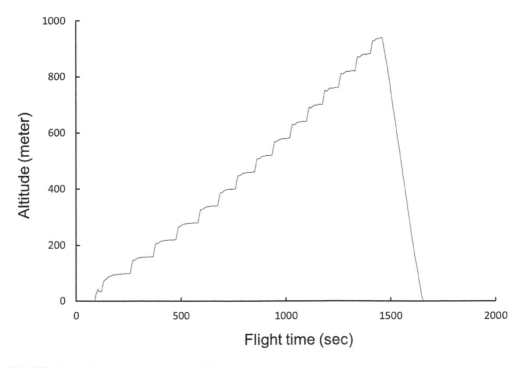

FIGURE 19.3 Example plot showing altitude plotted on the y-axis and the time that has elapsed during the flight on the x-axis. A chart like this can be created by highlighting the column of Altitude data and selecting a 2D line option under Charts.

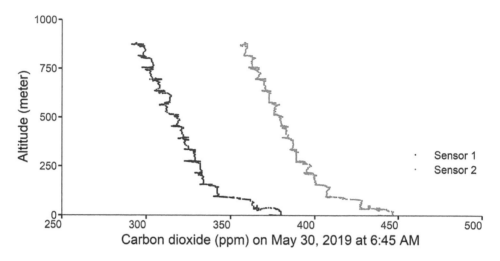

FIGURE 19.4 Example plot showing CO_2 measurements plotted on the *x*-axis against altitude plotted on the *y*-axis. The plot was made using data from two sensors created during Step 5 of Part 2.

may need to adjust the range of the *x*-axis to show all your data. An example plot is shown in Figure 19.4.

Note: this plot can be a bit tricky in Excel. Select both the CO2_1 and CO2_2 columns and select a 2D line chart. By default, the profiles are plotted horizontally instead of vertically. To flip the x- and y-axes, you need to edit how the data are displayed. Right-click the chart > Select Data. Click on "Series 1," then click Edit. The "Edit Series" window will open. Under "Series X values," change the values so that the data are reading the C column. Under "Series Y values," change the values so that the data are being pulled from the "B" column. Click OK when you are done.

The sensors used to measure carbon dioxide can have unique biases, so the sensors should be calibrated with an on the ground gas analyzer. These calibrations generate offsets that can then be applied to each sensor. The offset for **CO2_1** is 31.67 ppm, and the offset for **CO2_2** is -14.20 ppm.

6. Create two new columns in I and J to calculate the corrected, or offset applied, CO_2 data. Label column I **Offset_CO2_1** and label column J **Offset_CO2_2**.

7. In cell I2, type =C2+31.67 and hit enter. To autofill the entire column, double-click on the bottom-right corner of the cell.

8. In cell J2, type =D2-14.20 and hit enter. Repeat the process to autofill all cells in the column. Repeat this step for each one of the flights (i.e., each sheet in your Excel Workbook).

9. Next, create a plot showing TEMP1 (*x*-axis) with Altitude (*y*-axis) from the first flight of the day for the *ascending* part of the flight only (use the rows you noted in Step 4 to select only ascending data). Label your plot and axes and adjust the axis ranges if needed.

10. Add the temperature from the second flight of the day to the TEMP1 profile you created in Step 7. To do this utilize the **Select Data** function in Excel and add a new set of data from the sheet labeled "7.30 am." Be sure to only select data collected once the UAS began to ascend. A good rule of thumb is to look for altitude readings greater than 1 and then verify that the measurements increase from there. Repeat this process of adding the TEMP1 data from the ascent to the graph for each flight of the day. At the end, you should have six temperature profiles on one plot. Add a legend.

11. Repeat Steps 7 and 8 to create similar plots for TEMP2, RH1, RH2, Corrected CO2_1 (column I), and Corrected CO2_2 (column J). Clearly label all figures and axes, adjusting ranges if necessary, and adding legends to all six plots that show profiles during the ascending portion of all six flights on May 30th.

12. Repeat steps 1–9 for the flights from June 7th, using the same CO_2 offset values as in Step 6. Begin with the first flight of the day contained in file `Jun7_1100_ALL.CSV`. Title this workbook "June7.xlsx."

Q5 Using the graphs of altitude that you created in Step 4, describe the general pattern of how the UAS ascended and descended during the flights. What might be the reason for following this type of flight pattern when capturing atmospheric measurements? Discuss why the pattern on the ascent does not match the pattern on the descent for most of the flights.

Q6 On which date and at what time did the highest flight occur? How long did it take for the UAS to ascend during this flight? How long did it take for the UAS to descend? (*Note: the time-stamps for the June 7 data are in milliseconds*)

Q7 For the first flight on May 30th (6:45 am), what impact do the offsets have on the CO_2 profile? Is there more agreement between the sensors after the bias correction was applied? Include two plots with your answer, one showing the uncorrected CO_2 data and one showing the corrected CO_2 data for the first flight.

Q8 Visually examine all six profiles of each variable with time for both days. Do any of the measurements look questionable? For example, do the two sets of temperature measurements from the two sensors (TEMP1 and TEMP2) differ dramatically during any of the flights? Do any of the CO_2 measurements have a larger amount of noise during any flights? What factors might introduce noise into atmospheric measurements captured from a UAS?

The following questions ask you to consider the structure and evolution of the ABL in the UAS data. You may want to return to the introduction to remind yourself of the evolution of the ABL, including lapse rates, inversions, and stable layers.

Q9 Compare and contrast the temperature evolution with time as measured by TEMP2 on May 30th and June 7th. Determine the change in temperature between the first flight of each day and the final flight of each day near the surface (below 50 m) and above 500 m. What are the differences between the first and final flights at the two altitudes?

Q10 Are any inversions present in the TEMP2 data? Only consider it an inversion if there is a consistent increase with height over at least 50 m. On what days and times did the inversions occur, and at what altitudes were the inversions?

Q11 The lapse rate (with units of K per meter) is the rate at which temperature decreases with height. Examining the TEMP2 temperature profiles for each day, how does the lapse rate between the surface and the top of the ascent vary over time?

Q12 Compare and contrast the RH evolution with time as measured by RH1 on May 30th and June 7th. Determine the change in RH between the first flight of each day and the final flight of each day near the surface (below 50 m) and above 500 m.

Q13 Examine your corrected CO_2 plot for sensor 1 (**Offset_CO2_1**) for May 30th. Which flight time had the largest CO_2 value? What was the value and at what height did it occur? Which flight time had the smallest CO_2 value? What was the value and at what height did it occur? Repeat this analysis (with **Offset_CO2_1**) for the flights on June 7th. How do your answers change?

Q14 On what day and at what time do you observe the largest change in CO_2 with height? By how much does it change?

Q15 Does CO_2 near the surface increase or decrease during the morning evolution of the boundary layer? What might explain why the amount of CO_2 in the atmosphere is changing during this transition time?

DISCUSSION AND SYNTHESIS QUESTIONS

S1 A temperature inversion indicates that the atmosphere is stable, and any air that is forced to move upwards will return to its original position. Examine the **TEMP2** and **Offset_CO2_1** plots from May 30th side by side, with particular focus on the lowest 300 m. How does a temperature inversion near the surface impact the amount of CO_2 and how it is distributed near the surface?

S2 Relative humidity is a ratio between how much water vapor is in the air and the maximum amount of water vapor air at that temperature is able to hold. Warmer air can hold more water. Examine your **TEMP2** and **RH2** plots from June 7th side-by-side. Does the change in relative humidity between the first and last flights of the day below 500 m match with theory? Why or why not?

S3 Does the morning boundary layer transition impact the vertical distribution of CO_2? All profiles were collected when the winds were relatively calm. If the winds were strong, and there was a large amount of mixing and turbulence in the boundary layer, how might the temperature, relative humidity, and CO_2 profiles differ?

S4 These data were collected in May and June in the U.S. Great Plains during a wet year. Vegetation was lush and green. Hypothesize how the amount of CO_2 in the boundary layer might change during a drought year when vegetation is reduced, dry, and/or dead. How might the CO_2 profiles differ in an urban environment?

S5 How would you expect these profiles to differ in 20 years if anthropogenic (human) emissions of carbon dioxide continue on their current path?

S6 As you saw in Part 2, some data are noisier than others (e.g., CO_2 8.15 am June 7th). What are some ways in which you could process the data to remove or minimize this noise?

COLLECTING THE DATA YOURSELF (OPTIONAL)

The data in this exercise were collected using a Tuffwing UAV Mapper, which is a commercially available airframe kit (Figure 19.5a), that was customized. The primary payload consisted of a pair of nondispersive infrared (NDIR) CO_2 sensors (SenseAir K30-FR) enclosed in a 3D printed case. Air from the environment in which the UAS is flying enters a 3D printed scoop (Figure 19.5b) on the exterior of the aircraft and is directed into plastic tubing that carries the flow of air between the two sensors. A diaphragm pump is used to pull the air through the cell and out an exhaust line near the rear of the airframe. The scoop is also equipped with two HYT 271 humidity sensors that can provide temperature and humidity readings of the parcel being sampled.

Mission Planner, an open-source software, was used to program a flight plan before operations, transmit the commands to the vehicle over telemetry, and monitor parameters and mission progress during flight. The data collected in this exercise used a **loiter ascent mode**, where a complete

FIGURE 19.5 (a) The fixed-wing sUAS, outfitted with a thermodynamic scoop and CO_2 payload, and (b) detailed view of the thermodynamic scoop with CO_2 intake of air occurring after encountering thermodynamic sensors.

oval loop was flown at a fixed altitude before stepping up to the next altitude. The number of steps, distance between steps, and maximum altitude were governed by the prevailing wind speed and cloud cover impacting the endurance of the aircraft, with a maximum permissible altitude at the field station of 5000' (1524 m) AGL. In general, loiter loops were spaced at least 50 m apart vertically. The outputs from the sensors and the vehicle autopilot provide a raw dataset, which is downloaded from the autopilot (as a .bin files) and converted to .csv files to be processed as shown in Exercise 1.

One additional consideration when processing CO_2 data collected by NDIR sensors is whether to apply a temperature and pressure correction. The volume of air is affected by the temperature and pressure but the concentration, or number of CO_2 molecules i not. By correcting for temperature and pressure variations, a more accurate value of CO_2 concentration in parts per million (ppm) can be obtained. The data provided in this chapter does not employ a pressure or temperature correction to the data, but this can be calculated from the provided data by employing the ideal gas law.

REFERENCES

Armstrong, E., Valdes, P., House, J., & Singarayer, J. (2019). Investigating the feedbacks between CO2, vegetation and the AMOC in a coupled climate model. *Climate Dynamics*, 53, 2485–2500.

Biraud, S., Torn, M., Smith, J., Sweeney, C., Riley, W., & Tans, P. (2013). A multi-year record of airborne CO2 observations in the US Southern Great Plains. *Atmospheric Measurement Techniques*, 6, 751–763.

Greene, B.R., Segales, A.R., Bell, T.M., Pillar-Little, E.A., & Chilson, P.B. (2019). Environmental and sensor integration influences on temperature measurements by rotary-wing unmanned aircraft systems. *Sensors*, 19, 1470.

Hammerling, D.M., Michalak, A.M., O'Dell, C., & Kawa, S.R. (2012). Global CO2 distributions over land from the Greenhouse Gases Observing Satellite (GOSAT). *Geophysical Research Letters*, 39.

Jacob, J.D., Chilson, P.B., Houston, A.L., & Smith, S.W. (2018). Considerations for atmospheric measurements with small unmanned aircraft systems. *Atmosphere*, 9, 252.

Keeling, C.D. (1998). Rewards and penalties of monitoring the Earth. *Annual Review of Energy and the Environment*, 23, 25–82.

Keeling, C.D., Piper, S.C., Bacastow, R.B., Wahlen, M., Whorf, T.P., Heimann, M., & Meijer, H.A. (2001). Exchanges of atmospheric CO_2 and $13CO_2$ with the terrestrial biosphere and oceans from 1978 to 2000. I. Global aspects.

Lan, X., Tans, P., Sweeney, C., Andrews, A., Jacobson, A., Crotwell, M., Dlugokencky, E., Kofler, J., Lang, P., & Thoning, K. (2017). Gradients of column CO_2 across North America from the NOAA Global Greenhouse Gas Reference Network.

Saeki, T., Maksyutov, S., Sasakawa, M., Machida, T., Arshinov, M., Tans, P., Conway, T., Saito, M., Valsala, V., & Oda, T. (2013). Carbon flux estimation for Siberia by inverse modeling constrained by aircraft and tower CO2 measurements. *Journal of Geophysical Research: Atmospheres*, 118, 1100–1122.

Schimel, D. (2007). Carbon cycle conundrums. *Proceedings of the National Academy of Sciences*, 104, 18353–18354.

Glossary

Active sensors: sensors that rely on measuring signals transmitted by their own source of energy (e.g., lidar), as opposed to sunlight.

Aerial cinematography: the art of photography and camera work in filmmaking from an overhead perspective.

Air base: the distance between two consecutive images on the ground.

Anemometer: measures wind speed by sending sound pulses back and forth between its sensors and measuring the speed of sound as it is changed slightly by the wind.

Atmospheric boundary layer: lowest portion of the atmosphere near the surface of the Earth

Boresight calibration: the process of computing exactly how the drone is moving so that the imagery or data being collected can be used for accurate measurements

Camera angle: position of the camera when a shot or image is captured

Camera obscura: earliest version of a light projection box, invented in the 11th century

Coastal foredune: a shore-parallel sand ridge that develops on the upper beach by deposition of windblown (aeolian) sand in vegetation

Combined georeferencing: see Georeferencing

Communications geography: a subdiscipline of geography that explores the relationships between information and communication technologies and human conceptions of space and place.

Control station: an interface used by the remote pilot or the person manipulating the controls to control the flight path of the UAS

Direct georeferencing: see Georeferencing

Discrete return: a lidar system that records multiple, individual points corresponding to the largest returns, or peaks, in the distribution of reflectance being received from the target.

Dishing: concave vertical artifacts that occur due to the image capture approach and flight plan

Doming: convex vertical artifacts that occur due to the image capture approach and flight plan

Familiar landscapes: areas where copious contextual data are available to aid the mission planning process

Feature detection (step in SfM): identifies distinct pixels within each image such as edges/corners of key objects.

Feature points: points that can be tracked from one image to another

Flight line spacing: the distance in the air between two adjacent flight lines

Forward overlap: the amount of image overlap intentionally introduced between adjacent images taken successively along a flight line.

Framing sensors: sensors that capture a snapshot of an area, which is then projected onto film or a two-dimensional array of detectors located in the camera focal plane.

Full waveform: a lidar system that records the full distribution of light that is reflected back to the sensor

Geomorphic change detection: using repeat, topographic surveys to infer changes in landforms or landscapes

Geomorphology: the study of landforms and their formative processes

Georeferencing: process of aligning the images to a known coordinate system or tying input data to its real-world. For SfM, georeferencing can be direct, indirect, or combined. **Direct georeferencing** uses images that have location information stored with exchangeable image file format (EXIF) standard metadata to scale and transform the model to real-world coordinates. **Indirect georeferencing** Uses data collected on the ground

(i.e., ground control points) to transform the model. The **combined** approach uses both known locations of the cameras and on ground data to transform the model.

Geoweb: short for "geospatial web," this term refers to the self-synchronization of network addressing, time and location that would allow location to be used to self-organize all geospatially referenced data available through the Internet.

Gimbal: device that holds and stabilizes the sensor from vibrations or platform movement

Global shutter (camera): captures entire scene at once

Greenhouse gas: gases in the atmosphere, such as CO_2, methane, and water vapor, that can absorb energy emitted from the Earth and trap it in the atmosphere as heat.

Ground control point (GCP): a known location within an imaged scene that can be used to indirectly georeference SfM point cloud data.

Ground control station: see Control Station

Ground coverage (image): distance on the ground covered by one side of the sensor array

Image classification: process of turning pixel reflectances or brightness values into useful information on the land covers in the landscapes.

Image enhancement: techniques applied to images to improve their appearance, making them easier to interpret

Image overlap: amount of overlap in the ground coverage of two adjacent (overlapping) images

Image scale: ratio of the distance of the image to the corresponding distance on the ground.

Image stitching: process of combining multiple images to create a seamless image or photomosaic.

Indirect georeferencing: (see Georeferencing)

Inertial measurement unit (IMU): a device containing gyrometers and accelerometers to measure rotation and acceleration

Infrared: type of light that is 'beyond the red light' region of the EM spectrum when referring to its wavelength

Inversion (atmospheric): when the stable atmospheric boundary layer is characterized by an increase in temperature with height

Lapse rate: rate at which temperature (or other atmospheric variables) change with altitude

Lidar: acronym for Light Detection and Ranging, sometimes written LiDAR

Loiter ascent mode: flight mode for UAS ascent where a complete oval loop is flown at a fixed altitude before stepping up to the next altitude

Macros: programs written in Visual Basic for Applications (VBA) to automate tasks in Excel

Mesh surface: a 3D structure on which the photos are fitted to create an orthophoto. It is similar to a triangular irregular network (TIN) but produced from a Structure from Motion point cloud.

Mesonets: networks of ground weather stations that have been constructed in many regions to observe mesoscale meteorological phenomena

Microbolometers: sensors designed to detect the radiation, or heat, emitting from a body or object

Mission: a flight design that provides the UAS flight control device with commands and instructions on where and how to fly over an area of interest.

Morning boundary layer transition: diurnal transition that occurs as the sun warms cool air near the surface of the Earth, causing it to mix with warmer air above.

Morphodynamics: changes in process-response system function and form over space and/or time

Multi-view stereo (MVS): an image processing technique, applied following Structure from Motion (SfM), that creates dense three-dimensional point cloud data from a series of overlapping two-dimensional images.

Nadir: point on Earth directly below the sensor or observer, which derives from the photographer, Nadar, who took the first aerial photo from a hot air balloon

Nocturnal inversion: atmospheric phenomenon that commonly occurs at night when warmer, less dense air sits on top of cooler, denser air.

Nugget effect (semivariogram): phenomena that occur when there is considerable variation between samples even at very small sample separation distances

Orthomosiac: a wall-to-wall view similar to what you would see in the satellite view of Google Maps created by stitching together overlapping, geometrically corrected orthophotos.

Oblique photograph: photographs taken when the angle of the camera is greater than 3 degrees

Orthophoto (or orthophotograph): aerial image that has been geometrically corrected, or orthorectified, to remove terrain effects and distortions that result from the camera angle and lens so that measurements can be made on the photograph as if it were a scaled map

Participatory mapping: when local communities take part in the creation of maps that often include their local knowledge and priorities and give a voice to marginalized populations.

Participatory methods: activities that enable people to play an active and influential part in the decision-making and data collection process associated with research that affects their lives.

Passive sensors: sensors that rely on an existing light source to illuminate objects or features.

Payload: load that a platform can carry

Person manipulating the controls: a person other than the remote pilot-in-command (PIC), who is controlling the flight of the UAS and is under the supervision of the remote PIC

Pilot-in-command (PIC): a person who holds a remote pilot certificate with an sUAS rating and has the final authority and responsibility for the operation and safety of an sUAS operation

Pushbroom sensors: operate by capturing images one row one at a time

Perspective: angle at which an object is viewed

Photogrammetry: science of obtaining reliable measurements of distances on Earth's surface via photographs

Point cloud: a vector dataset containing *XYZ* locations (i.e., latitude, longitude, elevation, or a local or arbitrary coordinate system). Individual points can have attribute data including RGB color information if created using Structure from Motion and/or Multi-view Stereo, a classification code identifying what the point represents on the ground (e.g., high vegetation, ground, building), etc.

Process-response systems: systems where exchanges of matter and energy via Earth surface processes give rise to distinct landforms and landscapes

Profiles: vertical meteorological measurements captured in the atmosphere

Radar: an active remote sensing technology for detecting, locating, tracking, and recognizing objects of various kinds at considerable distances from the sensor

Radiometry: the science of measuring electromagnetic energy

Radiosonde: small, expendable sensor package attached to weather balloons to capture meteorological data

Range (semivariogram): the spatial lag, or distance between samples, at which variance plateaus in the semivariogram

Regionalized variable: term used in spatial statistics and geostatistics to describe variables that are distributed in space

Regulation: statement issued by an agency on how that agency will enforce laws under its directive

Remote sensing: science and art of obtaining reliable information about an object, area, or phenomenon through the analysis of data acquired by a device that is not in contact with whatever is being measured

Rolling shutter (camera): scans across the scene

Sample variogram: a graph of the plotted semivariogram points

Semivariogram: a tool used in spatial statistics and geostatistics to evaluate the scales of spatial dependence in a measured variable. It is created by plotting the variance between sets of sample pairs that are separated by the same (or similar) distances

Side overlap (sidelap): the amount of overlap between images from adjacent flight lines.

Sill (semivariogram): the semivariance value on the y-axis at the point where the range occurs.

Spatial autocorrelation: the similarity of a variable with itself through space

Spatial dependence: the value of a variable measured at one location depends, in some way, on the value measured for that same variable at a different location.

Spatial frequency: the number of changes in pixel brightness values per unit distance in an image

Spatial lag: the distance between samples

Spatial media: the new set of services and channels that enable and enhance our ability to interact with and create geographic information online networked or cyberinfrastructure environments

Stereoscopic parallax: the change in position of an object from one photograph to the next caused by the change of perspective

Stereoscopic representation: the merging of two or more perspectives into a 3D representation of the object or scene

Strahler method: a method of stream ordering devised to characterize the confluence of smaller stream channels into larger channels in a watershed. All links without any tributaries are assigned an order of 1 and are referred to as first order. Stream order increases only when streams of the same order intersect.

Structure from Motion (SfM): an image processing technique that creates sparse three-dimensional point cloud data from a series of overlapping two-dimensional images.

Thalweg: line of lowest elevation in a channel

Unfamiliar landscape: areas where high-resolution imagery is unavailable or landmarks are absent in the mission planning software

Unix Epoch: timestamp based on the number of seconds that have elapsed since 1 January 1 1970

Vertical photographs: images captured with the optical axis of the camera within +/– 3 degrees from perpendicular to Earth's surface

Visual observer: a person acting as a flightcrew member who assists the small UA remote pilot in command and the person manipulating the controls to see and avoid other air traffic or objects aloft or on the ground.

Waypoint: sets of coordinates to locate the beginning and end points of each flight line or a target location for the UAS.

Wavelength: the distance from one electromagnetic wave crest to the next

Weather balloon (sounding balloon): a special type of high-altitude balloon that carries meteorological instruments through the atmosphere and transmits data on atmospheric pressure, temperature, humidity, and wind speed back to a ground station on Earth by means of a small, expendable device called a radiosonde.

Index

Milton Keynes UK
Ingram Content Group UK Ltd.
UKHW050301161024
449569UK00051B/737